Rethinking Curating

Leonardo

Roger F. Malina, Executive Editor

Sean Cubitt, Editor-in-Chief

See <http://mitpress.mit.edu> for a complete list of titles in this series.

Rethinking Curating

Art after New Media

Beryl Graham and Sarah Cook

foreword by Steve Dietz

The MIT Press
Cambridge, Massachusetts
London, England

For information about special quantity discounts, please email special_sales@mitpress.mit.edu

This book was set in Stone Sans and Stone Serif by Graphic Composition, Inc.
Printed and bound in the United States of America.

Library of Congress Cataloging-in-Publication Data

Graham, Beryl.
Rethinking curating: art after new media / Beryl Graham and Sarah Cook; foreword by Steve Dietz.
p. cm. — (Leonardo books)
Includes bibliographical references and index.
ISBN 978-0-262-01388-8 (hardcover: alk. paper)
1. New media art. 2. Museums—Curatorship. I. Cook, Sarah, 1974– II. Title.
NX456.5.N49G73 2010
709.04'07075—dc22

2009018942

10 9 8 7 6 5 4 3

Contents

Acknowledgments

The Curatorial Resource for Upstart Media Bliss (CRUMB) for curators of new media art is a collective effort, and first thanks go to all those who generously have shared their knowledge on the CRUMB discussion list, at symposia, at CRUMB crisis/bliss workshops, or through interviews on the Web site. CRUMB's research activities are supported by the University of Sunderland and have received substantial funding from the Arts and Humanities Research Council of the United Kingdom. Sarah Cook's postdoctoral post has also been supported by an Early Career Fellowship from the Leverhulme Trust, 2006–2008. Particular thanks go to Brian Thompson at the University of Sunderland for his long-term support and enthusiasm, and to Tim Brennan for establishing the new master's in curating at the university, which has informed this book. We thank Doug Sery at the MIT Press for supporting this book over a number of years as well as Roger Malina and past and present Leonardo series editors Joel Slayton and Sean Cubitt for their help.

Thanks to all those who read drafts of chapters and offered feedback throughout the writing process, including curators Jean Gagnon, Christiane Paul, Ronald Van de Sompel, Steve Dietz, Kelli Dipple, Chris Byrne, Tom Holley, Axel Lapp, and Susan Kennard, as well as artists Saul Albert, Kate Rich, Jon Thomson, and Alison Craighead. Special thanks to CRUMB's postdoctoral researcher Verina Gfader for reading, editing, tracking references, image research, and more. Ilana Mitchell, Heather Russell, Jo Wilson, Kate Taylor, and Deborah Bower ably supplied other editorial work, and Valerie Cornell and Becky Thompson did transcription work. Our partners in CRUMB's latest networked-research initiative, Charlie Gere at the University of Lancaster and Amanda McDonald Crowley at Eyebeam, were also terrifically supportive—Amanda provided opportunities for curatorial practice and Charlie offered encouragement about the writing process.

Both authors thank their families and friends for putting up with them during lengthy periods of being absent-minded (and overtaxed) writers who did not (have time to) reply to e-mail. Beryl Graham thanks, in particular, M for dense R&R and all the wolves of Black Wood for keeping her just about sane. Sarah Cook offers her gratitude to her network of collaborators on the many exhibitions and curatorial projects she foolishly undertook at the same time as writing this book, which only served to remind her how much she enjoys curating new media art in the first place.

Series Foreword

The arts, science, and technology are experiencing a period of profound change. Explosive challenges to the institutions and practices of engineering, art making, and scientific research raise urgent questions of ethics, craft, and care for the planet and its inhabitants. Unforeseen forms of beauty and understanding are possible, but so too are unexpected risks and threats. A newly global connectivity creates new arenas for interaction between science, art, and technology but also creates the preconditions for global crises. The Leonardo Book series, published by the MIT Press, aims to consider these opportunities, changes, and challenges in books that are both timely and of enduring value.

Leonardo books provide a public forum for research and debate; they contribute to the archive of art-science-technology interactions; they contribute to understandings of emergent historical processes; and they point toward future practices in creativity, research, scholarship, and enterprise.

To find more information about Leonardo/ISAST and to order our publications, go to Leonardo Online at <http://lbs.mit.edu/> or e-mail <leonardobooks@mitpress.mit.edu>.

Sean Cubitt
Editor-in-Chief, Leonardo Book series

Leonardo Book Series Advisory Committee: Sean Cubitt, *Chair*; Michael Punt; Eugene Thacker; Anna Munster; Laura Marks; Sundar Sarrukai; Annick Bureaud

Doug Sery, Acquiring Editor
Joel Slayton, Editorial Consultant

Leonardo/International Society for the Arts, Sciences, and Technology (ISAST)

Leonardo, the International Society for the Arts, Sciences, and Technology, and the affiliated French organization Association Leonardo have two very simple goals:

1. to document and make known the work of artists, researchers, and scholars interested in the ways that the contemporary arts interact with science and technology and

2. to create a forum and meeting places where artists, scientists, and engineers can meet, exchange ideas, and, where appropriate, collaborate.

When the journal *Leonardo* was started some forty years ago, these creative disciplines existed in segregated institutional and social networks, a situation dramatized at that time by the "Two Cultures" debates initiated by C. P. Snow. Today we live in a different time of cross-disciplinary ferment, collaboration, and intellectual confrontation enabled by new hybrid organizations, new funding sponsors, and the shared tools of computers and the Internet. Above all, new generations of artist-researchers and researcher-artists are now at work individually and in collaborative teams bridging the art, science, and technology disciplines. Perhaps in our lifetime we will see the emergence of "new Leonardos," creative individuals or teams that will not only develop a meaningful art for our times but also drive new agendas in science and stimulate technological innovation that addresses today's human needs.

For more information on the activities of the Leonardo organizations and networks, please visit our Web sites at <http://www.leonardo.info/> and <http://www.olats.org >.

Roger F. Malina
Chair, Leonardo/ISAST

ISAST Governing Board of Directors: Roger Malina, Jeffrey Babcock, Greg Harper, Meredith Tromble, Michael Joaquin Grey, John Hearst, Sonya Rapoport, Beverly Reiser, Christian Simm, Joel Slayton, Tami Spector, Darlene Tong, Stephen Wilson

Foreword

At some point soon after I had founded the new media art program at the Walker Art Center in 1996, I was speaking with the museum director, who said words to the effect that to her eye, Net art just wasn't visually compelling. I responded with words to the effect that maybe (certainly) Net art wasn't "about" looking like the painting or sculpture or installations or video or film or performances normally presented at the Walker, despite its institutional predisposition for the avant-garde in multiple disciplines. Maybe (certainly) it was about, for instance, interactivity, networks, and computation as much as about how it looked. To her credit, she "got" the general point and seemed to accept it as a legitimate argument about how to approach a new art form, even if she never fully immersed herself in the specifics or embraced the art form itself.

I wish I had had this book then.

My subsequent experience ranged from curating the online Net art *Gallery 9* and commissioning collaborative installations by Raqs Media Collective with Atelier Bow-Wow in a multidisciplinary museum context to presenting large-scale, interactive, and participatory public art such as Akira Hasegawa's *D-K San Jose* in a multidisciplinary biennial context. The scope of these contexts means that the scope of the understanding also needs to be broad. *Rethinking Curating: Art after New Media,* however, clearly articulates an often obfuscating set of issues, including the internecine debates that too easily divide what Lev Manovich refers to as Turing-land (so-called new media art) and Duchamp-land (so-called contemporary art). Beryl Graham and Sarah Cook rigorously differentiate and compellingly reintegrate the competing claims of these two camps so that we can focus on what really matters: the art.

Rethinking Curating is based not only on the authors' own extensive curatorial work in a wide range of contexts, but also on a generous accumulation of community knowledge and experiences. The online program that Beryl and Sarah run, the Curatorial Resource for Upstart Media Bliss, or CRUMB, is the source of much of this community-based praxis, but the authors also range far and wide from other Net lists to contemporary art theory. Although perhaps not their primary intention, this book reminds me of the

Whole Earth Catalog or, perhaps a little closer to home, *A Concise Lexicon of / for the Digital Commons* by Raqs Media Collective. Both crystallized a certain cultural moment not with abstract theory, but with an almost exhaustive cataloging of actual experience by a community of practitioners. In *Rethinking Curating,* the sheer depth and breadth of intelligent reflection among a dedicated, global group of loosely aligned peers belie every summative, simplistic question or statement one has heard or made. "How much does it cost?" "What's new about it?" "Why is it art?" "What's next?" "It's about process." "It's computational." "It crosses boundaries." "It's new." These questions and statements are not "bad," but in this book Beryl and Sarah give them the context they deserve—the context necessary to move on to the real-world questions and issues of working with dynamic and emerging contemporary art.

This book is, of course, more than a compilation—more than an oral history of a merry band of pranksters knocking at the gate. It ultimately is a subversive and passionate argument with two prongs: it's not a book about new media, it's about art; it's not a book about curating new media, it's about rethinking curating.

Graham and Cook strategically define so-called new media as a set of behaviors, not as a medium. Once you go down this road, it becomes readily apparent that a similar strategy is equally useful for much of contemporary art. At one time, the new media of photography both changed the aesthetic understanding of painting and participated in the creation of a cultural understanding of (fixed) time and representation. At another time, the new media of video changed the aesthetic understanding of film while participating with television in the creation of a cultural understanding of (real) time and distance. The art most recently known as "new media" changes our understanding of the behaviors of contemporary art precisely because of its participation in the creation of a cultural understanding of computational interactivity and networked participation. In other words, art is different after new media because of new media—not because new media is "next," but because its behaviors are the behaviors of our technological times.

Similarly, although pragmatic issues attend the curating and presentation of the art formerly known as "new media," from bandwidth to special ports that may need to be opened in a firewall to allow passage of a certain Internet protocol, there is also the exciting opportunity for new modes of curating of any art form, from collaborative to participatory to algorithmic, and in any setting, institutional or alternative.

The book is thus both a bridge and a goad. It is a bridge to the so-called contemporary art world, whether institutionalized or alternative, in that it lays out so clearly and knowledgably how the art of Turing-land is both completely consonant with and as distinctive as any other art practice from Duchamp-land, whether it is conceptual or video or performance or activist. Once this realization sinks in—that art in general has been altered after and by new media, or more broadly in "technological times"—it becomes a goad to rethink one's curatorial practice at least to be more inclusive and more repre-

sentative of all of the art of our times. And I believe this to be equally true for curators in either "country."

I often joke that the problems of curating the art formerly known as "new media" are self-correcting. Everyone who isn't a fish swimming in the aquarium of these technological times will eventually die off, and what is strangely disorienting now will become the normative context for a new generation of curators. If we read this book, however, we may lead a more upstart and blissful life.

Steve Dietz
Artistic Director, *01SJ Biennial*
Executive Director, Northern Lights

1 Introduction

New media art: Just like anything else, only different.
—Steve Dietz, "Collecting New Media Art," 2005

As curator Steve Dietz states so succinctly, new media art is like other contemporary art, but it also has particular characteristics that distinguish it from contemporary art and by extension from the systems involved in the production, exhibition, interpretation, and dissemination of contemporary art—the realm of curators. These differences have raised questions regarding the boundaries between kinds of media, types of institutions, and the practical roles of those who work inside and outside of them. Dietz was in this case discussing the collecting (or lack of) of new media art by museums and galleries, and outlining how the perceived differences of new media art did not comprise an insurmountable barrier to its accession into a collection. This book takes on a similar task across the broad field of curatorial activity—looking at the production, exhibition, interpretation, and wider dissemination (including collection and conservation) of new media art.

The book is aimed at curators of contemporary art, but because curating is necessarily led by the art, it should also be of interest to artists and those engaged by the gnarly diversity of the field of new media art. It starts by identifying how some of the characteristics of new media art are like certain characteristics of other art forms more familiar to art curators—including video art, socially engaged art, conceptual art, and performance art. However, new media art forms have suffered in the past from being understood through metaphors that only partially fit. As in the folk tale where several people in a dark place might variously identify the part of the elephant they are touching as a snake, a tree trunk, or wings, which metaphors people use for understanding new media art rather depend on which cultural history they are coming from: thus Internet-founder Ted Nelson might see hypertext where art critic Jack Burnham sees sculpture or media theorist Lev Manovich sees database-driven video narrative.[1] As artist Jon Winet has testified, when working at Xerox's Palo Alto Research Center he found that after a while everything started to look like a "document." He related this experience to a different folk saying: "When you're holding a hammer, everything looks like a nail" (1999).

In order to provide a suitably flexible framework for curators to understand new media art better, this book therefore also attempts to identify exactly how new media is "different," and *to relate these differences as opportunities to rethink curatorial practice.* The starting point for the research that led to this book was the authors' direct experience of curating exhibitions that included new media art—clutching assorted ill-fitting theoretical and practical tools from the varied fields of lens-based media, fine art history, design, installation, philosophy, politics, socially engaged practice, and the art lab. The site for this research is the Curatorial Resource for Upstart Media Bliss (CRUMB), an academic initiative intended to help curators with the challenges and opportunities presented by working with new media art. This is one of the first books authored on the subject (at least at the time of writing), so it bears the burden of having to cover a great deal of ground and having to translate between fields; we hope primarily to explain to curators what is significant about current new media art, but also to reveal some aspects of curatorial practice to those working with new media. We are therefore assuming a certain level of knowledge of contemporary art in the reader, and as such the book differs from other books in this series. What unites the book's aims and you who read it is a fascination with such a stimulating set of art practices. New media art is always the starting point and is what leads this book through the challenges of curating it. The book's first task, therefore, is to explain our understanding both of new media art and of curating.

What Is New Media Art?

Like a shark, a new media artwork must keep moving to survive. . . . Fixity equals death.
—Jon Ippolito, *Standards of Recognition*, 2007

As curator Jon Ippolito states, in terms of naming, labeling, and documenting, it is in the nature of new media art to change, and curators and critics must accept and keep up with that change or risk fixing the art to death. Some part of new media will always be in emergence, and even the historical frames of understanding what is "new" will change (as explored in chapter 2). The exhibition *The Art Formerly Known as New Media* (2005), for example, marked the tenth anniversary of the Banff New Media Institute, a production facility where artists continue to work with many emerging media, from virtual reality in the 1980s to cell phones in 2005. However, rather than select a ten-year timeline of artworks literally produced at the institute, curators Sarah Cook and Steve Dietz chose artists who had studied, researched, and experimented there at some point in the development of their practice, and then selected artworks that had been produced at a later point. As the title of the exhibition suggests, nomenclature might change, but the important thing is the maturity of the artwork rather than the newness of the technology. It is therefore with the proviso that *new media art* is an unsatisfactory term that we attempt to give a working definition of it and to explain why we chose the terminology of *behaviors* rather than *media.*[2]

Figure 1.1
Installation view from the exhibition *The Art Formerly Known as New Media* (2005), showing the timeline of work by irational on the back wall. Photograph by Sarah Cook.

Each of the words in the term *new media art* can be hotly contested. To start with *art,* we do not attempt to define it; rather, we point out that the histories in this book relate not only to art, but also to everyday culture, sociology, politics, commerce, design, science, and technology. As described in this book, new media technologies are used for commerce, education, and social communication as well as for art, and the distinctions between the uses of media in these fields is often blurred. The term *new media* without *art* usually refers to commercial broadcast forms such as interactive television; some people in fine art thus classify all new media as outside the bounds of art and instead as forms of broadcast. If new media art is classified not as art, but as technology or science, then there are more subcategories to be explored, such as software or data visualization. For example, Stephen Wilson includes chapters on biology and physics alongside chapters on algorithms, mathematics, kinetics, telecommunications, digital information systems, and computers in his book *Information Arts* (2001). Some from the field of new media art, however, would exclude biology and physics from their definitions in order to

prioritize the media aspect. Lev Manovich in 1996 controversially drew a line between computer art and fine art by describing the former as being from "Turing-land," based on computer pioneer Alan Turing, and the latter from "Duchamp-land," based on the artist Marcel Duchamp. He characterized Turing-land as a land that takes technology very seriously and is interested in experimental research processes, whereas Duchamp-land satirizes technology and wants a finished art product.[3] Although the divide between the two cultures of art and science is acknowledged in this book—and is an ongoing area of exploration for the MIT Press Leonardo series—we feel that in relation to curating, the divide between the two "lands" may be bridged by the art world's continued interest in process-based artwork and more recently by curators' own interests in participatory and collaborative systems. We also acknowledge that many other lands are being discovered in the gap between new media art and art, but that the gap is getting smaller all the time. In particular, we believe that histories of technology need to be understood alongside histories of art if there is to be a bridge between the lands. The book's second part proposes ways of curating that can value the research processes of Turing-land, such as festivals and laboratories, and the concluding chapter (chapter 11) examines how we might tackle the unresolved categorical tensions between art and technology.

The artworks currently or formerly known as "new media art" have amassed around them a varied nomenclature, including *art & technology, art/sci, computer art, electronic art, digital art, digital media, intermedia, multimedia, tactical media, emerging media, upstart media, variable media, locative media, immersive art, interactive art,* and *Things That You Plug In.* Categories and the terminology of new media art have been frequently explored on the CRUMB discussion list, and in 2004 a small collection of names, terms, and keywords revealed that the naming described not only the media of the artwork, but also genre, content, theme, and everything in between.[4] Unsurprisingly, curators' own categories for describing works of art have perhaps proved most useful for the introduction of new forms of art both to established hierarchies in the art world and to neophyte audiences.

Some Curators' Categories

As curator of new media in an encyclopaedic museum . . . where the art wing includes nine distinct curatorial departments: European Art, Prints and Drawings, Israeli Art, Modern Art, Contemporary Art, Design and Architecture, Photography, East Asian Art, and the Arts of Africa, Oceania and the Americas . . . locating new media in this hierarchy of artistic practice becomes a daunting challenge. Last month we opened a "new media" exhibition *Liquid Spaces* and resolved the classification issue in our institution by locating the show in the Design and Architecture Pavilion. Promoted as an interactive experience . . . in essence the exhibition crossed the boundaries between art, technology, and design and the design gallery location provided the "space" to be able to consider how all these genealogies could come together.
—Susan Hazan, "Re: February Theme of the Month," 2004

The traditional art museum has a set of categories determined by medium, geography, and chronology that was ungainly even before the challenge of new media. In the mu-

seum that curator Susan Hazan mentions, it would be a problem to know where to locate a contemporary photographic artwork created by a Euro-Asian artist or into which gallery (other than "temporary exhibitions") a curator would put an exhibition that included artworks from various departments. In Hazan's case, what is notable is that it was the interactive behavior of the artwork rather than the media used that eventually found it a home within the spaces allocated to design and architecture.

Curators need to be clear about their categories because they need to know what kind of exhibition they are putting together, be it chronological, medium based, or thematic. Curator Christiane Paul's book *Digital Art* (2003) was released at a particularly foggy and confused moment in the history of new media art and provided great clarity in defining where digital media is being used as a tool, a medium, or a theme (for example, "activism" or "embodiment"). Paul also identifies some characteristics of the media, such as "nomadic networks," which have more to do with the ways in which the processes behind the production and the distribution of the artwork function—what we would call the artwork's behaviors. This distinction leads to the set of namings that we decided to use in this book as reflecting those behaviors of new media art that present the greatest opportunity for curators to rethink their practice.

Behaviors, Not Media

Sometimes I use another language to try to look at what I do. It's interesting because First Nations' languages are not object-orientated. They're verb-orientated. They're always doing something so even when you end up with a product, the product has to do something.
—Tom Hill, in Karen Atkinson, "Gathering Voices," 1996

In chapter 3, we describe new media as being characteristically about process rather than object, and Tom Hill's invaluable comment reflects why we are using verbs of behavior rather than nouns of medium to describe artworks. New media art has frequently had problems with categories of medium because of its mixed-media, multimedia, intermedia, or hybrid media nature. These terms are subtly different: a *mixed-media* artwork might include items of felt, bronze, and water in an installation; a *multimedia* CD-ROM in the 1990s might have included sound, still images, and video; *intermedia* was a term used by Fluxus artists who felt their conceptual art and life practices were slipping between established media formats; a *hybrid media* artwork includes a degree of mutual cross-fertilization between media to produce a melded whole. For example, in commercial media, the word *convergence* is used instead of *hybrid,* but on a practical level they mean the same thing: that television, Internet surfing, computer games, and e-mail are likely to meld into one commercial service and possibly one piece of equipment. In acknowledgment of this difficulty with discrete media, some theorists have declared that we are now *postmedia.*[5] The postmedium emphasis on behaviors and context is a highly useful one for considering new media art and is used throughout this book. The trouble with proposing a description not based on media, however, is that there is a tendency to

lapse back into the tradition of art aesthetics that is heavily based on what things look like rather than on how they work, which might lead to mistaken categorization: Lev Manovich (2002, 2007) has pointed out that some art critics have identified the data-based artwork of Lisa Jevbratt (see chapter 3) as "abstract art," when in fact it is highly representational because it represents data and code. New media art therefore may not be ready to be totally postmedia because it demands accurate subcategories of description that can identify the particular behaviors of particular media. The kinds of media employed in the production of a work of art are obviously not unrelated to the kinds of behavior that work will exhibit. In this book, we therefore simply consider artworks by behavior first and then describe the media secondarily, where more detail is needed.

This approach is hardly new: Russian constructivism, for example, was intimately concerned with function and behavior, and considered the characteristics of poster printing or film in terms of their behaviors of reproducibility and distribution. When digital media was being discussed in the 1990s, it could broadly be defined as any digital version of analog media, but was often most usefully defined in terms of what it could do that was not possible or was more difficult previously. Media theorists analyzed the cultural characteristics of digital photography and video, for example, as those of simulation, virtuality, sampling, or montage, and placed them in the wider contexts of images of war, advertising, and technological culture. One example of considering art in terms of "medium-independent behaviors" comes from Blais and Ippolito, who use six nouns from viral genetics as their concepts of the functions of new media art: *perversion, arrest, revelation, execution, recognition,* and *perseverance* (Ippolito 2003, 48; Blais and Ippolito 2006, 231).

Curator Steve Dietz's (1999, 2000b) three categories for new media are *interactivity, connectivity,* and *computability,* which may be present in any combination. Interactivity is evident in Rafael Lozano-Hemmer's *Body Movies,* where a computer program responds to participants' shadows (see chapter 5); connectivity is evident in Thomson & Craighead's *Light from Tomorrow,* which transmits live signals around the world (chapter 3); computability is evident in artworks using algorithmic programming to make generative artworks, such as Cornelia Sollfrank's *Net Art Generator* (chapter 2).

The naming of the behaviors with terms such as *interactivity* and *computability* helps to highlight and then to understand the particular challenges that these behaviors present to curators. For example, the exhibition of work by Monica Studer and Christoph van den Berg, *Package Holiday* (2005), included the installation *Mountain Top* (2005). It consisted of a large-scale digital print of a computer-graphic representation of an alpine landscape on the wall, facing which was a bench for viewers to sit on. A video camera observed the bench, and a small screen on the opposite wall showed the closed-circuit video feed from the camera. The live video of audience members apparently enjoying a mountain view was also streamed live to a Web site, and a text sign in the gallery informed users of this detail. In another room, two kiosks with large LCD wall screens showed *Vue des Alpes,* the

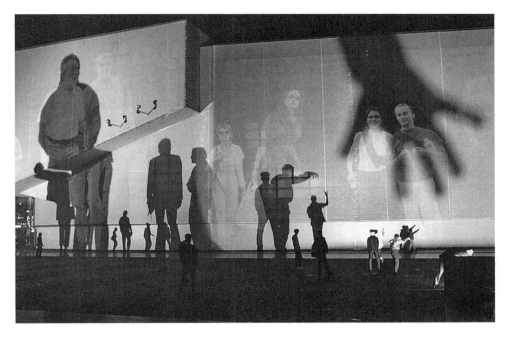

Figure 1.2
Rafael Lozano-Hemmer's *Body Movies, Relational Architecture No. 6* (2001), installed in a public square in Rotterdam, the Netherlands. Photograph by Arie Kievit.

ongoing online project by the artists where users can check in to a Web-based computer-graphic manifestation of a hotel and can explore the fictitious constructed alpine landscape for the duration of their virtual stay. *Mountain Top* was made specifically for the dimensions of the gallery space in the contemporary art center in which it was seen, so was the work therefore a new commission or simply a variable "version" of an installation of *Vue des Alpes*? How is the technology of the display equipment, such as the screens, distinct from the integral components of the artwork, such as the camera or the streaming server or even the bench that technicians constructed to the artists' specifications? Given that the art venue in which *Mountain Top* was exhibited did not have departments with curators responsible for particular media, the mixed-media nature of the work was not a problem, but the work's behaviors sparked discussion. First, the "interactivity" of audience members physically sitting on the bench was addressed by making the physical grammar of the display as obvious as possible: sitting was allowed. The signage stated so, and attendants were briefed to encourage participation. The "connectivity" of the piece raised several questions, including the privacy issue of having to warn the audience that their images were being relayed live to the World Wide Web (where a wider public would know that they were there at that time, with that particular companion).

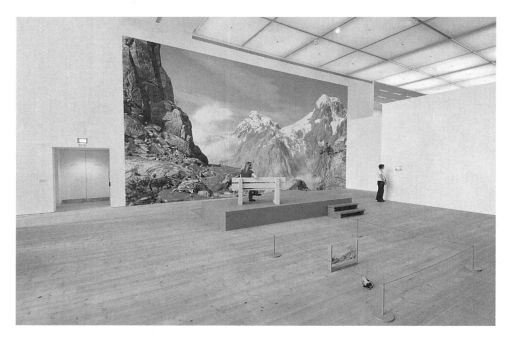

Figure 1.3
Installation view from the exhibition *Package Holiday* (2005) by Monica Studer and Christoph van den Berg, showing the installation *Mountain Top*. Photograph by Colin Davidson, courtesy of the BALTIC Centre for Contemporary Art.

The Internet's connectivity in terms of the wider cultural context of tourism and "life in technological times" in terms of the virtual presence via webcams were highlighted in the interpretative wall-text panels and related educational events. "Computability" was less of an issue, although inherent in the creation of the artwork itself, which was generated through the artists' use of software. That the artists were working in a team with Web programmers and information designers meant that collaborators were necessarily credited on the Web sites. The behaviors of new media frequently raise these issues, and throughout the book we discuss examples that share similar issues of presentation.

The categories of or names for the behaviors exhibited by works of new media art are themselves mutable. Dietz (2004b) has updated his original three characteristics—interactivity, connectivity, and computability—in terms of "virtuality." A few years later Sarah Cook (2004b) pointed out that these terms might have corollaries within the art world that would make these behaviors more familiar to curators: *collaborative, distributed,* and *variable.* The factors of production and distribution recur throughout this book, and the issues of translation between technology and art world languages are reprised in the concluding chapter (chapter 11).

Figure 1.4
Installation view from the exhibition *Package Holiday* (2005) by Monica Studer and Christoph van den Berg, showing the installation of *Vue des Alpes*. Photograph by Colin Davidson, courtesy of the BALTIC Centre for Contemporary Art.

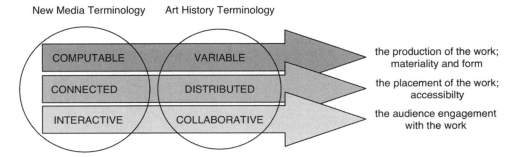

Figure 1.5
Diagram mapping art world terminology onto Steve Dietz's three characteristics of new media art (interactivity, connectivity, and computability). From Cook 2004b, 40.

So, in this book, what is meant by the term *new media art* is, broadly, art that is made using electronic media technology and that displays any or all of the three behaviors of interactivity, connectivity, and computability in any combination. Hence, artworks using digital versions of analog media, such as digital photography, are rarely referred to here and are well documented elsewhere, anyway. Likewise, artworks that may have science or technology as a theme, but that do not use electronic media technology for their production and distribution are not at the center of this book. Artworks showing these behaviors, but that may be from the wider fields of contemporary art or from life in technological times are included, however.

What Is Curating?

For me curating is a mode, not a simple question of display or production, curating is always authorial in some way (I can outsource control but not my responsibility for starting something) and you are likely to find as many models suitable for contemporary art and for new media art, because at its heart curating for me is not about the display of work (be that in a gallery, or on the Internet), it is about the development of critical meaning in partnership and discussion with artists and publics.
—Barnaby Drabble, "Fw: March Theme," 2003

Because of the relative invisibility of the curatorial process, a computer programmer is likely to be just as puzzled as to what curators actually *do* as vice versa. *Curating* is another contested word. As traditionally used, it referred to the act of caring for a collection, and the Latin root *curare* (to care) is reflected in the usage of the noun *curate* in the United Kingdom for someone who assists a priest in caring for the needs of a congregation. So the basic definition is "caring for objects," but a curator of contemporary art is just as likely to be selecting artworks; directing how they are displayed in an exhibition; and writing labels, interpretational material, catalogs, and press releases. The curator is basically in this case acting as a kind of interface between artist, institution, and audience in "the development of critical meaning in partnership and discussion with artists and publics," as Barnaby Drabble states.

Opinions differ, therefore, on the role that a curator should take: Is a curator a curate, humbly caring, or a high priest (or even a god), segregating the sheep from the goats? Some believe that a good curator should be invisible (Burnett 2005), whereas others think he or she should form part of a highly visible star system. The variable roles of curating are illustrated by the different education routes available: although many curators have a background in art history, in many countries there is also an additional choice of museum studies (with an emphasis on collections and interpretation skills), arts administration (finance and management, with an emphasis on events), or contemporary curating (highly variable, but often with a "critical" or cultural theory bent). Much existing curating literature concentrates on theories of curating and can be argued to do more for the reputation of individual curators or theorists than for the sharing of curatorial

skills. A small but growing body of published material specifically concerns "curating now" rather than art theory and describes some curatorial process,[6] but as Maria Lind states, "Mary Anne Staniszewski even suggests that the history of exhibitions is one of our most culturally 'repressed.' The contextualisation of space and its rhetoric have been overshadowed by contextualising in terms of epochs and the artists' oeuvre, despite the fact that exhibition installations have had such a crucial significance for how meaning is created in art" (2005, 91). Although we believe that a good understanding of the art-work—its behaviors, processes, and cultural context—is the vital starting point for all curating, there are roles for the curator that differ fundamentally from the roles of those who are engaged in art history or art criticism, so this book concentrates on the *practice* and *practicalities* of contemporary curating and offers images of exhibition installations wherever possible.

As explored in chapter 6, various "curator as" metaphors might be adapted to the particular challenges of curating new media art, from "curator as filter" to "curator as context provider." Again, this book therefore defines *curating* loosely, leaving room for change and improvement. Rather than describing curatorial practice in terms of schools, gurus, or kinds of exhibitions, we describe the practice critically in terms of *how it works*—the behaviors of curators, as it were, in response to behaviors of new media art in particular contexts, not just museums and not just exhibitions.

The Structure of the Book

It's different when a canon is being created, as opposed to a movement.
—Sara Diamond, in panel discussion in "Sins of Change" conference, 2000

Although new media art cannot really be called a movement, it nevertheless shows a need to keep moving. This need presents a quandary for writing a book, which is necessarily fixed in a moment of time. As discussed in chapter 2, we are at a point on a hype cycle, or perhaps a series of hype cycles, as each new media emerges. That moment is an interstitial one: we are past the heady utopian days when a "democratic" Internet first promised to liberate all art from the stuffy gatekeepers of art museums and yet not quite at the point where new media art is integrated into contemporary arts institutions. Fortunately, this moment is an interesting one, when the practical systems of possible utopias can be critically discussed in the light of experience, but before the exciting possibilities of change in the arts are forged into a heavy immovable canon.

Given that we are using the fixed form of a book, we have had to adapt the form slightly to reflect the timescales of new media art. Because of the hype cycle, we have not necessarily concentrated on the latest emerging technologies, theories, or artworks, but have spread our references over several years, most between 2000 and 2006 (when we founded CRUMB and when we started writing this book), with some material from 2007 to 2009 included in the latter stages of editing. Because fixed theoretical positions and

neologisms tend to look rather foolish in the face of rapid new media change, we have avoided a static model and have used common-language terminologies wherever possible. Therefore, what this book does *not* attempt to do is to write a canon; the artworks included here are chosen as examples of different kinds of new media behavior in relation to curating, not as gold standard models of art. Likewise, the examples of institutions and exhibitions are given not to create model curators, but rather to reveal the processes and methods of curating new media art in ways that might be useful to other curators. Rather than rely on scanty documentation, we have tried to reference artworks or exhibitions only via firsthand experience (with the exception of some historical examples). This approach has obviously restricted the geographical range of the examples referenced, and they may not involve the highest-profile institutions or individuals. We deliberately describe the ways of curating as "modes" rather than "models" to avoid the impression (however devoutly wished) that we have a silver bullet of an answer to the curatorial challenges of new media art.

The practices of making and curating new media art are notable for their participative and collaborative ethics and discursive formats—including discussion lists, conferences, blogs, and Web sites. Our main activities here have therefore been naming, categorizing, digesting, moderating, and editing rather than imparting godlike opinions. In this way, the model for this book differs substantially from the model of the single-authored art theory book (with "curator as editor" our main metaphor, perhaps, rather than "curator as connoisseur"), but it aims to reflect new media methods more accurately. It is important that full credit must be given to the discursive, collaborative nature of the research and to all of those people whose words appear here. Other people have been very generous with their knowledge, and it is only fair that they are generously cited. The choice of who we quote was also very deliberate: we regard artists and curators as experts in their field; we are very grateful that those who are open about their artistic or curatorial process choose to share their expertise in a field that sometimes prefers to draw a veil of mystique over itself rather than promote a critical practice. As we noted while trying to define new media art, the state of movement and flux means that many of the quotes here are taken from "gray literature"—conference proceedings, discussion lists, reports, and Web sites. We acknowledge the more informal style of this material, and because this book is one of the first on the subject, it is sometimes densely referenced so that it will serve as both a resource for the future and an impetus to further research.

This book is not a theory book. Its structure reflects the CRUMB approach to research, which discusses and analyzes the process of how things are done rather than theoretical positions (see C. Jones 2006a). The published literature adjoining the curating of new media art includes art history, technological history, media theory, cultural theory, sociopolitics, interface design, curatorial theory, museum studies, and a quite separate literature of technical handbooks for curators. This book sits on the very small, underdeveloped area of overlap in this complex Venn diagram; it concentrates on practice

and process, but it is not a technical handbook. One of its arguments is that knowledge of a broad network of technological histories and cultural forms, rather than of a single history or canon, is important for understanding new media art. This argument has necessitated a broad approach: we have foraged across the different literatures for crumbs of knowledge that may be of specific use to the subject of curating new media art. The brief references to these fields are intended to act as signposts to a broad interdisciplinary network of knowledge for future development rather than as an in-depth analysis of each position. Books that specialize in new media in relation to sociopolitics or design, for example, do exist and are referenced here, but to cover the full complexity of these disciplines would obviously be outside of the scope of a single book. Where the book does go into detail is in comparing different kinds of "systems" from different disciplines. Another of the book's key arguments is that because new media art concerns systems, processes, relationships, and behaviors rather than objects, then these systems must be understood as well as possible, using tools from any discipline necessary.

The book is not a history of new media art, primarily because other books (including those in this series) do that rather well—not only attempting to integrate histories of technological art production, but also questioning the processes and methodologies of art history. Edward Shanken, for example, is very open about his own processes of taxonomizing and organizing, and states that "along these lines, the study of technology as a hermeneutic method must be incorporated as part of the art historian's standard methodological toolkit" (2007, 56). This incorporation of critical practice is a good sign for future histories of new media art and underlines the relationship between curators and historians: curating influences the writing of art history, and it is important for curators to understand the histories of materials and processes, whether bronze casting or computer programming. In attempting to provide "methodological toolkits" for future curators, including collaborative methods, this book aims to offer ways of keeping alive an enthusiasm about the art and an awareness of the exciting opportunities for artists, curators, participants, and audiences.

Last, for those curious about coauthoring a book, we agreed collaboratively on the overall structure, assigned chapters to ourselves, and commented on each other's work. We divided up the reading and exchanged some relevant passages by e-mail. We used a database of quotes, and a wiki acted as a file repository. Although we did not agree on everything, we did not fall out, although one shameful incident of wiki rage was reported.

This book works in two halves. The first half explores those characteristics peculiar to new media art and the histories of art relating to those characteristics—including video, conceptual art, performance, and activism. The chapters in this part use the themes "space and materiality," "time," and "participative systems," acknowledging that these factors are interlinked by the common behaviors of new media art. Examples of artworks

and exhibitions illustrate how the institution, audience, exhibition, and curator's role can be rethought in light of those new media characteristics. The examples are drawn from a variety of ways of curating, including commissioning, touring exhibitions, and group exhibitions in and out of the museum or gallery.

The second half is concerned with "modes" or ways of curating—again both inside and outside institutions. After establishing some common areas of difference for new media art—those of interpretation, display, and audience—this part describes some modes of curating that match the particular structures of new media art, starting from the more familiar default mode of the museum and moving to parallels with publishing or festivals and more recent modes of networking and collaboration. These modes bring up issues of production and distribution rather than the more traditional concentration on the exhibition.

Chapter 2, "The Art Formerly Known as New Media," aims to form a grounding for the first part by differentiating the hyperbole around "the new" from those avant-gardist and postmodern characteristics of new media that genuinely demand new ways of working. Issues of institutional critique, authorship, ready-mades, simulation, hacking, and Web 2.0 are discussed. Examples referred to include the 1985 exhibition *Les Immatériaux,* Cornelia Sollfrank's generative artwork, and Harwood@Mongrel's *Uncomfortable Proximity* commission, which involved modifying the Tate's Web site.

Chapter 3, "Space and Materiality," discusses histories of conceptual art, including mail art and Fluxus, and explores issues of systems, networks, immateriality, process, and the exhibition of Net art in particular. Examples include the 1970 *Software* exhibition curated by Jack Burnham, location-based artwork by Thomson & Craighead, and *Let's Entertain,* a touring exhibition from the Walker Art Center in Minneapolis. References are also made to Seth Siegelaub's curatorial practice, the exhibitions *Data Dynamics* and *Beyond Interface,* as well as the artwork of Hans Haacke, Glenn Lewis, irational, and Lisa Jevbratt.

Chapter 4, "Time," acknowledges the difficulties of separating time and space in new media practice and goes on to compare histories of time and "liveness" in video and performance art practice, including mediation and reenactment. Particular new media issues—such as real-time systems, online time, and the performativity of code—are explored via historical examples, including the productions and performances of *Experiments in Art and Technology,* Rachel Reupke's slow webcam narratives, and the audience dwell-time exhibition strategy of the Media Centre in Huddersfield, United Kingdom. The exhibition *Art, Technology, and Informatics* for the 1986 Venice Biennale, Alexei Shulgin's "performing" software, and the *Database Imaginary* exhibition are also referred to in relation to production and curatorial process time.

Chapter 5, "Participative Systems," attempts to resolve the differences between reaction, interaction, and participation, and discusses *Learning to Love You More,* an artist-led participative Internet-based project that has adapted to the needs of art museums,

and *Serious Games,* a touring exhibition of interactive art. It briefly compares histories of activist media and socially engaged art with the new media concepts "open source" and "autonomy." It looks at the historical example of the *Information* exhibition from 1970 and at Robert Morris's ill-fated 1971 sculpture exhibition at the Tate. As well as examining fine art understandings of audience participation, including curator Nicolas Bourriaud's writing on relational aesthetics, it describes the interactive strategies of David Rokeby, Rafael Lozano-Hemmer, and Perry Hoberman.

Chapter 6, "Introduction to Rethinking Curating," describes in broad terms the landscape of contemporary curating and the role of the curator (for example, the curator as producer, filter, or editor). It outlines the curator's position in relation to the organization (embedded or adjunct) and discusses types of exhibiting practice—such as touring shows, festivals, and platforms. The introduction argues that some "modes" of curating (such as iterative, modular, or collaborative models) can offer ways of working that better fit or mirror the processes of new media art.

Chapter 7, "On Interpretation, on Display, on Audience," addresses three fundamental issues: first, that there is confusion between new media as used for interpretation or education and as used for art, but that these contexts share certain values via events and platforms; second, that changing the means of display changes the meaning of the artwork; and third, that the relationship between audience and artwork is different for new media art, in particular if the audience is online or participating. The key example discussed is Tate Media, with additional reference to the *University of Openess*, the exhibition *Curating Degree Zero Archive,* Rhizome, low-fi Locator, discursive events, and formal audience research.

Chapter 8, "Curating in an Art Museum," looks to this default location of exhibition practice and addresses questions arising not only from infrastructure (building or departments), but also from the way institutions manage the perception and reception of art (marketing departments and documentation). It uses the key example of the San Francisco Museum of Modern Art (SFMOMA) and examines the role of museums in the historicization of new media art, starting with documentation of exhibitions and moving on to collections. It summarizes ways of starting, exhibiting, and conserving a collection with reference to the Variable Media project, the Walker Art Center, the work of curator Richard Rinehart, the *Seeing Double* exhibition, and the role of private collectors.

Chapter 9, "Other Modes of Curating," looks beyond the museum to organizations that support both production and distribution of new media art—the festival, the art agency, publishing and broadcast initiatives, and the lab. It looks to public art and other media distribution systems such as radio for other models of curatorial practice, with many examples showing artists doing it for themselves (Vuk Ćosić's presentation at the Venice Biennale and Kate Rich's streaming radio projects are described). The chapter explores the flexibility of non-gallery-based organizations via New Media Scotland and the challenges of interdisciplinary production via V2_ in Rotterdam.

Chapter 10, "Collaboration in Curating," moves still farther outside the traditional landscape of curating to look at artist-led, self-institutionalized, collaborative, and recent open systems of curating, leading to the question of what happens when there is no curator or where the audience plays a curatorial role. The event NODE.London is the key example, and the challenges of these modes as well as their suitability for art after new media are explored.

Chapter 11, "Conclusions: Histories, Vocabularies, Modes," summarizes the book's three key arguments and considers some of the statements given by curators as to why they do and don't work with new media art. The subtexts to these statements are met with possible solutions concerning the position of new media art in relation to contemporary art in general. We propose that the task at hand for curators working now is to engage in translation between the systems of contemporary art and new media art.

Notes

1. In the early days of text-only computing, Ted Nelson ([1965] 2003) identified the ability to make links and nonlinear narrative as "hypertext." Curator Jack Burnham, in his 1968 book *Beyond Modern Sculpture*, related computer systems to histories of conceptual and kinetic art, and Lev Manovich has both made and critiqued "soft cinema," where moving image clips are accessed in a nonlinear way (Manovich and Kratky 2005).

2. We have written at various stages about working categories and taxonomies for curators of new media, which we only briefly summarize here (Cook and Graham 2004; Graham 2005, 2007, forthcoming b).

3. Others have disagreed with the extent of this split between "lands" and have sought to question the borders between art and new media art—an issue that we return to in chapter 11 and that various authors cited in this book have addressed (see, e.g., Arns 2007; Arns, Diederichsen, and Druckrey 2007; Lovink 2008).

4. The table of categories was made in response to a debate on the CRUMB discussion list on taxonomies, which referred to Transmediale's decision in 2004 to remove the three categories image, interaction, and software for its award in order to leave the category up to the artist (Graham 2004e).

5. Lev Manovich (2001b) has written about "post-media aesthetics," and art theorist Rosalind Krauss (2000) has written highly critically of the "postmedium condition." (See chapter 2.)

6. Recent publications, many of which are the result of curatorial seminars or talks, do include discussion of curatorial practice as well as theory, although these publications tend to take the form of curators reporting on their projects (Gillick and Lind 2005; Lind 2007; Marincola 2002, 2007; Möntmann 2006; O'Neill 2007).

I Art After New Media—Histories, Theories, and Behaviors

2 The Art Formerly Known as "New Media"

The context: The exhibition attempts to characterize an aspect of our contemporary situation, associated with the new technological revolution. When suitably processed, matter can be organized in machines, which in comparison may have the edge over mind.
—Jean-François Lyotard, *"Les Immatériaux,"* 1996

[Lyotard] created a network of technological, artistic and scientific experiments, all of which fit into an overarching language-theoretical formula, consisting of: sender>receiver>bearer of message>code containing message>subject to which message refers. Lyotard did not see *Les Immatériaux* as an exhibition in the traditional sense, but as a postmodern time-space filled with flowing information and invisible interfaces in which the borders between various areas fade and old "unities" dissolve.
—Jorine Seijdel, "The Exhibition as Emulator," 1999

In the early summer of 1985, the French philosopher Jean-François Lyotard, author of *The Postmodern Condition: A Report on Knowledge* (written in 1979 but not published in English until 1984) curated a wide-ranging exhibition at the Centre Pompidou in Paris, *Les Immatériaux*. Art historian Charlie Gere writes, "At the time it was the most expensive exhibition the Pompidou had hosted, costing 8 million francs, taking two years and fifty people to put together" (2006a, 140). The exhibition was designed to demonstrate how new technologies of communication and information management were affecting culture and included interactive installations, sound works, responsive environments, and experiments in early forms of electronic communications (such as an online bulletin board) (Gere 2006a, 19). Artist Simon Biggs writes,

The show focused as much on the installation of the works as [on] the content itself. The aesthetic, as the title of the event suggests, was to dematerialize the artifacts so that the systems of communication, value and power that they existed within, and were defined by, could be revealed. To achieve this the show was designed such that individual exhibits became blurred in their boundaries, one piece merging into another. Some exhibits were distributed so that you would not be able to determine just where they began or ended. Many of the works were also physically transparent or almost immaterial in their physicality anyway (one of the few "serious" art shows ever to include holography, for example). (2001a)

The exhibition did not have an itinerary or kiosks but instead an audio guide, which, rather than allowing visitors to select tracks based on the works in front of them, was

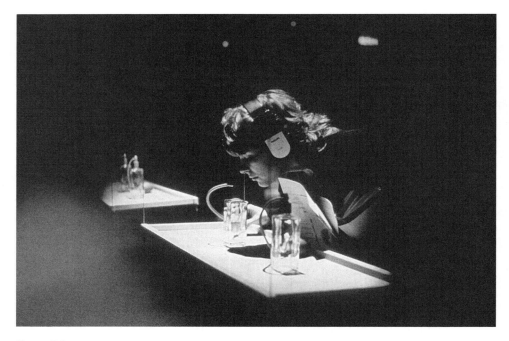

Figure 2.1
Installation view from the exhibition *Les Immatériaux* (1985) at the Centre Pompidou, Paris, show-ing the audio guide system in use. Courtesy of Bibliotheque Kandinsky at the Pompidou.

tuned in to the space, the data triggered by the visitor's location in the exhibition. There was also no distinction between artifacts and artworks. "This allowed for a polyvalent narrative to emerge in the show, allowing the viewer to find their own chronological and hierarchical path through the work, thus also functioning to further simultaneously reveal and dematerialize value" (Biggs 2001a). The catalog was unbound, and because the sheets were without numbers, they could be randomly shuffled by the reader, again working to render "all information equal in its delivery, the idea being that new or un-usual readings of value could emerge as new patterns and relationships between things could be discerned" (Biggs 2001a). Charlie Gere has described one element of the exhibi-tion in detail, the "Writing Tests" in the section titled "Labyrinth of Language":

[The "Writing Tests"] gave the visitor access to a number of dialogues or conversations between thirty writers and thinkers, on fifty topics relevant to the exhibition. These dialogues were con-ducted over a period of two months via networked computers on the Minitel system, and were, in effect, a proto-bulletin board system. Visitors were able to read the ensuing discussions on termi-nals in the exhibition, as well as read them in transcripts printed as part of the catalogue material. Among the topics discussed were "Artificial," "Code," "Interface," "Nature," "Time," "Language" and "Voice." The more well-known among those involved in the discussion included Christine

Buci-Glucksmann, Daniel Buren, Michel Butor, Jacques Derrida, Bruno Latour, Philippe Lacoue-Labarthe and Isabelle Stengers. (2006a, 19)

Les Immatériaux was an instantiation of Lyotard's philosophical ideas that society had reached the end of the age of grand narratives and that owing to technological progress, particularly as regards communication and media, society was now formed within a postmodern condition of dealing with a plurality of competing and subjective narrative structures or language games. The exhibition manifested this plurality through its emphasis on technologies of communication, such as the Minitel system, and for that reason is widely cited as being a precursor to current exhibitions of new media art as well as to the development of the field of media-based art. Yet few curators or historians can name a single artist or artwork included in the exhibition. Unlike exhibitions of art and new technologies seen more recently that seek to show off the newest artistic experiment or wunderkind, *Les Immatériaux* has come to signify the idea of an exhibition as event, as multiauthored platform for participation, without single works by single artists. This strategy is now quite common in exhibition making (and something we come back to in chapter 9), but at the time it participated in forging a new way of thinking about the communications revolution, a decade before the actual widespread adoption of the Internet.

By considering the legacy of the ground-breaking initiative that was *Les Immatériaux*, this chapter seeks to establish a historical context for any examination of new media art *right now* and to see how new media with its "information flows" and "invisible interfaces" works toward, in curator Jorinde Seijdel's words, making "the borders between various areas fade and old 'unities' dissolve" (1999). We hold that it is necessary to understand how the characteristics of new media have emerged in order to understand how best to present or curate new media art. Whereas other chapters look to specific characteristics of new media art, such as its time-based nature in chapter 4, this chapter follows on from the introduction (chapter 1) and our definition of terms iterated there to consider a longer historical legacy and to ask what is significant (or not) about the "new" in new media art.

Because this book is not intended as a history of new media art forms, we have chosen, for reasons of space and time, to emphasize the moment of new media art as it was understood in the years between 2000 and 2006, when the term *new* in *new media art* was most widely accepted and used. After the hype of those years, from 2006 until today, understandings of new media art in relation to contemporary art have changed significantly, and the use of the term *new* has become outmoded. At the time of writing, new media art was more commonly understood as art (formerly known as "new media") or even through greater awareness of its many subgenres rather than being lumped together under the term *new*. We recognize that we are still at an inconclusive point for a future definition, never mind a history, of new media art (nor is our task to define the future of new media art) and so have chosen throughout to emphasize instead the search for (art)

historical precedents for new media art because that helps to determine how some of the characteristics of new media art that we take as substantive have evolved.

In this chapter, we question newness by considering the relevance of new media art's avant-garde tendencies in how it has and has not gained acceptance within the field of art (either as its own art form or as a genre of art practice). The next and more wide-ranging question we ask is whether postmodernism—the movement that is still cited as having most affected contemporary art's production, presentation, reception, and dissemination—still plays against new media art as we move forward in our post-postmodern or postmedium condition.[1] By differentiating the hyperbole around "the new" from those characteristics of new media that genuinely demand new ways of working—its questioning of authorship and openness to collaboration,[2] its adherence to the ready-made, the simulated, the cut-and-pasted, the hacked—this chapter establishes the ground for an examination of the behaviors of new media art. In the second half of the chapter, we map out some of the challenges curators face when working with new, avant-garde work that deliberately positions itself in a critical stance toward structures of legitimation of new art, such as the museum.

The Hype of the New

What is new media? In 1839, it was photography. In 1895, it was motion pictures. In 1906, it was radio. In 1939, television. 1965, video. 1970s, computer graphics. 1980s, computer animation. 1994, the World Wide Web. 1995, Mosaic. Then Quicktime, Shockwave, Real, Flash. 1999 was the year of the database; 2000, transgenic art; 2001, PDAs. . . . There are two converging trend lines regarding new media. One is the contraction of the periodicity of the introduction of new media. The other is increasing specificity as the present is approached. This is known as marketing and is better diagnosed as myopic conflation of technology (materials) and medium. There is no such thing as Palm Pilot art.
—Steve Dietz, "Signal or Noise?" 2000a

From its inception, new media art has been greeted with an "overenthusiastic glorification of its novelty" (Frohne 1999, 11) by perhaps everyone but the artists making it (as discussed in relation to the press in the conclusion, chapter 11). Curators and critics have been seduced by the hyperbole of the new, and from one angle even Lyotard can be included in that list because he created an exhibition that was about the new information age rather than about artworks that pass comment on the current state of things. The hyperbole thus begs the questions, How did the term *new media art* rise to prominence? And if the term *new* has now been superseded, then by what other terms?

The widespread adoption of the Internet as a personal addition to one's media landscape, never mind as an art medium, and the speed at which it happened generated a great deal of the initial hype at the end of the 1990s. Museum director David Ross said, "To begin with, the logic of net art is astounding—even breathtaking. It seems to be an

art form that is contained within an aesthetic movement that itself is contained within (and simultaneously the harbinger of) a set of radically innovative social structures, all embedded in a set of technologies evolving at a pace unprecedented and unpredicted in an age defined by its passion for velocity" (1999a, 5). It is clear that new media art was not easily understood as art, but was also distinct from other forms of mass media.

That said, Web sites have a notoriously short life span and demand constant updating. And so, the hype of the new and the attention it brought to these new works—as far as the practices of Web-based art in the early 2000s were concerned at least—seems to have come at the expense of engaging in something that might actually last (in comparison to those early Web-based works, many of which are now lost because of changing browsers and upgraded software). Interestingly, many of the works of Web-based art from the early 2000s deliberately played with the desire of curators, critics, and art historians to historicize the work. The works instead fixed themselves solidly in the present of their making, such as Thomson & Craighead's *TriggerHappy* (1998), the artists' take on the game *Space Invaders*, or JODI's early work, which mimicked fleeting computer viruses.

While acknowledging all the issues around historicizing contemporary work, if I have one generic "beef" about the net art world in general, it is a kind of obsession with what's new, today, this minute, right now. It's not *all* about newness. While it may be "old" as a strategy, for instance, I still find Alexei Shulgin's *Form Art* fascinating. Just one example. In one sense this work from 1997 is "classic," already part of the power of the line, but in another sense, we still haven't digested it. (Steve Dietz in Bosma 2000, emphasis in the original)

Hype is also a self-fulfilling prophecy, and in the dozen years of the World Wide Web's existence we have witnessed a "contraction of its periodicity";[3] in other words, each step in its development has been almost a full step change (that is, full twice what it was before—in size, in storage capacity, in global reach, and so on), and this predictability of its growth and development has given rise to even greater expectations of its potential. As we indicated in chapter 1, curators working with new media have increasingly sought out ways to highlight at times and downplay at times the newness of the technology rather than emphasizing the work's other characteristics. It is hard to downplay newness when that is all anyone else is focused on, however.

The "hype cycle," a concept developed by Gartner Inc. in 1995, showing the acceptance of new technologies, suggests that every development in hardware or software can be mapped in terms of its visibility (in the press for instance) and its maturity (or its adoption rates by users).[4] The cycle follows an up then down path at first, the "technological trigger" (i.e., we can now do something with this technology), then shows a "peak of inflated expectations." After such a peak naturally comes a fall, the "trough of disillusionment" (for example, the point when everyone who has a camera phone starts to complain about the quality of the pictures it takes). After a gradual rise on the "slope of enlightenment," the new product or service eventually arrives at a productive stage,

Figure 2.2

The Gartner hype cycle, redrawn in 2005 to apply to forms of new media art. Hype cycles used to map technological developments often indicate the number of years those developments have taken to reach each stage; in this case it may be that Holography has taken ten years or more to reach the Trough of Disillusionment, whereas Net art has reached the Plateau of Acceptance in less than five years. Diagram by Sarah Cook and Verina Gfader.

the "plateau of acceptance." Some technological developments fail at any one of those stages, never progressing into a viable, visible maturity.

What does the market clamoring for the new and technophilia in general mean for new media art and the curators who are showing it? An observational attempt to map the development of new media art onto the hype cycle shows that rather than being at any one stage with new media art as a whole, each different "form" of new media art is at a different stage of emergence and adoption and might move along the cycle at a different speed. (See the chart in figure 2.2; the acceptance of new media art into the mainstream of art is discussed in chapter 8). Likewise, the death of painting has been widely noted, but in fact (in economic terms, depending on the state of worldwide markets, at least) it continues to be a force within the art world. Economist Chris Anderson has suggested in his idea of the Long Tail (see figure 2.3) that with new "leveling" technologies such as the Internet and the social networking it affords, market supply and demand need not match up in the conventional sense. The *Long Tail*, a term from the study of sta-

tistical distribution, is actually a "demand curve" where we can see a greater number of people demanding a wider number of goods, thus flattening the peaks and troughs evident in most other centralized distribution systems:

Many of us see the same movies and read the same books because the bookstore can store only so many books and the movie theater can play only so many movies. There isn't enough space to give us exactly what we want. So we all agree on something we kind of want. But what happens when the digital age comes along, allowing the bookstore [i.e. Amazon] to store all the books in the world? Now, it doesn't sell 1,000 copies of one book that we all kind of want; it sells one copy of 1,000 books each of us really wants. (Gladwell 2007)

The theory of the Long Tail suggests that communication technologies such as the Internet enable the improvement of access to previously unavailable content and encourage user choice ("niche markets"): the user can choose from the whole catalog or database and not just what the centralized authoritative institution puts forth, the "hits," or, in the case of a museum, from within a linear narrative selection of the most important artworks in its collection. The Long Tail theory indicates that you don't have to have a thousand people like something in order to legitimate its place in the system, and it recognizes that the system doesn't have to be centralized, either. Put the hype cycle and the Long Tail together, and it can be argued that focusing on newness is not only technophilia, but also a potential strategy for legitimation and acceptance, something new media art has struggled with in terms of the centralized institutional structures within the art world, such as museums.[5]

From 2000 to 2005 and earlier, many forms of new media art rose up and down the hype cycle before artists and curators started to understand that aiming for the "plateau of acceptance" didn't have to mean just acceptance by the centralized systems of the art world, but could just as legitimately mean acceptance by the "niche markets" of a more distributed and decentralized community of art makers, technologists, producers, curators, institutions, and everyone else. Theorist Marina Vishmidt cleverly points out how new media art isn't necessarily similar to other forms of contemporary art, but that each uses the other to define itself in terms of its acceptance into the "cycle." It is worth quoting her at length:

Minding the heterogeneity and contradictions that traverse each field, it's still possible to schematically argue for a contemporary art discourse that would call itself the "proper" artworld, with established organs of criticism, reception, funding, publicity, all the cultural vectors and financial mechanisms that denote a self-, and culturally assumed, understanding of art as verified cultural specialty. It could then correspondingly project "media arts" as a sort of nebulous default structure of everything that partakes of technology in a way that's constitutive of the work but doesn't partake in the same critical and market circuits that operate, and operate through, the proper artworld. Media arts, in its turn, would enact a hypothesis of artistic production that is not fetishistic about its adherence to constructs of "art" or seeks legitimation as art but is more interested in the creative and social possibilities of new(er) technologies. . . . Media art/s and contemporary art share a tendency to evaluate one another by the terms which they would most like to expunge from their

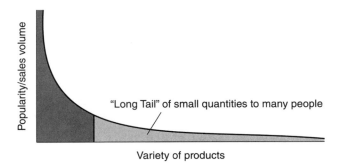

Figure 2.3
Diagram of the theory of the Long Tail, as proposed by Chris Anderson. Diagram by Verina Gfader.

own spheres: hence media arts becomes "techy" and uncritical, an ornamental redoubt of media activism, as contemporary art becomes commercially led, by turns vapid and abstruse. Clearly, there are also crossovers and mutual encounters, but unless media art is canonized within a particular critical or historical inscription of contemporary art, the "media arts ghetto" is always there, with a defined funding stream and a warm bowl of soup. (2006a, 4)

Vishmidt's characterization of the two fields echoes the divide between the worlds of contemporary art and technology art (or research-based scientific art) noted by theorist and artist Lev Manovich, but updates it by considering the exclusion zones around each.[6]

Which brings us back to the question of how the "new" in "new media art" came to matter and whether or where it does still. Answers five through eight to Manovich's question "What is new media?" read,

5. New media as the aesthetics that accompanies the early stage of every new modern media and communication technology.
6. New media as faster execution of algorithms previously executed manually or through other technologies.
7. New media as the encoding of modernist avant garde: new media as metamedia.
8. New media as parallel articulation of similar ideas in post–WWII art and modern computing. (2003a, 20)

Manovich suggests that the "new" in new media isn't only about the technology—the medium—but, as point seven says, that something older and premediated is going on in technology's relationship to modernism and the avant-garde. So if the "new" in new media art continues to be under scrutiny at the expense of scrutiny of the other characteristics and behaviors of new media art—those things the contemporary art world like to expunge from its own self-evaluation—where is the idea of the new in the work of contemporary art more generally? Museum historian Didier Maleuvre, citing Martin Heidegger's writings on the work of art,[7] writes,

If the work of art were not new, then it would correspond to an a priori notion and would thereby stop being original. However much an artwork may be influenced preceding art, it cannot be a mere copy, or the sum of its historical sources. Otherwise it would be industry, and as such would not surpass the material reproduction of mere existence. Yet art's newness is not a passion for the new-fangled either, no mere rebellion against models (otherwise it would shackle itself to tradition, negatively). Art's newness is the very condition of the work's ontology: the fact that, in the artwork, the concept is the form and does not precede it. (1999, 65)

This suggestion, that art has to be new in order to be art and that the concept is the form, helps with our understandings of new media art. The inseparability of form and content, linked by the protocols within computer programming, is evident particularly in Web-based art, which takes its production method (the coding of pages using hypertext markup language [html]) as its distribution method (html is communicated to its users using hypertext transmission protocols [http]—both are based on hypertext). Furthermore, the technologies that make up works of new media art by design also enable simulation—a Web site can be a book, a film, a radio program, and an image all at once. The new medium has built into it inherent behaviors that differentiate it from other media.

One way to unpack these ideas is to look away from the hype around the new to the historical precedents for new media art—in other words, where its characteristics came from—to see if new media art's modernist or avant-garde tendencies have affected how it is understood and curated.

New Media Art—Modernist or Avant-Garde?

So Nothing Remains "New"?
New media evokes the tensions of avant-gardism so integral to late modernism. When a new medium becomes popularized into mainstream distribution, artists flow into the practice as access becomes more generalized. Others flee, searching for the next avant-garde form.
—Sara Diamond, "Silicon to Carbon," 2003

In 2006, the artists' network Rhizome.org was host to a debate concerning the avant-gardist tendencies of the field of new media art, a debate that had started over questions of whether its use of "gee-whiz-technology" was its primary limitation to acceptance within the mainstream art world.[8] Many on the list commented that new media technologies are an intrinsic part of contemporary culture—from cell phones to Web browsers—and so art that engages with new media is by necessity the most current and avant-garde art form. But even that rational technophilia was cautioned against: "If media art is only measured by its supposed 'cutting edge' of technology I would personally find it all pretty boring. For me, it's the context, the communities that use it, the networked nature of it, the ideas that come out of it, the content created with it, the fact that it is free (almost) from historical control and lame Canons and there is more, so much more" (Garrett 2006a). Others have argued more recently that in fact the issue

is not the newness of new media art, but that the art is constantly in emergence (each form taking its own time to travel up and down the hype cycle). "New media are not just emergent; more importantly, they are everywhere—or at least that is part of their affect. Computers, databases, networks, and other digital technologies are seen to be foundational to contemporary notions of everything from cultural identity to war. Digital media seem to be everywhere, not only in the esoteric realms of computer animation, but in the *everydayness* of the digital (e-mail, mobile phones, the Internet)" (Galloway and Thacker 2007, 10, emphasis in the original). So we come to the question of whether art that is made using new media is part of an avant-garde practice because of its detournment of the everydayness of the technology it uses.

Interactive media professor Steve Anderson, drawing on histories of structuralist film from the 1960s as avant-garde practice, defines *avant-garde* as "a non-singular and contradictory range of minor practices that are dialectically related to—i.e. both resistant to and constitutive of—dominant media systems. These works are characterized by multiplicity, micro-politics and formal experimentation, and perhaps most disquietingly, they are often exo-commercial—that is, positioned in a marginal but necessary relationship to the economically sustaining infrastructure of the entertainment and advertising industries" (2006). (In other words, it sits quite happily on the long tail of supply and demand). This emphasis on new media art's being both resistant and constitutive of the dominant media is what causes such tension and debates to erupt cyclically on lists such as Rhizome whenever a new form of practice emerges and artists try to come to grips with it. Part of the question as to whether new media art is avant-garde or not has come in trying to figure out if it is a movement or a genre or a type of practice, and how it is thus distinguished both from other forms of art (perhaps as the blind spot within contemporary art) and from other instantiations of media in contemporary culture.

The avant-garde is often equated or exemplified in modernism, particularly with regard to the question of originality and movement toward greater resolutions (the trope of progress). Yet this equation is problematic for a reading of new media art because much of new media art's avant-gardism comes from wanting to throw off grand narratives of progress and development and to continue to play in the messy field of experiments. New media is deeply critical of the modernist idea of progress, even though some technology-based art projects have modernist tendencies (such as being tied to a particular idea of form). A case in point might be the art/science collaboration projects often associated with new media art: whereas the field of science often understands art to be modernist—formal visualizations of data such as those by C5 and Lisa Jevbratt, for example (discussed in the next chapter)—curators usually assume that all contemporary art is at the very least avant-garde if not also postmodernist even if it has formal tendencies. In modernism, there is a distinct move toward formalism, reduction, and essentialism (as in abstract painting). By contrast, although some new media art projects are formalist reductions of data, it is more widely understood that new media art is not

always abstract (even though it may appear to be so due to its immateriality, as discussed in chapter 3).

Curator Andreas Broeckmann has also commented on the split between new media art and contemporary art by considering how ideas of progress and the avant-garde play within technological art:

> In a grand essay published in 1991, Peter Weibel has forcefully argued for the advent of a new, technological aesthetic that separates the age of media art from traditional art. In a generally accepted "post-modernist" argument, Weibel claims the Industrial Revolution and its technologies have created an historical situation in which issues of truth, of authorship, originality, etc., are no longer tenable as aesthetic categories. They are replaced by notions of simulation, signs, media, etc., which are most strongly articulated by electronic art. For Weibel, the artistic use of technology is in itself a sign for the possibility of humans to create and transform their world, it is a sign of the emancipatory potential in our existence. (2005)

In addition to its newness and its use of emergent technologies, new media art has an interdisciplinary nature. It works across art and technology and across all the associations of newness inherent in both fields. This meander through the question of modernism is but a rouse to consider whether new media art is an avant-garde form of art or not. Most likely, no one will ever agree on this point, as the Rhizome debates suggest, but many artists and curators agree that new media art does exhibit avant-garde tendencies.

From Postmodernism to a Postmedium Condition

> It is precisely the availability of postmodern technology which differentiates [the postmodern avant-garde's] cultural practices from those of modernism.
> —Nicolas Zurbrugg, "Postmodernity, Metaphore Manquée, and the Myth of the Trans-avant-garde," 2000

When considering the history of new media art's emergence and the example of the Lyotard exhibition, we should ask: Is new media art a result of a postmodern culture, or does it exemplify our postmedium condition? *Les Immatériaux* sought to show how technology is the differential in cultural exchange. Philosopher Nicolas Zurbrugg suggests that there are "three defining characteristics of postmodern culture: its existential shifts, its conceptual shifts, and its technological shifts" (2000, 49).

Zurbrugg argues that conceptual shifts "simplify, amplify or systematize formal innovations" of the preceding movement[9] and that the "innovatory concepts . . . find refinement, elaboration and fulfillment" in the new works of the subsequent movement. He does warn that movement isn't always positive—systemization can lead to "methodological consolidation"—but contends that the process by which this realization and elaboration takes place is *through* technology (2000, 52, 53). Indeed, the consolidation—if indeed it is technologically driven—can make the subsequent movement seem less like a forward progression and more like a detour, just for the sake of it being possible.[10] With

increased "systematization" and elaboration of the ideas of the prior movement playing out through technology, the postmodernists have been accused of responding to the mass media at their own expense. In our new postmedia condition, how does experimental work made with new media technology distinguish itself from the mass media? Some answers are to be found in how new media art enunciates the postmodernist existential, conceptual, and technical shifts from the avant-gardes that came before. Some of these shifts, which can be thought of in the same way as Vishmidt's description of how new media art and contemporary art evaluate each other by terms "expunged" from their own spheres, are elaborated here, recalling that they are based not just on media, but also on behavior.

Self-Referentiality and Authorship

As digital technologies are becoming more prevalent, art that reflects on them needs to become less self-referential, less autistic, and more culturally and aesthetically ambitious. It must continue to articulate these experiential layers, it must confront, dramatize and, at times, negate them.
—Andreas Broeckmann, "Discussing 'Media Art,'" 2005

With all the hype about the new coupled with the postmodernist condition of refining previous avant-gardist tendencies, one would think that new media art is about reinventing the mouse wheel each time. In fact, according to media theorists Jay Bolter and Richard Grusin (2000), new media art exhibits the tendency of "remediation"—in other words, it takes the form of a new update to the previous medium, but foregrounds the new medium itself in the process. New media art is full of self-referential projects, much like contemporary art is: we have seen formalist paintings about the qualities of paint, and we have seen single-channel video projects designed for broadcast that are specifically about the nature of television. To these examples we can add Net art mailing list projects that are *about* mailing lists (Jonah Brucker-Cohen and Mike Bennett's *Bumplist* [2003] allowed only a minimum number of subscribers and, whenever somebody new subscribed, bumped off the one who had been on the list longest) and Web-based art projects that are specifically about the browser window and the tropes of Web site design (the reactive Internet-based project *Midnight* [2006] by Olia Lialina and Dragan Espenschied uses the slick Google map cross-navigation bar interface to unleash familiar and kitschy animated icons from the early days of the World Wide Web).

Any form of self-referentiality that hopes to be taken seriously is imbued with a spirit of irony, and irony, or a distrust of grand narratives, is a defining feature of Lyotard's described postmodern condition as much as it is a feature of new media art and a defining characteristic of the kind of work readily accepted into the art world. Yet irony in new media art circles is often deeper, a kind of playful investigation of the technology's actual capabilities—making it do something it wasn't intended to. For instance, David Rokeby's project *The Giver of Names* (2002) assigns to a computer the task of naming objects placed

in front of its all-seeing camera eye. The objects are mostly plastic toys, so the piece is an ironic comment on language as much as on artificial intelligence or image-recognition systems.

Both contemporary art and new media art might be self-referential about the medium (marble, paint) or technology (Web browsers, cameras) employed in the work, but this self-referentiality also serves to distinguish the two fields. For new media art, audiences are possibly more familiar with the medium than they are with the media of other forms of contemporary art (more people arguably know how to use the Web than know how to apply oil paint to a canvas). Furthermore, if new media art is continually making reference to popular culture, that might make it more understandable than a work, in whatever medium, which is understood only in relation to the history of art. Contemporary art is replete with strategies of appropriation—from other media as well as from other "cultures" outside art. Here it helps to consider how the work behaves: Diedrich Diederichsen (in Arns, Diederichsen, and Druckrey 2007), like so many others we have encountered by now, also distinguishes two cultures, that of media art and that of gallery art, arguing that the latter engages in methods of displacement, negation, caricature, and repetition, which distinguishes it in behavior and "cultural habits" from media art, and that the former seeks to chart new paradigms of perception, humanity, and the physical. Both contemporary art and new media art are replete with examples of art imitating prior art and art imitating life. Both also have examples of art that is self-referential about its own maker. Tied to this question of self-referentiality is of course the question of authorship, and it is here that new media art has one up on most contemporary art in that it often explicitly invites the maker of the work to be the audience or the machine or both in collaboration (as we see in chapter 5).

Postmodernism is often identified with the death of the author, not just because the grand narratives are in question, but increasingly because technology allows one to cut and paste, copy, and fake both texts and the identities of those who wrote them. Much contemporary art plays with the trope of replicating or simulating reality (Jeff Koons, postmodernist artist par excellence, makes super-realistic heavy aluminum versions of inflatable pool toys)—and, after all, we do live in an age of mechanical reproduction. New media is different because the tools can do it all for you if you want—copy and paste and manipulate and hack. Adrian Ward's "handmade" software work *Auto Illustrator* (2000) is a spoofed or hacked version of Adobe Illustrator, where the menu choices for automatic image modification are updated from "Van Gogh" to "Mute Magazine." This piece is also suggestive of another aspect of new media art—the Duchampian gesture of taking ready-made, often off-the-shelf technology and hacking it to do something other. For instance, Kelly Dobson's piece *Blendie* (2003) is a standard kitchen blender hacked to respond only to voice commands—namely, the sound of someone growling like a blender. This practice of hacking within new media art has a tinge of formalism about it, based as it is on reforming an existing object or existing software, and thus might seem

more modernist than postmedium. Jack Burnham noted that "craft-fetishism, as termed by the critic Christopher Caudwell, remains the basis of modern formalism" (1968b, 32). But as Zurbrugg has pointed out, it is possible that the formalist experimentation is but part of the shift from one avant-garde to another. Steve Dietz writes:

The Duchampian gesture of the readymade suggested, at least initially, that art could be what the artist asserted. It changed . . . a lot. To say that Michael Heizer's *Double Negative* (1969) owes something to Duchamp is not to suggest it is a readymade or to deny that it is executed in a medium with some of its own distinctive characteristics. It is to acknowledge the definitional role of artistic practice per se. In this sense, net art is more of Duchamp. It is what the artist makes of it. What is different, perhaps counterintuitively, is the network of distribution, of access. (2000b)

Postmodernism is defined by the possibility of inserting artworks into existing technological systems (as Barbara Kruger did, for instance) in order to manipulate their meanings. Hacking and manipulation of existing media amounts to appropriation—long a strategy of avant-gardist artists—and, again, so much the easier with the rise of networked technologies. Recontextualizing someone else's content by displacing it geographically, physically, or intellectually highlights immediately the lack of autonomy of the work of art and how much of its meaning is generated through its place within the institutions of art and in relation to audiences. Distribution and access come up again later in the chapter 9 on how curatorial models best fit new media art practice, but it is worth noting here the importance of distribution to seeing new media art as part of a larger field of art making that is aligned with strategies familiar from postmodernism. Taking over the distribution system entirely (doing away with the institutions of art) is yet another tactic well employed by new media artists.

Art Example: Cornelia Sollfrank, Net Art Generator(s) and Female Extension
In 1997, a museum in Germany posted a call for submissions for the first ever contest of Web art. Old Boys Network cofounder Cornelia Sollfrank, a confessed cyberfeminist, decided that rather than submit a single of her works, she would use her fledgling project, *Net Art Generator*, to create automatically hundreds of html-based collaged works and enter each under a different female pseudonym/identity. The project *Female Extension* has become legendary because the museum didn't notice the intervention and proudly announced how many responses the call had generated and how interesting it was that so many were from women artists. On the day the winners were announced (all men), Sollfrank revealed her intervention.

This project and the larger initiative Sollfrank has undertaken with her "generators," in which "the smart artist makes the machine do the work," suppose a questioning not only of authorship (when an artist collaborates with technology as both tool and method of art making, who is the named author of the resulting work?), but also of the institutional frames in which artists might perform and in which art is understood to behave. She writes,

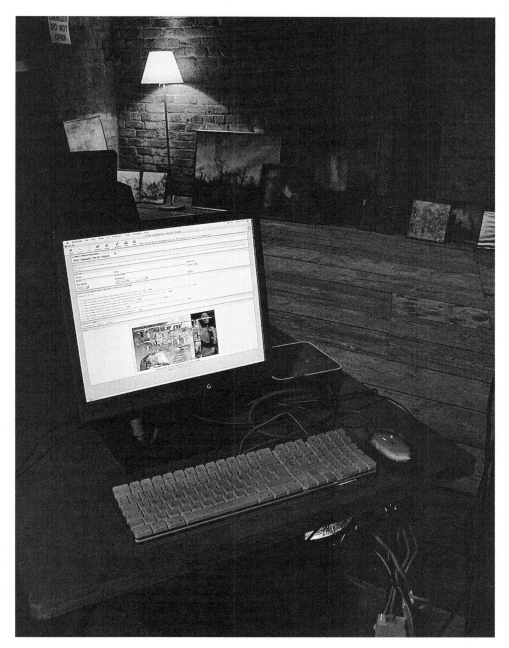

Figure 2.4
Installation view of Cornelia Sollfrank's *Net Art Generator* project in the *StoryRooms* exhibition at the Museum of Science and Industry, Manchester (2005). Photograph by Lizz Shaw-Griffiths.

The call for contributions to [the competition] *Extension* noted explicitly that exhibition would be not for art on the Net, but rather, for Net art. Traditional works of art were not to be represented in digital form; instead, artistic works that applied familiar art concepts, such as "material" and "object" to the Internet. This announcement was typical of the zeitgeist of the year 1997. The established art world had started to become interested in the new art form and was trying to deal with it more or less "appropriately." . . . But unfortunately, there were soon problems with the conditions for participation. One of the conditions was that the submitted projects had to be uploaded onto the server of the art museum. What would remain of works based on communication, exchange and interaction with the user and are in a permanent process of change? What about works linked to other sites? What's more, the call for contributions implied that the Internet and the World Wide Web were the same, thus limiting net art to web art. So the call for participation was already starting to force the new art form into traditional categories of "work" and "author," which many net artists had dreamt of escaping. (2004, 133–134)

Although for the past decade the Web has lent itself effortlessly to possibilities of melding one's identity, doing so in a museum context is nothing new (Duchamp adopted the name "R. Mutt" when he exhibited his urinal). But the possibilities of networked communication and tools of collaboration question the museum's propensity to value individual creative authorship. This is in evidence in the many "hacks" of museums' attempts to engage with net-based art that have ensued since Sollfrank's *Female Extension*, such as the well-publicized response by the activist artist group RTMark to being included in the 2000 *Whitney Biennial* exhibition: in a radical reaction that spread publicly across the Web, the group auctioned off its exclusive VIP opening invitation in order to raise funds for future projects, thereby deflating from the inside much of the hype about the new.

Postmedium: Using Any Media Necessary

Postmodernism differs from modernism in advocating eclecticism, hybrid and pluralistic styles.
—Frank Popper, "The Place of High-Technology Art in the Contemporary Art Scene," 1993

As noted in chapter 1, this book concerns itself with the behaviors of new media art and how they present challenges to curatorial practice. Where those behaviors come from or how new media art *acts out* in the way it does are questions for art historians to mull over for decades to come. As such, we are not focused on any form of "medium specificity" in the works of art we consider, but instead on their characteristics and behaviors, such as interactivity, connectivity, and computability. In the following chapters, we look to histories of conceptual art (Fluxus and mail art), socially engaged art, participation structures, and systems to see how new media art engages any medium necessary for its realization.[11] The overarching impression of new media art is that it is deeply hybrid in approach, method, content, and form. This quality aligns new media art with our postpostmodern time or postmedium condition. As mentioned earlier, by considering works made during the years from 2000 to 2005, we can more easily see the shift toward our

current moment, when social software and the media landscape are in intense transition, opening up and moving beyond mere hype and into tangible effects on practice.

"Media art" is, however, such a problematic term, exactly because it is imprecise; it can refer to work that *deals with* so-called "new media," or work that is simply *made with* such media technologies; in the latter case, however, a distinction from contemporary art is impossible to draw, since all art uses some sort of a medium, and many modern and contemporary artworks have used media technologies without qualifying as "media art" in a narrower sense. It seems that, more than anything else, "media art" is a way of looking at works. (Broeckmann 2005)

In fact, as noted in chapter 3 about space and materiality, new media art is often immaterial in its realization (as opposed to dematerialized, as Lucy Lippard [1973] argued regarding conceptual art). This immateriality has led some theorists and artists such as Lev Manovich and Mark Hansen to wonder, following the logic put forward by art historian Rosalind Krauss, if new media art is actually a manifestation of the postmedia condition. According to Krauss, "Although [medium-specificity] is another, unfortunately loaded concept—abusively recast as a form of objectification or reification, since a medium is purportedly made specific by being reduced to nothing but its manifest physical properties—it is (in its non-abusively defined form) nonetheless intrinsic to any discussion of how the conventions layered into a medium might function. For the nature of a recursive structure is that it must be able, at least in part, to specify itself" (2000, 7). If we are to consider the issue of the physical properties of the work of new media art rather than its conventions or how it behaves, we would be continually chasing a vapor trail because the physical properties of new media are so mutable, emerging, evolving, being upgraded, and becoming defunct. Mark B. N. Hansen (2006) has cautioned against defining new media too specifically by its digital medium because doing so would be taking a page from the modernists and trying to seek out new media's "essential" qualities, which is especially difficult considering that the digital is capable of simulating most other media. "It is rather," Kanarinka points out, "that the advent of the digital has created a situation where all attempts at media essentialism (sculpture is this, painting is that) are impossible" (2004).

Yet that distinction is not very helpful to us, either, unless we move to a middle ground where we can identify the work's characteristics (an engagement with the virtual, for instance, or a use of databases and relational programming) and from that consider its aspects of computability and thus recognize its intrinsic behavior—that it executes an algorithm or software code. Sollfrank's intervention is again a good example—the work is the artist's intent toward an interventionist action, toward institutional critique—it is executed by the computer and realized (in seemingly immaterial Web-based form) by the framework of the institutional competition.

The use of algorithms in new media art might suggest that the work has the characteristic of being concerned with protocols, systems of control, or standardization. But this

refinement, too, would be missing the point (as Jon Winet says, when you are at Xerox, everything starts to look like a document). To understand the behaviors of new media art, one has to be more specific than Krauss's (1986) argument that modernism is equated with the standardizing rubric of the grid and more specific than Bourriaud's (2002) argument that artists are like video disc jockeys, sampling and postproducing contemporary culture. Both of these readings are focused on the level of tool—the machine in the studio—when in fact new media art uses a totally different system of relating meaning, one that is not based solely on the separation among maker, tool, and work. The combination of technology and media is not just a tool in the studio, but a medium, indeed a system, for making the work and informing the methodology of the artist and the means of the work's distribution.[12] The same set of media can be used for both production and distribution (systems as media for art are discussed further in chapters 3 and 5).

For much of new media art that isn't object oriented but borne of social processes, the network and the system are the medium, and there are all kinds of systems and networks to choose from with varying degrees of complexity, including their hubs, nodes, centralized or distributed systems (discussed further in chapters 3 and 9). Sollfrank engaged in a network established by the museum, then generated one of her own, and faked women artists within that network. To truly understand the "mediums" of new media art, one has to understand the complex structure of the network new media art creates and uses, as well as its protocols, through the nodes within it—namely, the artist, the artwork, the curator, and the audience.

The Cultural Context and Institutional Critique

Once contemporary art had left the conventional frame and plinth behind it was inevitable that it should depend more directly on the whole context in which it is seen.
—Sandy Nairne, "Exhibitions of Contemporary Art," 1999

The growth of cultural studies over the more traditional art history methods in the 1970s is also indicative of the postmodern condition, searching out a plurality of interpretations and stories to explain the past and the present. Inke Arns (in Arns, Diederichsen, and Druckrey 2007) argues that new media art is simply the most relevant art today because it engages in the context of art making and our intensely technological, media-saturated age. The wider cultural context for new media art thus necessarily includes popular culture and the mass media, and the critical and self-referential nature of many works of new media art can be seen to be aligned with the contemporary art practice of institutional critique. Critical of these other cultural contexts, such as corporations or the entertainment industry, many new media artists have adopted the strategies of faking their identities (or self-institutionalizing, as discussed in chapter 10)—creating their own corporations or mini-industries, such as the artist group C5 based in Silicon Valley, which appears as a technology "startup" company but pushes the development of

technology for social and aesthetic ends, not commercially corporate ones. Similarly, the Yes Men have a very successful practice spoofing corporate companies and agencies as the means to realize their activist performance art projects—staging corporate pranks and attention-grabbing interventions in the media landscape. They use the Web and e-mail to entice their unwitting collaborators, organize their willing volunteers, and spread news about their projects after the fact (their exhibitions often take the form of press releases, documentary films, and newspaper coverage of their activities, both online and offline).

Because new media artists are so well placed to co-opt the usual means of distribution of ideas within popular culture, they are more firmly outside the usual "institutional" modes of legitimating their activity as art (as we discuss in chapter 10). Yet an essential condition of art's creation—whether avant-garde, postmodern, or postmedium—is its relationship to exhibition and hence to sites of exhibition, such as the museum. Works of institutional critique within the field of contemporary art—such as those curatorial and performance-inflected projects by the likes of Hans Haacke, Andrea Fraser, and James Luna, who exhibited himself and objects pertaining to his life in a performance at the Museum of Man in San Diego—mean that museums come in for their share of criticism for their role in legitimating and defining practice as something static—away from the messy interconnectedness of real life. According to Didier Maleuvre,

As Peter Burger argues, the first historical avant-garde gathered momentum by challenging the separation of art from the praxis of life. It denounced artistic autonomy as a sinister swindle . . . the result of an injurious trade-off. Art was given its autonomy only on the conditions that it relinquish its power over the polity. The museum may well be art's gift of exclusivity, but it is the clause of a settlement drafted by the enemy. The avant-garde thus appointed itself the bad conscience of the institutionalization of art. (1999, 50)

New media art's avant-gardist tendencies are best seen in its challenge to the site of the museum institution as sole distribution mechanism for art and ideas about art. Like Cornelia Sollfrank's intervention, Graham Harwood's artistic challenge to the Tate's institutional power, discussed later in this chapter, is a good example of institutional critique that not only challenges the museum's ability to drain art of its lifeblood, but also co-opts the usual distribution mechanisms not by being an exhibition or performance staged within the walls of the museum, but by being a spoof of the Tate's presence in the media landscape—a hack of its Web site. As we have discovered, however, challenges of this nature are still not always successful: "In rejoining the principles it sought to oppose, the avant-garde confirms the argument that the relation between the museum and the artwork cannot be thought to be merely external or contextual. The museum cannot be taken out of art, any more than a piece of music can be played without signifying its difference from the din of the city or the quiet of the countryside," Maleuvre points out (1999, 55). The question of autonomy in these "technological times" (which comes up again in relation to the question of space and materiality in new media art) is quite

different because new media art seeks autonomy not just from the museum or the system, but from all of mediated contemporary culture. This may be one of the greatest challenges for the curator—to see how new media art redefines culture.

Rethinking Curating

Unlike other "avant gardes" or emerging media (photography, video, film), "new media art" has been institutionally embraced within the same generation of its introduction. By embrace, I mean included in major biennials, have become a funding category for foundations like the Rockefellers, even generated its own funding orgs., and now with the fact that you can earn an MFA in net art, created its own department within the academy.
—Gloria Sutton, "Taxonomies, Definitions, Archives, Etc.," 2004

Whether new media art is avant-gardist in tendency or influenced by the strategies of production and reception brought forward by postmodernism and refined in the post-medium period since then, it is clear that it is an evolving, ever-changing field. This book seeks to examine how new media art is and can be the subject, theme, and method of curatorial practice. Specific chapters address specific qualities or characteristics drawn from this very hybrid beast—such as its emphasis on time or on participation—and question how they affect the conception of the exhibition, the institution, the audience, and the role of the curator. As Ursula Frohne writes, "The characteristics of certain kinds of artistic production, particularly interactive media art structured for a temporal event rather than a permanent presentation, constitute a challenge to the museum to experiment with new exhibition methods in order to deal with an 'electronic avant-garde'" (1999, 10). Although we are not just focused on the museum as the sole site for exhibitions, in the second half of book we do look at the possible "new exhibition methods": chapter 8 deals with the question of the museum in particular, and chapter 9 examines alternative models beyond the institution. This chapter is different in structure from the three that follow in that instead of looking at how the characteristics of new media art affect the exhibition, audience, institution, and the curator's role, it scrutinizes the frames for understanding new media art and how those frames have affected its presentation. These frames include the shifts mentioned earlier: the perceived emphasis on newness; the questions of self-referentiality and authorship; and how new media art, like other forms of art, participates in institutional critique by engaging with the current cultural context.

Newness Matters

The history of "media art"—art that uses electronic communications—is a peculiar one of regular false dawns and lost histories as its previous waves have dissipated, leaving little trace on the art world as a whole.
—Julian Stallabrass, *Internet Art: The Online Clash of Culture and Commerce*, 2003

If they're there [at the Venice Biennale] and for a few minutes have exposure to net art then that's terrific. It means that the next time they see net art, they will have a little bit of a context. But if people only dance the novelty hustle, then that's a problem. You've got to see works more than once to understand a context. It takes reflection to figure out what something is.
—Barbara London, in Sarah Cook, "Multi-multi-media: An Interview with Barbara London," 2001e

One problem as far as the acceptance of new media art into the mainstream of the art system is that it has been briefly taken up as a novelty and shown only for its newness. The hype surrounding the technology driving new media art hasn't helped its long-term engagement with the art world, either, as Gloria Sutton comments:

If the discourse on new media art was condensed into a single body and hooked up to a monitor to get a read of its vitals, two sharply different lines would zip across the screen. One would be a rapid succession of peaks and valleys reflecting the frenetic activity of artists and curators generating an exponentially growing number of exhibitions, festivals and catalogues devoted to new media art that has largely determined the parameters of this burgeoning field. If the second line recorded the amount of sustained critical analysis brought to bear on new media art by historians and critics, it would practically flat line across the screen setting off a shrill, incessant alarm. (2002, 18)

The development of the field of new media art has not been a smooth modernist "progress," but indeed a rollercoaster of "false dawns and lost histories." As we will see in chapter 8 concerning the museum, there have been definite hype cycles in terms of new media art's acceptance into the institution, and the hype over technology is one reason why new media art has at times been ignored by curators and at other times been overexposed. In particular, historians, journalists, and critics have often misperceived new media art, but curators also have fallen for the technological hype. For example, the exhibition *Database Imaginary* (2004) included projects spanning thirty years that employed databases in their realization. Although the exhibition sought to sustain an investigation into the aesthetics and nature of databases in art, the earliest such project included, Hans Haacke's *Visitors' Profile* (1971), was made with a computer compiling results in real time and today is fascinating for the early use of that now quotidian technology as much as for its social and political content (Dietz, cited in McGarry 2005).

Given that museums have mandates for preserving the past for future generations, it is in their interest to be "conservative" and not fall for the hype around the technology. "In place of 'institute,' read 'museum,' its curators drafting and redrafting that canon, sometimes trying to stem the flow of new discoveries by keeping them, temporarily at least, out of the museum's halls and galleries" (Schubert 2000, 146). This means that institutionally based curators, in particular those tasked with acquiring art for the collection, are dealing with long-term cycles, and if they are caught up in the hype, they will find themselves moving on to the next new thing without having first digested the last new thing. Not much has changed since Ross's characterization of net-based arts as a "breathtaking" new movement. Although general developments have taken place in museums, such as the changing of departments to keep up with the new fields of

practice (as discussed in chapter 8), it often seems as if curators can't do much beyond rearranging the furniture. "To keep a collection alive was no longer just a matter of adding to it, but became a question of combining objects in forever changing and unexpected permutations in order to explore their myriad meanings. This transition from [the] static-monolithic to the dynamic-temporized museum has taken place over the course of the last two decades" (Schubert 2000, 135).

The question is whether all curators by definition have to take such an approach and find themselves stuck with older forms and categories, making them inherently hostile to newer media. Curators are tasked with the problems of identifying provenance and histories for works of art as part of their legitimation process—an incredibly difficult task with respect to emerging art forms.[13] Video art curator Barbara London comments, "When I began my curatorial work in the early 1970s, video attracted me because it was on the cutting edge. Today, the new kid on the block is digital art and I still have the urge to be on the cutting edge" (in Thea 2001, 123). Even if art institutions manage to catch up in terms of showing or accessioning the work, they still often take longer to catch up with the criticality of the field. Curators have to strike a balance between being open to change and experimentation and providing historical continuity in terms of the types of work they support; they often end up sticking with categories that feel long dead at the expense of changing the categories to fit in something new. Or as Alex Galloway puts it, quoting philosopher Jacques Derrida, "One never sees a new art, one thinks one sees it; but a 'new art,' as people say a little loosely, may be recognized by the fact that it is not recognized" (Galloway 2006).

Curating the Avant-Garde

One of the most interesting characteristics of network art is that its means of circulation are also those of its storage, display, conservation and reproduction. This, along with the speed of the technologies involved, means that the rhythm at which it is produced and commented upon is unprecedented.
—Charlie Gere, *Art, Time, and Technology*, 2006a

The new media are the fried chicken of the information age. People are saying that things are moving so fast that it's a waste of time to write up proposals, because other people will just move on things, and you'll be left behind in the dust. . . . We seem to be witnessing the "maturation" of a volatile, half-baked culture.
—Tom Sherman, *Before and after the Information Bomb*, 2002

On the flip side of the debate, by the time institutions have caught up, the garde is avant, it's moved on, leaving the institutions to scurry around collecting the detritus left behind. Curators are in a difficult situation of having to predict where art is going next and invite into the organization those avant-garde artists who are busy creating their own new structures for legitimating their practices. This situation has long been a point of tension in the field of new media art. "If you were all really underground and avant-garde

you wouldn't give a crap about the Ars [Electronica] prize, or whether you got the nod from the art museums. . . . [Y]ou guys talk endlessly about definitions but in the end your definition of what art is comes from a historically conservative place" (Joy Garnett in Cook 2001a).

New media artists often lament that the historically conservative institution that is the museum is applying old methods to new fields, but unsuccessfully. The institution often demands that work be or act a certain way in order to qualify for inclusion (in the exhibition or the collection), such as trying to make Web-based work look like video installation. Instances of artists revolting against the institution's normalizing practices have recurred throughout art history—such as the futurists demanding the burning of the museum—and we address some of the issues behind the revolts, such as the materiality of the object of art or its participatory potential, in subsequent chapters. With the hype about new media technologies, artists have been able to get into the museum (often through educational outreach or marketing activities rather than through collections-based activity) and deflate some of the hype. They have been able to tell their own version (as Cornelia Sollfrank did in the *Female Extension* project). Artists are still doing this, but some institutions are increasingly better placed to respond:

Put cynically, the decline of the British video sector and the rapid rise of digital video and computer graphics (to be followed rapidly by CD-ROM, virtual reality and the Internet) provided critics and theorists with a great get-out clause. Namely, why maintain the excruciating focus on video when so many new dynamic and under-analyzed production [technologies were] bursting into view? So, continuing in cynical vein, many critics—though not all—quietly shut the door on one untamable playroom and entered the bigger, more challenging, more "now" spaces of new media technologies. (Hayward 1996, 211)

Yet even if a museum is well placed to respond to the technical or formal concerns of a work of new media art, it still might not be equipped in terms of its critical engagement, and that balance is the hardest to strike. Responding to new art comes with a risk or the investment of time, money, and energy in a bubble that might burst. Charlie Gere (2006c) has spoken of the museum as being like a host to what is essentially a ghost of the avant-garde ("host" because you don't know how your guest will behave: you have to cater to it, but it is unpredictable; "ghost" because the avant-garde was killed by the museum long ago, in the days of Marcel Duchamp). There is no model for this way of working (although later in this book we try and enunciate some modes of working that are sympathetic to this difficulty).

Yet looking back across a recent history, we see that curating the avant-garde did seem to change the institution, as much as the institution changed the art in order to make it something worth exhibiting (and not an experiment or a ready-made). For instance, in the case of the avant-garde of conceptual art in the 1960s, catalogs and other text-based material became much more important (than exhibitions in some cases) as a way of acknowledging the immaterial process-based nature of the work (Altshuler 1994).

When the artist has a commodity—a thing in limited supply—to offer, his problems are merely those of demand, which, if he has a dealer, it becomes the dealer's duty to stimulate; but where his art by nature offers no transferable "rare" "physical" product, the artist attempting to work and earn as an artist with a system which . . . is geared to sale (and thus implicitly or explicitly the "valuing") of rare objects, must either starve or fabricate (or allow his dealer to fabricate) criteria of rarity for what may, indeed, depend for its very identity as an endeavor within the domain of art upon the irrelevance of such criteria. In these circumstances distinctions between those artists who will permit their work to be "dealt with" and those who will not become distinctions with potentially critical overtones. (Charles Harrison, cited in Wood 2000, 66)

Postmodernism—Cultures of Display and Institutional Critique

Museums are inherently conservative. At the same time, they are compelled to be speculative, looking for points of rupture in their collection, in their understanding of what constitutes "important" art. . . . [B]oth art history—or the desire for it to continue—and social history—or the desire for its containability—provide a range of soft spots within the museum. [Museums] are riven with interdepartmental factions and disciplinary approaches, bids for new angles on which careers can be made. At the same time for artists, they act as a megaphone which can be grabbed, through which public thought can be taken on a detour. Perhaps we may even consider that ". . . being 'recuperated'—a fate so deeply feared by most avant-gardists—may be the most efficient way to obtain one's objectives."
—Matthew Fuller, "Breach the Pieces," 2000b

Emma Barker (1999) has written about "cultures of display" as way of differentiating the practices artists have engendered to critique the institutions of art—given that there are so many different kinds of institutions (museums, galleries, magazines, commercial spaces) and so many angles from which to critique them. This idea hasn't been lost on curators, who have long realized that their status as authorities on objects is in question in this age of the "death of the author," just as the validity and relevance of the objects themselves is questioned.

The authority of the curator, as object expert, is no longer the locus of power for exhibition planning. In [Eilean Hooper-Greenhill's] opinion, there is a shift to team planning, and a change in the distinction between the private space of the curator and the public space where the visitors circulate. . . . So the curator's role has shifted and the status of the object has also shifted. I believe that the commodification and fetishization of art objects, as repositories of human contemplation, wealth and status, are losing ground to the commodification and fetishization of information and the tools, both soft and hard, for manipulating it. (Mastai 1996, 148–149)

A number of conferences have been devoted to this question in particular: the role of the curator as author when authorship itself is at stake (Marincola 2002; Wade 2000). If, as Judith Mastai suggests, curators begin to fetishize the information itself over the object, this act augurs both well and ill for new media art. In the worst case, it leads to greater confusion over whether the work of new media art is in fact a tool or medium rather than a work (as new media art's status as an object is itself in question). In the best

case, it enables new media art to spread its wings and engage in a criticism of the status of information (as data-objects).

What this means for the practice of making exhibitions is complicated. Exhibitions can now be liberated from the museum entirely, existing as informational structures within a mediated landscape. As with *Les Immatériaux,* it is possible to think of presentation formats as themselves hybrid creations: part exhibition, part lecture, part workshop, part interview. Online, with thanks to the network that is the browsable Web, and "emancipated from the pressure of old value systems, you can navigate with lightning speed through the Louvre as a hypertextual network; you can zap your way through stately museum rooms, 'browse' an exhibition with ethnographic objects and scan in nervous relaxation through spaces with the most tempting, 'clickable' points'" (Seijdel 1999). A different example of knocking on the museum door and challenging the notion of interactivity, exhibition making, authorship, and institutional critique is the commission undertaken by the Tate for its Web site, Harwood@Mongrel's *Uncomfortable Proximity.*

Exhibition Example: *Harwood@Mongrel,* Uncomfortable Proximity

In 2000, as part of a plan to promote Tate's Web space as a unique venue with the opening of Tate Modern and the rebranding of the Tate Galleries at Millbank as Tate Britain, Graham Harwood, a member of the artist group Mongrel, was commissioned to create an online work of art. Mongrel represents many of the characteristics of postmodern artists: it is a loose collective of designers, artists, educators, and political activists who use technology—often modifying it to suit their own needs—to engage in discussions about memory, place, and access with communities of interest and social groups. Their work is as often as much research or outreach as it is art. Yet, like most artists, they have been able to use the institutions of the art world to their benefit, even if they don't fit the mold of being single authors of static works (for example, the Centre Pompidou acquired Harwood's project *Rehearsal of Memory* [1995], created in association with a group of staff and patients at a high-security mental health hospital).

The resultant Tate commission, *Uncomfortable Proximity* (2000), was in essence a fully realized "other" (or spoofed) version of the Tate's own Web site. The "mongrelized" version of the site was launched in a browser window behind the actual Tate site and was at first glance indistinguishable. Closer inspection revealed a mish-mash of images and texts: close-up digital photographs of famous works of art in the Tate's collection had been spliced together in often gruesome detail with close-up photos of real people (the artist's relatives) and of hair, muck, and the Thames riverbank; texts about the Tate's mission, collections, and educational programs had been rewritten to give a different story about the slave-trading, sugar-fueled financial empire through which the collections of the cultural institution were in part acquired. As commissioned critic Matthew Fuller wrote at the time, "If you dial an incorrect phone number, you can expect the person at the other end to let you know and put

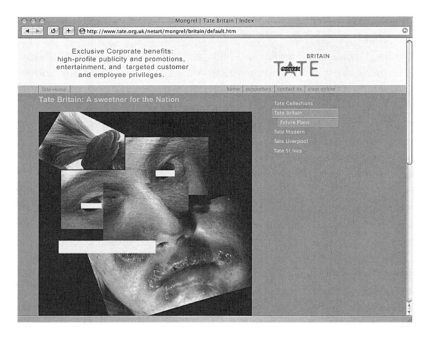

Figure 2.5
Harwood@Mongrel, *Uncomfortable Proximity* (2000). Screenshot from the Web-based artwork. Courtesy of the artist.

the phone down. You don't expect them to start filling you in on the secret life, the dodgy deals, the affairs, the backhanders of the person you were calling. Harwood's take on the Tate does precisely this. He reshuffles the collection, messes it up, flips the register in which art is spoken, makes links" (2000b).

As expected, *Uncomfortable Proximity* generated a flurry of press interest and had the "guest" curator, Matthew Gansallo, who commissioned the project—and who worked not within a curatorial department, but for "national programs" as an education consultant—scurrying between the marketing department and the artist. Stories about the "little" artist being censored by the "big" institution and about artistic intervention into branded spaces were published. In one sense, the Tate had invited this debate, generated in part by the knowing tactics Harwood employed—mockery and pranksterism, collage and pastiche, irony, rewriting history, questioning authorship, questioning existing value systems—in a spirit of institutional self-critique. However, this critique was short-lived; the project remains online, but at the time and since, no platforms or events have been organized (online or otherwise) to discuss issues raised by the work, and any feedback received by e-mail was not publically circulated.

The Cultural Context—Networks and Authorship in an Age of User-Generated Content

If actual curating of online stuff can only be done online, it is done by everybody alive and it is called "links." And if you are able to draw sufficient attention, as a quality broker of dialogue about quality ideas, you will get people visiting your curatorial site and the links you have put there.
—Vuk Ćosić, in Cook, Graham, and Martin, *Curating New Media*, 2002

In Lyotard's exhibition *Les Immatériaux,* the "Writing Tests" area included computer terminals showing documentation of dialogues conducted over a period of two months via networked computers (Gere 2006a, 19). Not then, but now one can offer full public access into the textual debate with the correspondents, which leaves the question: Would that be a good idea? At the time that the Tate commissioned Mongrel, it thought not (the Tate now hosts many online forums focused on its exhibitions and commissioned art). As we will see in subsequent chapters, letting the masses in poses a big challenge to curating, even if technologically it is easier now. In instances of institutional critique, such as that of Cornelia Sollfrank's project described in this chapter, curating the Other can quite quickly become curating yourself and your peers. It is important to keep some sense of context regarding digital culture today in order to see how new media art most challenges the role of the curator and our understanding of the audience. In 2002, this potential mode of online curating that Net artist Vuk Ćosić describes—in which anyone, curator or otherwise, sifts out content from context in the pools of cultural production online—was called "linking" or "filtering" and was nicely outlined in an article by curator Anne-Marie Schleiner (2003) (see also Nedkova in Cook, Graham, and Martin 2002, 96–97). Half a decade later, and the Internet is now awash with the new so-called Web 2.0 technologies like Twitter that allow users to share their thoughts and bookmarks online easily and to create networks based on relationships (friendship, likemindedness), which can automate, to a degree, a viewer's search for new art. *Web 2.0* is a hyped-up buzzword that refers to the current incarnation of the World Wide Web in which users can upload content to sites without having to download and learn software packages. Examples of Web 2.0 sites include (at time of writing) the globally popular photo- and video-sharing sites such as Flickr and YouTube and the social networking sites (where you can connect to friends and share photos, videos, audio tracks, etc.) myspace.com and facebook.com. In fact, what Web 2.0 allows anyone (amateurs) to do— such as keeping a journal (weblog or blog) online—has always been possible with a little knowledge (or professional training).[14] This filtering activity, once the preserve of the curator (or artist), has now taken on an even more popular face, and the model of "curator as editor" is increasingly prevalent and indeed is how popular blogger Régine Debatty of *we make money not art* describes herself (discussed in detail in chapter 9).

Early Internet applications that made the Web accessible, such as file-sharing software and blogging software more recently, served to distribute authorship around the Web,

creating a plurality of narratives on any given topic. An often-cited example of the success of this opening up of authorship and decentralizing of knowledge is *Wikipedia,* a collectively authored encyclopedia built using wiki software (which allows users to edit the content on a Web page and to add pages automatically, often without review procedures or even log-ins). Similarly, "tagging" sites such as del.icio.us, which allow users to share their bookmarks, favorite linked Web sites, or indeed any media uploaded to a Web site (such as a photo or video) with others, using keywords as identifiers, have dramatically changed how data are accessed online and how knowledge is filtered and shared. Tagging as a practice has led to the creation of "folksonomies," or popular user-generated taxonomies. With tagging, museums can now opt to open up their digital collections to being searched by "folksonomy" rather than by authorized taxonomy. With these systems, everyone can be a curator of what they find on the Web, just as everyone could previously be an author. As producer and artist Sara Diamond has cautioned, "In the world of peer-to-peer technologies and heightened exchange between individuals and collectives, and in a context where participants change media objects that are posted to peer-to-peer sites, the roles of artists as originator and curator as interpreter are certainly challenged, if not made obsolete" (2003, 161).

However, curating user-generated content is quite different from user curating (i.e., allowing your audience, through filtering and tagging systems, to determine the content on view)—although both can exist in one work, where the artist acts as a curator filtering user-generated content, such as in the work *Learning to Love You More* discussed in chapter 5. A number of new media art projects, such as runme.org (discussed in chapter 10), have investigated the possibility of letting the users of the system decide—something increasingly commonplace in online culture with Web sites such as Digg, which determines the most important news headlines by allowing registered users to choose to promote or demote stories of interest. There are nuances within how these systems work, both within popular culture and within the institutions of art, or even within the emergent field of new media practice. For instance, some systems use voting to determine the active interests or politics at play, whereas other systems use voting just to indicate popularity over relevance or simply the most used or common content. (The BBC's news Web site has a feature that shows the most read and most "shared"—e-mailed or reposted—articles; sometimes they are not the most recent news items: on Fridays or slow news days, for instance, they are often out-of-date or timeless amusing stories about mishaps or sex scandals that have just been noticed). *Wikipedia,* by contrast, is a less-automated version of a similar phenomenon of handing the authorial (and legitimating) role over to the site's users/readers, who are also the ones writing the articles in the first place (this possible mode of curatorial practice—allowing the audience to be the curator—is discussed with reference to artist-led projects in chapter 10).

Projects that are open to participation—where the audience is invited to comment on and collaborate in the making of the work using a technological system set up by the cu-

rator, institution, or artist—do question authorship. But authorship, it turns out, is not the biggest problem in our age of user-generated content. Who made it becomes of secondary importance to who uploaded it, who tagged it, and who now owns it (one need only think of photos from high school days that old acquaintances have posted on Facebook tagged with your name and that you have little to no recourse to remove). In the case of a digital version of a museum's collection that is open to "curating" by the public (as discussed in chapter 8), authorship of the works featured is not in question, but attribution—who tagged Cezanne's painting of apples with the word *portrait,* making it accurate or accessible or not—can become a problem. Also, with more recent Web 2.0 sites, the content—the public's own videos, for instance—is clearly held on centralized servers owned by corporations rather than on individual computers connected across the Internet.[15] That users are geographically distributed but their material outputs, their uploaded photos, and texts are centralized raises the issue of ownership and copyright over the content more than the issue of who made it.

Summary: Curating in a Postmedium Condition?

Following Dickie's Institutional theory art is a largely self-certifying activity:
- "A work of art is an artifact of a kind created to be presented to an artworld public."
- "A public is a set of persons the members of which are prepared in some degree to understand an object which is presented to them."
- "The artworld is the totality of all artworld systems."
So "yes" new media art *is* "art," if we say it is. New media art is an "artworld system" in this definition, which to me is helpful, as we can understand it as one of many artworlds that make up a totality and not some orphan excluded from the "mainstream artworld."
—Tom Corby, "Re: Art," 2004

Following on from chapter 1, this chapter has sought to question some of the theoretical territory that new media art ranges across from its position as an avant-garde art form within a culture of postmodernism and beyond. Art historians and theorists have questioned whether new media art is itself a movement or if it exhibits tendencies of other movements (as discussed in chapter 3 in relation to conceptual art), or, indeed, if it marks an epoch or style of art (Mark Tribe and Reena Jana in Quaranta 2006). The split between the traditional art world and the new media art world has been pronounced, but it is still possible to consider works of art beyond their technological newness and to think of them as "formerly known as new" or as art in a postmedium condition. Indeed, Lyotard had this goal in part in his exhibition *Les Immatériaux:* to mix together art, technology, and evidence of the cultural changes taking place because of information technologies so that these boundaries between disciplines and knowledge bases dissolved or were made more permeable. Lyotard's legacy is felt within the field of new media art, which is seen, on the one hand, to be quite modernist in its formalist approach to the use of technology and its illustration of the new, but, on the other hand, to be critical of

the modernist idea of progress by ironically and self-reflexively remediating its media at each turn and questioning authorship, sometimes by inviting the audience in. Whether new media is a style or a tendency in art, in all cases it is important to note how the technological characteristics of the work are factors in its reception by institutions.

This cultural change brought about by technology (as witnessed in the transformation of an avant-garde modernism into a postmodern hybrid condition) obviously isn't solely confined to the field of new media art, but is evident in art as a whole. Curators are aware of art's role in commenting on current conditions using strategies from modernism and postmodernism, just as those who follow new media art are tired of the "new" and tend toward thinking of the latest technological form of art more inclusively as the form "formerly known as new media." Our current condition also means we have to rethink what curating means in terms of new networked structures, database structures, and an increasingly technology-led society.

Whereas this chapter looks at the attendant theoretical and conceptual shifts, showing how new media art and contemporary art engage in similar practices of questioning authorship and ironically critiquing structures of presentation and legitimation, the subsequent chapters look more specifically at the technological shifts—considering how art functions within a network or system and acknowledging how complex those systems can be and how time-based technologies of "remediation" such as video present challenges to our understandings of the behaviors of art.

As we have seen here with the discussion of institutional critique, postmodernism has thrown into question the museum and academy as venues for the telling of the tale of art and culture. Indeed, the ramifications of the opening up of authorship are being felt across the whole art system and the whole landscape for presentation and mediation of culture: the shop window, the arcade, the department store, the theme park, the cinema, the theater, the world fair, the trade show.[16] Many of these places are discussed in subsequent chapters by looking at particular characteristics of new media art—its relation to histories of time in art, space and materiality, interaction, and participation. Curator and artist Jon Ippolito has suggested that we don't want just to add new media artists to an existing canon, but to create a whole new network.[17] As such, the new, the avant-garde, the postmodern, and the postmedium as manifest in art present a challenge not just to the curator, but to the critic, the art historian, collectors, and many others besides.

Notes

1. At time of writing, curator Nicolas Bourriaud has coined the term "Altermodern" to refer to this post-postmodern condition in art, claiming that postmodernism is dead. See his manifesto online at http://www.tate.org.uk/britain/exhibitions/altermodern/manifesto.shtm.

2. The topic of collaboration recurs throughout this book and is discussed in more detail in chapter 5 concerning participation and chapter 10 concerning artist-led initiatives.

3. *Periodicity:* the quality of occurring at regular intervals or periods (in time or space) and in different contexts.

4. The hype cycle is a widely documented graphical representation often applied to specific items of new technology. More information about it can be found online at http://www.gartner.com/hypecycle.

5. In other words, museums can practically and physically show only so many artists and so many works, but when technologies such as Web sites and databases are brought into the equation, more users can be reached online, and more images of works and information about those works can be made available.

6. As discussed earlier, "Turing-land" and "Duchamp-land" were originally posited in Manovich's *The Death of Computer Art* (1996). He writes: "The typical object which is admitted in Duchamp-land (i.e., counted as contemporary art) meets the following characteristics: . . . 2) Ironic, self-referential, and often literally destructive attitude towards its material, i.e., its technology, be it canvas, glass, motors, electronics, etc. The examples are the awareness—which has largely shaped artistic modernism—of the tension between the illusion and the flatness of the canvas; ironic machines by Duchamp; self-destructive machines by Tinguely. Perhaps the best and most relevant example is the first exhibition of Paik where he screwed technology—ripping open television sets or changing TV signals by affixing magnets to the monitors."

7. Martin Heidegger's philosophy of technology is linked to art in that he bases it on the Greek word *techné,* which, according to him, is "the name not only for the activities and skills of the craftsman but also for the arts of the mind and the fine arts" ([1953] 1993, 318). For more on Heidegger's philosophy of art and technology, see *The Origin of the Work of Art* ([1935] 1993) and *The Question Concerning Technology* ([1953] 1993).

8. The debate was sparked by a comparison Charlie Gere made between new media art and the mapping software Google Earth; he was cited in an article by the Turner Prize–winning artist Grayson Perry in the pages of a mainstream Sunday newspaper. (Perry 2006).

9. As can be seen in the history of art—for instance, in relation to color field painting.

10. This phenomenon is what computer software developers call "feature creep." One thinks here of the number of early Web sites that had midi sound files on them simply because it was possible to include them, even if they didn't actually heighten the experience of Web browsing.

11. New media art's emphasis on "any medium necessary" can be aligned to contemporary art theories about "amenable objects" in their shared use of ready-mades.

12. A note about tools: elsewhere in this book, it is argued that because new media art is made using computer tools, the qualities of those tools will affect the outcome of the work. As such, a great deal of new media art is by necessity collaborative; sharing tools means that the lines between art and design, between art and engineering, and between information design and education are blurred. In chapter 5, we discuss collaboration in relation to the tools artists use.

13. This task also applies to curators whose responsibility it is to collect art (discussed in chapter 8); this book deals with all manner of curatorial practice, however, including exhibition making and art commissioning—forms more conducive to supporting new forms of art.

14. The exhibition *My Own Private Reality* (2007) at the Edith Russ Haus, co-curated by Sarah Cook, made this argument. Further information on the exhibition is available at http://myownprivate reality.wordpress.com.

15. These sites developed from bulletin board systems include the popular (but now defunct) music-file-sharing site Napster as well as software such as bit-torrent, which allows the distributed uploading and downloading of files. Some have argued that Web 2.0 isn't new, but rather just a preemptive strike against true peer-to-peer file sharing, which is difficult to commodify or sell advertising in relation to (Kleiner and Wyrick 2007).

16. Many of the ramifications of the opening up of authorship have been theorized in detail in the works of philosophers such as Theodor Adorno, Guy Debord, and Jean Baudrillard, and more recently in the work of new media theorists such as Peter Lunenfeld.

17. See Blais and Ippolito 2006. These debates have been ongoing for a decade or more, as witnessed in the tongue-in-cheek series of imaginary books about Net art that Vuk Ćosić proposed on his Web site as an ironic joke, many of which have now actually come into being as art critics and curators take advantage of the opening up of publishing (for instance, through print-on-demand initiatives) to publish quick histories of new media art.

3 Space and Materiality

And I would say there is no art without media, mediating between you and me.
—Johannes Goebel, "Re: Definitions," 2004

The distance from this sentence to your eye is my sculpture.
—Ken Friedman, Fluxus score, 1971

In the introduction to her edited volume *Curating Immateriality*, Joasia Krysa asks, "If the assumption is made that traditional curating follows a centralised model, then what is the position of the curator within a distributed network model?" (2006, 16) The previous chapter considered how avant-garde and postmodern tactics in contemporary art and new media art have changed the field of institutional curatorial practice by critiquing the centralized networks of the art world—its museums and exhibitions, which value discrete unique works by single artists. The increasing internationalism of art, made up of communities of interest networked across space, shows how the global network itself is now more important than the formerly key nodal points New York or Paris or London. This move away from an emphasis on "centers and margins" has begun to change the system of the art world and by extension the role of its curators, who now globe-trot their way through their research. Art has long been concerned not just with geographic space, but with abstract space—its creation and exhibition—and by extension with the question of materiality. For new media art, these concerns go even farther into the realms of the virtual.

Without seeking to define the "formal" aspects of the individual artwork or take too object oriented an approach, this chapter unpacks Krysa's question by investigating the role of space (the space of the work, the space of the exhibition) and its material (of the work and its presentation) to force a rethinking of contemporary curatorial practice. The key history here is that of "dematerialized" and network-based art, some of which was first described in the 1960s and 1970s as "systems-based art."

Dematerialization—From Conceptual Art to Systems Art

I was trying to do shows that would be so dematerialized they could be packed in a suitcase and taken by one artist to another country, then another artist would take it to another country, and so on, so artists themselves would be hanging these shows and taking them around and networking. We would bypass the museum structure. [. . .] [Seth Siegelaub] was talking about exactly the same things, so we had a meeting of minds around trying to dematerialize shows that bypassed the institutions.
So the idea was really, one could say, about finding other circuits.
Yes, alternative venues, alternative circuits. It wasn't just Seth and me; the idea was in the air at that point. My idea was a show that could physically be put in a box.
—Lucy Lippard, interview by Hans Ulrich Obrist, 2008

In her 1973 book *Six Years: The Dematerialisation of the Art Object from 1966 to 1972,* Lucy Lippard did a kind of database-driven activity: she compiled in chronological order the exhibition invitations, the announcements for actions and happenings, and the extracts of reviews of projects that took place over a set period of time. Read from beginning to end, this compilation makes the notion of the increasing "dematerialization of art" quite clearly obvious—exhibitions start with objects but gradually become descriptions of objects in space, then just descriptions or just space—all framed by the artists' ideas. Most of the works created in the six years can be appreciated by simply reading their descriptions—straightforward sets of instructions, communicated in written words and text. This development in art was, of course, not confined just to the six years on which Lippard focuses, nor was it confined to her home territory of New York. In the other realms of art activity that she touches on—minimalist sculpture, architecture, even music—the idea was prevalent that the work was dematerializing into sheer volumes in space, which were to be considered from a number of angles as they were encountered by a viewer.

Lippard's book, itself a kind of artist's book, shows that it was possible for art to be immaterial and for form not to matter (in other words, the art could be described, legitimated, even shown, but without the artist's engaging in material concerns directly). But were artists striving for their works actually to be immaterial? For instance, artists such as Sol LeWitt, Ken Friedman, and Dan Graham, who were creating projects that could be communicated through written instructions on a single sheet of paper, were as much interested in breaking down the barriers between art and life (including the rituals of the gallery space) as they were in systematizing the process of making art. At the time, this approach was a political act because processes are not often things that can be commodified or sold as objects. The genres or types of art practice that were such a feature of the late 1960s and early 1970s ranged from conceptual art to tangible mail art to performative actions, all of which could be seen as a part of a larger interest in system-based art (Burnham 1968b). For his exhibition at the Howard Wise Gallery in 1969, Hans Haacke wrote, "The working premise is to think in terms of systems; the production of systems,

the interference with and exposure of existing systems. Such an approach is concerned with the operational structure of organizations, in which transfer of information, energy and/or material occurs" (in Lippard 1973, 123).

The transfer of information or material or both is a key point here because materiality wasn't necessarily the goal. In fact, neither was the static objecthood of art; as Craig Saper writes, "The artists' networks and intimate bureaucracies examined here do not fit neatly into an art historical context in part because the individual works in any given assembling often, and often intentionally, lack aesthetic sophistication. Even an advocate of antiaesthetic sensibilities might argue that many of the individual texts have little value to anyone other than the sender and possibly the receiver. . . . The works are about process, contingencies, and group interactions, not lasting truth or eternal beauty" (2001, 150). The move of art toward prioritizing a fluid process rather than an object or product, resulting from a unique, singular, action, was only partly influenced by the technological developments of the time, such as telecommunications, fax machines, and the rise of networked databases, even if the desire toward systematization of art practices was more so.

The prevalence of conceptual art practices in the 1960s were part of a larger historical development concerning the systematization of society, of lived experience, as theorized at the time by professor Jack Burnham, who curated the exhibition *Software: Information Technology: Its New Meaning for Art* at the Jewish Museum in New York in 1970.[1] The exhibition was developed because in Burnham's mind "at least two-thirds of extant 'computer-art' consisted of computer programs designed to simulate existing art styles [so] with all this in mind, I decided with *Software* to forget about 'art' as such and to concentrate on producing an exhibition that was educational, viewer interactive, and open to showing information processing in all its forms" (Burnham 1980, 205). The exhibition nevertheless included artists such as John Baldessari, Nam June Paik, Joseph Kosuth, and Hans Haacke, who produced his piece *Visitors' Profile,* which was intended to use a computer to tabulate data from surveys and questionnaires filled in by gallery visitors. Artists who were working with these new methods and methodologies were not just adopting a style of working, but an entirely new process. The process involved getting art out of the gallery as much as getting it out of the system, or the commercial model of art making.

If we were to try and consider these works through the lens of a technological history, as Charlie Gere does in his book *Art, Time, and Technology* (2006a), then we might see that—exact systems (questionnaires, measurement, faxes, mimeographs, etc.) aside—a concern with the space of art has been inseparable from the concerns about its dematerialization. In other words, if you were going to make art immaterial, where would you put it? Or how would you know it was immaterial art if not because of where you had put it?

Figure 3.1
Installation view of the exhibition *Software: Information Technology: Its New Meaning for Art* (1970) at the Jewish Museum, New York. The artwork shown is *SEEK*, by Nicholas Negroponte and his colleagues at MIT's Architectural Machine Group. Aluminum building blocks and gerbils were placed in a vitrine with a computer-controlled robot arm that rearranged the blocks in response to the gerbils' movements. © 1970 SCALA, Florence.

Figure 3.2
A page from a questionnaire as part of Hans Haacke's work *Visitors' Profile* in the exhibition *Directions 3: Eight Artists* at Milwaukee Art Center, 1971. The answers were processed and correlated at regular intervals by the University of Wisconsin in Milwaukee, and the results were posted in the exhibition. A similar poll had been proposed for the *Software* exhibition (1970) at the Jewish Museum in New York, but did not materialize because the computer-aided processing of the answers did not function. © Hans Haacke. Courtesy of VG Bild-Kunst.

These questions and your answers are part of

Hans Haacke's VISITORS' PROFILE

a work in progress during "Directions 3: Eight Artists", Milwaukee Art Center,
June 19 through August 8, 1971.

Please fill out this questionnaire and drop it into the box by the door.
DO NOT SIGN.

1) Do you have a professional interest in art,
 e.g. artist, student, critic, dealer, etc.? ☒ yes ‾ no

2) How old are you? 22 years

3) Should the use of marijuana be legalized, ☒ legal ‾ light ‾ severe
 lightly or severely punished? punishment

4) Do you think law enforcement agencies
 are generally biased against dissenters? ☒ yes ‾ no

5) What is your marital status? ‾ married ☒ single ‾ div. ‾ sep. ‾ widowed

6) Do you sympathize with Women's Lib? ☒ yes ‾ no

7) Are you male, female? ‾ male ☒ female

8) Do you have children? ‾ yes ☒ no

9) Would you mind busing your child to integrate schools? ‾ yes ☒ no

10) What is your ethnic backround, e.g. Polish, German, etc.? Russian

11) Assuming you were Indochinese, would you
 sympathize with the Saigon regime? ‾ yes ‾ no

12) Do you think the moral fabric of the US is strength-
 ened or weakened by its involvement in Indochina? ‾ strengthened ☒ weakened

13) What is your religion? Jewish

14) In your opinion, are the interests of profit-oriented
 business usually compatible with the common good? ‾ yes ☒ no

15) What is your annual income (before taxes)? $ 0

16) Do you think the Nixon Administration is mainly
 responsible for our economic difficulties? ‾ yes ☒ no

17) Where do you live? ☒ city/suburb ‾ county ‾ state

18) Do you consider the defeat of the supersonic transport ☒ yes ‾ no
 (SST) a step in the right direction?

19) Are you enrolled in or have graduated from college? ☒ yes ‾ no

20) In your opinion, should the general orientation of the
 country be more conservative or less conservative? ‾ more ☒ less

Your answers will be tabulated later today together with the answers of all
other visitors of the exhibition. Thank you.

Exhibiting the Immaterial

Sol LeWitt's *Paragraphs on Conceptual Art* emphasized ideas over physical instantiations, even viewing unrealised concepts as works in their own right. . . . [T]o view works now as realisations of ideas was no longer an attack but an avenue of aesthetic renewal. And as concepts became focal their linguistic presentation moved to center stage. Artworks could be embodied by statements, and a collection of statements could become an exhibition.
—Bruce Altshuler, *The Avant-Garde in Exhibition: New Art in the 20th Century*, 1994

Exhibitions of system-based arts briefly flourished and, as curator and historian Bruce Altshuler believes, brought about the notion of the curator as creator when curators and gallerists such as Seth Siegelaub[2] charted new territory in producing exhibitions in a range of formats—printed catalogs, mailed-out invitation index cards, and advertisements in art magazines. Of course, even though artists were interested in getting out of the commercial system or getting art out of the gallery, many of the new ways were found to reify the process-based nature of the work:

Conceptual artists working within the commercial gallery system . . . claimed a political significance for this work by arguing that it challenged both the art historical and gallery definition of the work as a cultural and marketable commodity. The institutional effect of this shift within avant-garde art practice was rapid. Many galleries adapted their marketing strategies to recuperate these works as saleable commodities. Hence documentation of performance, site-dependent and conceptual art was offered to the collector in the place of the work itself. (Marshall 1996, 65)

The *Software* show suggests an interesting approach to artwork that is about the way things are done rather than about the things themselves: "Burnham had chosen works that could fit into the category of cybernetic feedback systems in the broadest sense. . . . The *Software* show was neither meant to be a demonstration of engineering know-how, nor an art exhibition in the traditionally accepted sense. . . . The *Software* exhibition is one example of the phenomenon in which conceptual art was institutionalized by and incorporated into the museum structure at exactly the same time as it was calling for a de-institutionalized system" (Buchmann 2006, 55).

The idea of a systematic selection, the presentation of research findings rather than finished products, was successful only in a very limited sense, however. More interesting were the off-site, interventionist, non-museum- or gallery-based projects that truly questioned the space of art's dissemination. In a 1969 interview, Siegelaub stated,

The nature of what I do and how I do it is much more private than a gallery in a sense. But I suppose that in some sense you could say I do, in a certain way, what they do. Except the type of art I'm involved with and concerned about has to do less with materiality than ideas and intangible considerations, you see. And so because I deal with that, or spend some time working with artists making art in that area, the needs for presentation of the work, and things of this nature, are quite a bit different than just putting up walls and making them available to artists, which is what a gallery does. . . . You see, much of the work being done today, like Kosuth's for instance, there's no condition for space at all. Space is totally ungermane to the work. It exists in space on a different level. (in Alberro and Norvell 2001, 32)

It would appear that one can today hold up these examples of conceptual art as proof that sometimes actual space doesn't matter at all when it comes to curating immateriality or the dematerialized art object.

In 2006, Tate Modern mounted the exhibition *Open Systems* and reprinted in their catalog Burnham's essay "Systems Esthetics" published in *Artforum* in 1968. Burnham's theories have become relevant again in that his notion of a "systems-oriented culture," where "change emanates not from things but from the way things are done" (1968b, 31; see also Skrebowski 2006), has resonance with the technologized, service-industry culture of the early twenty-first century. *Open Systems* contained a number of objects—documentation of performances or events, alongside modernist sculptural interventions—as well as instantiations of art as information, all from the 1960s and 1970s, many of which were quite exact reconfigurations of space.[3]

A criticism of the exhibition—also a subject of its attendant online and symposia educational events—was its ignorance of placeless and truly *open* (subject to change and modification by the user) technological systems, both of then and now, such as the kind of interactive artwork seen in the *Software* exhibition. Theorist Matthew Fuller wrote that the danger of such an historical presentation is that conceptualism might be seen as a "style" rather than as "as an invention of a new dimension within art systems" (2005).[4]

Systems, Networks, and Space

Galleries or museums begin to become a cliché situation, because they're not equipped to deal with the art that's being made today. You know, they conform and it's new wine in the old bottles again. . . . [A]nd in a certain sense, that's why I've been able to function, because I create an environment that has nothing to do with space.
—Seth Siegelaub in Alexander Alberro and Patricia Norvell, *Recording Conceptual Art*, 2001

"The network" comes in various shapes: each formal or technical definition has its own affordances, as well as subsequent legal, cultural constraints and so on once it gets implemented.
—Simon Pope, "Re: Exhibiting Re-enactment and Documentary-Based Art," 2005

What Burnham described as a system can be thought about in terms of linked-up networks, and, indeed, it is difficult to talk about systems without lapsing into a kind of generalized discussion about how "everything is connected." Alex Galloway's writing about networks in relation to computer technology describes clearly the most common kinds of networks: *centralized networks,* which have hierarchies, a clear center point (hub), and nodes that shoot off from that hub; *decentralized networks,* which have more than one center point (many hubs), each with a team of nodes attached (essentially a "multiplication of the centralized network"); and *distributed networks,* which have no center but many links, shaped a bit like a honeycomb. Galloway frames these kinds of networks within a discussion of "protocol layers and universal languages"—the way in which communications across the Internet are realized—commenting that "the material substrate

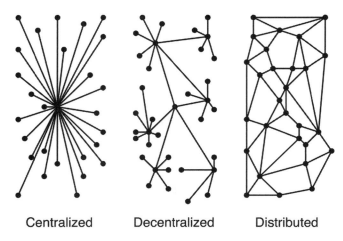

Centralized Decentralized Distributed

Figure 3.3
Diagram of centralized, decentralized, and distributed networks, based on Paul Baran's study
On Distributed Communications Memorandum RM-3420-PR, published by the RAND Corporation in
August 1964. Diagram redrawn by Beryl Graham.

of network protocols is highly flexible, distributive, and resistive of hierarchy" (2004,
29). In other words, many kinds of networks might make up a system.

For instance, the system of showing art—that is, the art world—has largely been a re-
sult of the linking together of the network of the physical spaces for presenting art with
the network of printed publications reporting on what is shown. Throughout history,
these "spaces" have ranged from private salons to public halls, yet the notion of the gal-
lery has remained constant, more so since modernism and the theorization of the white
cube and the *Kunsthallen* (Möntmann 2006; O'Doherty 1986). The previous chapter in-
troduced the idea that the institution of art conditions its reception and understanding.
In the 1960s, conceptual artists tried to break out of the system and find entirely new
spaces and new networks for art, or they deemed space irrelevant to their art. As Sandy
Nairne writes in his essay on the "institutionalization of dissent," "With the advent of
Minimal and Kinetic Art in the early and mid-sixties, as artists asserted a direct and seem-
ingly unaltered employment of everyday materials within the gallery, so the *use* of space
became a critical factor in exhibition making" (1996, 394).

Outside the white cubes of the gallery, space doesn't always equate with place. In look-
ing at the histories of conceptual art, in particularly mail art, it is possible to view the
work as both immaterial and site specific. In 1973, artist Glenn Lewis invited artists to
post to him works of art to fit in a plexiglass box. *The Great Wall of 1984* installed in the
lobby of the then-new National Science Library of Canada contains 365 boxes, some of
which are empty, others with contents long since rotted away. The work shows a trans-

Figure 3.4
The Great Wall of 1984 by Glenn Lewis (1973). Site-specific installation in the lobby of the National
Science Library, Ottawa, Canada. Image courtesy of Centre for Contemporary Canadian Art.

lation from one medium (the call for participation sent to a network of artists by post
and fax) to another (the plexiglass box and contents) via a third medium (the postal
service).

To take artwork out of the studio decontextualizes it. Whether artists decide to work
with or against this decontextualization is a systematic choice—and Lewis's taking on
a kind of curatorial or organizational role by inserting his work into a social network
other than the gallery is a good example of such a choice (chapter 9 discusses other ex-
amples). What is at stake in putting work into a gallery or other public space where its
context or site will serve to define it is the dissolution of the autonomy of the art object
(Lippard 1973). Putting work before the public means putting it into a field of social rela-
tions. As Sabeth Buchmann writes, "the self-reflexive system and the decentralization of
the object lead not only to a relativising of the idea of artistic production. These changes
also lead to a complete emptying of the societal meaning of production. Thus within a
fully integrated cultural system the audience becomes a producer, but only to consume
their own participation as a product" (2006, 56). Another way of looking at the concep-
tual artworks in which participation was the end goal, such as the Lewis piece described

earlier, is to consider that when the work is immaterial or the process of making and consuming it has resulted in its dematerialization, then what is left is an aesthetic of its transmission or communication—in other words, an aesthetic of distribution.[5] What if, however, the context that is sought to define the work is the (seemingly immaterial) network or system itself?

Even with instances where space is irrelevant to understanding and appreciating the work, the question of how the work is distributed is brought to the fore. Public spaces, theaters, and cinemas represent kinds of distribution networks that are different from the gallery (as discussed in chapter 9), yet nevertheless are a part of the system of legitimating, valuing, and validating art. When the work is immaterial—is framed and understood only through participation in the system itself—then the network of its distribution is highlighted.[6]

Looking at the *Software* show, this [new mode of production] meant that the artist was situated in a much wider and more abstract frame of reference than the studio, gallery and museum could offer. The loss of meaning (even if only temporary) which the object-oriented process of production suffered through changes in strategies of distribution, resulted in a shift and expansion of artistic production into a technological realm. This then required other, more media-dependent and media-conscious self-promotion strategies than those that had been needed by artists who understood themselves exclusively as creators or authors of art objects. (Buchmann 2006, 59)

Debates about the presentation of new media art tend to hinge on a binary opposition between the white cube gallery and the black box cinema or theater (Manovich 2003b; Paul 2003).[7] Both types of spaces have their own unique properties and constraints—cinemas and theaters designed for seated viewing of works with set durations, galleries for ambling and gazing. New media art projects are often hybrids of these varied modes of engagement (as chapter 5 on participation seeks to show). However, whether the artwork is in the white cube or the black box, essentially the same process of reification has happened to it. What is of concern here is how these venues for art condition how we think about the "spaces" of new media. For instance, where—white cube or black box or other—is the space of Web-based art?

How New Media Art Is Different

New media art is something that is neither highly materialistic nor immaterial.
—Josephine Bosma, "Art as Experience," 2006

In her interviews of many of the leading artists of the 1960s and 1970s, Patricia Norvell asked them about Burnham's theory of systems. Many of them either hadn't read it or generally discounted it, as Robert Smithson did in criticizing Burnham for having too utopian a view: "['System'] is a convenient word. It's like 'object.' It's another abstract entity that doesn't exist. . . . I see no point in utilizing technology or industry as an end

in itself, or as an affirmation of anything. That has nothing to do with art. They're just tools. So if you make a system you can be sure the system is bound to evade itself. So I see no point in pinning your hopes on a system. It's just an expansive object, and eventually that all contracts back to points" (in Alberro and Norvell 2001, 133).

So it is here that the debate around the tool used for producing the work and the medium in which the work is manifest first comes up as a problem. In the 1960s, a novelist would have used the tool of the typewriter to write his novel, but this does not necessarily mean the typewriter was a stylistic influence. Yet when Carl Andre undertook his concrete poems, the typewriter and the edges of the page were both interesting aesthetic constraints that went into the decisions about the form of the work. In this sense, the typewriter—not an object, but a system for working—was at once the tool *and* the medium *and* the methodology.

As argued in chapter 4, video and time-based practices cannot easily be commodified and are experienced over a duration rather than consumed as static objects; the same can be said of dematerialized, system- or network-oriented artworks. Many new media art projects (though certainly not all) are not interested in the object outcome, but rather in the process, the engagement, and the interaction. *They are interested in how the system becomes both the space and the material of the work.* In this sense, unlike new media design or architectural projects that are the result of new media tools, new media art is not necessarily materialistic, but is instead concerned with method rather than with final form.

For instance, Thomson & Craighead's *Short Films about Flying* (2002) recombines live webcam footage with live Internet radio feed and texts from online chat rooms to compose real-time and on-the-fly films that are then rebroadcast and streamed from the artists' Web site. Each film has content that is completely different, but in some senses exactly the same. The automation/systems aspect of the work doesn't mean that the artists didn't undertake any "material" aesthetic decisions (they did, such as the length of the leader before the film starts, the size of the window it opens in on your screen). The project's punctum is not in its material form, but in its operating system.

New media art has been theorized to be like earlier forms of conceptual or systems-based arts, in particular mail art, in a number of ways. These similarities include the aforementioned dematerialization with regard to the immateriality of code and algorithm; the artists' and audiences' participation at a distance and transmission across space and time (Chandler and Neumark 2005); communication in a (social) network and the nurturing of "intimate bureaucracies" (Medosch 2002b; S. Pope 2002); and the fact that most early Net art was based on reading text (Saper 2001). However, there are also some fundamental differences in how new media art behaves and why it isn't entirely immaterial.

As Rudolf Frieling (2004) writes, in new media "form follows format," and each format for media art has specific qualities—not just in shape and size, but in what is possible,

what is determined by the code. The materiality of new media is variable and hybrid—a large projection, a multiuser environment, a mobile phone text message. Although these material elements may be seen as manifestations of the intent of the artwork—visualizations of its system, perhaps—it is also the case that a viewer will "see" this material form for the work and only with further investigation discover the layer of the work that is about the system, the flow, the interaction. Technically, one can get even more reductivist about the "system" of new media art, as Johannes Goebel suggests. "Maybe 'new media art' means 'moving electrons' as material, condition, and consequence for artistic works which are 'time-based' (as opposed to 'static' (granting that nothing is static—but that is another issue)). Works in 'new media' integrate the condition of 'moving electrons' as tool and thus as material and thus as part of the experience" (2004)

It has been all too easy for histories of art to try to explain new media by deferring to histories of media, co-opting such examples as photography (reproduction) and cinema (projection) to explain the immateriality and placelessness of the digital. But the new media are fundamentally different. Although both photography and cinema histories are useful for understanding some of the qualities of new media art and some of the places in which it is encountered, as Goebel shows, they are far from the only histories that bear relevance here. Even just naming the qualities of the new media art object has been a struggle. "The term *intermedia* (Dick Higgins's term for much Fluxus activity) plays off of, but is not synonymous with, *multimedia* precisely because the stress is on works that resist formal categorization as belonging to any (or even many) media. Fluxus members specifically rallied against the notion that art should follow certain (modernist) rules of form" (Saper 2001, 43).

In her attempts to engage with video art history in relation to the formalist concerns of modernism and their disintegration in postmodernism, Rosalind Krauss (2000) posits the notion of a postmedium aesthetic (as discussed in chapters 1 and 2). She suggests that looking at how mediums (the physical forms of the work) are continually reinvented is a way to explain the significance or value of the endlessly reproduced and distributed possibilities of technology-driven art forms such as video, which by their lack of a unique original have no "aura"—the traditional marker of the work of art. Mark B. N. Hansen (2006) argues that the problem with adopting a postmedia approach is that all it does is distinguish physicality from convention, when in fact new media work's behavior is also fundamentally different, not just its form. Nevertheless, links are to be found with conceptual art and Fluxus because of new media art's approach to space and material: "The direct links between mail art and electronic art represent a widely known example of the importance of networks and networking in contemporary art beyond any particular medium. And the preoccupations and particular aesthetic codes of these underground art networks, with their emphasis on an explosion of information, appear as key components in the definition of an electronic cultural milieu of world wide web and Internet mail systems" (Saper 2001, 43). What, then, are some of the other different characteris-

tics of new media art in relation to this history of materiality in art? They include what can be described as virtuality, or new media art's ability to simulate space; the use of the algorithm and seemingly immaterial computer code; and the often invisible but crucial connection to a network or to live data, which is distributed across space as well as across time. We address each of these characteristics in the next few sections.

The Virtual

While cyberspace per se is an exclusive realm, its production depends on the material space beyond its interfaces. Cyberspace is real estate in terms of data space on computer disks and in mainframes, personal space in seats in front of computer workstations, frequencies on the broadcast spectrum, satellite space off which to bounce signals, and room in the bandwidth of fiberoptic cables that global corporations struggle among themselves to own and control.
—Margaret Morse, *Virtualities: Television, Media Art, and Cyberculture*, 1998

Understanding the space and materiality of new media art demands that we leave art history aside for a moment and turn to media theory and a technology-based history—the theorization of cyberspace and virtual space. Although some forms of new media art, such as net-based practices, may take place across distance through a network and therefore in that sense be like mail art, there is the potential for difference. New media technologies allow for immersion, for moving beyond reading words on a page or a screen or seeing photographic documentation to actually experiencing another type of virtual space dimension. "Virtualities are inevitably linked to materiality and physical space, be they in terms of the body or the technological apparatuses that generate virtual images or the geographic localities over which they are mapped" (Morse 1998, 179). The idea of virtuality is not so far from the notion of process-led informational systems at play in conceptual art. As N. Katherine Hayles writes, "virtuality can be defined as *the perception that material structures are interpenetrated with informational patterns*" (1995, 5, her emphasis).

A big debate within the history of new media art is about how virtual realities (virtual reality installations) might lead us to a state of disembodiment. In fact, this was how the field was perceived by other more material, static arts, but the consensus within new media realms now is that this is not the case at all; as Hayles writes, "in fact, we are never disembodied . . . we can see, hear, feel and interact with virtual worlds only because we are embodied" (1995, 1). Morse further refines the point: "The very notion of *immersion* suggests a spiritual realm, an amniotic ocean, where one might be washed in symbols and emerge reborn. Virtual landscapes can also figure as liminal realms of transformation, outside of the world of social limits and constraints, like the cave or sweat lodge, if only by reason of their virtuality—not entirely imaginary nor entirely real, animate but neither living nor dead, a subjunctive realm wherein events happen in effect, but not actually" (1998, 185, emphasis in the original).

The Immateriality of Code

A [digital] object is composed of both the data that describes it and the code that will operate upon it. As such, every object has within it everything it needs to go about its business. If an object is to be drawn it will draw itself. It will contain its own code for how to do that; it will not need to refer to or be acted upon by an external program.
—Simon Biggs in Steve Dietz, "Beyond Interface: Net Art and Art on the Net," 1998.

Lucy Lippard writes that "conceptual art, for me, means work in which the idea is paramount and the material form is secondary, lightweight, ephemeral, cheap, unpretentious and/or dematerialised" (1973, vii). Tilman Baumgartel argues that Lippard's characterization is an accurate description of much early Net-based art practice (2002, 65), and the argument that the idea of the work is paramount to its form is certainly supported by new media artists whose chosen medium is software itself. A concern with the system—the functioning of a computer or a program—and not with an object (though sometimes the action of an object is triggered by the code) suggests a preoccupation with virtuality. Code (the html, the protocols governing Net-based practice) is immaterial or, at least, mostly tangibly imperceptible. To work with it, work on it, and effect change through it—to mediate ideas through the medium itself—are a kind of invisible, dematerialized activity.

However, all art is seen to be some kind of mediation and to involve an element of translation or, as Friedrich Kittler (1996) would say, "transmission." As instances of conceptual art like the Glenn Lewis example have shown, some of that mediation might be according to a system or established process. With new media technologies, the possibility exists that the mediation can be automated or established by yet another imperceptible routine or algorithm.

But the idea that new media art is immaterial is not entirely accurate either. Lippard's description of conceptual art cannot be said to apply to all forms of new media art—beyond Net art and software art perhaps—because the technology, the interface to the work, is anything but lightweight, inexpensive, and unpretentious. As Matthew Fuller writes, "the materiality of the media is integrated into the work. Reflection on the technicity and particular natures of networked and computational digital media involves an acknowledgement, and a testing of the social construction of the media. Hence for instance the currents of work engaging with software" (2000a). A further problem with considering new media art as immaterial is that it discounts the physicality of the networks of people who engage with the tools, software, and computer programs of new media, even completely aside from the technological medium of the work of art. The autonomy of the artwork, which conceptual artists strive for to some degree, is impossible with media art (as Mark B. N. Hansen and others have argued; see Fuller 1998 and Hansen 2006).

[There is the] necessity of wresting a conception of materiality away from a preoccupation with the medium that continues to haunt discussion of new/digital media. And in a sense, this is a haunt-

ing of new media by modernism and by the autonomy of art supported by modernism and modernist art histories. Materiality in the practice of so many digital/new media artists/non-artists is not medium-based but produced out of the technical and social relations of network culture. (Munster 2005)

Distributed—Connected, Networked, Dispersed?

Space is ordinarily conceived of as a continuous or at least, as its most abstract, as a homogenous void. Yet a unified virtual nonspace or cyberspace can be distributed discontinuously over physical space.
—Margaret Morse, *Virtualities: Television, Media Art, and Cyberculture*, 1998

A number of media artworks exhibit the combined immaterial characteristics of virtuality, but within or connected to a tangible and social space. Many of these works originated from experiments with media technologies such as fax, video, and television networks in the late 1970s and early 1980s and have now extended into the seemingly more "virtual" and disembodied spaces of the Internet; for instance, curator-artist Skawennati Tricia Fragnito describes her project *CyberPowWow* as "a virtual gallery + chatspace + distributed Internet event" (2001).[8] It is in such works that the characteristics of connectivity and distribution come to the fore. "Even though the speed of networked access collapses space and the body may become a node for vectors of information, as Patrick [Lichty] has put it, the 'material' (the code in the broadest sense) will only become meaningful through an extended process, prolonged active exchange, often in a social space" (Paul 2005b).

The idea of the active exchange is what differentiates the early media art experiments with broadcasting and more recent work based in a network. Much like the exhibition *The World in 24 Hours*, seen at Ars Electronica in 1982 and described by Braun in his essay "From Representation to Networks" (2005), the project *TV Swansong* by Nina Pope and Karen Guthrie (further discussed in chapter 10) emphasized the live exchange process over product: "Both the way that *The World in 24 Hours* worked and its consequences indicate that projects like it were not conceptualised from the outset to create particular objects of 'artworks,' via fax for instance, although these were what reached the public. Rather they were conceived to produce and drive dialogical exchanges and relationships among participants and to produce communicative events. In a certain sense the constellation of the project itself presented the actual 'work'" (Braun 2005, 80).

In the case of Internet-based projects, such as *TV Swansong* and *CyberPowWow*, both the space and the material of the work are very much distributed and are composed almost entirely of interconnections in a network. As artist Jorn Ebner describes, "The form of the work of art matters, though, as it is in its materiality of communication and of exchange in which it manifests itself (or is given an opportunity to manifest itself), and where its properties can be discussed. That is, that location is no longer its prime concern" (2004). However, the physical locations of the interconnecting nodes matter

enormously, which raises the question, Is the space of new media art in any way site specific?

Location often implies a kind of public space. Putting aside the debates about whether the Web is a public space (with overarching commercial constrains and a history of alignment with confidential, if not outright private, military agendas), it can be argued that on the Web it is possible for work to be site specific. (In chapter 9, we discuss curating new media art in relation to curating public art, the results of which are often site specific.)

Net-based artworks use not only the connection in the network of computers—the protocols of communication between computers—but also the browser window. Both connection and window are site specific. In virtual reality projects, the equipment— for instance, a Cave Automatic Virtual Environment (CAVE)—is not available everywhere and not easily transported.[9] Therefore, the work is site specific by dint of its technological dependence. When new media art is activist or socially engaged, then, yes, it too can be site specific. The technologies of the Web or of cell phone networks might be used as tools to distribute information about an action or intervention widely, but then the participants in the work gather in a definitive location for the work's production and presentation. Works that use location-based technologies, such as global positioning systems or geographic information systems, might appear to be site specific, but they might not be: given that some of these networks are in fact global, each work can be enacted/performed/realized in any number of locations using the same overall system (as is the case with C5's *Landscape Initiative* project, 2001).

The question of place is inherently tied to the question of the work's distribution.[10] The Bureau of Inverse Technology's *Suicide Box* (1996) is based entirely on the Golden Gate Bridge (it takes the form of a "motion detection video system," including software that records the number of people who jump from the actual bridge or from any building to which the system is affixed), and yet the end product of the work's research and development is a video in the style of a promotional marketing film, which can be distributed through all the usual exhibition and festival channels. By contrast, the Bureau's project *Bang Bang* (2002) is itself a distribution channel—a series of webcams and pirate radio stations operated by uniquely programmed automatic triggers, which then broadcast locally relevant information to a local audience, such as a car crash at a notoriously dangerous intersection or the rising of air-pollution levels over a landfill site.[11]

Site specificity thus means a whole different thing with new media, and the locative aspect of technology is still a hotly contested field of practice,[12] with some artists arguing that this body of new work cannot be reconciled with other art systems at all: "The audience differs from the museum or gallery public—one is likely to encounter hobbyist or specialists in GIS [geographic information systems] and mapping, archaeology, history, education, performance, urban studies, naturalists, tech aficionados, etc. The lack

of a targetable audience, the close affiliation of the medium with the infrastructure and function of commercial interests, its site-specificity, taints the medium for an elite and conservative art system" (Spellman 2004). Although this view might be extreme, it is worth noting the suggestion that art that is inherently distributed and not easily contained in a physical location might indeed present the biggest challenge to its inclusion in the museum.

Art Example: Thomson & Craighead, Light from Tomorrow

With the appropriation of network data traffic, the possibilities of creating installations that are live and responsive are almost infinite. British-based artists Jon Thomson and Alison Craighead often "recycle" material found online and repurpose it for other aesthetic ends. They have worked on the Internet and specifically with the World Wide Web since 1995 and have been at the forefront of a tendency in new media art to make manifest in the real-world activity taking place in the online world—for instance, their tea towels printed with versions of the Netscape and Internet Explorer browsers showing specific Google search results. Given the art world's hot and cold attitude to new media installation art, Thomson & Craighead have consistently attempted to bridge the gap between the Web and the gallery, and in addition to making work that is collected by museums have used other forms of media distribution such as print. A version of their project *Decorative Newsfeeds* takes the form of a permanent public-art installation in the window of a grocery store in south London. It takes Really Simple Syndication (RSS) newsfeeds of headlines, chosen where possible for their relevance to the location and local populace (e.g., politics in the Middle East, entertainment items, international football/soccer stories), and winds them prettily across a screen of light emitting diodes, like a scrolling ticker display with a dilly-dallying mind of its own. This piece is but one incarnation of an interest Thomson & Craighead have in making material and perceptible the intangible, speedy information of what is happening *now;* "artworks that sculpt with time, in real time," as they describe it.

For the "Pacific Rim" strand of the festival ZeroOne (2006) in San Jose, California, Thomson & Craighead traveled to the Kingdom of Tonga, just across the international date line, and in a reconfigured kind of tourism brought back to San Jose the *Light from Tomorrow.* Their online blog chronicled their visit and documented each of the personal and technical details—from lost luggage to the water-repellent properties of tinfoil—that went in to creating their work of telematic art. A light sensor installed in Tonga communicated via the Internet with a computer attached to a custom-built light box hanging on the wall of the San Jose Museum of Art. As the light levels changed in Tonga (sunrise, sunset, passing clouds), the light box reflected the changes and broadcast them out, visually yet blankly, to the gallery visitor. The artists wrote:

We describe, *Light from Tomorrow* as, "an experiment in time travel," which is literally true if you adhere to the International Dateline from the relative position of the light box in San Jose, but patently untrue

in many other ways—not least because the sun sets in the west and rises in the east. We think this is implicit in the work and offers a fundamental paradox/contradiction from which a reading of the work can be made. . . . By highlighting the temporal distance between two relatively local geographical spots and then exacerbating it in a satirical manner, we wanted to expose the "arbitrary" and "imaginary" nature of the dateline. (Thomson and Craighead 2006)

Although this project appears to be about time more than anything else, it serves as an excellent example of the material concerns emerging from a seemingly immaterial, connected yet distributed process, a visualization of a journey and the resulting network—social, geographic—made manifest.

By considering the characteristics of works of conceptual art, system- and network-based arts, and the immaterial and dematerialized process-oriented approach to art, a plethora of connections to contemporary new media art practice have been uncovered. Yet there are some differences, too—in the way new media art approaches the question of virtuality, how technology determines materiality, and how the location of the interaction in the network can be specific and influence the way in which the work is distributed and received. Clearly, many works are hybrid combinations and to be understood more fully when viewed beyond "pasted conceptualism" (Fuller 2005). Networked and connected artworks imply that a societal joint care giving is required for their realization and sustenance. Unlike in broadcasting, where the receiver is but a passive viewer or listener, in network-based art the connectivity and active engagement in return determines the work's output (as process not product). As Joachim Blank wrote in the very early days of Web-based art practice, "[Net art] often deals with structural concepts: A group or an individual designs a system that can be expanded by other people. Along with that is the idea that the collaboration of a number of people will become the condition for the development of an overall system. Netart projects without the participation of external persons are perhaps interesting concepts, but they do not manifest themselves as a collective creativity in the net" (1996).

Location-based activities resulting from Net connections, social software programs, and Web site projects developed with user-generated content suggest a further manifestation of a network-based practice that is anything but wholly virtual and immaterial and that debunks the myth of the placelessness of art (discussed further in chapter 5). Unlike some of the earlier examples of system-based art, new media art projects often have built in the idea of feedback, of computability and connectivity between many rather than one to many. Works that are distributed across space and are dematerialized by dint of their emphasis on process instead of product are somehow more material in the consideration of their presentation because of the social connections and the possibilities for engagement.

Figure 3.5
Installation view of Thomson & Craighead's *Light from Tomorrow* (2006) as installed at the San Jose Museum of Art. Photograph by Steve Dietz.

Rethinking Curating

What do curators find more problematic about new media art: interactivity or ephemerality? Does the answer to this depend solely on whether a curator creates a permanent collection or a temporary exhibition? Are there any curators out there who think new media art should be left to its own domains (the public domain for example) completely? . . . I have trouble understanding the lower value of "immaterial" (of course there often is some kind of material residue) work in the Art System (for want of a better term). How influenced or dependent are art institutions and curators by/from the art market? How influenced and dependent are their sponsors and funding sources by/from the art market? Could curators raise more financial support/reward for "immaterial" art?
—Josephine Bosma, "Curating Critically," 2002

The characteristics of the work of new media art raised here—its distributed nature, its networked existence, its combination of physical and virtual elements—are in some way all contributing factors to how it "behaves" in space and what physical manifestation, what material form, it takes. The next chapter investigates the temporal concerns of the

work; here, the fundamental question is how the "where" of presenting art to a public has changed with new media and in particular with the Internet.

Space, Materiality, and the Exhibition

The more new media and public spaces, the more vital and omnipresent the exhibition.
—Jorinde Seijdel, "The Exhibition as Emulator," 1999

In the early, heady days of the identification of new media art as a category of art practice, much was written about how exhibitions could take place solely on the Internet and how perhaps virtual shows of virtual art would replace actual real-space museums and exhibitions (Mirapaul 2001). The practice of curating Web art, specifically Net art, on the Web remains strong, and Christiane Paul (2003) has written extensively about this phenomenon.[13] Net art demands the context of the Internet and the browsable World Wide Web, and yet curatorial approaches on how to present it have varied hugely as curators come to grips with what the Internet is and how deeply embedded it is in the work of art they are attempting to show. Should the work be shown solely online or in actual space? Or should it be divorced from its locative context and isolated in the gallery or be left in situ but presented formally? "The Internet remains free and quintessentially anarchic. Formally, the Internet is already more than digital image and hypertext, more than Real Audio sound and Quick Time video imagery, more than edited narrative constructions propelled simultaneously in multiple directions" (Ross 1996, 347).

The first hurdle for curators is to get past what are seen as the usual tropes of the Web—that it is a network for hoarding data and a window in which to look at these data. The curatorial role in relation to exhibiting Net art is often seen as filtering or highlighting or sometimes just list making (as described in relation to artist-led models of practice in chapter 10). What is more interesting is when curators view the Internet as more than just a distribution mechanism—a list of links—for art (as discussed in chapter 7). As Jorine Seijdel cautioned in 1999, "We see the appearance of World Wide Web versions of exhibitions, cd-rom catalogues of physical exhibitions, physical exhibitions of websites and physical catalogues of cd-roms. The Web is largely a storage and display medium: it launches countless virtual exhibitions, presents itself as a public vehicle for the distribution of knowledge and art, and often imitates the presentation models and ordering principles of exhibitions by dividing information into various cultural sections and categories" (1999). Many of the initial Web-only exhibitions took this form—with pages of links to projects launched on other pages, sometimes in separate windows. As the founder of one of the first Net art galleries online, artist Olia Lialina has commented, "On-line galleries and exhibitions are nothing more than lists, collections of links. On one hand, it fits the nature of many-to-many communication; the Internet itself is also only a collection of a lot of computers, and it works. On the other hand, list by list compilation brings us to an archive-like situation, to a story about keeping and retrieving in-

formation. On-line galleries only store facts and demonstrate that a phenomenon exists. They neither create a space, nor really serve it" (1998). Although Lialina noticed these distinctions long before the museums that followed her lead, the so-called browser wars of the late 1990s and early 2000s, along with the existence of a variety of Net artwork that wasn't cross-platform or that sometimes required specific plug-ins, seemed gradually to result in the demise of Web-only exhibition in an institutional sense (too many details to worry about and not enough curatorial control?).[14] Instead, the move—by artists, with curators following—has been toward physical installations of Web-driven projects.

With many museums having abandoned their curatorial remit to commission, collect, and exhibit Web art, what lies before us now is a litany of dated projects or neglected interfaces and platforms, with only a few stellar shining lights to guide us and inform historians of this field, such as Steve Dietz's exhibition *Beyond Interface* (1998).[15] Both Christine Paul and Dietz have written about their curatorial forays in presenting Net-based art and their move toward more direct contact with artists to realize their Net-driven pieces in physical spaces. As Paul commented in relation to her exhibition *Data Dynamics* (2001),[16]

I believe there is no one rule or model of [presenting this type of art in physical space]. I would always decide on a case by case basis. There are works where I would say, leave them alone, put up a kiosk or a computer with a monitor and let people interact with them one on one. I don't believe that projection is necessarily the best solution because it can end up creating an experience similar to watching TV—one person having the remote control and 50 people watching in the background—that could really hurt the piece. All of the net art pieces in *Data Dynamics* are shown as projection-installations but mainly because all of them make sense in physical space or already have that component. (in Cook 2001c)

Many exhibitions have struggled with the presentation of Web-based art or Net art, and many attempts have been made to find a common physical platform for what essentially can be a simple html page of links. Widely cited is the example of Jeffrey Shaw's *The Net.Art Browser* (1999) for the exhibition *Net_condition*.[17] Extensively criticized at the time by visitors and artists alike for its clunky look and feel and for its overdesigned presentation, the "interface" consisted of a touchscreen that could be guided along a long wall, linking in to different projects at points along the wall. Artist Vuk Ćosić (2001a) likened it to Maya Lin's Vietnam veterans memorial in Washington, D.C., suggesting that the curators had made an inadvertent point about the death of Net art.

Given that Web works can be accessed from anywhere anyone has a computer connected to the Internet, the question "Why put this immaterial-seeming work into the gallery?" is raised repeatedly (Mirapaul 2001). Any form of locating the work for people to access it should be welcomed, although curators' tactics vary enormously.

Art on the Internet—it's not that it's hard to understand, but it's hard to find for some people and it's hard to contextualize. Unless you go to Rhizome or some place that contextualizes the art for you, in some cases I'm not sure you're going to understand what you're looking at. I do think the

Figure 3.6
The Net.Art Browser, used to show works of Web-based art, in the exhibition *Net_condition* at ZKM (1999). Designed by Jeffrey Shaw.

gallery context has a benefit in terms of audience and potential for didactic material. I mean, I think you're right—there's no better way to present this work but on this wacky new thing called the World Wide Web. It's huge—I hear it's really taking off. I think Rhizome's Artbase 101 was a good example of physical installation of Internet art. They had a flat screen monitor that showed a "recording" of a piece . . . but they were also presented in their Web form in the gallery. So there was both this more physical presence and a network presence—which I thought was really engaging. It can exist in both of these spaces and both of these spaces are equally important. One is for you if you just want to stand back and see it. And another one is if you want to delve deeper into a project. (C. Jones 2006b)

Ćosić (2001a) suggested that there is a "minimum analytical unit problem" for curators— a term from archaeology meaning the minimum number of fragments that might suggest an ancient object. The CRUMB Web site has gathered some fragments that might be pieced together to inform a unique solution for individual artworks, including single or group viewing, beanbags or benches, desks or counters, locked-down browsers or offline locally held files (see also the discussion on display in chapter 7). Each fragment must suit the artwork itself and be flexible enough to deal with emerging media. As Patrick Lichty writes,

In a show that is based solely around the concept that art of the nomadic body is even more fragmented than the Net, the ideal model would be to give a person a Palm, a Cassiopeia [both types of personal digital assistant or PDA technology] and a WAP [wireless application protocol] phone and tell them to curl up and knock themselves out. However, the logistics for this would be prob-

lematic to say the least, as there would be guaranteed some loss of devices. In addition, the concept of a nomadic show once again begs for networked gallery space only. (2001)

In exhibitions of Net art, museums have to consider not only the computer and connection settings, but also the space of the gallery where the installation is sited, which has raised a debate about lounges alongside all the usual decisions curators have to make about the presentation of the screen-based work, such as, Should it be in the form of a kiosk, a wall-mounted display, or a revolving door?[18] We address the specific questions regarding lounges in chapter 7, but the example of the exhibition *Art Entertainment Network* serves to open up the discussion here.

Exhibition Example: Let's Entertain *and* Art Entertainment Network, *Walker Art Center*

In 2000, the Walker Art Center in Minneapolis mounted an ambitious international exhibition dealing with the idea of the spectacle in contemporary art, *Let's Entertain*. The curator, Philippe Vergne, was interested in new media and design, and drew on the knowledge of his fellow curators in other departments at the Walker, going so far as to ask them to contribute elements to the expansive group show. The new media curator at the Walker, Steve Dietz, simultaneously curated an online exhibition of work with a similar theme, *Art Entertainment Network (AEN),* and commissioned design collective Antenna to create a "portal" or physical interface to the online show for exhibition within the gallery-based show.

In retrospect, *AEN* appears as a rare example of a curator making an inspired decision not to disadvantage the works of Net-based art by leaving them out of the physical space of the museum altogether. However, it also shows how to avoid two other common problems with presenting Net-based art in the gallery: either interfering with the aesthetic of the works by forcing them into a generic exhibition presentation (a room of computers, as was installed at Documenta X, as discussed in chapter 9, or a showy projection of the exhibition's Web site for one visitor to click through while a dozen or more look on, as was the case at the *Whitney Biennial* 2000) or hampering them by divorcing them from the context of the Web entirely and installing them on individual machines, local servers, and sometimes even offline. Antenna's portal wasn't perfect, but it did function in a way that not only allowed individual access to each of the works in *AEN* with a minimum number of "click throughs," but it also held its own in the gallery next to some rather flamboyant works of art—for example, Felix Gonzalez-Torres's work *Untitled (Golden)* (1995), a gold-plated beaded curtain, and Piotr Ulanski's *Dance Floor* (1996), an illuminated disco dance floor. Dietz writes in his very comprehensive essay about "interfacing the digital" and the making of material installations from diverse distributed Net-based practices:

One of the challenges of presenting digital art is that the context and the work are generally displayed via the same means: the screen. How to differentiate between the metadata and the experience? One strategy is simply to open the project in a new window. . . . The complaint from artists about such a strategy is that it creates a curatorial gateway that viewers must pass through before getting to the heart of the matter, the actual experience. . . . Even with a painting exhibition, while there is reams

Figure 3.7
The physical "portal" for the Net art works in *Art Entertainment Network*, curated by Steve Dietz, as seen in the exhibition *Let's Entertain* (2000). Portal designed by Antenna. Photograph by Dan Dennehey, Walker Art Center, Minneapolis.

of research about the best length, tone, style, etc. for didactics, the working assumption is that most people look at a painting first and then read the label—the help file, so to speak—if they want more information. Even when net art exhibitions present the artwork first, it is often because the only curatorial context is a list of links, which is an equally unbalanced approach. . . . [Antenna's design] was appropriate to the concept of the online interface—as a portal. It also didn't assume that the goal of the interface was to create a comfortable browsing situation for hours of enjoyment. Like much gallery behavior it was designed for more casual browsing. A holder next to the didactic label contained printed bookmarks, which visitors could take and use to later log on to the site at their convenience and in their favorite viewing position. (2003)

Although the intangible online works had been carefully selected and "installed" in specially commissioned spaces both on the Web[19] and materially and tangibly in the gallery through the portal, their place within the framework of the parallel exhibition *Let's Entertain* wasn't secure. The Antenna portal was not added to the checklist of artworks traveling with the exhibition to subsequent venues and so physically didn't go with the show; as a result, the physical, material connection between the two exhibitions—*AEN* online and *Let's Entertain* offline—was lost.[20]

Does it matter? *AEN* is still available online, but the physical static works in *Let's Entertain* (seen in a modified form in Paris at the Centre Pompidou with the title *Au-delà du spectacle*) have long been dispersed, returned to their owners and collections. Yet the photographs documenting the physical exhibition of the mostly static artworks are now held up as examples of interesting installation design, whereas the online exhibition, with its clever programming and sympathetic interface, seems forgotten and neglected or perhaps considered just a remnant of a particular historical moment in Web interface design.

This example demonstrates that there are very different ways to include in physical exhibitions those digital networked art forms that are based on a single computer screen: from high-tech, designed interfaces such as that of Antenna's portal to more low-tech and do-it-yourself approaches, such as putting a computer terminal on a desk within the exhibition and printing small cards with the Web address for viewers to take home to look up the work online. Of course, the variability of presenting dematerialized, networked art in physical space applies not just to the furniture surrounding the work's presentation, but also to its active, engaged inclusion in the framework of the show as a whole, as the example of the *Art Entertainment Network* exhibition demonstrates. In the exhibition *Use nor Ornament* (2000), three Web-based artworks were commissioned from the New York artists group M.River and T.Whid Art Association (MTAA).[21] The curatorial decision was made not to launch the new works at the time of the opening of the show, but instead at two-week intervals throughout the run of the show, anticipating that the audience would return to the Web site and the exhibition repeatedly to see each one in turn.

Plenty of artworks also use immaterial network data but have substantiations that exist in physical space as an intrinsic part of the work and are thus not just documentary

Figure 3.8
Installation view of the billboard of Lisa Jevbratt and C5's work *1:1* (*Interface: Every*) http://
jevbratt.com/1_to_1/ as installed in the exhibition *Database Imaginary* (2004). Photograph by Lisa
Jevbratt.

in nature. Lisa Jevbratt and C5 have installed their database-driven piece *1:1* (1999)—
which maps the Internet protocol (IP) addresses that make up the Internet and displays
them through five different "map" interfaces—as a computer terminal where audience
members can access the work and use the interfaces to query the database online. It has
recently been shown both as a giant vinyl billboard image of one of the interfaces (*Every*),
which functions as a kind of charcoal rubbing or impression of the Internet, like a map
in real scale but missing any legend to make it useful, and as digital printouts of images
of each of the five other interfaces.[22]

The question of translation in transmission is raised again here. Consider, for instance,
the example of different strategies to exhibit the art outputs of irational both in the exhi-
bition *The Art Formerly Known as New Media* (2005) and in the group's retrospective exhi-
bition at Hartware in Dortmund (which toured to the Glasgow Centre for Contemporary
Arts in 2007).[23] In both instances, irational's site-specific, process-led, socially engaged

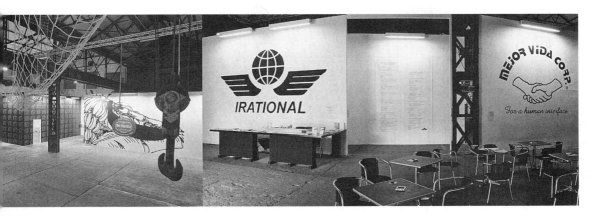

Figure 3.9
Installation views from *The Wonderful World of irational.org: Tools, Techniques, and Events 1996–2006* (2006) at Hartware MedienKunstVerein in Dortmund, Germany, showing on the left a view of the central exhibition space (*from left to right:* Kayle Brandon and Heath Bunting, Red#Net; Daniel Garcia Andujar, Technologies to the People research department; Minerva Cuevas, Mejor Vida Corporation and Del Montte International Media Campaign); and on the right, logo displays in the lobby (irational, Technologies to the People, Mejor Vida Corporation). Photographs by Thomas Wucherpfennig (labor b).

practice was translated into other media for exhibition in a gallery space. These media ranged from printouts from the Web site and a timeline of projects marked in chalk on a wall-sized chalkboard to archival documentation in the form of photographs and videos to online computers isolating separate projects for visitor interaction. This approach also reflected the characteristics of the work itself. For instance, one of irational's projects, Heath Bunting's *Status Project* (2005–, ongoing), uses Boolean logic and a database to chart all the possible routes between one type of state-recognized identification, such as a senior citizen's bus pass or a tenancy agreement, and another type, such as a passport. The project takes the physical form of questionnaires, booklets, visualizations and mappings, and complete proofs of identity for sale online. "The variability and modularity of new media works implies that there usually are various possible presentation scenarios: artworks are often reconfigured for the specific space and presented in very different ways from venue to venue. However the changes in the curatorial role tend to become most obvious in online curation, which by nature unfolds in a hyperlinked contextual network" (Paul 2006, 86).

The methodology at work in the curating of online projects is often entirely conditioned not by any external or institutional constraints that the curator might encounter, but rather by the fluidity of the online working environment—the interconnected communicative space of the World Wide Web—and as such is more collaborative than controlled, subject to the back and forth of multiparty discussion.

Figure 3.10
Heath Bunting's *Status Project* (2005–). Detail from a map of the database of conditions for establishing individuals' identity status, showing the status for a homeless person. From http://status.irational.org/visualisation/maps/A1010_homeless.pdf. Courtesy of the artist.

Space, Materiality, and the Audience

Artefacts and even space itself can be "cyberized" by programming that simulates some other space, time or agency. . . . An electronic and virtual art may work through metaphors that are realised across different degrees of virtuality and materiality.
—Margaret Morse, *Virtualities: Television, Media Art, and Cyberculture*, 1998

The challenges of presenting Web-only works of art, not just in physical space but also in cyberspace, are also found in presenting other forms of new media art, considering that computer systems are capable of simulating and representing many types of lived experience. Distinguishing Web-based art from the rest of the cultural production found on the Internet is a challenge for an audience member not familiar with what he or she is looking at or for. Works of art that deal specifically with this melding of virtual and physical space are that much harder to "frame" for a viewer's experience. So how does one present works of art whose primary characteristic is the simulation of another, not physically tangible reality?

Works of simulation-based art, such as immersive video games, are a challenge to present because they are premised on the idea that the awareness of the mediation should be the viewer's primary experience. Aside from their physical interfaces—the headset and joystick—virtual reality gaming environments prioritize the mediation of digital intangible "information," and the viewer encounters the work as a "user" making choices affecting how the experience unfolds. Each encounter is unique, so the curatorial role in the presentation of this kind of immersive installation may simply be in the entering and exiting of the mediated space. At the National Gallery of Canada, for instance, users of Char Davies's immersive installation *Ephémère* (1998) had to sign disclaimer forms and be coached in the physical actions required to navigate the digital landscape.

Many forms of simulation work are time based, determined by the artist rather than by the viewer, and take on the form of event-based "experiences." Rod Dickinson's *Nocturne* (2006) was the re-creation, at an empty racetrack on the outer reaches of London, of the soundscape of the standoff between the FBI and the Branch Dividians at Waco, Texas, in 1993. Seemingly immaterial in that the art work is aural, the setting and the conditions of the time and place of the experience were carefully planned and staged by the artist in collaboration with the curator. The audience is therefore the direct point where the work's intangibility is made material. This isn't the same thing as saying that the audience is the point at which the work gains meaning or value—which is true of any artwork—but rather that the conditions are constructed for a circuit to be completed by the viewer's action or presence. This was the case with the installation *Mountain Top* (2005) by artists Monica Studer and Christoph van den Berg (referred to in chapter 1). Their closed-circuit video camera captured the presence of people in the gallery, thereby completing the illusion for visitors to the Web site that gallery-goers were on top of a digitally crafted mountain rather than in a gallery in the United Kingdom.

Figure 3.11
Shadow silhouette as seen during a performance of the virtual reality environment *Ephémère* (1998) by Char Davies. Courtesy of the artist.

As discussed in the previous chapter about user-generated content online and the possibilities of direct participation on the Web, here the question is how curators can best facilitate participation in these distributed, immaterial, variable projects (also discussed in chapter 5). Vivienne Gaskin comments: "To me in some ways [reenactment is] creating a virtual environment . . . an environment where everything is a signifier that will take you back to that original event, and nothing can be a distraction. . . . That's an active suspension of disbelief, this isn't a way of tricking people or a way of conning them, but the events only work once the audience believe that they are—or they deliberately believe—that they are part of an active event" (2004).

Space, Materiality, and the Institution

Caitlin Jones: Your work exists in multiple formats: as an object and as installation, but also as pure code that you freely distribute over the Internet. Now that you're starting to sell work in the art market, what does this multiplicity mean to a collector or an institution that buys it? Is it something that you think about? Do you really care?

Cory Arcangel: Not really. [Laughs] It just means it's better, right? That the work will exist in all these different worlds, that it is circulating in all these other forms—and, especially valuable, it will be circulating on the Internet. So you know eight trillion more people are going to know what the project is—and they've actually been able to see it [not just a photo of it]. Which, for me, was the whole point in the first place.

—in Caitlin Jones, "My Art World Is Bigger Than Your Art World," 2005a

Museum institutions are built on valuing objects and maintaining collections. What does that mean, however, when the work is seemingly immaterial and has no tangible value other than that of exchange? With conceptual art practice, the documentation became the commodity. The history of video art demonstrates other peculiar, ill-fitting attempts to make unique an infinitely reproducible material (as discussed in chapter 4). Matthew Barney's films are sold in an edition of ten, but come with sculptural installations—display cases—that function as unique museum objects. When curator Caitlin Jones asked artist Cory Arcangel to comment on this tactic in relation to his own work, his answer was suggestive of what is an extensive debate with regard to Net art—namely, creating the right kind of space for it. "Net art seems to call for a 'museum without walls,' a parallel, distributed, living information space that is open to interferences by artists, audiences, and curators—a space for exchange, collaborative creation and presentation that is transparent and flexible" (Paul 2006, 81). The striving for a space that is "transparent and flexible" has led a number of museums to build "lounges" into their galleries, though it is disputable how successful these lounges are (an issue addressed in chapter 7). As curator Matt Locke commented in relation to the Tech_nicks festival (2001), "The Site gallery, who have recently built a gorgeous new white-cube space that is superb for showing photography and installations, had used informal furniture (including bean-bags!), artists at work, magazines, books, etc, but no matter how informal and accessible it was supposed to be, the austere architecture made it look like an exhibit, not a place you were likely to get dirty and play around in" (2001b). And according to Ittai Bar-Joseph,

As an artist, I personally find the idea of exhibiting my work in a "spacy," "soft," "comfy," "funky" space quite intimidating. Every artist wants their work exhibited in a way that the presentation serves the work and not the other way around. Funky, cool "lounges" or "bars" might be very compelling and inviting to sit and hang out in, but tend to overshadow the works. It is difficult to give an artwork the proper semi neutral environment in a dominating place over-designed in order to achieve a certain "effect." (2001)

Many other types of art organizations have emerged as a result of the need to engage with the immateriality of the artwork and a desire to present new media art in a formally

appropriate fashion, such as on the World Wide Web. As technology develops, platforms for engagement that position themselves against the necessity of presenting work in an institution, such as Rhizome and low-fi Locator, are increasing in number and kind.[24] For instance, hundreds of artists are now choosing either to release their audio and video works—or possibly a "documentary after the fact" or advance promotional material about their work—through online platforms such as the iTunes music store and the video-exchange site YouTube. "Most shows of Internet art have failed to translate [the networks that exist for the participants] into the gallery. (Galleries are using a different operating system)" (Medosch 2002a).

Space, Materiality, and the Curator

The [so-called] *Xerox Book* . . . was perhaps one of the more interesting [projects] because it was the first where I proposed a series of "requirements" for the project, concerning the use of a standard size paper and the amount of pages, the "container" within which the artist was asked to work. What I was trying to do was standardize the conditions of exhibition with the idea that the resulting differences in each artist's project or work would be precisely what the artist's work was about. It was an attempt to consciously standardize, in terms of exhibition, book or project, the conditions of production underlying the exhibition process.
— Seth Siegelaub interview by Hans Ulrich Obrist, 2008

As we have seen with the descriptions of the conceptual art exhibitions of the 1960s such as Siegelaub's *Xerox Book* and the 1970 *Software* exhibition, with the dematerialization of the art object came a foregrounding of the curator's role because someone had to select what of the seeming nothingness could be shown and in what form. Within new media art practice, this emphasis has led to the common characterization of the curator as a "filter." If, indeed, the work in question is wholly immaterial, then the decisions not only about what and what not to include, but also about eventual presentation, naturally condition the work's resultant aesthetics. In the 1960s, selection criteria and the curator's role were not as fully developed as they are seen to be now—in part because of the overt political angle with which most conceptual art was imbued. For instance, there was a great debate around mail art that all works sent had to be included—no jurying could take place (Altshuler 1994; Saper 2001). It is far more common now for curators to be appraised for their editorial skills. The curator's personality and taste has come to the forefront far more. With new media art, the selection criteria is similarly nuanced, though less determined by curatorial whim and more likely conditioned by available resources—space, technology—and by the preordained context for presentation—online or off. Steve Dietz writes:

In the call for submissions, I wrote "b e y o n d . i n t e r f a c e is an online exhibition of juried and curated net art projects for which the Net is both a sufficient and necessary condition of viewing/experiencing/participating." . . . We combined a modified Duchampian philosophy—it's net art if the artist intends it to be—with an end-user perspective—no matter how integral the Net was

to the project, if a network connection alone wasn't sufficient to {insert your definition of an art experience here}, then it didn't make it. The prime regret with this latter condition is that it precluded many fascinating, online, real-time, performative experiences that don't really work asynchronously. You had to be there then, and we didn't see a huge difference between documentation of such an event and documentation of a painting exhibition, although the two original events are obviously very different. (2003)

The curatorial politics of exhibiting dematerialized and network-based art are limited not just to its selection, but also to its installation. Yet at the time of the first mail art exhibitions in major museums, criticism was leveled at the curators' judgment: "What you and I might deem fit for a wastebasket, the Whitney Museum of American Art judges worthy of its exhibition space," wrote Hilton Kramer (in Held 2005, 97). For Net-based art, this debate isn't as significant, in part because exhibiting it on a museum's Web site doesn't attract as much attention as giving up valuable real estate on the gallery floor does.

Summary: Dematerialized or Just Distributed?

These tendencies are even more legible in curation that undertakes to deal with art that is substantively information-based and not traceable to a single authoring subjectivity, like most software and net art. But does this then portend the dissolution of curatorial practice into these forms that it is embracing?
—Marina Vishmidt, "Twilight of the Widgets," 2006b

Describing the telecommunications projects on view at Ars Electronica in 1982, Reinhard Braun says that the exhibition *The World in 24 Hours* was "used as both the coordinating platform and a medium for the artistic projects themselves. Differences between process and the product or between the creative medium and its presentation no longer made any sense" (2005, 80).

As we have seen, new media art isn't necessarily always immaterial, although elements of its computability and connectivity can be invisible to the eye. Similarly, conceptual and systems art of the 1960s and 1970s posited that the idea was more important than the form, making the medium of the work often immaterial. One of the links among conceptual art practices of the 1960s, networked and systems-based art practices of the 1970s, telecommunications works of the early 1980s, and Internet-based art of the 1990s is the approach to the question of the dissolution of the autonomy of the art object (Lippard 1973). This approach has then, by extension, had to address a critique of the institutions that present art and that thus precondition its autonomy. The striving toward autonomy is, some argue, ever more prevalent, perhaps even a prerequisite, for works of new media, which exist in a technological context shared by other media and entertainment that have educational and other commercial objectives. In this, it would seem that no matter the form of the artwork, the medium never matters as much as the context. However, the more interconnected the work to its context, the greater the change in the way the work of art might be curated or approached by a curator.

A consideration of conceptual, virtual, sonic, and ambient art suggests that no matter the work's material, the possibilities of its place of presentation, in terms of distribution, have changed with the advent of new communication technologies. The work itself is now distributed across space and time (transmission and participation at a distance is addressed in chapter 5). What happens when the curator attempts to adopt a methodology in line with the work? It is not physically possible for a curator to be in many locations at the same time, and thus more collaboration with local partners (or what Iliyana Nedkova and others have called "guides on the side" or "guides onsite") is needed. Curators who are truly interested in the decentralized, dematerialized activity of network-based arts have tried to change their curatorial tactics to be more in line with the artists, even if that means being increasingly misaligned with the traditional institutions for the presentation of art.

Notes

1. *Software, Information Technology: Its New Meaning for Art* was exhibited at the Jewish Museum in New York in 1970. For further information about the exhibition, see the exhibition catalog edited by Judith Burnham 1970, Buchman 2006, Burnham 1980, and Gere 2006a.

2. Seth Siegelaub ran a gallery in New York in the late 1960s and early 1970s that held such pioneering exhibitions as *The Xerox Book,* in which artists were invited to submit a single page for inclusion in a publication that was the exhibition. For information about his exhibitions, see Altshuler 1994, 239 and Siegelaub 2008.

3. For example, Dan Graham's work *Public Space/Two Audiences* (1976) consists of two rooms divided by glass and a mirrored wall.

4. The idea of a dimension is interesting because it is this aspect, of course, that new media presents problematically to the curator. Fuller's point is that "pasted conceptualism" is not adequate for understanding all aspects of contemporary new media art production.

5. Annmarie Chandler has recently written about precursors to Net-based art practice by positing a kind of theory of "distancing" in art, drawing on the histories of mail and network art in conceptual practices of the 1960s (see Chandler and Neumark 2005).

6. We discuss the idea of the social network participating in and supporting the work in subsequent chapters.

7. In his tenure as director of Documenta 11 (2003), Okwui Enwezor proposed that the venerable art fair would adopt the black box approach, but in the context of the kind found on airplanes—cracking it open to hear firsthand accounts of what happened in the event of a crash. And, as such, Documenta 11 included a large number of artist-made documentary videos and films.

8. *CyberPowWow*, conceived in 1996 by Skawennati Tricia Fragnito (and collaborators), is part Web site and part "palace"—a series of interconnected, graphical chat rooms that "allow visitors to interact with one another in real time. Together, the Web site and palace form a virtual gallery with digital (and digitized) artworks and a library of texts." From the Web site: http://www.cyberpowwow.net/about.html.

9. A CAVE is a contained six-sided area approximately ten feet by ten feet by ten feet, with rear screen projections, three-dimensional audio, and the facility for three-dimensional graphics (with users wearing 3-D glasses) and motion-tracking software.

10. Of course, on the Net the notion of a local audience literally goes out the window, which brings us closer to the discussion not of site specificity, but of distributed although connected communities of interest.

11. Information about the Bureau of Inverse Technology can be found on its Web site at http://www .bureauit.org .

12. The proceedings of the debate about "exhibiting locative media" (April 2004) is online on the CRUMB site at http://www.crumbweb.org.

13. Paul outlines models of online curating, from online exhibitions (organized by museums, artists, curators) to systems or platforms of presentation "in which the public or software system assumes a curatorial function" (2003, 89). We discuss this topic further in chapter 10.

14. The so-called browser wars occurred between Netscape Navigator and Internet Explorer in the early 1990s in their attempts to gain the greatest market share; the wars included not only races to add new features, but also a number of antitrust legal debates.

15. *Beyond Interface* was curated for the 1998 "Museums and the Web" conference (which subsequently has not invited explicit curatorial projects for its annual meetings). See Dietz 1998 and Packer 2006.

16. *Data Dynamics* was seen at the Whitney Museum of American Art from 22 March to 10 June 2001. For information about the exhibition, see http://whitney.org/datadynamics/, Mirapaul 2001, and Paul 2007.

17. *Net_condition* (1999) was curated by Peter Weibel and others and shown at ZKM in Karlsruhe, Media Centre d'Art i Disseny in Barcelona, and at NTT InterCommunication Center (ICC) in Tokyo. See http://www.zkm.de/netcondition.

18. Matt Mirapaul wrote in the *New York Times:* "A defining characteristic of online art is that it can be seen anywhere by anyone with an Internet-connected computer. But even though cyberspace is a vast, all-access gallery, the artworks that are 'hung' there are usually experienced by a lone viewer sitting in front of a single monitor. Now that museums are commissioning Internet-based art projects, they are confronting a digital dilemma: how to present virtual, small-screen art in a real-world, public space. One solution is to recreate the one-on-one environment with a bank of computers, but this risks turning the museum into an expensively decorated cybercafe. An alternative is to project a virtual artwork on a wall, and while one visitor points and clicks, others can view the interactions. This is rather like watching your spouse change television channels with the remote control" (2001).

19. The Web site design was made in collaboration with artist Vivian Selbo and could be customized by the visitor in terms of color, layout, and audio soundtrack: http://aen.walkerart.org.

20. Interestingly, the same was the case with the Raqs Media Collective and Atelier Bow-Wow's project *Architecture for Temporary Autonomous Sarai (TAS)*, commissioned by Steve Dietz for the

Walker Art Center exhibition *How Latitudes Become Forms* (2003) to show the online work of Raqs and other artists. This exhibition toured to other museum venues also, but without *TAS* as part of the checklist.

21. The exhibition *Use nor Ornament* was cocurated by Sarah Cook and took place at the Northern Gallery for Contemporary Art in Sunderland, United Kingdom. Further information about the exhibition is online at http://www.newmedia.sunderland.ac.uk/usenor/unohome.html. Information about MTAA's work can be found on its Web site at http://www.mteww.com.

22. Lisa Jevbratt and C5's work *1:1* (1999) consists of an IP database containing the IP addresses to all hosts on the World Wide Web. The project uses the database to create five interfaces for navigating the Web and to generate a new topography of the Web. The project was included in the online component of the 2002 *Whitney Biennial*. Further information about the project is available on the Web site at http://www.c5corp.com/projects/1to1/. As noted on the Web site, the five interfaces are (1) hierarchical: the Web as directory structure; (2) every: a complete mapping of all Web servers in the database; (3) petri: clusters of networks and navigational traces; (4) random: randomly generated IP addresses from the database; and (5) excursion: access to the Web's unsearched places.

23. irational is a loose collective of artists based mostly in the United Kingdom who have documented their work on a shared server since 1996 (http://www.irational.org). They describe themselves as "an international system for deploying 'irational' information, services and products for the displaced and roaming" (from the Web site).

24. See http://www.rhizome.org and http://www.low-fi.org.uk.

4 Time

The term "real-time systems" refers to the information, telecommunication and (multi)media technologies that have come to play an increasingly important part in our lives. . . . "Real time" can also stand for the more general trend towards instantaneity in contemporary culture, involving increasing demand for instant feedback and response, one result of which is that technologies themselves are beginning to evolve ever faster.
—Charlie Gere, *Art, Time, and Technology*, 2006a

As outlined in chapter 2, the relationship of new media art to time in general concerns the ambivalent state of being new and the peculiar timescale of the technological hype cycle. As Charlie Gere (2006a) states in his book *Art, Time, and Technology*, not only is the development cycle of technology accelerating, but the concepts of real-time connectivity and real-time computer processing are becoming inextricable from the behaviors of new media technology. This "real time" differs from the concepts of "time based" or "live," which may be more familiar to video or live-art curators, and, of course, all three concepts come as a fundamental challenge to curators of objects. With the proviso that time and space are particularly difficult to separate in new media, this chapter examines how the histories of time-based arts range across video art and performance or "live" art. Several of the most high-profile institutional new media curators—including David Ross, Barbara London, and Eddie Berg—came from a background of working with video art, and parallels are often made between new media histories and video histories,[1] but is this the most appropriate field for comparison?

Time presents particular challenges to curators because, as outlined in chapter 3 on space and materiality, any artwork that is not a static object involves the timescale of process in some way. This chapter discusses the ways in which the timescale of new media art differs from that of video art or performance art and what these differences mean for exhibiting beyond the paradigms of the white cube of the art object or the black box of video art. Audience expectations of the speed and availability of new media, such as the twenty-four/seven nature of the Internet, also figure here. Jeremy Deller's *Steam Powered Internet Computer* (2002), for example, is of interest not only because of its juxtaposition of new and old technology, but also for its deliberate frustration of the idea of

Figure 4.1
Jeremy Deller and Alan Kane's *Steam Powered Internet Machine* (2006), a version of *Steam Powered Internet Computer* (2002), which was shown in the exhibition *Ill Communication* at Dundee Contemporary Arts in 2003. Image courtesy of the artists and the Modern Institute, Toby Webster Ltd. Glasgow.

the twenty-four-hour museum, or audience expectations that the Internet is always on. When installed at Dundee Contemporary Arts in Scotland, the installation functioned only during certain time periods, when the local hobbyists who ran the small steam engine were able to come to the gallery to tend the power source.

Time-Based Arts—Video and Performance

Video Time

New media makes a time-based dynamic multimedia a new communication default—and of course cinema was the original time-based dynamic multimedia (rather than the status illustrated book)—so we might as well look at what we can take from its techniques and bring it into new media.
—Lev Manovich, in Geoffrey Batchen, Rachel Greene, and Lev Manovich, "Voiceover," 2002

Lev Manovich, in defending his choice to base his 2001 book, *The Language of New Media,* firmly on cinema and video, underlines the simple commonality of moving images. Video, like sound, has a duration, and this durational aspect has become one of the

things that differentiates new media art from digital art (the latter might include digital imaging and computer graphics, but these elements are generally excluded from the former). Time is of obvious importance to video, and curating a durational event differs from curating an object, as illustrated by the exhibitions *Seeing Time* at SFMOMA in 2000 and *Video Time* at the Museum of Modern Art (MoMA) in New York in the same year. Video curators are excellent at differentiating the time characteristics of cinema and video (such as frame rates), as well as at relating this difference to the physical and to the "time/space collapse."[2] They are also familiar with mediation and remediation and how these processes affect time: "In its manifestation as a reproduction, the work engenders a 'reconfiguration in times,' and by doing so reconfigures 'the dimensions of the work' in time" (Miriam Bankowsky paraphrased in Frohne 2005, 31). In considering time rather than hardware as a characteristic, video perhaps shares the postmedia vocabularies of behavior with new media art; the term *lens-based media* for film, video, and photography has been at least in part replaced by *time-based media* for any moving image.

Time is highly differentiated in video and hence useful for considering new media art. In the late 1970s, Rosalind Krauss identified a key characteristic by which video differed from the other visual arts—that it was capable of recording and transmitting at the same time and hence of producing instant feedback (1978, 45). Artist Dan Graham was famously concerned with video space and time and was accurate down to the seconds of neurophysiological perception when describing the reasons for his choices of feedback delay: "The time-lag of eight seconds is the outer limit of the neurophysiological short-term memory that forms an immediate part of our present perception and affects this 'from within.' If you see your behavior eight seconds ago presented on a video monitor 'from outside' you will probably therefore not recognize the distance in time but tend to identify your current perception and current behavior with the state eight seconds earlier" (Dan Graham in Gere 2006a, 167). Thus, although video time shares its beginnings in the cinema and the moving image, it is hardly a slave to linear narrative. It can critically deal with concepts of remediation, feedback, animation, and discontinuous time, including the loop, which dates back to the early days of cinema (Manovich 2001a, 64).

Performance Time

Because no editing equipment was available until the mid 1970s, and the tapes were not compatible with the broadcast signal, most of the early artists' videos focused on real-time closed-circuit conceptual projects. . . . They would perform in front of the camera until the tape ran out—tape length became performance length. Video was perfect for this kind of "real-time" performance.
—Margot Lovejoy, *Digital Currents: Art in the Electronic Age*, 2004

As Margot Lovejoy illustrates, concepts of time for both video and performance were firmly related to the characteristics of the technology. This understanding of mediation, real time, and the live also points to historical commonalities between performance art

and media. Fluxus, for example, included artists such as Nam June Paik and Yoko Ono, who might now be classified as video or performance artists, but the term *time-based arts* covers many of their Fluxus pieces. The relationship between video and performance art, however, is not one of simple documentation. In her exhibition *Video/Performance* (2000), curator Barbara London showed how video was used not just as a document during the performance, but also as an inherent part of the practice, a means of manipulating the meaning of the performance in postproduction and feedback (Thea 2001, 121). Performance art has much to offer when considering definitions of time in relation to reenactment. In 2001, Jeremy Deller realized *The Battle of Orgreave,* a reenactment of the clash between police and striking miners in 1984 in the United Kingdom performed by historical battle hobbyists and volunteers, some of whom were involved in the original event. In considering this work and other reenactments, Sarah Cook comments: "The projects are experienced both over time in a repeated/looped linear fashion (the time it takes to watch the event and its subsequent documentation) at the same time as they make evident the time that has passed between the event and its re-presentation/re-mediation" (2006a, 194). As discussed in chapter 3, new media's facility to simulate, remediate, or reenact realistically has made the relationship between live performance and other iterations of the event particularly complex. The field of performance art has a well-established critical differentiation between the live, the reenacted, and the document, which is useful when dealing with new media art, but it has to be acknowledged that much live art is opposed to using documentation of any kind instead of live bodily experience. The use of bodily endurance as a marker of time in performance art is one that recurs: Ulay & Abramovic's *Relation in Time* in 1977, for example, involved their sitting for seventeen hours with their hair tied together.

The perform*ing* arts, as opposed to perform*ance* art, have highly developed critical positions on time, based on process and event rather than on object, positions that include, for example, understanding nonlinear narrative in the systems-based sound performances of John Cage. The event-based structure of "the performance" means a period of time in which to concentrate on the unfolding of the artwork, which is very different to the rhythm of an art gallery. Artist Marcel Duchamp considered the prolonged period of concentration in, say, chess, particularly important for art, and he is seen using a chessboard as an interface to generate a composition by Cage. This kind of cross-fertilization between performance and new media was characteristic of early *Experiments in Art and Technology (EAT)* events, which were primarily performance based, including the *EAT* precursor *9 Evenings: Theater & Engineering* in 1966.[3] The performing arts often combine the media of sound, light, and bodily presence, and as such can be related to a history of "multimedia" as well as to a history of theater.[4] With such a wide range of media and time issues within the field of performance, ranging from dance to formal music, it is no surprise that curators struggle to understand fully the range of temporal dynamics in new media art.

Figure 4.2
Marcel Duchamp and John Cage playing chess on a board wired as an interface to generate a compo-
sition by Cage, while Alexina "Teeny" Duchamp looks on. At the event Reunion in Toronto (1968).
© 1968 Shigeko Kubota, courtesy of Maya Stendhal Gallery, New York.

Some artists, however, can lead the way in working with the particular characteristics
and temporalities of the different media. Lynn Hershman Leeson, for example, has had
a practice that includes video art, interactive installation, Net art, feature-length films,
and, more important, durational live performance art and installations. In her project
Dante Hotel (1973–1974), she booked a room in a low-rent hotel in a down-and-out
area and installed items giving clues as to the occupant's identity. The room was open
twenty-four hours a day for nine months, until a 3:00 A.M. visitor mistook wax items for
corpses, and the installed items were taken away by police, in whose collection they re-
main. In 2007, Hershman Leeson launched *Life Squared* in Second Life (an online virtual

world)—a reconstruction using documentation of her hotel performances, where three-dimensional graphics represent the hotel space in which the artist's and visitors' avatars can view the documentation and interact with each other. Her work therefore often functions in a way that questions time, reenactment, and remediation. In this wide range of work, she has used the characteristics of media-specific temporalities alongside issues of space, embodiment, and context in a way that clearly articulates the differences between them.

How New Media Art Is Different

The economy of abundance makes truly epic (life-long) works possible, but extreme evanescence is equally potential.
—David Ross "Net Art in the Age of Digital Reproduction," 1999a

Some video curators, such as David Ross, Kathy Rae Huffman, and Jean Gagnon, built on the experience of introducing new time-based video to institutions and went on to champion new media art and understand the new characteristics it presented. Other curators who tried to apply the critical and physical structures of video straight to new media art—for instance, applying cinematic narrative and timescales very literally to "interactive" versions of movies with plot choices—understandably may not have liked what they saw and stopped right there. Curators are sometimes simply unaware of the histories of technology that run alongside histories of video.[5] This section identifies how the time characteristics of new media art differ from those of video and performance, with reference first to the culture of technology and then to the behaviors of connectivity and computability.

The Culture of Speed

If this first generation defined its task "in opposition to the dominant use of television technology and televisual practice," then contemporary reference points for today's "new media" artists are the producers of interactive games and computer entertainments.
—Charles Esche, "Video Installation, Conceptual Practice, and New Media in the 1990s," 1996

Some gallery based video art was defined in opposition to the fast editing of commercial television, which resulted in a caricature of video art: large-scale, static installations that moved at glacial speed in order to be defined as art. New media art has an even stronger culture of speed as a starting point. Computers, as products in general, are measured by the speed of their processors. One of Lev Manovich's eight definitions of new media is "faster execution of algorithms previously executed manually or through other technologies" (2003a, 20). Video games are often measured by their speed of response, and David Rokeby has described this intoxicating speed as relieving the users of the responsibility of consciousness and moral dilemma (1995, 155). Theories of speed, of course, are informed by technologies of war and work as well as of culture. In the 1970s, mod-

ish management theories predicted superefficient computers able to leave us all free to frolic in garden suburbs in our enhanced leisure time rather than machines poised to check every keystroke of harassed international call center operators, and it is this rhetoric of time efficiency that new media artists have roundly satirized. Futurenatural's *The Bank of Time* (2001), for example, is a screen saver that uses idle time on your computer to grow plants on your screen and to log exactly how much inefficiency you are achieving in an idleness growth table that compares you to other users. Because of this culture of speed, it is therefore more transgressive of new media artists to proclaim proudly, as the artists JODI do, "the slower, the better" (in Baumgartel 1997). The software art *Time Based Text* (2007–) by Jaromil and JODI, for example, turns computers' ability to quickly manipulate huge amounts of text into a slow, meditative performance where poetry is shown being typed by an invisible author in real time, complete with mistakes, corrections, and edits.

Connectivity and Liveness

Some netartists were in the music scene. Some of them were in publishing. Some of them in performance. But very few in video. In fact I think video artists have been most resistant to working with new media. In part because they lose control. They spent so many years taking control and making their medium do exactly what they wanted, and coming to terms with how to edit so the medium did exactly what they wanted. When you put your work on the Internet, like TV, you lose control.
—Kathy Rae Huffman, "A Conversation Between Kathy Rae Huffman and Julie Lazar," 2000

Quite different from the speed of processing is the speed of connectivity, distribution, or broadcast. For video, this second type of speed concerns either closed-circuit systems or broadcast, and these means of distribution both excite video artists and, as Huffman states, provoke concerns about loss of control. Kit Galloway and Sherrie Rabinowitz undoubtedly expanded cinema with early live public-satellite linkups such as *Hole in Space* (1980), but artists' access to means of distribution such as television continued to be a struggle. In 1998, Ursula Biemann was still asking, "Why didn't museums ever bother to buy satellite time?" For video, connectivity and distribution are additional options, whereas for new media such as the Internet, the means of distribution is built in. In 1986, Tom Sherman was cocurating *Art, Technology, and Informatics* for the Venice Biennale and commented in retrospect on a connectivity that was never quite fast enough: "Real-time digital had arrived, somewhat lamely in the form of low-resolution, slow-scan video, decent audio (over standard phone lines), and shared-screen text and drawing experiments" (2002, 194). Today, however, not only the speed but the structure of moving image on the Internet has changed, with the many-to-many nature of file-sharing sites fundamentally affecting velocity of distribution, liveness, and the kinds of narrowcasting that are feasible. Artists Arin Crumley and Susan Buice, for example, explored the gamut of creative new media distribution options for their film *Four Eyed Monster* (2005–) about their meeting online and subsequent relationship. First, the film was

available in eight episodes on the Internet, then the artists were one of the first groups to persuade YouTube to put a feature-length film on its site, and now the movie is part of a long-running network of online video responses and publicity sites. Using a tactic reflecting the phenomenon of the Long Tail described in chapter 2, when enough people in one town request online to see the film, then physical distribution to a public venue in that town is arranged—a process dubbed "critical mass ticketing." If artists are able to facilitate their own distribution, then they gain control of it, even if not in the sense of traditional video art (Lovink and Niederer 2008).

The connectivity characteristics of both video and new media may or may not be live, but the assumptions for Net art are that it is "live" (i.e., connected to the Internet) and that the data can be refreshed at any time. For both video and new media, however, the live is seldom exactly live. In broadcast, there is a delay in case the signal needs to be cut in the event of profanity, violence, or the general unexpected happening. Even with the best telephony or videoconferencing, there tends to be a slight delay that always leaves the person on the other end looking a little slow on the uptake. On the Internet, the delays are unpredictably technical, although Marina Grzinic argues in discussing telerobotics that the delay adds to the "aura" of the experience because glitches are part of the authenticity of technology (2000, 220). Some video artists still see the variable speed and bandwidth of the Internet as a problem for high-resolution video, but new media artists such as JODI are more likely to feature these characteristics—as they say, "the slower, the better."

Art Example: Rachel Reupke, Pico Mirador

Artist Rachel Reupke worked with video and image manipulation for some time before working with new media. Her work *Infrastructure* (2002) shows long shots of a landscape—an everyday landscape with roads and shrubs. The shot does not pan, but shifting clouds and traffic indicate that it is a moving image. Small human figures are eventually noticed moving about, and a slightly voyeuristic and sinister feel emerges, like a long take in a Hitchcock movie: There must be a reason for their action—a narrative? The figures are too small to see clearly, but now one of them is lying down, disappearing among the foliage. What is happening is never explained, but movie references imply something criminal, something bad, fleeting and yet slow. This work is most often installed in the usual video art manner of large projections or screens, so that viewers can see the detail and spend some time with the art.

Reupke became interested in online webcams in particular for their representations of landscape and their strange relationship to time. Webcam images "refresh" slowly online; depending on the speed of the connection, it is like watching a slow photographic flip book rather than a movie. Night or bad weather sometimes engulfs the fixed camera, meaning that the screen is black or gray for long periods. Reupke used this particular characteristic, the slowness of online "live" time, to construct *Pico Mirador*, an artwork with a choice of

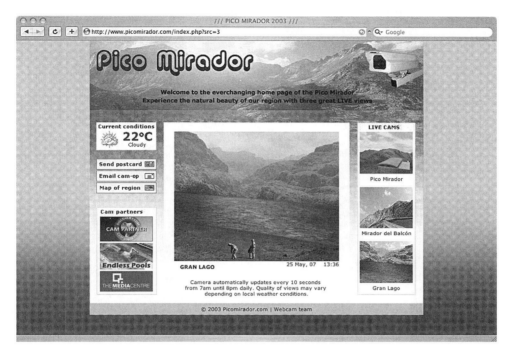

Figure 4.3
Screenshot from Rachel Reupke's Web site *Pico Mirador* (2003). Courtesy of the artist.

webcams viewing the fictional Pico Mirador National Park. The Web site has the advertising and signifiers of a genuine webcam site, but the webcam images are by the artist and slowly unfold a "narrative" ruled by slowness and chance, with gaps in the action intended to frustrate the expectation of movie thrillers or fast-download Web sites.

Liveness certainly has an aura, but whether people *believe* it is live is another matter. There may be a healthy conspiracy theory as to the authenticity of the moon-landing images, and as Rachel Reupke's work shows, new media artists are adept at using the simulation and virtuality of the media. David Ross comments, "The real-time nature of the Web itself, its instantaneous quality, masks the fact that net time can be composed and manipulated, can be condensed and extended, can be used in juxtaposition of the real or unfettered and the virtual or manipulated" (1999a, 9).

There is another simple area of difference for new media art: it often deals with live data rather than with live visuals and sound. Lise Autogena and Joshua Portway's *Black Shoals: Stock Market Planetarium* (2001), for example, is an installation showing "stars" projected onto a small planetarium-like dome. The data that control the stars, however,

Figure 4.4
Installation view of Lise Autogena and Joshua Portway's *Black Shoals: Stock Market Planetarium* (2001), in the exhibition *Art and Money Online* at Tate Britain in 2001. Image courtesy of the artists.

are live international stock-market figures, which means that the installation in London showed flurries of activity at odd times in the art gallery day, when the New York market opened for trading. It is obviously important for these artworks that these data are live, but data can be much less familiar than live images, to both curators and audiences.

New media systems can continuously respond to live data, and can be added to and amended at any time. In relation to the abundance of connectivity available via the Internet, there are also the longer-term issues regarding the longevity of Net art in particular. We explore the general issues for the conservation of new media art in more detail in chapter 8, but even with regard to the shorter term David Ross (1999b) asks how a piece that has not yet ended might be collected, but the answer rather depends on what is meant by "ended." Participative art projects such as *Learning to Love You More* (2002–) (discussed in chapter 5), for example, grow for as long as people continue to contribute to the Web site. Other artworks are more singularly authored, but still exist in ever-evolving versions that reflect the nature of software production: "Considering that many of the artworks are time-based and/or rely on continuous input from the audience, there is a loss of control over content, too. Not to mention that many of the pieces are in a state of 'permanent beta' and never resemble a finished product and commodity" (Paul 2001b).

The answer to how new media art differs from video art therefore lies not only in the new kinds of distribution and connectivity offered by the Internet, but also in what the software itself is doing over time.

Computability and Real Time—the Opposite of Live?

The concept of interacting with the computer, begun in the 1960s, referred then to programmers and analysts developing their software and retrieving their data in real time instead of waiting for hours or days for batch-processed results to be eked out of the computer.
—Regina Cornwell, "Interactive Art: Touching the 'Body in the Mind'" 1992

"Real time" for video means instant feedback: the ability to record and show at the same time differentiates video significantly from film. "Real time" for computers concerns instantaneity of processing and manipulation of data. Real time used to mean not having to leave the mainframe computer to process overnight and hence concerned the speed of processing within the computer itself. It can be argued that real time for video was therefore an inherent part of camera and monitor from inception, whereas computer processing has struggled to attain "live" processing. Thus, in 1995 Char Davies's virtual reality installation artwork *Osmose* was still notable for having such a detailed level of three-dimensional computer graphics generated "in real time" so that viewers would have a quick response to their movements in a "virtual reality" helmet. Again, it can be argued that if video's default option is the simple recording and transmission (albeit mediated and reproduced) of real-time visual information, then the computer's talents lie in the manipulation of data (ideally in real time). Thus, computer software such as digital video editing can manipulate images, and video jockey software has relatively recently enabled VJs to manipulate, cut, and paste video clips in real time. Those artists who are well experienced in both fields tend to be the ones who are able to identify the subtle differences of analog or digital time within manipulative tools: Nam June Paik has described how he wanted to "handicap" himself and do low-tech video rather than use high-grade computers all of the time because he was interested in both very rapid and very slow imaging in artworks such as *Living with the Living Theater* (in Zurbrugg 2004, 285). Other artists who come from a background in video have vouched for the effects of new tools on practical production: "When I edited a tape with the computer, for the first time in my life I saw that my video had a 'score,' a structure, a pattern that could be written out on paper. We view film and video in the present tense—we 'see' one frame at a time passing before us in this moment" (Viola 2003, 465).

Is computer real time the opposite of "live"? If the term *live* is used here as in "live art," then this field, like performance art, centers on the presence of a live human performer. If so, then new media has an interestingly ambivalent relationship to this kind of live because it is usually considered the opposite of live—the mechanical reproduction, the android, artificial intelligence, or the cheap ersatz imitation of life. It is precisely this reputation that Alexei Shulgin plays with in *386DX* (1998–). The artwork is essentially

a piece of software that makes computer-generated voices sing cover versions of songs such as *California Dreaming*—badly. A solo computer has also been known to perform the work—sitting on the streets of Moscow as a lone electronic busker. Shulgin's deadpan performance adds a live projection of the software code, as, of course, does his live persona on stage, with a computer keyboard slung where an electric guitar should be. Shulgin, in fact, does not need to be on stage because the computer program can perform the instructions alone. He can change the code live, however, as many performers of electronic music do, in which case the performance is live and in real time. These distinctions in liveness are not always obvious to the uninformed viewer, but they do form a key area of difference between new media and live art.[6]

Inke Arns (2004) has examined "the performativity of code" in relation to computer programs and software art. Programs can offer instructions that then can perform over time. In addition to acting as a straightforward "score," these programs allow for improvisation and for elements to react to each other over time. Autogena and Portway's *Black Shoals: Stock Market Planetarium*, as previously described, turns stock-market figures into stars. However, another layer of programming creates simple graphic creatures that feed off the energy of the stars and exhibit flocking or cannibalistic behaviors using basic artificial life metaphors. These behaviors evolve, are not fully controlled by the stock-market data, and may not be wholly predictable to the computer programmer. Thus, the score of a computer program is a much looser performance than the score of a conventional musical performance, but it can be argued that computer code displays performativity.

To summarize, the time-related factors of new media art have been informed by the histories and understandings of video, performance art, performing art, and live art. Technological histories add a particular culture of time. These understandings of the behaviors of time characteristically move across seemingly incompatible categories, including, for example, Meg Webster's minimalist sculptural installations, which sometimes include video, and Mark Napier's Net art, in which software by the artist can be set off to forage across the Internet for code that is then combined in unpredictable ways: "It outlines a more broad-based strategy in which the seemingly incompatible work of artists such as Meg Webster and Mark Napier both can be construed as 'performed.' As a behavioral model, the initiative articulates a performative dimension that is not fixed but fluid, not congealed but contingent, such that a work can be simultaneously installed, performed and interactive, thus upsetting a predisposition toward mutually exclusive categories" (J. Fiona Ragheb in Sutton, Scholz, and Ragheb 2002, 18). To be exact about these behaviors, it is in the characteristics of both connectivity (primarily the distributed nature and "liveness" of the Internet), and computability (the real-time, generative nature and performativity of the computer program itself) where the major differences in "new media time" lie. The key question is: How might these differences change the ways in which the artwork needs to be curated?

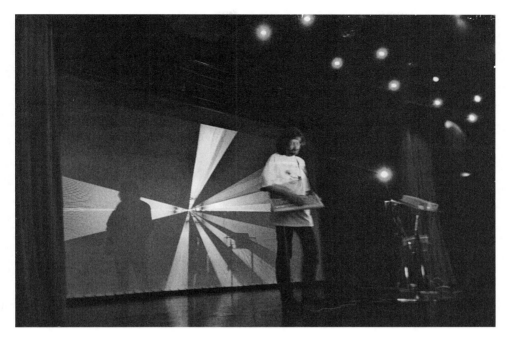

Figure 4.5
Alexei Shulgin performing his *386DX* in Athens in 1998. Photograph by Jenny Marketou, courtesy of the artist.

Rethinking Curating

Caitlin Jones: There is also the issue of duration. I mean, how long do you expect someone to sit and engage. It's not like walking by a painting—you sort of have to sit down and engage before you decide. And in terms of making a space more accessible—you don't need to squeeze down a long corridor or wrangle a large heavy curtain to assess whether or not you actually want to watch something. This black box thing—it does pose some major problems.
Michael Connor: A lot of times the black box is trying to rebuild a cinema in a gallery. But they never do it as well. A cinema is just an installation but you have a sense of entrance—when the door shuts behind you, you know how long you're going to spend in that space—you don't worry about time so much.
—Caitlin Jones, "Conversation with Michael Connor," 2006b

Time is a highly context-specific concept and may differ for each piece of new media artwork. Any moving-image work of reasonable duration, however, faces the metaphors of cinema or video. If video art, with its history of forty-odd years, is still often enduring uncomfortably on a hard chair in a white box, then new media art is truly wandering in the no-man's-land of lobby, education space, and performance space. For institutions,

the choice of traditional venues is stark: either the formal theatrical space—which has fixed seating comfortable enough for a few hours, variable lighting, and decent sound—or the echoing gallery space, often with regulations about the seating used—usually elegantly minimalist benches encouraging a dwell time slightly shorter than on bus-stops' plastic perches. In most cases, neither of these options is wired for Internet access. Curators of new media art are often faced with a choice between two unsuitable options—the white cube or the black box—rather than being in on the planning of a new hybrid option. Curator Christiane Paul, however, makes an important distinction among film, video, and new media: "Artworks that require an extended viewing period are problematic per se—since museum and gallery visitors tend to spend only a minimal amount of time with the work—but the time-based nature of new media art is far more problematic than that of film or video owing to the inherently nonlinear qualities of the digital medium" (2007, 253). This section considers curatorial responses to these differences in timescale, both in production and in exhibition.

Time and the Institution

Work is being produced for the gallery paradigm and there is a worry that new media will suffer from the same constraints that film and video suffered in the gallery paradigm.
—Clive Gillman, from a presentation at the "I'll Show You Mine If You Show Me Yours" workshop on new media spaces, 2001

The conventional gallery is conceived for the time span of looking at an object rather than at anything based on time—so much so that Clive Gillman has argued that once video is in a gallery, it can cease to behave as a time-based medium. The Foundation for Art and Creative Technology (FACT) in Liverpool hired Gillman as a new media artist to work with it on the design of a new media art building to ensure that a flexible set of spaces was created. Their answer was to create some hybrid spaces that can deal with the "event" nature of some time-based work (using theatrical equipment) while also being able to deal with cables necessary for Internet connection. "The main exhibitions space is 200 sq. meters and is dedicated to showing new media artworks. It has been designed with classic gallery proportions and has raised floor systems and hanging grids with theatrical lighting" (Gillman 2001).

Crossing between event and gallery may already cause boundary anxieties for institutions, but when the full range of "process" rather than object is explored in the form of workshops, labs, or other production models, then time becomes even more of a factor, as described in further detail in chapter 9. Any kind of production also demands different administrative systems of institutions. Even if we consider just the reception of the artwork, however, the systems of the institution may be affected, such as basic opening times. "Events" of cinematic duration usually happen in the evenings, and, as Stella Rollig says, it is odd to show artworks that "demand closed shutters where the others

show off their best side in broad daylight, and that might only then be able to unfold all of their qualities when they are permitted to get a bit noisy" (2004, 354). Institutions do not necessarily need a performance space to do this.[7] Online galleries are, of course, open all day and all week by their nature. Steve Dietz has proposed a "24 x 7 x 10" network museum to take into account the pace of change for new media—an open-all-hours museum that would be dissolved after ten years, echoing Archigram architect Cedric Price, who thought that buildings were like exhibitions in that they have a limited life (see Dietz and Sayre 2000, 29; Obrist 2000, 50).

Time and the Audience

Going to a museum and looking at art is also about a "time slot." I became acutely aware of that when I was walking with a colleague at Ars Electronica two years ago and he said to me "I don't understand this whole Internet gallery here [Electro Lobby], I think it makes no sense." I said to him, "What if we were to sit down and look at all this work now?" He said to me, "I would never do that. I would go home and I would look at it from home." I said, "Would you?" He said ". . . No, I wouldn't."
—Benjamin Weil, in Beryl Graham, "An Interview with Benjamin Weil," 2002b

People know approximately the "time slot" of a movie or a concert, or how long they might be in a major museum exhibition. Video art, sound art, performance art, or new media art, however, may have a nominal or compulsory duration of anything from a few seconds to many hours. Artspeak publicity is notoriously vague about this topic for the novice, and video art labels still neglect to mention the duration before members of the audience step into a dark room. Curator Hannah Redler confirms the important fact that the audience "need[s] to know the level of 'commitment' in advance" (2001). The primary frame of reference for an art gallery is still dominantly the short time allotted to each of a series of objects; according to Carol Stenakas, even in dealing with installation art, "we work in seconds" (2001). A. D. Coleman remarked some years ago, "You really need an hour alone with the thing, which is impossible under the circumstances of everyday museum attendance. . . . How do you attract an audience with an attention span of three seconds?" (1994, 29). Coleman was describing *Sonata* (1991–1993) by Grahame Weinbren, a single-screen, interactive, narrative video work. The cinematic metaphor of narrative obviously has repercussions for audience members' time expectations while they sit uncomfortably in a gallery. The lure is the obvious long-term engagement so desired by artists and institutions, but the problem for galleries is that this longer period creates traffic-management problems, especially for an artwork designed for solo use. The audience also jealously guards such time: if you need an hour alone with the artwork, then the fact that other people are looking impatiently over your shoulder is very uncomfortable. Even if a new media artwork is not narrative, then time is still necessary to understand new concepts and new interfaces.

If we are considering Net art in particular, then the argument as to whether to view it at home or in a museum goes beyond the hardness of the chairs. In the United Kingdom, at least, only 56 percent of households had broadband in 2008, and local telephone calls are not free, making dial-up Internet access a pay-per-minute ticking clock. This factor tends to change radically one's time perception. However, Net time is not as simple as pure duration; like computer time in general, it is both speedy and slow:

The abolition of waiting time is the Grail of the Internet and of computing as a whole. Yet, in contrast to the impatience at seconds or minutes spent waiting for pages to load, the easy slipping away of hours spent online is caused by the constant urge to move on to the next thing. . . . Time on the Net is not experienced unfolding smoothly but in an irregular, juddering pattern, for the command to move to a new location initiates, not mobility but a pause, and then (with a slow link) a page loading element by element or (with a faster link) apparently all at once. (Stallabrass 2003, 40)

With regard to interactive art, the time issues get even more complex (so we come back to this topic again in chapter 5). Again, it is artists who tend to be most fully informed on this topic, and some disagree entirely with the "time-based" categorization of this type of art.

I disagree with the idea that interactive art is time-based. You cannot apply the rules of video or cinema, for instance, to interactive installations that may not have time-constraints, or that do not have a predefined start and end. Except for a few pieces, such as Char Davies's *Osmose,* participants may interact with an electronic artwork for as long as they want and in this sense the pieces are not "art rides" with theme-park statistics such as "client throughput per hour." Instead, some people call electronic art "event-based," i.e. the piece unfolds according to user and program exchanges. My own description is that electronic art is "relationship-based." (Lozano-Hemmer 2001b)

For the audience, the time characteristics of new media art can be confusing because they are based on the mixed metaphors of event, cinema, and video game. For the curator, they are equally confusing, with choices to make between metaphors of means of exhibiting new media art and limited information on time and audience to inform these choices.[8]

Time and the Exhibition

In the absence of a two-speed system, the museum experience is accelerated for all comers. . . . And that is why, with our libraries as well as our museums, what we are trying to do is organize an almost urban noise soundtrack alongside experiences that facilitate focus and slowness.
—Rem Koolhaas, in Hans Ulrich Obrist, "Evolutionary Exhibitions," 2001b

Lesson 22: Sometimes you need to slow visitors down. Yes, an exhibit needs to respond immediately to a visitor's input, but that does not mean that the entire experience should be completed within five microseconds. Sometimes it is necessary to design an exhibit so that visitors have to take more time and care to complete the activity. Hopefully this will mean that they are more thoughtful.
—Ben Gammon, "Everything We Currently Know about Making Visitor-Friendly Mechanical Interactives," 1999

It's perhaps unusual to find Rem Koolhaas and a science museum exhibit designer in agreement, but the need for a fast response yet a slow digestion is reflected in many areas of exhibiting practice and is echoed by the fast/slow nature of computer time. Koolhaas's mention of libraries also tallies with the many different interfaces that can be offered to the same data and even to the different "levels" of difficulty that might be offered by a video game to a player or by a library to different levels of researcher. This need is to an extent reflected in the needs of video art, and video curator Mark Nash commented on the exhibition *fast forward* (2003) that the vast space of the Zentrum für Kunst und Medientechnologie (ZKM, Center for Art and Technology) exhibition hall in Karlsruhe, Germany, "enabled both sculptural dialogue between spatially co-present work, and a more reflective engagement in dedicated screening spaces, all attuned to the requirements of individual artworks" (2007, 151). For the particular need to cater for the slow digestion of new media art, however, many organizations have tried the media lounge. The Media Centre in Huddersfield, United Kingdom, however, went one step farther in offering different exhibition areas for differing amounts of time available.

Exhibition Example: Medialounge, the Media Centre
The Medialounge in the Huddersfield Media Centre was an unusual approach to the duration of new media art. Sited physically in the lobby of a mixed-use building and metaphorically in the wider debate about whether a lounge is a suitable home for new media art, the lounge was "not a gallery and . . . not a visitor attraction," according to Matt Locke (2001a). The three small areas were designed specifically for people who may have different amounts of time:

• Zone 1—the first 10–15 feet of the space is the "passive zone." Text panels in this zone introduce projects in outline, engage initial interest and may encourage people further into the space on this or a subsequent visit. The amalgamation of the very obviously public space of the reception area and the start of the media lounge means that many visitors can read the text panels to while away the time in the reception area. There is no interactivity—for this, you need to go further into the space—but this is what you need to engage in the space for the first time.
• Zone 2—[the] 10-minute zone. This contains stand-up interactive installation pieces, using Holopro screens. These are particularly useful in this kind of space as they can be used in daylight, and research has shown that darkened spaces often make people feel alienated and uncomfortable.
• Zone 3—At the back of the Medialounge is the "sit-down" zone, which is designed for people who want to spend around 30 minutes. Basically the premise is that the further into the space you go the further you are engaged.
(Locke 2001a)

This plan was obviously specially made for the building and users, and was intended to function as "the physical 'home page' of the building" rather than as an Internet lounge (there was an Internet café on the other side of the lobby) and rather than as a destination in itself. At the time of planning, the issues were expected to concern the works themselves: "The Medialounge is not just an arts space. It's important that the tenants in the Media

Figure 4.6
Installation views of the lobby and display areas of the Media Centre, Huddersfield, around 2001.
Courtesy of the Media Centre.

Center are able to show their commercial products, research and development outputs. . . .
Work needs to be sourced which will work in the space. This might be film/video pieces but
works which are not linear in narrative because of the way in which the space works and
the time constraints of the users. Works which are linear would need to be 'micro-shorts'"
(Locke 2001a).

The space and the equipment in the Medialounge had been designed to maintain max-
imum "flexibility," so the equipment was on wheels and the space could be changed.
The intended time-banded arrangement reportedly did work effectively, and the artwork
changed four times a year. In 2001, the exhibition space had themed exhibits such as *Tech
and the City,* but from 2002, with a new curator, it had moved to solo-artist shows, including
those of Lucy Kimbell and Thomson & Craighead. This flexibility therefore proved to be
necessary, and thus the lounge did eventually turn into a more conventional single "gallery"
space rather than a mixed showcase based on time.

In the Media Centre, the lounge is used as a point of departure—like an airport lounge—
rather than as a place for relaxing. In considering time, many consider the social lounge

a good alternative for artwork that might benefit from having the audience stick around. Natalie Bookchin points to [plug.in] gallery in Basel as "a comfortable media lounge-like environment that encourages people to stick around for more than the normal brief time it takes to consume art objects, and to mingle with others on and offline" (in Graham 2001a). The physical territory of a media lounge can also create a time territory for new media: rather than waiting for the occasional blockbuster, people can drop in because they know there is always going to be new media work there. The metaphors for lounges vary widely, from louche nightspot to café, shop, and library, all of which imply a lei-surely amount of time to be spent cruising or browsing. At the New Museum in New York in 2004, before it moved into its new building on the Bowery in 2008, the downstairs floor contained the store, a spacious reading room, and an exhibition space for interac-tive projects, installations, and performances. As curator Chris Byrne commented, "The visitor is already in 'inquiry' or 'browse' mode. . . . '[L]ounge' spaces attempt to bridge the gap between institutional space and domestic space. It is interesting that many of the end results resemble (at least superficially) night clubs, also home to a particular (group participatory) variety of digital culture" (2001).

If we are considering time outside physical venues, then, of course, communications media mean that Web sites can be updated at any time from any place, but each type of media has its own expectations and rhythms. In his *Surrender Control* (2000) project using Short Message Service (SMS) text messages sent to cell phones, Tim Etchells was working outside his background of performance, but was interested in the constraints of the medium, including the different expectations of the place and time that people would be receiving the messages (see Locke 2003). As Inke Arns illustrates, once outside

Figure 4.7
Installation shots of the Zenith Media Lounge at the New Museum, New York, at its 583 Broad-way location. On the left is *Location/Dislocation* exhibition in 2001; and on the right, *polygon den[c]ities, Lab[au]*, a real-time audio and visual project for the Belgian new media and architecture group Lab[au] and local New York sound artists Glomag, Secret Agent Gel, Klevervice, and Bubbly-fish, 23 January 2003. Courtesy of the New Museum and Anne Barlow.

the boundaries of a gallery (as new media art often is), time becomes a much more fluid commodity. "The exhibition *Dispersed Moments of Concentration. Urban and Digital Spaces* addresses the effects of new communication technologies on urban spaces. . . . How does this information that is available at (almost) all times and in (almost) all places alter our behavior in spaces that have been 'augmented' to such an extent?" (2005).

However, the timescales of the conventional gallery or museum are not entirely unsuitable for new media art, if Benjamin Weil's concept of the contemplative "time slot" as described in this chapter is understood. In cocurating the group exhibition *Database Imaginary* (2004), Sarah Cook was faced with the challenge of artworks that were often deep and dense as well as conceptual in nature; artworks such as Alan Currall's *Encyclopaedia* (2000), where users could select short video clips from a very extensive database of definitions, had a very different pace of use from Cory Arcangel's *Data Diaries* (2003), which were twelve-minute videos condensing a day's worth of computer screen activity. Cook commented that "we were careful to choose works that we thought would engender a great viewing experience for the visitor to the gallery—this would be a different show were it not in a contemplative gallery space, contained within four walls and the average visitor's time allocation for engaging with a work" (in McGarry 2005).

Time in the gallery, however well a curator might plan a "route" through an exhibition, may not be linear, but instead a variable and discontinuous factor. Curator Kathy Rae Huffman discusses observations she made at Cornerhouse, Manchester, concerning both video and new media work:

I think the time element would depend on the person and how long they have to go into the work. They will come with an hour to spend or ten minutes to spend, so at times it becomes more on the user's back than on the artist's back. If it's a video or a projection of a linear kind, then yes it's time factors there, but people quite often ignore that and just look at say ten minutes of it and leave. It's something that you can't really control. . . . I think if they get a little bit of something and they want to come back later or whatever, at least they've got a view into it. (2004)

With regard to exhibitions as a whole, another key time factor for new media art is the length of time for which it is shown: as described in other chapters, if the artwork is participatory or simply uses delicate emerging media, then the short showings (days rather than weeks) of festivals or labs might be more suitable because the artwork might otherwise simply wear out and indeed might also wear out the exhibition staff and curators.

Time and the Curator

The resonances could be found in really diverse areas, including in art practice, in social movements such as the ecology movement, in management theories based on cybernetics, and in computer science in the work of programmers creating various kinds of algorithm-based visual and sound works. It was fascinating to look through the archives at this work and to talk to practitioners of the time.
—Lisa Haskel, "Re: XX Years since *Cybernetic Serendipity*," 2005

At the beginning of the curatorial research process, there is the question of the time needed to gain knowledge of a field that is inherently interdisciplinary and relates to the culture of "technological times." Lisa Haskel, working in 1998 on an exhibition marking thirty years since Jasia Reichardt's exhibition *Cybernetic Serendipity* at the Institute of Contemporary Arts (ICA) in London, found that her research led her into disciplines other than art. Curator Julie Lazar concurs that these research detours are important, yet time-consuming:

When curators who exhibit new media art have no formal art-historical background, or at least experience with other media like photography, film, video, radio, sound, graphic design, or performance, etc., connections to the progressions of artists' ideas risk getting overlooked or lost. The situation is further complicated because new media art creation and conceptual strategies are also being derived from a much wider arena including engineering, biology, behavioral science, politics and so forth. . . . Think of the kind of time that involves! (in Cook 2001b)

Universities, with an increasing interest in art practice, are generating research likely to be useful to curators of new media art, but there are still some incompatibilities between "art world time" and "academic research time."[9] Although it can be argued that this challenge of interdisciplinarity applies to the curating of art with any type of wider cultural reference, in this case we have to take into account the pace of the newness of new media at a time when invisible curatorial labor is being greatly accelerated: "When I started to curate exhibitions at the beginning of the 90s, I very often did two or three years of research before an exhibition opened. At the end of the 90s, it was more often that I had six to eight months for research before an exhibition," Hans Ulrich Obrist once remarked (2000, 46). Curators themselves are not, of course, immune to the glamorization of speed and of their internationally busy lives. If, as established in chapter 3, process is more important than object, then curators are likely to need to be more involved in artists' working processes. However, when it comes to the important curatorial task of the studio visit, new media seems to have particular prejudices to overcome. A leading curator reportedly told one new media artist: "I can walk into a studio and see a painting or sculpture and know in one minute if the work is interesting—with an Internet or interactive piece I would have to spend too much time and it is not worth it" (in Lozano-Hemmer 2001b).

If curators choose to work in teams in order to address the research and process time required, then there is also the extra time needed for effective communication and collaboration, as outlined in chapter 10 on collaborative models. Artists are excellent, however, at puncturing the rhetoric of busyness and speed: Victoria Vesna's project *n 0 time* (2001–) came from attempting a cross-disciplinary project with busy academics at nine different university campuses, complicated further by a California work schedule that made even synchronizing meetings impossible. For Vesna, the logical conclusion was to "conceptualize an environment that would act autonomously, largely independent of

direct, real-time human interaction, and not requiring direct participation by those who are represented by the information they carry" (in Harkrader 2003b, 287).

The production of the artwork itself can also work on a different timescale. This invisible time of research and experiment had already been noted in the early days of *EAT* in the 1960s: "Billy Kluver has specified that over 8,500 engineering hours went into the Armory events, amounting to $150,000. For the critics this was akin to an elephant's going through two years' gestation and then giving birth to a mouse" (Burnham 1968a, 361). Patrick Lichty points out a change in curatorial structure in response to a very different timescale of production for new media art, related to the variability or "versioning" of the work. Describing his curating of the exhibition *(re)distributions: PDA* and *IA Art as Cultural Intervention* (2001), he states:

Until now, my stance on construction of a curatorial project has been quite standard in making a call, adjudicating the work, and then assembling the pieces within the "gallery" space. However, taking into consideration the nascent quality of the work, a number of pieces remained in beta stages of development at the time of the original opening date. . . . Because some of these concepts were intriguing to me, I added two components to the exhibition that ran counter to the traditional format. First, I constructed a "still in beta" section to accommodate works in progress that I felt were interesting enough to mention. It is my hope that by the end of the "accretion" period . . . many of the beta versions will join the finished works in the exhibits. (2001)

Exhibitions in themselves can become much more variable, depending on very new emerging works. With the exhibition *Database Imaginary* (2004), the curators also noticed how the checklist changed during the tour to include artworks that weren't available at the start or other projects that related to the conditions of the exhibiting venue (Cook in McGarry 2005). All this variability means more time for the curator in preparing each new version of the show. Another layer of complexity is added to this continuously evolving nature of exhibitions with the generative nature of computability, where software programs themselves evolve over time, as in the financial parasites in *Black Shoals: Stock Market Planetarium*. If, as explored in the next chapter, interactive and participatory technologies are followed to their logical conclusion, so that the exhibition evolves at every point *during the show*, then that is a very different structure for the curator, who may traditionally be whisked off to the next job as soon as the show has opened. This change in modes of working is obviously huge for any curator working in any medium, and as Obrist points out, such change has repercussions for the audience as well as for the curator.

What is to be made of Dorner's quest for "evolutionary/evolving displays," growth displays? If we consider the life of an exhibition as ongoing, we can view it as a complex dynamic learning system—provided it comes with feedback loops that encourage voices of dissent. As you begin the process of interrogation—i.e. the research—the exhibition emerges. It would be an exhibition under permanent construction; the emergence of exhibitions within your exhibition; the self-generated

exhibition. But such a time-based exhibition or museum would have to be created in relation to the sense of timing of the viewer, the time he or she spends in the museum. (2001a, 128)

Summary: Curating in Real Time?

Making, promoting and buying art are real-time activities. That is to say, they happen within the day-to-day flow of normal experience. Only Art Appreciation happens in ideal, nonexistential time.
—Jack Burnham, in Charlie Gere, *Art, Time, and Technology*, 2006a

In the 2006 book *Art, Time, and Technology*, Charlie Gere examines theories of time for both media and technology and applies them to contemporary new media artworks. Gere points out that, in relation to time, both the theory and the practice differ significantly between the older and the newer media because of the differing cultural understandings of "real time."

Curators find this difference reflected in the particular practical challenges of showing this kind of work, challenges that are not fully addressed by the previous time-related experience of dealing with video or performance alone; hybrid artworks require knowledge of hybrid histories. Particular to new media, the culture of speed, the variable temporalities of new media connectivity, and new media computability mean that the time characteristics of audiences, exhibitions, and institutions must be taken into account. Curating happens, as Jack Burnham comments, not only in space—the traditional philosophical territory of curators—but also in actual day-to-day time, which puts constraints on the processes of research, installation, and the understanding of new systems for the reception of art, including participatory systems. This particular attention to time, therefore, not only is important to curators of new media art, but also is necessary for contemporary art curators in general, curating art after new media.

Notes

1. Like new media, video art can exhibit different "behaviors" in different contexts, and the spread of literature reflects this variability. For example, video literature is very good on issues of narrative related to time: for books that are starting to integrate new media, see Caldwell and Everett 2003, Rieser and Zapp 2001, and Shaw and Weibel 2002. Likewise, video art literature is good on issues of space and installation as well as, to a lesser extent, on issues of time; for examples, see Frohne, Schieren, and Guiton 2005; Hall and Fifer 1991; Morse 1998. Those with a better grasp on connectivity, broadcast, and technological times unsurprisingly come from a background of communication, media, or cultural studies; for example, see Hayward 1991 and Lister et al. 2003.

2. This phrase is taken from Marina Vishmidt (2006b, 45), who relates it both to the connective and immaterial characteristics of new media and to the culture of speed. Margaret Morse, in suggesting two types of video installation art differentiated by tense (1998, 162), is also strongly linking time and space, but video art curators in general are much stronger on space than time because of

their material approach. David Ross (1996) neatly traces the transformation of video from a radical practice, with dreams of distribution and participation, to the gallery installation forced into the mold of object.

3. The Daniel Langlois Foundation has an excellent collection of EAT material, and specific references to Cage and EAT include Dietz 2005; Gere 2006a, 2006b; Kahn 1999; and Obrist 2005.

4. The links between performance, performance art, and multimedia works are discussed in Grau 2007, Packer and Jordan 2001, Rugg and Sedgewick 2007, and Rush 1999. Others occasionally bring a history of multimedia performative or installation artists into their video-based curating: Gregor Muir in 2002, for example, called Nicolas Schöffer the "Father of Cybernetic Art and Video Art" because of his multimedia work *Spatiodynamism* (1948), *Luminodynamism* (1957), and *Chronodynamism* (1959).

5. Curators don't tend to read technological history books. In 2001, the seminar "Moving Image as Art: Time-Based Media in the Art Gallery" at Tate Modern specifically asked, "Which history?" Although it was very specific on the different histories and characteristic of photography, film, and video, it placed new media in "the future" rather than with any kind of history. Those who have attempted to present moving-image histories and new media histories together include Frieling and Daniels (1997, 2000), Gere (2002, 2006a), Hanhardt (1987), and Manovich (2001a, 2003b).

6. Shulgin's work and other examples of the relationship between new media and live art are explored in Cook 2006a and Graham 2007a. Issues of embodiment are also discussed in chapter 3 on space and materiality.

7. Others to comment on the importance of alternative institutional opening schedules in relation to new audiences include Kathleen Forde of SFMOMA (Graham 2002a), Vivian Gaskin of the ICA (Gaskin 2004), and Karen Moss in relation to the Walker Art Center ("Nicolas Bourriaud and Karen Moss" 2003).

8. As explored in chapter 7, some of the anecdotal and formal research on audiences and duration may be useful to curators. The little research that has been done on the duration of audience attention suggests that, yes, some new media artworks can hold attention for longer than the few seconds' glance at an art object, but that the dynamics are very variable. Above all, artists tend to have a firm grasp on how long is needed to get a reasonable impression of their work, and they feel that curators should strive to cater to this time frame, even it means having comfy chairs in their gallery. Graham (1997) draws together some findings from user research on interactive interpretative installations and observes some interactive artworks in museums and galleries. The findings are briefly summarized in Graham 1999.

9. It is notable that this quandary regarding research time has been aided (in the United Kingdom at least) by the recent growth in well-funded, art-practice-oriented research programs in universities. Both of us are employed by a university; Banff New Media Institute has received substantial Social Sciences and Humanities Research Council grants in Canada. Universities have also supported a great deal of experimental new media art production as well as cross-disciplinary art and technology projects beyond the slender time allotted to commercial research and development.

5 Participative Systems

The individual tendencies of participatory art—the playful and/or didactic, the "pastoral" and the "sociological"—have at least one thing in common: the background of institutional criticism, the criticism of the socially exclusionary character of the institution of art, which they counter with "inclusionary" practices. For all of them, "participation" means more than just expanding the circle of recipients. The form of participation and the participants themselves become constitutive factors of content, method and aesthetic aspects.
—Christian Kravagna, "Working on the Community," 1998

If, as described in previous chapters, new media art is about process and systems rather than about objects, then a critical question is, Who is involved in the systems, and how? Not all new media art involves interaction or participation; nevertheless, this question is at the center of the power relationships among artist, audience, and curator, and crops up frequently throughout this book when discussing the behaviors of new media and the roles of "the audience."[1] The history of participative systems, however, stretches back across not only diverse art media, but also the social and the political. Christian Kravagna traces a history of participation in art via El Lissitzky and Russian productivism, stating that "participation can also be initiated, as with the Dadaists, through acts of provocation" (1998). The histories that feed into participatory new media practice are therefore represented not only by conceptual art, video art, installation or live art, but also by the histories of political activism, cultural systems, mass media, and design.[2]

The history of the Internet, like that of mass-communication media, has been highly political, activist, and commercial as well as artistic, so it has often been those individuals from a background in cultural studies or media theory who have been most analytical of the question of who is involved in the systems and how. Ricardo Miranda Zuniga, for example, quotes from parts of Hans Magnus Enzensberger's 1974 media theory table to ask whether "the Internet's dialogical potential will be consumed by a decentralized global panopticon" (2002, 9).

Repressive Use of Media	Emancipatory Use of Media
Centrally controlled program	Decentralized program
One transmitter, many receivers	Each receiver a potential transmitter
Immobilization of isolated individuals	Mobilization of the masses
Passive consumer behavior	Interaction of those involved, feedback
Depoliticization	A political learning process
Production by specialists	Collective production
Control by property owners or bureaucracy	Social control by self-organization
(Miranda Zuniga, 2002, 9)	

Decentralization, receiver as transmitter, mobilization, audience feedback, interaction, process, collective production, and self-organization all feature in the table, and there are clear parallels here with the new media artworks that use peer-to-peer networks or open systems where the user is the content provider. These differences of language highlight the complex similarities between participative systems and new media participative systems, and this chapter attempts to unpick those complexities. This chapter is entitled "Participative Systems" in a broad acknowledgment of this range of issues, which work across both immaterial systems (as explored in chapter 3) and physical interactions. To unpick the very "seamy" nature of these debates, the sharpest tool is first to define some words that are used notoriously loosely.

Interaction, Participation, and Collaboration

"Interactivity" was the buzzword, the promise and the catchall phrase for a certain techno-euphoria taking shape in the early and mid-90s. The false promises of "democratizing" art that were attached to the term are slightly embarrassing to recall.
—Chris Darke, "Tall Ships (Slight Return)," 2003

Catchall phrases are also rather popular outside the world of technology. Politicians and contemporary art curators, for example, are prone to using the words *interaction, participation,* and *collaboration* with the vague sense that they are "good things," but without having any clear idea of the levels of engagement involved in each or the practicalities of making it happen. Certain art theorists use the words interchangeably and are equally vague about who might be involved. Artists? Audience? Curators? We offer the following quick and usable definitions for the purposes of wading through the confusion:

Interaction: "acting upon each other." Interaction might occur between people, between people and machines, between machines, or between artwork and audience. However, examples of humans and machines or humans and artworks truly acting upon each other are relatively rare. What is popularly termed *interaction* in these cases is often a more simple "reaction"—a human presses keys or triggers sensors, and the machine or computer program reacts. Some have argued that an artwork can "act upon" a human in terms of a mental or emotional reaction, but considering that some kind of human reaction can be expected from any kind of external stimulus, then this "default option"

makes almost everything "interactive," and then the word becomes an inaccurate catch-all. So Gary Hill's video artwork *Tall Ships* (1992) is "reactive" because the bodily presence of people triggers the start of video clips: it is undoubtedly emotionally affecting, but it is not *strictly* interactive.

What computer programs can offer are highly complex, branching, evolving reactions. This reactivity can significantly affect the audience experience in terms of choice, navigation, control, engagement, or (as already explored in this book) time and space. Definition of categories and levels of interaction or reaction has been usefully undertaken, for example, by Stroud Cornock and Ernest Edmonds, who subdivide their typology into the dynamic, the reciprocal, the participatory, and the interactive.[3] What computer-based media *cannot* offer is the kind of truly symmetrical interaction between human and machine that would approximate a good conversation (verbal, visual, or otherwise). No computer program has yet passed the Turing Test for artificial intelligence, where a human judge must decide whether his or her typed dialogue is with a human or a computer.[4] Thus, it is important to be accurate about between what and whom the interaction is taking place because what computers *can* do very effectively is interact with each other and, alternatively, to facilitate a platform for kinds of interaction between human and human. The artworks of Rafael Lozano-Hemmer, Rirkrit Tiravanija, and Ritsuko Taho discussed in this chapter are examples of this approach, which can be described as the artwork's acting as a "host" or platform for human interaction: as Enzensberger's table indicates, providing for the "interaction of those involved" is highly important.

Participation: "to have a share in or take part in." Participation implies that the participant can have some kind of input that is recorded. In common language, "more interactive" can actually mean "participative"—that is, not just getting reactions, but also changing the artwork's content. There is a range of levels of participation: political participation can mean simply voting once every few years or being much more activist; artistic participation can mean just showing up (or logging in) or having real creative input. Those defining types of participation most sharply have often been from sociopolitical fields and have experience of power relationships within systems designed by the powerful. Sherry Arnstein (1969), for example, uses examples from city planning to describe eight rungs on the ladder of citizen participation, ranging from Manipulation and Therapy (Nonparticipation), through Informing, Consultation and Placation (Tokenism), to Partnership, Delegated Power, and Citizen Control (Citizen Power).[5]

In art, the "user" is most often participating in a "system" designed by someone else, artist or otherwise—for example, the *Learning to Love You More* project described later in this chapter. This model of "user-generated content" is a common one on the Web, including commercial forms such as YouTube, but there are levels of control within these models concerning whether the "open submissions" are selected, filtered, or curated in any way.

Collaboration: "working jointly with." Unlike *interaction* and *participation,* the term *collaboration* implies the production of something with a degree of equality between the participants. Collaboration between people is an inherently participative and interactive process, hence the confusion between the discourses. However, collaboration in the present context is the "odd one out" because whereas interaction and participation concern primarily the relationship between artwork and audience, collaboration usually concerns production, which may be between artists or between curators or a combination of both. Socially engaged art undoubtedly offers useful systems of collaboration between artists and nonartists—for example, in the power relationships and roles embodied in community video projects. In this book, however, we discuss collaboration mainly in other chapters.[6]

What emerges from an examination of the use of the three words *interaction, participation,* and *collaboration* is that quite often the rhetoric used (more often by the press or curators than by artists) claims at least "one rung above" the actuality. Hence, reactive artworks are claimed as interactive, participators are hyped into collaborators, Arnstein's Tokenism is sexed-up into Citizen Control, and a "relational" approach promises relationships that will be in some vague way fulfilling. A decent critical grasp of these behaviors necessitates managing these expectations, even if that means stepping down a rung or two on the ladder. Therefore, in order to describe artworks conscientiously, this chapter deals a little with examples of reactive artworks, but more with those artworks that encourage interaction between audience members and with those artworks that gain participation from an audience. As noted, models of collaborative production of art and of collaborative curating are explored in later chapters. The examples here come from both new media art and the wider culture of politically and socially engaged art; it can be argued that both fields necessarily have a highly critical and practically informed view of interaction, participation, and collaboration. It is therefore reasonable to ask whether the experience of curating socially engaged art can be usefully applied to curating the interactive characteristics of new media art.

Necessary Media, Ephemera, and Other Audiences

You can throw as much technology as you want at a community, but if they do not have an existing context of communication and participation in democracy they will not participate electronically.
—Stuart Nolan, in Alan Dunn, "Tenantspin—Simple Complexity," 2003

Stuart Nolan asserts that political participation and new media participation are closely linked. What, therefore, do they have in common? "Socially engaged art" shares with "new media art" a rather unsatisfactory name—or, rather, a series of names. "Community art," "art in the public interest," "new genre public art," "social sculpture," and "empowering/enabling/facilitating/socially inclusive art" are just some in the parade

of names. Likewise, socially engaged media projects have been known as "alternative media," "community media," and, more recently, "tactical media."[7] These names have succeeded each other in an attempt to define behaviors and concerns that differ from those of the mainstream art world, but they have done so without necessarily being fully digested or critically understood. What they have in common is a concern for sociopolitical function, for participatory and collaborative production, and for the relationship between the artwork and the audience.

Because both new media art and socially engaged art are more concerned with process than with object, another thing they tend to have in common is a need to use any media necessary to achieve their ends. Gregory Sholette, via Vladimir Tatlin, has called this not "old," not "new," but "necessary" media (in Carpenter 2004a). The media used by socially engaged artists may be video, food, or online communication tools, and the media are chosen for their participatory potential, low-budget accessibility, or ease of distribution. Much artwork is achieved without major funding and, as Sean Cubitt points out, outside the archive: "Activist art has also another virtue: that it is by and large cheap to reproduce in quantity and easy to transport. . . . Like video, posters are easily bundled, easily smuggled, easily copied and proliferated, and easily disposable once their work is done. . . . The instability of cheap inks and papers, like that of magnetic media generally, dissuades archivists, and curators are only too ready to shuck another burden" (2005, 427). As process-led rather than object-led art, both new media art and socially engaged art share a problem with mainstream museums because of politics, authorship, documentation, and collecting. Above all, socially engaged art challenges the museum on issues of distribution and audience. The debate around socially engaged art has been sharply honed on the questions of who is participating, whether the participants *are* the audience, and who is watching—ultimately questioning whether this type of art shares an audience with fine art at all: "But as socially minded artists work to make their projects more inclusionary and bring those usually outside art institutions into their work—through subject matter, noninstitutional locations, or actual involvement by nonarts participants—many from the art world audience flee; a substitution rather than expansion of audience occurs" (Jacob 1995, 56).

This necessary awareness of audience and economics has strongly informed the development of a critical language for discussion of artwork/audience relationships, in advance of the recent enthusiasms for "platforms," "new" audiences, or the relational aesthetics discussed in the next section, because it addresses the crucial question for those working with participatory systems: *How?*

Critical Categories in Common: *How* Participative?

Web artists who privilege open-source systems have provided perhaps the greatest historical challenge to the art world's voracious cultural and commercial impulses—in part because many web artists straddle these systems (one closed, based on ownership, authorship, and monetary value; the

other open, based on open source systems, community, and, if you will, "cultural value"), and are deviously conversant in the languages of both.
—Caitlin Jones, "My Art World Is Bigger Than Your Art World," 2005a

Curator Caitlin Jones acknowledges that the systems used by new media fundamentally challenge art institutions in some of the same ways that socially engaged practice does— via understandings of open or closed systems and authorship. Those individuals with experience of socially engaged or interactive new media necessarily must have some kind of critical view of participation beyond the bland assurances of "democracy." Both fields have practical vocabularies of systems, whether political systems or the systems and networks of new media, including "open systems" and open source (as discussed later in this chapter). In all of these cases, the understanding comes from experience of the ways in which systems work and the related development of critical languages of description. Therefore, those from politics might use the descriptive terms *ladders, collectives,* and *cooperatives;* those from socially engaged art might use *dialogic systems* and *collaboration;* and those from new media might use *interaction* and *open systems.*[8]

What socially engaged and new media art have in common is languages for identifying different types of participative relationships between artwork and audience. What these languages in turn have in common is that they are generally not shared by the general world of contemporary art. Nicolas Bourriaud's book *Relational Aesthetics* (2002) is rather vague as to whether the relationships are between art and context, culture, or space, between art and audience, or between users in a space, as is the case with Rirkrit Tiravanija's social places projects.[9] Claire Bishop has criticized Tiravanija's feel-good position by pointing out that all participatory systems, whether outside or inside an art gallery, must be able to deal with conflict if they are to be truly participative. As Bishop acknowledges, the art world labors under a system that demands an individually authored object rather than a process, or if the system *has* to deal with a process, it demands that the artist (or curator) had better be an art star (2004, 65–79).[10] The lack of reference to artworks and participative systems outside the art world and its oppositional politics means that it is difficult to establish a language of critical response before moving on to an "aesthetics of participation" for mainstream art discourse.

What socially engaged art and new media art practitioners have in common, therefore, is a critical typology of participation that is beyond the purview of contemporary art. As Ted Purves comments, the artwork's behaviors are more important than its position in the art world and can be informed by technological times: "The cultural context that they are made 'as' is less interesting as a central point of discussion than a consideration of what they 'do.' By moving action and project-based art practice into the world, it opens such work to be considered simply as an act placed in a world of acts, alongside good neighbor days, telemarketing drives and acts of petty theft" (2006). Those who have a broad awareness of contemporary culture, including new media, are usually the ones able to offer the most useful vocabularies for systems of participation, from fine

art or otherwise: Sal Randolph (2008), for example, points out that two terms Joseph Beuys used briefly and interchangeably should be more finely differentiated because *social sculpture* implies an observer, whereas *social architecture* implies a use.[11]

In our ongoing examination of the common critical vocabularies, some useful tools have emerged, in particular the vocabulary of conversation. In 1995, Suzy Gablik placed her "connective aesthetics" in contrast to the individual artist as author and talked of "a new kind of dialogical structure" (76). From a background in socially engaged media art, Grant Kester references in his book *Conversation Pieces* both Homi K. Bhabha's "conversational art" and Tom Finkelpearl's "dialogue-based public art" (2004, 10).[12] New media definitions of systems of interaction have also used metaphors of conversation, including the conversation theory (widely applied in education) that Gordon Pask (1976) developed from cybernetic systems. A very useful aspect of the metaphor of conversation is that, in contrast to use of the confused term *interaction* or the specialized terms of politics, people tend to have an established critical framework for judging levels of dialogue, from a formulaic verbal exchange of pleasantries, to a dialogue with a boorishly poor listener to a satisfying symmetrical conversation between equals, where each person develops the other's responses in creative ways. This development of a language to describe different levels of participation is useful to both socially engaged art and new media art.

Despite the many commonalities between new media art and socially engaged art, there is currently remarkably little crossover between the fields in the literature or practice, and few people are "deviously conversant in the languages of both" (C. Jones 2005a). Although they both sit on the margins of the art world, they appear to sit on different margins, which may be due in part to the fact that the documentation of both fields is marginal and in part to different languages and politics.[13] Beyond the differences in politics, however, issues concerning the characteristics of new media itself also differentiate the two fields.

How New Media Art Is Different

The openness in open source is often misunderstood as egalitarian collaboration.
—Felix Stalder, "On the Difference Between Open Source and Open Culture," 2006

The term *open source* has been used in art contexts rather loosely to indicate anything from interaction to collaboration, but here Felix Stalder, in keeping with the developed vocabulary of new media, makes a delicate differentiation between two kinds of systems, using both technical and political language. Artist Mary Anne Francis has also avoided claiming too high a rung of "openness" in her acknowledgment of the gaps between different participatory systems—or, as she calls it, the "frisson—or abrasion—of open source and art-in-practice" (2006, 197). *Open source* is a specific term for collaborative production of software, where the source code of how the system works is available for

modification by any programmer. However, the collaboration may not be egalitarian; hierarchies of skill and time most certainly apply and are acknowledged by those inside the system. The *free* in the acronym free/libre open source software (FLOSS) additionally acknowledges that because open source is about production of usable products, then the economic and political issues of the distribution of these products is also important.[14] For new media, the political, social, and commercial structures of "work" are often based on systems that differ from old understandings. At the time of the Industrial Revolution, the cooperative movement stood as a clear alternative to capitalism and to the company store. For socially engaged art, collaborative practices are clearly challenging individual authorship, the art museum, and art audiences. For new media art politicized practices, the position in relation to "work culture" is not quite so clear. The book *Economising Culture* (Cox, Krysa, and Lewin 2004) explicitly links the development of new media art to the new management structures enabled by new media, such as the structures of surveillance that monitor the efficiency and keystrokes of computer workers and the management system of just-in-time supply, which heightens the precarity of jobs that can be disposed of at a moment's notice. These systems of precarity ironically often go hand in hand with companies who like to consider themselves as "alternative" or as drawing on Californian hippy heritage.[15] Those working within the cherished alternative political stances of open source software, however, are often clear-sighted about the way in which these systems work and of their own position within the systems. Armin Medosch, for example, recognizes that some of the collaborative production systems of open source software are shared by mainstream capitalist production systems and so has ironically named certain kinds of software "OpenEmbedded" (2006, 237). Some from the field of socially engaged art would regard with suspicion this ambivalent position between "embedded" and "alternative." They see any technological tool or new media as being inextricably linked to the military-industrial complex and hence as grounds for irreconcilable differences between new media and the other media used by socially engaged art, such as posters or newspapers. These differences have a long history in the meanings of technology; as Jack Burnham pointed out in 1980, many in the arts "consider themselves 'humanists' with strong feelings concerning the encroachments of technology on nature and cultural traditions" (207).

Within the rhetorics of control, consumer "choice," and commercial media spectacle, the meaning of the technology and its behaviors can therefore be a source of serious political differences for socially engaged art. Computers can react to sensors and other human input by producing satisfyingly spectacular images and sounds as output. Early video theorists cited narcissism as a primary pleasure of video feedback for both artist and audience, which leads on to the pleasures of command, control, and mastery of interactive systems: new media not only can feed back images of the users, but also can produce amplified, elaborated reactions.[16] However, new media artists such as Rafael Lozano-Hemmer are perfectly aware of the ambivalent allure of control and spectacle.

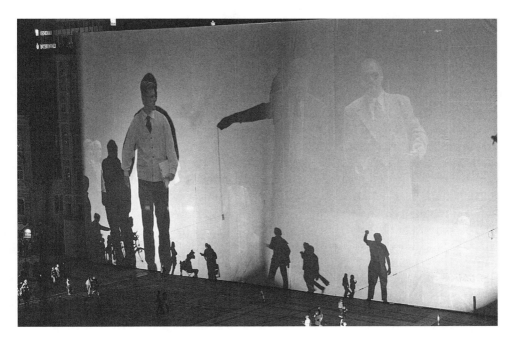

Figure 5.1
Rafael Lozano-Hemmer's *Body Movies, Relational Architecture No. 6* (2001), installed in a public square in Linz, Austria. Courtesy of the artist.

His *Body Movies, Relational Architecture No. 6* (2001) is a huge installation for outdoor plazas and public squares, and offers users the opportunity to make giant shadows with their bodies, much larger than advertizing billboards. The opportunity for bombast and spectacle, not to mention for the amplified conflict of shadow-play violence and sex, is obvious. The artist has described, however, that trust should be placed in the participants to deal with the dynamics in ways appropriate to their own culture. The participants in Madrid, for example, showed a marked territorial respect for the shadows of other people, whereas those in Rotterdam brought along props for visual comedy and even discovered that they could remove from the limelight any participants who got too dominant or brainlessly violent by standing together in front of the spotlights (see Hor-Chung Lau 2005 and Lozano-Hemmer 2001a).

The differences between socially engaged works that use new media and those that do not use new media lie, very obviously, in the choice of media used. These choices are sometimes made for political reasons informed by the cultural meaning of the technologies, but they are also sometimes made simply because of sheer unfamiliarity with the newer media. Within the general heading "new media," however, particular behaviors differentiate the cultural meaning of new media from older media.

Connectivity and "Distance"

Connecting people, creating interactive, communicative experience. . . . What for? If you forget the "what for?" I'm afraid you're left with simple Nokia art—producing interpersonal relations for their own sake and never addressing their political aspects.
—Nicolas Bourriaud, in Claire Bishop, "Antagonism and Relational Aesthetics," 2004

Both socially engaged art and new media art can offer "platforms" for interactive, communicative experience. The difference between them in this case is that new media (or any connective communications media) can offer this interaction remotely or *at a distance*. In their 2005 collection of essays *At a Distance: Precursors to Art and Activism on the Internet,* Annmarie Chandler and Norie Neumark identify "distance" as a common factor in fax art, immaterial art, and Net art. Technologies of connection have been met with a combination of utopian rhetoric and deep suspicion since before the invention of the telegraph.[17] In the epigraph, Nicolas Bourriaud criticizes, as many would, "simple" commercial connectivity, but he does not refer to how artists, rather than commerce, have used the technology. Curators and artists who use new media interactive connectivity are now usually past the utopian phase: Tim Etchell's artwork *Surrender Control* (2001) consisted of mysterious text messages sent to cell phones at odd times of the day or night, which commanded the user to perform certain activities. Curator Matt Locke commented that the artwork "explored the darker shadows of communication technologies, illustrating the *umheimlich* twin of the shiny, happy world of ubiquitous connectivity that we are always being promised" (2003).

Those involved in socially engaged art have a particular issue with the term *distance* because it connotes distance from audience, from responsibility, and from face-to-face feedback. Thus, when a Critical Art Ensemble speaker claimed that because capital was now primarily fluid and online, the appropriate activist responses should also be fluid and online, Matthew Fuller responded as devil's advocate by asking whether this approach might mark a "white flight into cyberspace," avoiding the rigors of face-to-face street-level interaction.[18] Those with a background in public art or community art are often disturbed by the "distance" of connectivity and scorn the ersatz nature of "online communities," even though the Internet may appeal to internationalist leanings. New media may be immaterial, but it can also be "located," and this hybridity between the site specific and the online is often found in the participative projects described in this book, including the example of *Learning to Love You More.*

Art Example: Harrell Fletcher and Miranda July, Learning to Love You More
The art project *Learning to Love You More* (2002–) is one of many that have attempted to gain creative public participation, but it has been unusually successful for the quantity and quality of responses it has received. This example therefore questions what kind of systems might encourage participation (whether "at a distance" or face to face) and what challenges this participation might present to mainstream arts organizations.

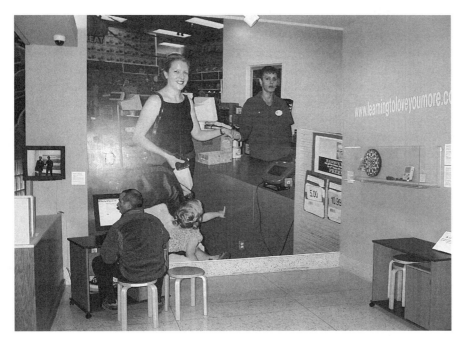

Figure 5.2
Installation of *Learning to Love You More* at Seattle Art Museum (October 2003 to January 2004) showing an enlarged image from the assignment "Take a picture of strangers holding hands." Courtesy of the artists.

The project Web site lists a series of "assignments" invented by the artists, including to "Take a picture of strangers holding hands," "Cover the song *Don't Dream It's Over*," and "Spend time with a dying person." Anyone can send responses to the artists and site manager, who will post the reports meeting the requirements of the assignments onto the Web site, but who also play a filtering role in occasionally removing certain assignments and related responses. Here the artists are acting as "hosts" for others' participation, which is recorded as text, images and sound online, and builds over time. Other such projects have been built, but nobody has come to them, so why did this particular project succeed?

The skills of gaining participation lie in making the guidelines open enough to allow individual creativity but directive enough to help those with less confidence find a starting point. The artists' skills come from filmmaking, performance, Net art, and sound art, but most strongly from "community art," including working with nonartists. By using the term *assignments,* the artists are explicitly referring to the familiarity of school homework assignments and playing with the domestic context of Internet use—participants are often carrying out their assignments in their homes.

The project is not a purely online "distance" project: when asked about how the responses were encouraged, Harrell Fletcher (2004) replied that they directly e-mailed likely participants who were already known to them. These contacts formed some early starting examples, which then led to the majority of responses being from the wider online community. Crucially, the project also exists in the physical world—it has been exhibited in several art galleries, and the production of assignments sometimes takes place in physical workshops with nonartist community groups. The "Sculpt a bust of Steve" assignment, for example, shows a photograph of Steve, the taxi driver who drove the artists to a workshop. The workshop participants made several busts (which Steve commented on), and their results are recorded on the Web site alongside those who contributed remotely. The project has been exhibited in physical form at various venues, including displays organized by participants rather than by the artists. Events associated with these exhibitions help to publicize the Web site, and documentation from these exhibitions is in turn displayed on the Web site. Because word of mouth is important in gaining participation both online and in the real world, the inclusion of real-world contact is important here for contributing to participation "at a distance." The Web site therefore acts as both a document and a means of distribution with a longer timescale than individual events: the *Learning to Love You More* site was very active for seven years.

Learning to Love You More was exhibited in the *Whitney Biennial* exhibition in New York in 2004. Institutional anxieties around online participative artwork tend to center on two issues concerning distance: first, control over the quality of the participants' contributions when anybody might be submitting from anywhere, and second, the immateriality of online work. The first issue was allayed by the artists' filtering role and the fact that the Web site already had a significant quantity of completed assignments; thus, the curators were able to reassure themselves as to the "quality" of the contributions. The second issue was addressed by having the Web site displayed on a screen in the gallery as a physical object. The Whitney, in addition, chose to commission Fletcher to make a "site-specific" sound installation for a museum elevator. He edited together some responses from the assignment "Make an audio recording of a choir" into a crescendo, which rose as the elevator went up. The Whitney therefore managed to address both institutional anxieties at once: here the artist's "hosting" and filtering roles changed into editing and authoring roles, which are much more familiar and comfortable for curators in mainstream art museums.

The base level of participation where individuals contribute to an edited collection is perhaps the most familiar example, but new media connectivity also offers ways of working at a distance that differ from the older models of broadcast or mass media. The Internet is a network and can offer many-to-many connectivity, which not only changes models of broadcast and publishing, but also means that the Internet can provide a platform for "interpersonal relations" such as chat rooms, discussion lists, or wikis. These relations are far from "simple" (as Bourriaud claims they are), and artists using these tools

in their projects are often highly aware of the tools' political aspects. Tactical media activist Geert Lovink, for example, described in 2007 how wikis "reflect a culture of pragmatic non-commitment" in the gamut of systems for collective production.[19] These interactions at a distance often work alongside physical interactions rather than replacing human contact. This fear of humans somehow being replaced by technology also relates to the second particular behavior of new media in relation to interaction: computers interacting with each other.

Interactive Autonomy

[Hans] Haacke's systems have a limited life as an art experience, though some are quite durable. . . . Systems exist as ongoing independent entities away from the viewer. In the systems hierarchy of control, interaction and autonomy become desirable values.
—Jack Burnham, "Systems Esthetics," 1968b

The generative nature of computer programs means that they can produce evolving changes over a period of time. Once programmed, they have a degree of "autonomy" that does not require human inputs after that. For example, in Sneha Solanki's *The Lovers* (2004), two computers sit in a gallery bathed in romantic red light. The computers are connected by a cable, and they pass the text of Robert Burns's poem "My Love Is Like a Red, Red Rose" between them. One computer is infected with a computer virus, which generates changes in the text that spreads to the other computer and evolves as each transfer happens over time. The word *virus* here points at the ways in which software can model simple ecological systems and the ways in which living organisms evolve and learn in response to conditions and chance.[20] "Autonomy" for technology tends to be the subject of science fiction nightmare rather than humble fact—computers taking over spaceships or robots taking over the world. In terms of participative art systems, this characteristic tends to mean simply that computers, in addition to their human input, can also do things automatically by themselves over time, as in Solanki's *The Lovers.*

A computer program is basically a set of instructions to be carried out, and various conceptual artists have also used this technique. A direct parallel with new media art was made in the exhibition *Generator* (2002) when the curators chose to show software art alongside, for instance, an artwork by Yoko Ono that included a set of instructions for the audience to "cut up and re-define territories, stick maps back together." Exhibiting instruction-based work, whether media based or not, raises the issue of control for curators: although they may be wary about permitting the audience to be participants rather than viewers, the "threat" posed by a computer virus or free wireless connections or a peer-to-peer network project is much less understood and all the more frightening for that.

In any summary of the key issues for participatory art systems, then, the lack of a critical vocabulary or an aesthetics of participation is a primary problem. Typologies of

participation do exist in politics (such as Arnstein's ladder), in socially engaged art (such as dialogic or conversational metaphors), and in new media art (reaction, interaction, participation, collaboration, and open systems), but these typologies do not often cross between the disciplines and may need "translation" en route. What these areas have in common is that they at least have the vocabularies based in the experience of critical practice that the mainstream art world lacks.

What divides socially engaged art from new media participatory systems is a political disagreement with technological systems, a distrust of distance, and an unfamiliarity with new media systems. Systems are central to new media art, and it can still be argued that particular computational systems, including open source, are still not generally understood by those in the art world. The history of technology is seldom taught alongside the history of art, even though the invisible open or closed systems of politics are a little more familiar (depending on the curating course). As curator Christiane Paul states, "The crucial dilemma of digital art, and [of] software art in particular, may very well be that the understanding of its 'backend' will always remain a fringe culture (closed system) that won't be integrated into the mainstream of (perception-oriented) art criticism" (2005a). Artists and curators, however, are continuing to struggle with the rewarding challenge of participatory systems and to articulate the "backend" of new media not only through the articulate exhibition of participative artworks, but through "doing"—using more-or-less open systems of curating.

Rethinking Curating

The best way to capture the attention of the audience is by showing hospitality, by creating playful and interesting spaces of engagement.
—Josephine Bosma, "Art as Experience: Meet the Active Audience," 2006

One of the possible roles of a curator is to act as a gracious host between the artwork and the audience—to provide a "platform." In reality, these hosting skills vary considerably. Also, if the artist is acting as the host, then what role is there for the curator? If the curator is not curating an object but a "participative system," then the invisible system itself needs to be thoroughly understood, not only by the curator, but also by the audience. These important challenges are not, of course, fully under the curator's control, but rather reflect the system of each arts organization and the local context that will affect how that system works.

Participative Systems and the Institution

It is telling that the first thing a viewer encountered at *Information* was Haacke's *MoMA Poll*. Placing the work at the entrance of the exhibition was, of course, central to its effectiveness and had been part of the artist's conception of the piece. More significantly, visitors' polls had been common at MoMA during its first several decades. Perhaps the most famous was at the *Machine Art* exhibition,

where the visitors' choices of the most beautiful objects were publicized and compared with those of the celebrity judges, who included Amelia Earhart and John Dewey. But at *Information* it was not the institution of the Museum of Modern Art that was staging a dialogue with its viewers: that role was now commandeered by the artist.
—Mary Anne Staniszewski, *The Power of Display: A History of Exhibition Installations at the Museum of Modern Art*, 1998

Some art museums have a very firm idea of who is responsible for participation: the audience is kept safely at arm's length—answered to by the marketing or education department (as described in chapter 7). The kinds of dialogue understood by a marketing department are usually restricted to a simple feedback model or "voting for favorites"—a model still popular in the twenty-first century, whether in museums, on television, or on the Web. As Mary Anne Staniszewski says, "When artists commandeer this method, the results are rather more political in tone" (1998, 27). Hans Haacke's *MoMA Poll* in 1970 at the MoMA in New York involved the audience placing their votes on a question concerning the reelection of Senator Nelson Rockefeller into glass ballot boxes so that visitors could see the levels of yes or no votes. This poll signaled clearly that even those with an essentially modernist and aesthetic interest in technology might have to face the political questions of who controls and consumes information. What institutions actually do with the information collected from audiences by marketing departments is a moot point. If institutions do not have to listen to feedback, then the "dialogue" is actually a monologue, and the activity remains on the "tokenism" rungs of Arnstein's ladder of participation.

"Yes or no" votes are a simple kind of choice, but when it comes to more complex interactions, as Staniszewski identifies, the artists are often the ones who articulate their institutional critique by agitating for a more interactive institution. According to Stephen Willats, "If the art museum is not to become even more academic, then quite different approaches to its use and function need to be established that render it interactive and responsive to the world outside, to the point where it becomes an active and considered part of the communication process between artist and audience" (1976, 62). Willats is an artist who has participated in socially engaged art projects and systems-based conceptual work and, just as important, in social spaces such as cafés and housing project tower blocks as well as galleries. His work serves to illustrate a dominant challenge for institutions, even those designed recently. The chilly white cubes of arts institutions are hardly the most conducive spaces for any kind of interaction, and the institutional and legal systems struggle with the "dangers" of participation.

In 1971, artist Robert Morris had a retrospective exhibition at the Tate in London where the public could physically interact with large sculptural forms. The exhibition received scathing press headlines and was closed after five days, when audience injuries were reported.[21] Steve Dietz's (2004a) article "Was It All Robert Morris's fault?" traces how the show was reinstalled as hands-off sculpture and how the "dangerous" participative

elements were safely confined to art objecthood via a film wherein a naked woman moves among the sculptures. Dietz jokingly blames Robert Morris for all subsequent institutional fear of physical interaction. Thus, participatory systems present problems to both the physical spaces and the legal systems of a conventional visual arts institution in terms of risk, insurance, and public safety, but these problems are by no means new or insoluble (van Heeswijk 2000). The perceived "dangers" of participation are, however, not so much practical as psychological and concern some deeply held value judgments. Michael Shepherd of the *Sunday Telegraph,* for example, was quite certain about the problem with the Robert Morris exhibition: "The trouble with participation, it seems, is that apart from making us forget what art's all about, and inducing the very restlessness of mind which it's supposed to ease, it makes people behave like wild beasts" (in Bird 2000, 88).[22]

Curators in contemporary art institutions can be expected to be affected by art critics' values, but in the case of this exhibition there is some evidence that from observing the "problem" of interaction, curators gained knowledge about spaces for conflict within any participative system. In a letter to artist Robert Morris, Tate curator Michael Compton stated: "I entirely understand the effects of social interaction. I think people responded a great deal to each other, rather than to the objects, to their relationship to the latter or to the awareness of their own physical processes. That is, they made up group games, competed, acted out their aggressions, showed off, etc." (in Dietz 2004a). Participatory art systems, like socially engaged art, are therefore often a challenge to the value systems of art institutions, and participatory new media art systems more often happen outside of art museums than within them (as explored in the sections on labs and collaborative modes in chapters 9 and 10). However, there are some signs of an institutional learning curve with respect to the participative audience, as explored in the next section.

Participative Systems and the Audience

They call on you to sort of participate in it. I'm not one for that sort of thing. I just like to stand and look at things rather than take an active part in it.
—Male visitor, from a museum visitor study in Adrian Mellor, "Enterprise and Heritage in the Dock," 1991

As the plaintive visitor in the epigraph illustrates, participation is not for everyone.[23] Those unversed in contemporary art may expect passive pleasures or may simply lack the confidence to risk doing "the wrong thing" in such a context. Conversely, if your audience is expecting to participate fully in art production, then hell hath no fury like a frustrated user. As explored further in this book, participative systems fundamentally challenge the very notion of audience if your audience is also an author or a selector. Even with the simplest levels of navigation and choice, then the question must be asked of the audience's motivation for doing this or that and whether the experience, after

Figure 5.3
Staged publicity photos for the participative version of the retrospective exhibition by the artist
Robert Morris at the Tate, London, in 1971. © Tate, London 2008.

branching rhizomatic options are negotiated, is rewarding. As Peter Lunenfeld says, sometimes "a rhizome is just a peanut, after all" (2003, 69).[24]

If the audience is asked to participate by contributing creative input, then Josephine Bosma rightly asks: "How did we get to this point? After all, surely the audience did not turn into cultural producers and art collaborators overnight" (2006, 25). In the context of a museum or gallery, participation is a relatively new experience for the audience, and meaningful participation is difficult to achieve. Many who launch participative projects are disappointed with the scale and depth of participation that they manage to sustain, but those that do succeed often do so by drawing on working experience of the process of participation and by using hybrid methods that exist both online and offline, such as the example of *Learning to Love You More* discussed in this chapter. When the project was exhibited in the *Whitney Biennial* it also highlighted some common curatorial concerns about participants as authors, because that authorship is outside of the quality-control of the institution. Curators concerned about the quality of the audience's contributions, however, may forget that these concerns are not applicable in all cases:

> The truth is, some users are better than others at generating results that are of interest to other viewers. How are we to judge works where the input is the user's? . . . For Kynaston McShine's acclaimed *Information* exhibition (1970), Dennis Oppenheim created a system for visitors to write a secret on a notecard and put it in a slot. In return, they received someone else's secret. After the exhibition all 2000-plus of the secrets were published, without editing. One would be hard-pressed, however, to argue that the quality of this essentially conceptual work was dependent on what people wrote. (Dietz 2005, 92)

For curators, the unspoken subtext behind "quality" is sometimes actually "censorship": What happens if a gallery comments book is full of scrawled obscenities? Institutional solutions to this problem have often been to remove the comments book, but there are actually much more creative solutions, especially for new media art. As already outlined, Rafael Lozano-Hemmer's *Body Movies* gives an audience in a public place free rein with large shadows of themselves to enact mock violence and cheerful obscenity, but, as noted, local cultures deal with these choices in their own way. Shadows are live and fleeting, but participation that is recorded, especially as text, can be more problematic.

In the United Kingdom, the *Speakers Corner* platform designed by Jaap de Jonge has been running since 2000, showing text on a LED screen around the outside corner of the Media Centre, Huddersfield. The platform is used for special projects such as SMS text-message poetry, but also for ongoing general messages. The input is made via a Web site or telephone; the site uses standard automated filters for certain swear words, but the messages are not otherwise edited. Despite running for more than six years in a very diverse and economically poor area, there has been only one occasion of physical dispute: a man disagreed with a political comment by another member of the public and broke a window one night. However, the man came back the next day and, after discussions with the curator, agreed to pay for the window to be mended. The curator saw such

Figure 5.4
Speakers Corner (2000–) display designed by Jaap De Jonge, on the exterior of the Media Centre, Huddersfield. Courtesy of the Media Centre.

face-to-face negotiations, including negotiations with the police concerning the responsibility of "broadcasting" such comments, as a necessary part of the job of sustaining an open participative system (Holley 2006).

Artists are usually the ones to have the detailed working knowledge of audience interaction: they know that if they build an artwork, the audience might come, but the audience might choose not to use the artwork if the interaction has not been carefully considered. In 1972, Joseph Beuys was writing reports on each day's proceedings at his *Bureau for Direct Democracy*, a room installation at the Documenta 5 festival where the artist sat for one hundred days aiming to develop discussion: "11:00 a.m. Until now about eighty visitors in the office. Half, however, remain standing in the doorway and look around, others walk past the blackboards, and then remain longer in the office. Some only come to the door and leave in fright, as if they had come into the wrong restroom" (Beuys and Schwarze 2006, 120). With any relational or participative artwork, the starting point for the audience is the sheer unfamiliarity of being asked to interact in an art context (or, indeed, in a room that looks like a bureau). However, new media artists have usually thought through interaction if that is the behavior with which they are working. David Rokeby (1995) has written about his observations on the physical

learning curve of his artworks that respond to gesture, whereby the audience tests gesture and response before proceeding to "play." Rafael Lozano-Hemmer is particularly critical regarding the interaction strategies for groups of people: "a voting interface where input gets statistically computed and the outcome is directed by the majority of votes . . . can be very frustrating and problematic because it's so democratic, it makes you feel that your discrete participation goes nowhere. The challenge is how to open a piece for participation without taking averages or taking turns" (2001b).

Lozano-Hemmer's solution is to make works that are intended to be enhanced best by group interaction; many people can interact with the artwork at a time, and the artwork encourages interaction between people. *Body Movies* (2001) actually enables two kinds of interaction: the audience can freely improvise with the huge shadows to interact with each other, but there are also projected photographic images of people, which the audience can see properly only when they cover the photographs with their own shadow. If individuals in the audience collaborate to cover all of the photographs, then the computer program reacts by projecting a new crop of photographs. The kinds of interaction encouraged are therefore very varied and work differently for groups or individuals: the man who just likes to stand and look at things will be satisfied; the shyer person may like to be "introduced" to the party by covering the photographs; and the extroverts will do their own thing with the shadows. Lozano-Hemmer vouches that "successful pieces that feature 'interactivity for groups' are usually out-of-control" (2001b), and fellow artist Perry Hoberman agrees with him: "Each action is modified by the computing system, which, in an ideal world, would actually be complex enough to make things unpredictable. In fact, everything gets really complicated only by the truly unpredictable force of other peoples' actions" (in Jeremijenko and Hoberman 2001, 55). Artists who have been working with new media and observing their audiences for a number of years have discovered important things about human–computer interface in relation to art—primarily that the limited nature of programmed interaction can serve to host the much wider range of human interaction.

The curatorial challenge of understanding "audience" in relation to participative systems is therefore very much informed by those new media artists who have thought long and hard about levels of participation. Likewise, curators experienced at working with interpretation, or audiences in public places, have developed the skills of negotiating local context, and the skills of interacting with an audience come as much from the cultural context as from the media used. These artists and curators are also familiar with the diversity of different audiences and have a capacity for dealing with conflict. With so much riding on the rungs of participation, both socially engaged art curators and new media art curators need to be aware of the gaps among intent, reality, and documentation, as well as of the potential gaps between different experiences of the same process: "I often find that public art projects can be documented in a certain way, which makes them look as if they were extremely effective, but the reality might have been completely

different, or different people's expectations or experiences of the project are so diverse: the artist might have thought it was terrible, but a participant might have thought it was fantastic" (Harding 2003).

Participative Systems and the Exhibition

At the *Information* show [1970] . . . the galleries became a vast, white, seemingly neutral container for the artist-directed installations. The idea of an amorphous museum gallery shaped by the artists' installations and by the spectators' interactions with these sites was seen even in the use of the unconventional beanbag chairs whose malleable forms were shaped by those who used them.
—Mary Anne Staniszewski, *The Power of Display: A History of Exhibition Installations at the Museum of Modern Art*, 1998

The idea of the gallery being shaped by "spectators' interactions" may strike terror into the hearts of certain curators, who would rather eat a beanbag whole than have one in their gallery. Leaving an indentation in a beanbag is hardly a radically participatory act, and the unfortunate items in figure 5.5 still look suitably intimidated in a vast white space, but this scenario may still display more malleability than some curators are willing to countenance. It is one thing for the linear gallery bench to be supplied so that visitors may spend a little longer in individual contemplation of an artwork, but it is quite another if people move seating around at will in order to interact with each other. In the strange grammar of art seating, the hardness of the chair implies timescale, but the shape and arrangement of the seating implies social behavior. Hence, the model of a media lounge might be designed either for prolonged individual viewing or for sociable sharing, or it might have options for both.[25]

There is a tension between solo viewing and group viewing in any art gallery, and, surprisingly, those who visit galleries together often squeeze themselves uncomfortably onto seating specifically designed for one person in order to share the same viewing (Graham 1997, 70). With single-screen new media works, this can be a particular problem, but something as simple as moveable seating can at least allow for varying participatory behavior. In 2003, curator Kathy Rae Huffman (2004) chose large inflatable balls as seats for the computer terminals in the *Lab 3D* exhibition at Cornerhouse, Manchester, and she observed the changing patterns of solo or group use as people moved them around. In Steve Dietz's section of the 2005 exhibition *Making Things Public: Atmospheres of Democracy,* the coolly clinical surroundings of ZKM were made a little more communal by having the users face each other and by there being room for more than one person on each bench. For participatory artworks, the choices of installation are even more important. Andreja Kuluncic's *Distributive Justice* (2001–2005), for example, is a Web site and physical installation where users can vote on social and legal issues. The need for thoughtful user participation demanded a user-friendly design for both the Web site and the physical installation, so the familiar voting interface of writing on paper and posting into a box was utilized. The simple fact that there were several computer screens and

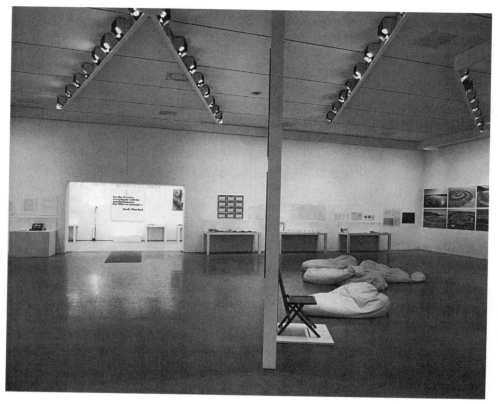

Figure 5.5
Detail of the installation by McShine and Froom at the *Information* exhibition (1970), showing beanbags for visitors. The chair is from Joseph Kosuth's artwork *One and Three Chairs* (1965). © 1970 The Museum of Modern Art and SCALA, Florence.

circular seating arranged so that more than one person could sit at a computer screen at the same time made social interaction between users much more likely. The seating was soft, which implies a longer comfortable use time, but the fact that it was brightly colored highlights an area of disagreement for artists or curators: in the context of one artwork, such a color choice might be user-friendly and appropriate; in another, it might smack too much of "hands-on fun for kids." It might simply work against the aesthetics of a certain artwork to show it on a "strawberry-flavored machine" (Bar-Joseph 2001).

Certain artists deliberately make interactive works that are designed to be enhanced rather than degraded by multiple users. Rafael Lozano-Hemmer's work is so designed, and Perry Hoberman's artworks, such as *Workaholic* (2001), use a tactic sometimes employed by interpretational interactive media, where people can literally gather around a

Figure 5.6
"Fair Assembly" section of the 2005 exhibition *Making Things Public: Atmospheres of Democracy* at ZKM in Karlsruhe, Germany. Image courtesy of ZKM.

table: "Another thing that happens when you take the screen off the wall and flatten it is that people around it are facing each other, which privileges a certain kind of social interaction" (Jeremijenko and Hoberman 2001, 54).

One of the simplest barriers to physical interaction in an art gallery is the "don't touch" tradition. In exhibitions that include both interactive and noninteractive works, this assumed visitor behavior can raise issues for exhibition layout and design and for the attending staff. The exhibition *010101: Art in Technological Times* (2001) at SFMOMA included screen-based works that were either active or passive and three-dimensional works, some of which were physically interactive and others of which were no-touch sculptures. *Softscape* (2001), by Karim Rashid, was composed of orange plastic-chair shapes that could be used (until they wore out) and screen images that weren't reactive. These variations in behaviors were a source of confusion for the audience and a continuing problem for gallery guards (Graham 2002a). The solution for the *Game Show*

Figure 5.7
Distributive Justice (2001–2005), at http://www.distributive-justice.com, a multidisciplinary project by Andreja Kuluncic, with coauthors Gabrijela Sabol, Ivo Matinovic, Neven Petrovic, Matija Puzar, Dejan Jankovic, Trudy Lane, and Momo Kuzmanovic, and with contributor Tomislav Janovic.

exhibition at the Bellevue Art Museum in 2000 was simple but effective: the "no touch" exhibits were shown on white walls; the interactive exhibits had black walls as a background. In an exhibition where all the work was interactive, such as *Serious Games* (1996), the task was simplified, but the audience still needed to be encouraged by "Please Touch" signs, clear labeling, and gallery staff briefed to encourage participation. The exhibition is included here as an example illustrative of several key issues for structuring whole exhibitions of reactive or participative artwork.

Exhibition Example: Serious Games, *Laing Art Gallery*

The *Serious Games* exhibition in 1996 showed eight "interactive" artworks, only some of which used new media. The aim was to show a range of reactive and participative artworks toward a critical view of interactivity, the strapline being "Not a show about new technology, a show about interaction." Beryl Graham curated the exhibition for two publicly

funded city center art galleries, the Laing Art Gallery in Newcastle and the Barbican Art Gallery in London.[26]

The challenges of curating an exhibition of interactive artwork started with the association of interactive technology with "hands-on fun for kids." The artworks were therefore chosen for serious content, such as Graham Harwood's *Rehearsal of Memory* (1995), which was a simple point-and-click CD-ROM, but the content of which was made with patients at a high-security mental-health hospital. Some of the artworks satirized the current hype about interactivity and choice. Elizabeth Diller and Ricardo Scofidio's *Indigestion* (1995), for example, allowed the user to choose the gender and class of the two protagonists in a reactive narrative, but the story always ended the same way, which highlighted the limited nature of the choices.

Another challenge for staging a whole exhibition of interactive art is the amount of time and energy needed for the active audience to experience the artwork. The artworks in *Serious Games* were therefore selected to vary in "pace": a full cycle of an *Indigestion* narrative took around seven minutes, whereas Bill Seaman's *Passage Sets* (1995) offered a slow reactive navigation through poetical words and images, but also offered pleasures of passivity for the viewer if desired.

The tension between individual use versus group use of the artworks was also addressed in the exhibition. Toshio Iwai's *Resonance of 4* (1994), for example, is a musical game designed to be enhanced if four players cooperate in making the music. Iwai's work is an example of the artist acting as an elegant "host" for interaction between people.

Two participative pieces underlined the curatorial challenges of maintaining participation. Ritsuko Taho's *Zeromorphosis: Swans and Pigeons* (1996) involved the audience in making grass balls with water and earth, and leaving messages fixed to walls. These activities were essential for the thoughtful, haptic nature of the participation, but necessarily involved the gallery staff in an ongoing process of physical tidying and maintenance. Anne Whitehurst's *NetEscape* (1996) was an early example of online participation, in which the artist posed playful questions and then responded to participants' answers. Both of these participatory projects, whether online or in physical space, involved the artist and the curator in a series of consultation, monitoring, intervention, and editing activities throughout the course of the exhibition and beyond the usual technical maintenance activities. This process obviously differs greatly from the usual rhythm of installing an exhibition, dealing with press reviews, and then moving on to work on the next show.

Serious Games therefore brought up the issues common to exhibiting interactive or participative artwork—criticality, pacing, group use, and encouraging and maintaining participation. The solutions for addressing these issues lay primarily in the selection of the artworks and in the expertise of the artists themselves. The institutional solutions always involved people: extra "helpers" were employed to encourage interaction in the gallery spaces, and guards or attendants were briefed with particular care to develop an "ownership" of the artworks and audience members' unusual behaviors. The press releases were

Figure 5.8
Ritsuko Taho's *Zeromorphosis: Swans and Pigeons* (1996) in the exhibition *Serious Games*. Installation view details from the Laing Art Gallery, Newcastle. Photographs by Beryl Graham.

carefully negotiated with the galleries in an attempt to represent types of interaction accurately and to avoid technological hype. Press coverage for the most part acknowledged the curatorial aim of the selection and particular combination of artworks by recognizing a differentiation of levels and types of interactivity or participation. For example, the reviewer from *Frieze* magazine commented that "Ritsuko Taho's *Zeromorphosis: Swans and Pigeons* (1996) . . . achieves participation and communication through a tangible act as opposed to merely asking to choose from preset options. . . . Harwood's . . . work uses the point and click method but the understated and affecting emotional charge overcomes the inherent limitations of such primitive interactivity" (Laniado 1997, 98).

So even though participatory new media art exhibitions may be nonstandard for an art gallery, the practical challenges can be overcome, and useful models for such exhibitions do exist. The most radically participative exhibition strategies do tend to be facilitated by the Internet and by open source methods.[27] An art gallery is not, perhaps, the most sympathetic context for interactivity, but as explored in chapter 9, those working in the context of public art or laboratories may provide for different contexts and different means of "showing" interactive work.

Participative Systems and the Curator

An art connoisseur who is expert at detecting quattrocento tempera is utterly innocent of any knowledge of electronic circuitry. Where he might turn to an artist's preliminary drawing for insight into the finished painting, he is reduced to helplessness when confronted with a kinetic artist's blueprint.
—Anonymous, in Jack Burnham, *Beyond Modern Sculpture*, 1968a

Burnham's use of the word *blueprint* here highlights the difficulties facing curators who try to understand the end object of a work without understanding the process. If blue-

prints are a set of instructions for making something, then participative artworks such as *Learning to Love You More* or Yoko Ono's projects often consist of "a set of instructions" for the audience-participants. The curator must be experienced in understanding the dynamics of the process after these instructions are issued and must be able to ensure that the audience can carry them out if they wish to. The curator is not placing an object, but providing a "platform" for participation according to the artist's blueprint. Curators should therefore understand how platforms work, from knowledge of either socially engaged art or new media art or public art or education. Rudolf Frieling, curator of *The Art of Participation* (2008), was driven to paraphrase a German comedian when reflecting that "participation is beautiful, but it's a lot of work" (2008, 33).

Because artists are discerning about the behaviors of interaction, then curators need to be, too; in particular, they need to be specific about whether the interaction is taking place between artwork and audience or between audience members: "Of course no interaction with a machine can currently approach the complexity of human interaction. Perry Hoberman's recent exhibits depend upon both interactions with the programme and interactions between other people using the exhibit" (Franklin 2001). New media art has been informed in this critical stance by practical experience, by a range of discourse from technology, media studies, and art history, and by commercial interaction design.[28] Fortunately, there are those who are willing to share their experience concerning working practices for meeting the challenges of participation in art contexts using new media. Trebor Scholz (2006), for example, has written widely on the importance of some central factors, including establishing a clear process concerning scale and time, defining self-interest, developing listening skills, and taking a good dose of humility. If curators are dealing with new media participative systems, then it certainly does help if they are intimate with the participative opportunities and pitfalls offered by that interface. Curator and artist Jon Ippolito, for example, explored the dynamics of online interaction in an artwork called *Adversarial Collaboration* (1999), where he, Janet Cohen, and Keith Frank attempted to collaborate via e-mail and mail despite their differences. The work reveals a great deal about New Yorkers' tenacity of argument and is highly illuminating about conflict and the various participative characteristics of online connectivity. In an article about the project written some time later, the artists were still disagreeing about the use of digital media and about collaboration (Ippolito 1999). Curators who use wikis and online discussion lists as part of their own practice, such as the NODE.London projects discussed later, are much more likely to understand how a wider audience can participate using those tools.

As noted in the example of the *Serious Games* show, there is a recurrent difference in the curating of participative work—the unpredictable need for curatorial servicing work throughout the whole process of the exhibition and for the relegation of socially engaged organization as "service," perhaps to an education department: "Problems occur due to the continuously evolving nature of audience-orientated works. . . . Sometimes

context-based artworks are dismissed by curators as service rather than art" (Scholz 2006, 198–199). The mention of art as service leads to a questioning of curating as service rather than selection and gatekeeping. The process of curating reflects the process-led nature of the artwork: as Christiane Paul says, "The necessity of a closer collaboration between curators and artists is mainly due to both the development process of the work—which may be a collaboration between several artists in the first place—and its presentation within the physical space" (2002). Because of the longer and more intense nature of the process, and because of requirements ranging from social skills to an understanding of political systems, the need for collaboration arises again as a useful mode of curating.

Lozano-Hemmer notes that "dependency on participation is a humbling affair. My pieces do not exist unless someone dedicates some time to them" (in Ranzenbacher 2001), and the rigor of curating such works is equally humbling, demanding an approach very different from that taken for the traditional solo connoisseur. If artists need to place a great deal of trust in their participative audience, then curators in turn need to trust both the artist and the audience. The characteristics of new media offer potentials for reaction, interaction, participation, and collaboration that are far more radical than voting or leaving a dent in a beanbag chair. Throughout this book, we examine the challenges that these potentials offer to the curatorial role, and in chapter 10 we explore the logical end point of participative systems, where curators not only have placed trust regarding the content of a participative artwork in the hands of the artists and the audience-participant, but also have placed the curatorial process and decision making in the hands of the audience-participant.

Summary: How Participatory Are These Systems?

The TVmeetstheWeb Seminar proposed that the future of interactive TV lies in gambling and quiz shows—that is, a form of button-pressing, passive interaction. *tenantspin* strives for a more active interaction and believes that such a relationship can only evolve over time. There have been numerous streaming projects in the UK that have been short-lived and, of the 29 current Superchannels across the globe, only eight are still broadcasting.
—Alan Dunn, *"Tenantspin—Simple Complexity,"* 2003

Participative systems can be deeply engaging and can fundamentally challenge and broaden notions of audience. As Superchannel, the Web broadcasting facilitators, have found, meaningful participation can also be challenging to maintain effectively in the face of more tokenistic, shallow reaction. The *tenantspin* project, for example, broadcasts television via the Internet from a housing project in Liverpool, with a production team of facilitators and elderly residents who have learned many technical skills. The *tenantspin* project was based on the producers' experience of a long history of community video projects that had developed into specific skills in individuals and institutions. A member of the group stated: "It all boils down to teamwork, and communication with

all the group, that's what it boils down to, and common sense. And a good memory" (Kelley and Dunn 2005). The skills that curators need to host real participative systems can come from the experience of socially engaged art, but also from an understanding of the specific dynamics of new media systems if those tools are chosen. As outlined in chapters 7 and 9, these skills may also be found in those individuals with experience of curating educational events, public art, or peer-to-peer publishing.

For the curating of participative new media art, curators need to be aware of whether the artwork is reactive, interactive, a host for human interaction, participative, or collaborative. Users gain a critical vocabulary through using the systems, and the problem for curators is that they are rarely users themselves—unless, like Jon Ippolito in *Adversarial Collaboration*, they explore systems in a spirit of curiosity and acknowledge the possibility of conflict. Whether the "systems" approach of new media involve truly open systems or not can be judged both from theory and from a critical understanding of the process and practice itself.

The critical vocabularies of how participative a system is might come from politics or new media, but may need a little translation before forming an aesthetics of participation understood by the art world. Those vocabularies that tap into existing critical systems perhaps have the most chance of forming a workable typology; many people have some kind of discernment about "how democratic" a system is, "how well hosted" a party is, or "how equal" a dialogue is. In theory, the critical knowledge of systems should be able to inform both socially engaged art and new media art involving interaction. In practice, new media art systems are simply not yet as familiar as older political systems. The particular cultures of technology mean that the languages used are different, and the political meaning of the technology itself may throw a barrier between the fields. Because of a convergence of interest around participation, however, the language of new media is beginning to find itself in the mouths of contemporary art critics and curators, albeit often via pejorative references to "Nokia art," chat rooms, and flash mobs.[29] It is the contemporary artists rather than the critics who have discerned the common behaviors of participative systems, whether new media or not. If the artist is making a platform for participation, then it is not necessarily the fabric of a physical platform that is important, but the knowledge of how the immaterial systems of participation operate: "I'm not a machine. I'm not a mechanical thing. I'm not a hardware, I'm a software" (Rirkrit Tiravanija in Harkrader 2003a, 109).

Notes

1. The relationships among audience, display, and interpretation are explored in chapter 7, and the role of the audience as curator is described in chapter 10. In the epigraph for this chapter, Kravagna places participation in a history of "institutional criticism," and throughout this chapter the "art world" is referred to as the institutionalized contemporary art system that does not include socially

engaged art or new media art within its overview. Art institutions and museums are discussed further in chapter 8.

2. With such a wide range and complexity of bodies of knowledge involved, this chapter can only hope to collect and arrange some references to those parts that might prove of most use to curators who wish to research the topic in more depth. Fortunately, a growing body of books is specifically about participation, and we refer to them in the chapter.

3. Within "interactive," interactions are more or less complicated depending on whether the interaction involves an individual, a small group, or a culture or is cross-cultural (see Cornock 1977; Cornock and Edmonds 1973). Definitions of kinds of interactivity for new media art are an area of some complexity and debate. Graham (1997) has collected some examples of categorizations of interactive art, including Cornock and Edmonds's categories, Roy Ascott's (1967) "deterministic" and "behavioral" categories, Frank Popper's (1975) tracing of the roots of "democratic art" via conceptual, political, and kinetic art, and Steve Bell's (1991) musical score analogy concerning the degree and manner of control of interaction. Based on these categorizations, Graham uses the common-language metaphor of kinds of dialogue or conversation to describe levels of interaction between programmed artworks and audiences in museums and galleries (see also Graham 1999, 2007a, forthcoming b). More recently, Nathan Shedroff has described continuums of interactivity differentiated by "the amount of control the audience has over the tools, pace, or content; the amount of choice this control offers; and the ability to use the tool or content to be productive or to create" (2002, 9). Art historian Katya Kwastek (2008) has also recently described kinds of interactivity.

4. Benjamin Woolley gives a digestible summary of the Turing Test (1992, 105). The Loebner Prize Competition, in which computer programs undergo a version of the Turing Test, has a Web site that documents transcripts of the "conversations" (Powers 1998). No program has yet passed the test, but the prize is awarded for the best attempt.

5. This chapter is informed by the research work of Ele Carpenter (2008), who compared systems and vocabularies of participatory practice across politicized socially engaged art and politicized new media art. Others from the political realm who have usefully differentiated kinds of political participation and systems of democracy include Chantal Mouffe (Miessen and Mouffe 2007) and tactical media groups such as the Institute of Network Cultures.

6. Because the term *collaboration* is more usually applied to relationships of production rather than to relationships between artwork and audience, issues for collaborative production are dealt with in this book in chapter 9 on other modes of curating and chapter 10 on artist-led and collaborative modes.

7. The term *socially engaged art* is used here as a rough approximation of all the terms listed. The terms *art in the public interest* and *new genre public art* come from Arlene Raven's 1989 and Suzanne Lacy's 1995 book, respectively. The term *socially engaged art* shares with *interactive art* the problem of being used as a catchall term because it is often stated vaguely that "surely all art is socially engaged/interactive in some way."

8. Particularly useful links between systems are made in Brickwood et al. 2007; Carpenter 2008; Lovink 2005, 2007; Paul 2005a; and Skrebowski 2006.

9. Rirkrit Tiravanija's artwork often involves creating spaces intended for audiences to eat, socialize, and interact with each other—for example, his fully functioning replica of his New York apartment

in the Serpentine Gallery in London in 2005. Tiravanija uses languages of participation that may be familiar to new media interaction: for example, he acts as a "host" and has created "platforms" for interaction between people (Nesbit, Obrist, and Tiravanija 2006). This role is arguably similar to the participatory strategies of new media artists such as Rafael Lozano-Hemmer, who has used the phrase *relational architecture* to describe his participatory approach (Lovink 2000). The relationship between contemporary art and new media art understandings of interaction and participation is further explored in Graham (forthcoming b).

10. However, the alternative artists cited, such as Thomas Hirschhorn, present a traditionally confrontational political approach to art institutions rather than offering any different approach to audience participation. As Claire Bishop comments, "Beyond occasional references to the tendency of [Hirschhorn's] work to get vandalized or looted when situated outside the gallery, the role of the viewer is rarely addressed in writing on his art" (2004, 59; see also Hirschhorn 2004). Bishop's book *Participation* (2006a) traces a history via the active readers of semiotics and the active audiences of performance and conceptual art, but stops short at the levels of audience participation that might involve creative input.

11. One particular thread of interest in participatory systems comes from architecture and design rather than art: in their recent book *Did Someone Say Participate? An Atlas of Spatial Practice* (2006), Markus Miessen and Shumon Basar range very widely across globalization, site specificity, and the connectivity of new media from a background broadly in architecture and new models of public consultation for design projects.

12. Curator Mick Wilson (2007) has also used a critical vocabulary of the symmetricality of conversation when discussing public art. Several theorists, including Grant Kester and Wilson, use Mikhail Bakhtin's concept of "dialogical" systems, although Bakhtin used the term in a much more technical sense concerning the development of language (Graham 2004b).

13. In her doctoral thesis, Ele Carpenter (2008) maps the parallels in concepts between politicized new media art and socially engaged art, and has noted the different vocabularies of similar systems or ways of working. For example, the people whom socially engaged art might call "participants," new media art might call "a community of users." She also identifies where there are differences in intent and process—for example, between open source and open systems, between electronic civil disobedience and hacktivism, and between tactical and strategic approaches.

14. Open source software is usually free, but sometimes there is a nominal charge, so there is both a production system and an economic system involved. The acronym FLOSS is used to encompass both systems. Felix Stalder (2006, 2008a, 2008b) offers accessible and practical comments concerning open source systems in relation to art. Dominic Smith's doctoral research concerns comparisons between open source and collaborative art production, and he led a theme on the CRUMB discussion list in April 2008 on the subject.

15. Allucquére Rosanne Stone (1995) has described examples of the behavior of certain computer companies who give employees minutes to clear their desks and be escorted off the premises should their services no longer be required. As Alex Galloway outlines, software companies have co-opted the rhetoric of activist collaboration to glamorize the vision of an "ad-hocracy" of fluid (disposable) working groups who act like hackers in order to make software and test it for security (Galloway and RSG 2002).

16. Theorists who have related the narcissistic feedback and reflecting qualities of video (Krauss 1978) to more recent interactive technologies include Margaret Morse (1998, 171), and Ann-Sargent Wooster (1991). Concerning the pleasures of "control" for new media in particular, artists David Rokeby (1995) and Grahame Weinbren (1995) offer illuminating insights.

17. Even before the telegraph, the new railway lines were promising in a poem in the *Illustrated London News* to "Link town to town; / unite with iron bands, / The long estranged and oft embattled lands" (in Penny 1995, 62).

18. These exchanges happened at the "Terminal Futures" conference in London (Fuller 1994). This debate has continued and can be seen running through interviews with Natalie Bookchin and Gregory Sholette (Carpenter 2004a; Graham 2001a). In 2005, Geert Lovink was still acknowledging that there is a distance between connective technologies and actually communities: "Organised networks should be read as a proposal, aimed to replace the problematic term 'virtual community'" (19).

19. Those researching the usability of such tools for commercial or educational applications often use the connective technologies in addition to, rather than as a replacement for, face-to-face communication. These tools have been increasingly examined recently in the context of art production and social networks by, for example, Warren Sack (2005) and his work on "very large-scale conversations." Sara Diamond (2004a, 2004b), in her search for an aesthetics of collaboration, has brought together usability researchers and artists, and identified the importance of conflict and flow within collaboration. She has also warned that the products of collaboration may at some stage become impenetrable for those viewing from the outside, which brings up issues regarding audience, explored later in this chapter and in chapter 7. The findings of research at the Banff New Media Insitute are further discussed in chapter 9 on labs and chapter 10 on collaborative practices.

20. Scientists have used artificial life software to try to model future changes in systems, but artificial life is not the same as artificial intelligence, as outlined in the definition of interactivity in this chapter. As part of the "Interact or Die" seminar, Mitchell Whitelaw described four subcategories of interactive systems that use evolving, generative, or artificial life software—categories that differentiate where software might be reacting to environmental stimuli or to people, and where people might be interacting with each other (DEAF07 2007).

21. The headlines included "Visitors Play Role in Funfair Art," "Assault Course at Tate Gallery," and "The Have-a-Go Show" (see Dietz 2004a). In May 2009, Robert Morris' exhibition was re-created at Tate Modern in London.

22. The contemporary art press and critical coverage of participative artworks have several layers of value systems to deal with. First, the lack of objecthood and the quality of participant's work is subjected to what Jack Burnham calls "craft-fetishism" (1968b, 32). Second, critical response often concerns personal-political tastes; for example, *Hole in Space* (1980), a satellite video linkup between public spaces in two cities, was reported as "over-democratized bedlam" (Youngblood 1999, 363). Third, as Suzy Gablik comments, layers of subjectivity and objectivity need to be unpicked: "there is no denying that the art world subtly disapproves of artists who choose interaction as their medium, rather than the disembodied eye" (1995, 85). If bodily interaction is involved, then the criticism often contains value judgments reflecting a Cartesian mind/body split, leading to a categorization of interaction as a shallow kind of play or hands-on fun suitable for children. The press coverage of both socially engaged art and interactive art therefore has to deal with the cultural and political meaning of interaction, participation, and collaboration, as well as with the content and media of

the artwork itself. Both socially engaged art and new media artwork outside or on the fringes of arts institutions tend to suffer from poor documentation and poor criticism, which militate against the development of an aesthetics of interaction, although some efforts made toward this development are outlined in this chapter.

23. Manovich reports that a surprisingly low percentage of those who use "user-generated content" Web sites such as *Wikipedia* and YouTube actually participate by uploading content: 0.5 to 1.5 percent (2008, 68).

24. Studies do exist of users' interactions with computers, but the products examined are usually educational or commercial software. We discuss some of these studies more fully in chapter 7 on interpretation and audience. Concerning reactive artworks in relation to branching choices, narrative, and pleasure, Martin Rieser and Andrea Zapp's book *New Screen Media* (2001) is an excellent collection.

25. In chapter 4 on time, we describe some examples of media lounges, including the Media Centre in Huddersfield and the New Museum in New York. In chapter 3 on space, we explore installation options for Net art in galleries.

26. This exhibition is outlined as a case study in Graham 2008.

27. The openFrameworks Web site, for example, is a venue not only for showcasing artworks made with that open source software, but also for sharing useful bits of code and illuminating the process of the programming. See http://www.openframeworks.cc.

28. We discuss the kinds of information produced from formal research on audience interaction and behavior more fully in chapter 7.

29. In criticizing art participative projects such as those by Rirkrit Tiravanija, Hal Foster points out that in the 1980s the reasons for providing art platforms for discussion centered around political issues such as AIDS activism, whereas "today, simply getting together sometimes seems to be enough. Here we might not be too far from an art-world version of 'flash mobs'—of 'people meeting people,' in Tiravanija's words, as an end in itself. This is where I side with Sartre on a bad day: often in galleries and museums, hell is other people"(2006, 194).

II Rethinking Curating—Contexts, Practices, and Processes

In one memorable instance, the speaker's identification with the notion of the curator as gatekeeper was so pronounced that he likened his role, seemingly quite comfortably, with that of a "cop." At the same public event, and at the other extreme, another curator made a claim for an intense and poetic subjectivism, extending, in his words, "from the fundamental polyschizophrenia of the curator figure to his internal laceration." I have become quite familiar with the idea of the curator as a kind of pioneer-discoverer figure, charting out new territory on the aesthetic or cultural frontier. And . . . we have been acquainted with the model of the curator-friend. We have also already discussed the idea of the curator as a "transgressive" figure—or facilitator of the artist-transgressor. . . . I have heard moving appeals to the role of the curator as guardian of a cultural ethics. And many curators . . . see their work as a form of cultural activism. . . . Finally, no such list could be closed without the idea of the curator as artist.

So, in finding myself on a panel on methodology, I find myself confronting a certain gap between the status of the curator as (inevitably) a desiring subject, and any notion of method as an orderly and logical curatorial procedure.
—Renee Baert, "Provisional Practices," 1996

In part II of the book, we move toward a more detailed investigation of curatorial practice: how curators account for the behaviors of works of new media art and what logical curatorial procedures they might undertake in response to it. In particular, we're interested in metaphors and modes of curating engendered by the characteristics of the work that present the greatest opportunities for rethinking what a curator does. We have seen how new media art crosses boundaries within the history of art and beyond the field of art—merging seemingly disparate intents within the avant-garde, conceptual art, video art, and socially engaged practice. Matthew Fuller has acknowledged that although other histories such as conceptual art can help in understanding new media art, perhaps the best response to this understanding is to "not recapitulate stylistics, but, make art" (2005). Similarly, it can be argued that if histories help curators to understand new media art, then the best response is not to recapitulate old ways of working, but to make new ways of production and distribution that best fit the art. As such, we have also noted how new media art is akin to other hybrid forms of art that challenge the spaces of art's exhibition as well as the level of engagement it demands from its audience. Now we see how new media art forces a crossing of boundaries beyond art history and within curatorial practice.

In chapter 7, we look toward the field of education and new media's use within interpretational frameworks for art; technology sits comfortably here, but confuses curators about whether it is art or not. It is often through a museum's educational initiatives that new media art first gets its foothold, sometimes by inviting greater participation from the audience. However, within the museum there are departments, and in chapter 8 we look at how new media challenges those pragmatic and practical divisions (both curatorial, as in sculpture or design, and operational, as in archiving or marketing). The landscape of curating contemporary art of course includes more than the museum, and in this second half of the book we query the suitability of those other kinds of spaces and places for new media art. For instance, in chapter 9, we look at festivals as sites of regular, periodic, yet also specialist exhibitions-events and consider if they are a good place to show new media art. We also investigate the "where and when" of exhibiting (as well as producing, documenting, and collecting) new media art, asking the difficult questions about what stage of development the work is at: Is it in emergence? Is it complete? Should it be in a museum at all?

In chapters 9 and 10, we focus on how new media art forces the curator to cross the boundaries between the possible roles a curator may take. Tied to all of this is a consideration of the contexts for the audience in encountering the work of art—whether an exhibition, a workshop, or a research environment. In chapter 10, we ask whether in fact the audience is the artist (making the work) or perhaps the curator (selecting the work) or both.

In each of the chapters of this second half, we return to the work of art as the raison d'être for curating and use specific examples of exhibitions to question the curatorial process practically and theoretically. Here we look at the curator's position and role, the types of exhibition practice he or she might engage in, and the mode of curating he or she might adopt. Every metaphor or methodology for the practice of curating, like those Renee Baert enumerates, has caveats and constraints, which might be made more or less stringent by the artwork's behaviors.

Curating in Context—In and Out of the Institution

We must ask ourselves, can we create structures that are both robust and transparent? Can we combine continuity—so necessary to build relationships with audiences, other institutions, artists—with the flexibility to embrace new modes of artistic production and reception? To be relevant in the twenty-first century, the gallery must be at once a permeable web, a black box, a white cube, a temple, a laboratory, a situation. It must take the form of a creative partnership, between a curator and the producer, object, or idea of art.
—Iwona Blaswick, "Temple / White Cube / Laboratory," 2007

The field of curating has changed from one of specialism—expert knowledge about a specific type of art or time period—to general knowledge of the process of making exhi-

bitions (Teresa Gleadowe in Wade 2000; Marincola 2002). The practical considerations affecting how a curator might approach the realization of an exhibition of new media art are often the result of the type of institution the curator is working within (from its size to its collection policy). It bears recalling that there are as many kinds of museums as there are kinds of curators.

Chapter 8 addresses specifically the curating of new media art in traditional mixed-media art museums, whereas later chapters show how new media art also has a history in other types of cultural institutions, from science and technology museums to industry trade shows and conferences. Many of the examples discussed and the problems and challenges they have raised can in fact suggest that, overall, the art museum is the wrong paradigm (or operating system, as Armin Medosch [2002a] has commented) for new media art. Technology-driven art projects might be better suited to the conditions available in a dedicated media museum or science museum—both of which may be familiar with questions of audience interactivity and used to "plugging things in," unlike the white cube art museum. The exhibition constraints of media-specific, nonart museums (discussed in chapter 9) are clearly very different—they attract different audiences (those who go to museums to learn versus those who go to contemplate)—yet the curatorial skills needed to commission and exhibit new media art might well be the same for both them and art museums.

Media-specific museums are not always the right operating system, either, and a case-by-case approach is needed. Such museums are often limited in their mandates and in the types of funding for which their projects are eligible (Morris 2001). Furthermore, audiences and their expectations are very different at interactive "visitor-attraction" museums from the audiences in art galleries and their expectations. Last, but perhaps most important, although the spaces and technological capabilities of a media-specific museum might be better suited for showing new media art, the risk is that much can be lost on the side of contextualizing new media art projects within the field of art practice. As Hannah Redler, curator of arts programs at London's Science Museum, has commented of her experience, "There was no problem in the Science Museum people's minds that all of this was art. The only problem that we had there was that it wasn't science" (in Cook, Graham, and Martin 2002, 77).

In the museum and gallery context, whether contemporary art or otherwise, curatorial roles are apparent: in the first, the curator works from within the institution ("embedded"); in the second, the curator works at arm's length from but is affiliated with the institution ("adjunct"). A possible third role is that of the independent or freelance curator.[1] These roles speak to the practicalities of curating as a practice and are detailed in this section.

The "Embedded" Curator

Thus the curator is at the interface of the museum as an institution and the public as consumers.
—Lawrence Alloway, "The Great Curatorial Dim-Out," 1996

A curator working from within a museum is usually a member of the collections or exhibitions program team or both.[2] The primary influence on their curatorial work is the structure and defining limitations of the institution itself—its direction, architecture, collection. For instance, in a mixed-media museum environment, the curator has to be a connoisseur of the objects in the museum's collection, and those which might be accessioned into the collection; he or she has to know the particular art histories told through those objects, so that the histories can be communicated to the public when he or she puts those works on display. This means that the curator in question spends the majority of his or her time within that museum structure judging works of art. As a result, when that curator seeks to organize a new show, his or her thinking and scope are in part delimited by this end goal of interpretation: What is this exhibition's relationship to current issues? Does it present new and original knowledge or show critical examination of contemporary practices? These questions are combined with a series of practical questions: What space is available, when, and for how long? How much of a budget has been allocated? What is the project's relationship to the rest of the program? What is the project's relationship to the collection and to the works on view in the other (collections) galleries?

The result of beginning from any sort of interpretative standpoint in relation to art is generally an exhibition that either looks inward at the work's own medium (what could be called a "formalist approach to curating") or looks beyond the work to its place in a biographical, historic, or thematic story (the socially and politically engaged approach to curating).[3] On many levels, the exhibition is itself like a temporary collection, representing a moment in time in terms of a specificity of art production. The embedded role suggests a curatorial desire to arrest artistic practice temporarily in order to better examine its results in controlled conditions.

From the examples discussed in this book, curators who can be seen as working in the embedded role include Steve Dietz at the Walker Art Center (in particular his curatorial approach to the exhibition *Art Entertainment Network,* discussed in chapter 3) or Benjamin Weil at SFMOMA and his curating of the exhibition *010101* (discussed more fully in chapter 8). The embedded role of curatorial practice is also evident, however, in noncollecting institutional contexts—for instance, where curators are working within organizations with fixed resources, such as media labs (discussed in chapter 4 in reference to the Huddersfield Media Centre, but also in chapter 9). It is often access to stable resources, the chance to work within a team, and a regular exhibition schedule that keeps curators embedded in organizations, as opposed to what might be seen as a less secure way of working—that of the adjunct curator.

The "Adjunct" Curator

Bringing in guest curators . . . is often unsatisfactory for both the institution and the guest curator because the curator lands there, he is there a few weeks, the artists fly in and then the whole thing is gone. I'm interested in the in-between of these two so that there are regular collaborations with curators and these curators are there part-time but they also work on other things and there is continuity. . . . [Harald] Szeeman had his office at the Kunsthaus in Zurich. He had no office hours and they didn't hire him full time; they just hired him to do one or two shows a year and he brought them some energy.
—Hans Ulrich Obrist, "Kraftwerk, Time Storage, Laboratory," in Wade 2000

Increasing numbers of contemporary art curators work freelance, but in conjunction with institutions. When mixed-media art institutions are looking for curators to work with, they might seek expertise on a project-by-project basis depending on the nature of the work to be exhibited, as Beryl Graham did in relation to the exhibition *Serious Games* (discussed in chapter 5). Museums have adopted this outsourced way of working with new media art more often than with other art forms.[4] While "embedded" museum curators often have their attention focused on past art production in the form of a collection, "adjunct" curators are able to take the time needed to focus on the contemporary culture that surrounds them, and most often choose to support avant-garde or emergent practice. In order to best support art, they commission new work, as we saw with the example of Harwood@Mongrel's work *Uncomfortable Proximity* at the Tate (chapter 2). In comparison to the embedded role, the adjunct role suggests a curatorial desire to keep pace with and continue to push artistic practice, primarily facilitating the ongoing process of the work's development.

Curator Christiane Paul is a good example of a curator working in an adjunct role in relation to, in her case, the Whitney Museum of American Art in New York. She admits to working against the museum's institutional constraints—from the practical consideration of its space allocations and timetables of exhibition to the more theoretical considerations of its mandate to show only the work of American artists. The results of her curating in the adjunct role have tended to be thematic yet very tightly focused exhibitions in which artists are collaborators in the process of preparing iterations or versions of their work for the particular exhibition structure, as was the case with *Data Dynamics* (2001). Drawing on the long history of institutional critique (chapter 2), artists have also taken on this adjunct role in their own curatorial projects—as seen in the example of Vuk Ćosić's projects (chapter 9). This adjunct role suggests a greater scope for curators to posit their own politics and tastes beyond that of the institution with which they are working. The adjunct role thus allows for a greater degree of risk taking by the curator.[5]

The "Independent" Curator

[Eighteen] months ago, nothing seemed so current, so desirable, so sexy, and yet so ephemeral and dubious, as being an "independent curator." So ephemeral, in fact, that all the hot air has probably

blown away by now, after debates about the mushrooming role of curators puffed up seminars and the pages of art magazines over the last couple of years like so many drunken air smooches.
—Craig Burnett, "The Invisible Curator," 2005

For those curators who find themselves caught between the desire to be embedded in an institution with the benefit of having real fixed resources (space, budgets, marketing teams) behind them, and the real need to be adjunct from the institution in order to gleefully trip after the interesting work that doesn't fit, it is worth considering other forms of independence which allow curators to sit between the positions of "embedded or adjunct," such as the freelancer, often invited as a guest curator, but more often self-identified as the independent curator, or more recently, "co-dependent" (O'Neill 2005). Much has been written—not all of it good—about the plight of the independent curator and about how institutionally bound curators have tried to emulate their style, becoming the authors and stars of the show above and beyond the artists' work (Burnett 2005, 4). Paul O'Neill warns that "independent curators working without an institutional post can be said to have co-dependency issues. Replacing the term independent with co-dependent merely acknowledges the impossibility of curating beyond institutional negotiation and highlights the dysfunctional aspect of these relationships that are often one-sided and emotionally destructive" (2005, 7). As he points out, truly independent curating is somewhat of an impossibility. Museums have adopted tactics that attempt to balance new energy from the world outside the institution with continuity of programming, but this attempt is made only in the short term (and not regularly, as in the adjunct role described above). For instance, art historian Julian Stallabrass, who curated the exhibition *Art and Money Online* (2001) at Tate Britain, was a fixed-term visiting curator from academia, and the Tate has rarely shown interactive new media art in a gallery space since then. The independent or freelance curator role shares some disadvantages with that of the adjunct curator role in terms of the place of the curator within the institution's power structure. For example, Christiane Paul is an "adjunct" curator at the Whitney, which implies a continuity for the institution that working with freelancers wouldn't. However, like a freelancer, her adjunct status does not guarantee a desk, a wage, or a budget for programming. Iliyana Nedkova has used the term *outsourced labor* to point out how arts institutions may use freelancers for short-term policies (2001). The roving cartel of festival curators (as hinted at in chapter 9) is another example of the ambivalence of the mobile modus operandi of freelancing.

At the 2005 seminar "Curating: Can Be Learned, but Can It Be Taught?" at the Northern Gallery for Contemporary Art in Sunderland, United Kingdom, Barnaby Drabble and others teased out the contradictions of the independent curator, where the pressures of "careerism" mean that the curatorial ego is often much more dominant than it is in institutional curating. Paul O'Neill comments that the upshot of this focus on and attention to the independent curator is that exhibitions become more self-reflexive:

Self-reflexivity within curatorial practice suggests that the ever-changing roles of curator and critic are ideologically, historically and culturally produced. It is fast becoming the most over-used populist buzzword linking the two activities. Exhibition curating has become self-reflexive about self-reflexivity itself. We are becoming so self-reflexive that exhibitions often end up as nothing more or less than art exhibition curated by curators curating curators, curating artist[s], curating artworks, curating exhibitions (all of which can be rearranged in the order of your choosing). (2005, 9)

The identity of the freelance or "independent" curator is a growing default identity for young curators; being an "independent" curator certainly offers an opportunity to act more quickly. Within new media, the benefit of the freelance new media art curator is the range of organizations that are open to collaboration, from art museums, to science and technology museums, to media-specific festivals. This positioning is often a result of the independent curator's voracious and by necessity wide-ranging interests.[6] But without a space of one's own it is hard to be truly and politically independent:

Maybe describing independence is as simple as saying that as long as producers are totally self-determined culturally and any funders they have keep their hands off their content, they qualify? It's doubtful: aside from sticky issues of behaviour, psychology and free will, this idea begs questions of differentiation, constituency, and global interdependency. If an independent cultural producer is producing cultural objects, social processes, or informational architectures roughly equivalent to those produced by a large corporate or institutional player, should their economic self-sufficiency still be fetishised? (van Mourik Broekman 2005, 5)

Models and Modes—The Practice of Curating

Let's forget this rigid defining of roles and this myriad of hierarchies and consider the art that is involved in the vital cultural debates of the time (for it is that which interests me), let's recognise that this process involves the active making of meaning, and let's accept that the exhibition has become a meta-layer in that meaning making process. If this is the case let's recognise that curating is in relation to art-production and art-theory a recognisable critical discipline, and in unison with these two a suitable definition of the term "contemporary art."
—Barnaby Drabble, "Fw: March theme," 2003

As we move into the second half of the book, it seems as though we have taken as a given the role of the institution (or of the curator in relation to the institution) in defining curatorial practice, but we could just as easily have approached the topic of curatorial practice from the other angle—the curator's output, which is predominantly but not always the exhibition. Exhibitions might take the form of thematic group shows or monographic solo shows or more simply exhibitions on their own terms with their own intrinsic narratives and constraints—the one-off show, the blockbuster. Museum-based exhibitions are a particular form of art legitimation, tending not to support emergence of new art forms as much as to consolidate a history. However, museums (as we see in chapter 8) also seek to sustain art through other activities such as collection and educational programs.

And yet when it comes to new media art, the curatorial approach Dietz adopted for the exhibition *Art Entertainment Network* (chapter 3), for example, is in some ways at odds with the traditional museum structure. Museums prefer more direct and authoritative forms of legitimation (a single curator selecting individual works by individual artists) than those developed through a highly variable filtering, collaborative process. The same might be said for exhibitions that take place outside the museum, such as the festival-exhibition or "the platform" (discussed in chapter 8). We have seen examples of exhibitions that seem to suggest that curators have tried to maintain their autonomy from the collaborative characteristic of new media art by applying embedded models of curating to (specifically, but not only) online art practice, most problematically in commissioning new online works as though they were static objects that can be separated from the context of the Internet, as was the case with Mongrel's intervention at the Tate or Sollfrank's project *Female Extension* (see chapter 2). With curators unsure whether to investigate the medium of the work when its objecthood is so clearly intangible (it is on the Web) or to investigate its critical engagement with the world (the Internet, activism, commercialism, design, etc.), but only from within the traditional white cube gallery, it's no wonder that most problems in curating new media in the institution arise here. Because the characteristics and hence the aesthetics of new media art are constantly evolving and being redefined, curators need an adaptable framework in which to investigate and exhibit new media art that allows for both the aesthetic and the practical consideration of not only those characteristics but also the behaviors of new media art to be evident.

Models of Exhibitions—Iterative, Modular, Distributed

Many exhibitions have moved beyond the predominantly illustrative, single authored narrative; indeed exhibitions are not the only outcome of curatorial ideas. Curating is a discipline using and adopting inherited codes and rules of behaviour. Institutional curating will coexist alongside co-dependent curating and, having learned from artists, curators will adapt forms of artistic practice for as long as artists continue to take on the role of curator and curators continue to produce semi-autonomous collaborations with artists. Why is it so difficult?
—Paul O'Neill, "The Co-dependent Curator," 2005

There is a wide variety of types of exhibition (from the monographic to the group show), and it is just as likely that one can identify a number of types of exhibition practice available to curators to match art (content) to space and place (context)—from commissioning new work for temporary or permanent installations to organizing one-off or recurring events. In efforts to be more specific in defining forms of curatorial practice that "work" for new media art, Sarah Cook (2008) has theorized and described three types of exhibitions by way of analogy: the exhibition as software program or data flow, the exhibition as trade show, and the exhibition as broadcast. These types might be considered more experimental forms of exhibition making and certainly aren't the only ones out there, but they fit well in response to the fluid, collaborative, emergent nature of new media art.

We come back to these types of exhibition practice in the following chapters and break down the distinctions between them further still.

It has been suggested that beyond the networked field of new media art, exhibitions can function as emulators (for other types of authentic experiences, for other landscapes or cultures, for phenomenon on a microcosmic scale) because of the representational nature of art practice (Seijdel 1999). Exhibitions that might not have the finished product of art at their center, but are more interested in the process of how art comes to be and knowledge is constructed, might be exercises (in collaboration, for instance) or might be experiments, as was the case with the exhibition *Les Immatériaux* discussed in chapter 2.[7] "For his part, Mr. [Okwui] Enwezor says the duty of a curator is to pay close attention to the world that gives birth to art, rather than to try to predict its next trend. 'Given the complexity of deep entanglements with which we live, it makes no sense to predict,' he said. 'I see the exhibition as more of a diagnosis than a prognosis'" (Dietz 2002a). In keeping with the idea of exhibition as diagnosis or as a speculative and changeable theory on a current state of affairs in contemporary art, Cook (2008) has also theorized some early models of curatorial practice aligned to the various types of exhibitions that exist: the iterative, the modular, and the distributed.

The iterative model is based on the work of Kathleen Pirrie Adams (2000) as "embedded" curator at Interaccess Gallery in Toronto, supporting research into art and technology.[8] It describes how an exhibition might change drastically from one venue to another each time it is installed, essentially growing new shows around successful works (like a sourdough bread recipe, wherein a first batch of ingredients forms the basis for subsequent batches).

The modular model is based on the work of freelance and "adjunct" curators such as Nina Czegledy and Iliyana Nedkova, in particular on how they have supported workshop-based events simultaneously in countries across the world (Czegledy 2002, 113). It describes how an exhibition might be just one incarnation of a multistrand or multilevel interpretational event structure (a platform) with "guides on the side" or local project managers at each location (Nedkova in Cook, Graham, and Martin 2002, 103). With the modular model, it is possible to scale back or drop discrete elements of a project without drastically affecting its overall coherence.

The distributed model is based on Net- or Web-based art practices and describes how formal exhibitions might not be the end result at all, but instead "exhibitions" in which independent curators create their own infrastructure—agencies—or squat existing platforms to support their practice of circulating and distributing art, whether into museums, galleries, or any other kind of space. Rob Labossiere's attempt to curate a show on the social networking site Facebook, *Blogumenta* (2007), is such an example.

These models recur in the following chapters, particularly in how curators working with new media art might turn toward structures that allow for the joint production as much as the distribution of art.

Modes of Practice—"Curator as . . ."

> In this time of mega-exhibitions the artist often doubles as the curator. "I am the head of a team, a coach, a producer, an organiser, a representative, a cheerleader, a host of the party, a captain of the boat," Orozco says, "in short, an activist, an activator, an incubator."
> —Hal Foster, "Chat Rooms // 2004," 2006

In March 2003, CRUMB hosted a discussion about curatorial models. What resulted was at first a great deal of discussion around the metaphors for the curatorial role, which can be added to Renee Baert's list given at the start of this introduction:

Curator as producer
Curator as collaborator
Curator as champion of objects and/or interactivity
Curator as outside the dictionary
Curator as curate
Curator as quoter of experts (artists)
Curator as brain surgeon (decisive) or politician (democratic)
Curator as communicator
Curator as a cooker of "raw" art
Curator as outsourcer/freelancer/critic of society/squatter/outsider to "the formal"
Curator as (low-paid) crony cultural imperialist
(in Graham 2003b)

In subsequent conferences, the list of possible metaphors has grown further to include "curators as theoretical beings" (Drabble 2005), curator as keeper (Gere 2006c), curator as conservator (Pierre-Yves Desaive in Cook 2006b), and curator as curator of people (McDonald Crowley 2006).

Why this fetish about the title "curator"? Why have we invested so much in it when it's institutionally no more important than being a registrar or a conservator, not that any of these jobs is unimportant. Of course none of them are as important as the role of artist, upon whose shoulders the art world is carried. :}

So, really, what's needed with regards to n*w m*d*a, is a technologist and perhaps an historian and a critic. Perhaps these three roles can exist as one person? (Murphy 2003).

What we have realized is that there are not really any models of curatorial practice, but rather "modes" in which curators function—many of which are collaborative.

Given both the theoretical uncertainties curators find themselves faced with concerning their own role in relation to new media art and the practical uncertainties in relation to the institution (finding the right space and getting the right technology), models of practice (iterative, modular, distributive) are useful, but understanding the modes is essential. It is these modes, particularly when it comes to collaboration, that best "fit" or mirror the processes of new media art. Therefore, part II of the book addresses the pros and cons of some of those "modes"—from working in a museum to creating platforms for engagements to curating a festival or running a lab to adopting modes from the practice of artists—all for both the production and the distribution of new media art.

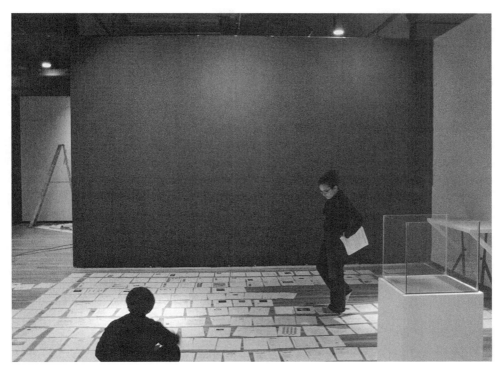

Figure 6.1
Installing the exhibition *The Art Formerly Known as New Media* and deciding on the contents of the chalkboard for the display of the work of irational. Pictured are "curator-as-filter" Sarah Cook and exhibition assistant Katja Canini. Photograph by Steve Dietz.

All the while, we are focused on how the characteristics of new media art force the curator to cross boundaries between roles and between departments within an institution. In chapter 7 on interpretation and education, it would seem that the default zone is still the museum, but new media art suggests other event-oriented structures for its inclusion. Chapter 8 on museums shows how new media art encourages cross-departmental collaboration. In chapters 9 and 10, which concern other modes of curating and examples of artist-led practice, new media art is seen as a more fluid part of a landscape. A distinct change in approach is evident, from a focus on the object of art to the landscape of curating outside the object.

Summary: Curating Now—Distributed Processes?

My "exhibition" was a kind of round robin between artists: Sol [LeWitt], Larry Weiner, On Kawara, Robert Barry, Steve Kaltenbach, Doug Huebler, among them, not in that order. Each one was asked to pass on an "instruction" to the next . . .

So it was almost like a group show as a chain reaction.
Yes.
—Lucy Lippard, interview by Hans Ulrich Obrist, 2008

How does a mode of curatorial practice match the structure of new media art? If we take the behavior of new media art as distributed, then we can suggest that the distributed model of exhibition practice (the touring show, the iterative way of developing exhibitions in different places in linear time) might seem the most appropriate way of working. Indeed, the world of contemporary art has many examples of curating in this way, not least the conceptual art exhibitions that Lucy Lippard curated in the 1960s and 1970s (other examples are discussed in relation to platforms and festivals in chapter 9). But what is the role of the curator within such a framework, and what mode does he or she adopt?

Curator as producer or project manager is one suggestion we have noted. Yet early ideas of distributive models of curatorial practice have been explicitly about the approach to the artwork; contemporary art has been well served for more than twenty years by office-based arts agencies, publishing initiatives, festivals, and the like. In chapter 9, we also distinguish further between the production and distribution of art with reference to these modes—looking at curators as editors and curators as filterers. However, current ideas of "distributed curating" tend more toward the shape of networks as described by computing culture—where a curator might be a "node" and what is distributed is not just the art, but the process of curating itself. This is the subject of the penultimate chapter of the book, on artist-led initiatives, which asks whether the most hybrid, adjunct, or independent mode a curator can work in is the most self-effacing: to engage in a distributed system where there is no curator at all.

Notes

1. These two roles were first theorized in Sarah Cook's Ph.D. dissertation, "The Search for a Third Way of Curating New Media Art: Balancing Content and Context in and out of the Institution" (2004b).

2. Program curators are often responsible for more than exhibitions and organize activities such as residencies, performances, and screenings.

3. The resulting exhibition might therefore include works from the collection or works that can be accessioned into the collection (making a commitment to exhibit a work is often a way for the museum to acquire it).

4. In fact, all the historical exhibitions mentioned in the first half of this book—Jean-Francois Lyotard's *Les Immatériaux* at the Centre Pompidou (1984), Jasia Reichardt's *Cybernetic Serendipity* at the ICA (1968), Jack Burnham's *Software* at the Jewish Museum (1970)—are evidence of the adjunct mode of curating.

5. The risk taking can't be separated from the financial precariousness of working as a curator in affiliation with or independent from a museum, discussed later in this section.

6. The development of independent curating closely maps the rise of networked art and so in many cases is a more appropriate model to work within when curating new media—as discussed in chapter 10.

7. An example of a process-oriented exhibition, suggested by curator Ronald Van de Sompel, is *This Is the Show and the Show Is Many Things* (Ghent, 1994–1995), where all the boundaries of exhibition practice were "blurred": the unlabeled works were permanently moved, removed, and reinstalled; the difference between "storage," "studio," and "exhibition" was introduced into the exhibition space itself; process-based works changed on a daily basis during the exhibition period; works were based on improvised collaboration between artists or with the audience; there were works with functional aspects, such as the café; there were lectures, talks, and performances in the exhibition space.

8. The origins of Interaccess are in a gallery founded in 1982 by a group of artists, architects, and people who worked in the media. The Artculture Resource Centre (ARC) was based around a media art production facility that provided access to equipment and training for artists. It quickly developed a reputation for showing mostly video art, and in 1987 it launched the Matrix, a network for free dial-up access and gateways for online communities to engage with the emerging Internet. In 1995, it opened Toronto's then only gallery venue for the presentation of electronic media artworks, which later became the Interaccess Electronic Media Arts Center. See http://www.interaccess.org.

7 On Interpretation, on Display, on Audience

You used the words "marketing" and "education." MoMA has always been curatorially driven, and when we did our website it was curatorially driven. It's not market driven . . . although we do think a lot about our viewers, and always try to provide a context so that neophytes have a hook and feel comfortable about their own interpretations.
—Barbara London, in Susan Hiller and Sarah Martin, *The Producers: Contemporary Curators in Conversation,* 2002

If the role of the curator is changing in response to a range of contemporary arts, then it can be argued that the changes in response to new media in particular center around recurring issues of interpretation[1] and audience. In the art world, the new media of Web sites, hand-held media devices, podcasts, and accessible databases are much more frequently encountered as interpretative media than as art media. The institutional Web site, the audio guide to the exhibition, and the online collection on a computer kiosk in the corner are all dominant forms of use of the media, and other forms need to be explained as differing from them. Hence, Barbara London feels obliged to explain the curatorial intent of the MoMA Web site as a default from the more usual intent of marketing and education. She is also, however, keen to stress the importance of education or context for any relatively recent media so that neophytes may have tools to grasp the new.

This chapter attempts to clarify areas of confusion between interpretational media and art media. It is notable, however, that this confusion (which is a particular characteristic of new media) is sometimes of benefit to new media art if such art can find a way into institutions "under the radar" via education departments or, to be more accurate, via departments that echo the new media blur between marketing, education, and curating, as illustrated here by the example of Tate Media. Nevertheless, such hybrid departments can put new media art in an ambivalent position within the institution. As Barbara London says, "Unfortunately, in all North American museums, education is the low 'person' on the totem pole" (in Hiller and Martin 2002, 126) and is often the first to be thrown overboard in any funding crisis. Outside of institutions, the crossover between curatorial and interpretational roles is much more fluid throughout the contemporary arts and is reflected in the growth of "platforms," or discursive events that evolve from group

discussions. We mention these curatorial modes briefly here and explore them in more detail later.

Interpretation, display, and audience are, of course, contentious issues in curatorial discourse in general, but this chapter outlines how new media characteristically works across those three areas and how the particular behaviors of new media can afford very different relationships among curator, artist, and audience.

Education, Interpretation, and Curating

As an Independent Curator working with an institution it's important to find the right staff who can let things happen in the way you want. This may be easier working with the Education Dept, than the Exhibitions Dept, but again it depends on the individuals and their understanding of the project.
—Ele Carpenter, "Re: Curating a Symposium," 2004b

On seeing a piece of new media technology in a gallery, a member of the public might be justified in assuming that it is some kind of interpretative aid rather than an artwork in itself. In the case of Susan Collins's *Audio Zone* (1994), her artwork used infrared headphones in a gallery space to trigger video projections of images including nipples and lips, while soft voices whispered seductive encouragement to touch. The desk staff who issued the headphones quickly noticed a common misconception in the audience, and the staff had to carefully explain to each person that the headphones were not, in fact, an audio guide to the group exhibition.[2] This confusion is unlikely to happen with respect to other art forms, unless deliberately intended by the artist—for example, in the case of Andrea Fraser's performative *Museum Highlights, a Gallery Talk* (1989), which comprised a fake docent tour of Philadelphia Museum of Art. Some new media artists also see the confusion as productive, but it has to be the artist's choice and depends very much on the context desired for a particular work. However, if the artist does *not* intend the context to be interpretative, then very clear signaling is needed to avoid the dominant cultural meaning. Despite education being low in status, as Barbara London describes, digital tools for the interpretation of art are relatively well researched, have international standards, and benefit from regular, well-attended, well-documented conferences such as the International Conference on Hypermedia and Interactivity in Museums, and Museums and the Web. Because of this dominance, education and marketing departments do, however, sometimes see new media technology as their own property: the curator and artist Skawennati Tricia Fragnito tells of her struggle to get six networked computers into an art gallery to show the Net-based art project *Imagining Indians* (2000), only to be told that the computers should also be used to show the institutional Web site—a situation that would be unlikely to happen in the case of other art forms: "If this was a sculpture, then would you be saying, 'Oh this could double as a coat rack'?—never!" (Fragnito 2001). Interpretation may be well resourced in comparison to new media art, but both

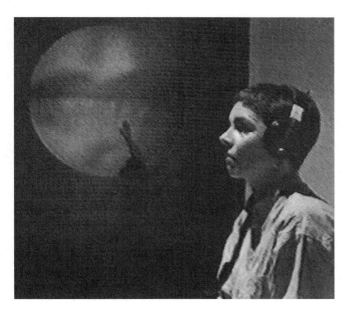

Figure 7.1
Installation view of Susan Collins' *AudioZone* (1994) in the exhibition *V-Topia* at Tramway in Glasgow in 1994. The photograph is a screen grab detail from video by the artist.

fields exist on the margins of art budgets, and it can be difficult to argue for exclusive use of equipment. The margins are expressed in the physical spaces of buildings, too: the lobby, café, or bookstore are all seen as prime interpretation and marketing space, and if new media art is placed there, then the audience has to rewrite the grammar of art buildings in order to understand it *as art.* With respect to the immaterial processes and roles of interpretation and curating, the confusions get more complex, if no less productive.

Those responsible for the interpretation of art have the responsibility of introducing "the new" to varied audiences; within this responsibility, they might be expected to have an understanding of process, collaborative work, participative systems, live events, and educational technologies—all of which can prove useful skills for working with new media art. In some cases, curators take responsibility for the interpretational role; in others, they most definitely do not: "So many curators, even today, and I think it's scandalous, think you can make the show and then just pass it over to the education department to deal with the public" (Peter Jenkinson in Wade 2000, 144). Some university courses on curating deal with interpretation, display, and audience in great detail, whereas some—especially those dealing with contemporary or creative curating rather than museum studies—barely mention these thorny issues.[3] However, for new media art in particular, the blurring of curatorial and educational roles, together with

the convergence of interest in the use of new media technologies, has produced some interesting examples of work across professional boundaries. At the Walker Art Center in Minneapolis, for example, Steve Dietz worked in New Media Initiatives, a department both founded to take advantage of the digital revolution to increase the amount of interpretation made available to the museum's audiences concerning its activities or collection, *and* given curatorial responsibilities. The Tate in the United Kingdom is another example, where the Tate Media departmental staff work in several roles.

Example: Tate Media

Digital Programmes at the Tate, now part of Tate Media, is responsible for both interpretational and art use of the Tate Web site and typifies a certain institutional relationship between curating, interpretation, and marketing. Digital Programmes developed across and between institutional departments. The first Tate Web site was launched in 1998, supported by one part-time web editor who was based in the Communications Department. The Web site soon involved the digitization of the collection and strands from the archive. Unusually for a U.K. arts institution, Tate was an early adopter of the practice of webstreaming interpretation events, instigated by new media artist Honor Harger, whose post title in 1998 was Webcasting Curator in the Interpretation and Education Department of Tate Modern. This role soon developed relationships with both the Exhibition and Education departments to take on the ongoing Net art commissions in 2007, and by 2008 Harger's successor, in the revamped Tate Media, was titled Curator, Intermedia Art.

The first Tate art project involving streaming was *Broadcast* (1999) by Karen Guthrie and Nina Pope, commissioned as part of Tate Modern's preopening program and including events broadcast live in Borough Market in London and a webcast online.[4] In 2000, the first Net artworks to be included on the Tate Web site were commissioned, including Harwood@ Mongrel's *Uncomfortable Proximity*, which copied and manipulated the Tate interpretation site (as described in chapter 2). Bringing in a freelance curator—Matthew Gansallo—raised some characteristic issues for curating Net art in that he found himself negotiating with the marketing department over artists' use of the Web site (Cook 2001d). The third time Net art appeared was at Tate Britain in the exhibition *Art and Money Online* (2001) curated by Julian Stallabrass, whose position was another temporary adjunct research-based post.

By 2001, British Telecom was sponsoring the Web site (in 2003–2006 for around two million pounds), then branded as Tate Online, and by that year the business plan was stating that the Web site should "function as a sixth site for Tate, featuring a distinct and identifiable program, appropriate to the medium" (Rellie 2004). The funding meant that a new team called Digital Programmes was set up, reporting to the director of International and National Programmes. Before becoming the new head of Digital Programmes, Jemima Rellie had an academic background in the social history of art, had been an intern at the ICA in London, and had worked in interactive television, Internet development, and art book publishing. This range of experience reflects the range of the post's responsibilities, which

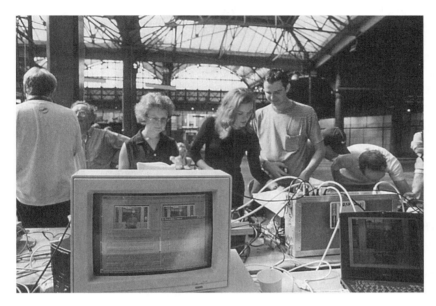

Figure 7.2
Documentation of the event *Broadcast (29 pilgrims, 29 tales)* (1999) by Nina Pope and Karen Guthrie at Borough Market, London. Photograph by Jet.

include the pressures typical of an education department—"21% of visitors to Tate Online in June 2003 gave e-learning as their reason for visiting"—and of a marketing department—"less than 1% of the 605 respondents specified net art as a reason for their visit to tate.org .uk" (Rellie 2004). These kind of conflicting pressures are characteristic of posts that have cross-disciplinary responsibilities and necessitate a very solid defense of the curating of new media art, together with the retention of a presence on the "first levels" of a Web site in order to develop an identity for Net art and build an audience: "needless to say this program includes net art as a central feature" (Rellie 2003).

The pressures of an interpretational objective are sometimes found crossing over into questions of curating—for example, with Heath Bunting's *BorderXing Guide* (2002–2003) which was a commission as part of the Tate's Net art program. The artwork concerns the free movements of people over physical national borders in Europe and is a guide to crossing points, but it deliberately frustrates the "free access" rhetoric of the Internet by being viewable only via "authorized" computers in certain locations such as immigrant community centers:

This tactic provoked a fair amount of discussion at Tate, where there was some concern that the piece would frustrate Tate's core objective of increasing access to and understanding of art. In fact what *BorderXing Guide* succeeds in doing is promote critical awareness of naïve, wishful interpretations of the Internet as somehow the great equalizer where movement is unrestricted and information is freely

available to all. In this respect, and on one level, it is a specific provocation to museums to reflect on their culturally imperialist tendencies, as much in evidence online as off. (Rellie 2003)

Working across the boundaries of interpretation and curating, therefore, can be seen to involve some inevitable border disputes, as explored in the rest of this chapter. In 2006, Tate Media was born, and Digital Programmes is now responsible for a joint structure of content and context/infrastructure (Tate Media also includes Tate Online and the "Digital Programmes" name has disappeared from the organization structure map). The Tate is characteristic of the ways in which new media art can gain an entry into institutions via interpretation departments and can help to start a discourse via well-documented seminar series (with public events), which has now become a valuable archive, and via well-integrated research programs, including the New Media Art Network on Performativity and Authenticity. It remains to be seen, however, whether the exhibition of Net art online will gain "equal status to offline sites," (Rellie 2003) considering that very little new media art has been exhibited in physical Tate galleries.

Outside the large institutions, the structures for working across interpretation and curating are much more flexible. For example, it can be argued that *Curating Degree Zero Archive* (2003–), curated by freelancers Barnaby Drabble and Dorothee Richter, is an exhibition of interpretational material—catalogs and other material supplied by various invited curatorial organizations. Although the material is logged on a central Web site, at each touring venue the means of display is decided by a guest artist, curator, or educator. At Spike Island in Bristol, United Kingdom, for example, there is not an education department, but an "interpretation group" that includes local artists. This group designed the exhibition's display as a minimalist "reading room," with the publications arranged by color. Other displays have involved publications shown in handbags on luggage trolleys, but the dominant metaphors are those of education—including one guest curator's choice of an archive style of display, with brown cardboard file boxes, indexes, and study tables.

Artists working with new media are often able and willing to share their process for educational ends; the Web site for the *Flat of Culture* (2001) webstreaming project by Hostexe (described in chapter 9), for example, is not only a document of the project, but also a contextual sharing of technical knowledge and an open description of the things that went right and wrong in the process. Likewise, the *University of Openess* (2003–) explicitly uses formats of open education and discursive practice as art. The wiki Web site used enables everyone to contribute and to edit each other's work on an equal footing. Anyone can start a new faculty, such as the Faculty of Sport, which includes notices about real-space urban climbing events, and the Faculty of Taxonomy, which includes rules for playing naming games. Again, this crossover between the technologies of education and new media art is significant, not only for the systems of organizations, but also for the shared values of discursive practice.

Figure 7.3
Curating Degree Zero Archive touring exhibition, installation version at Spike Island Art Space in Bristol (2005), designed and reinterpreted by Julian Claxton, Karen Di Franco, Toby Huddleston, Laura Mansfield, Lizi Sanchez, and Daniel Stringer. Courtesy of Barnaby Drabble.

Interpretational Events—Platforms and Discourses

Curating and setting up symposia/conferences is a political act—many of the decisions made regarding such occasions and venue-tagging, are a declaration of the curator's/organizer's intentions, a message. A way of saying something, sculpting something using context as a palette and of course exploiting circumstance—and usually a clear statement (amongst acknowledging peers) defining position and status. Territorial shifting, tagging in a cultural way.
—Marc Garrett, "Curatorial: Cultural Tagging," 2004

In a discussion on whether a symposium can be "curated," Marc Garrett (an active participant in the NODE.London event described in chapter 10) uses the new media terminology of "tagging."[5] This desire to "share," to link resources, and to debate is, of course, not the exclusive domain of new media; nevertheless, many new media technologies do these things particularly well and have found a comfortable home in interpretation contexts rather than in the more territorialized landscape of curating. Garrett also points

out, however, that tagging can be seen as an immaterial, advance-guard version of territorial marking. The Tate's series of webcast seminars, for example, has dealt with issues of open source software far in advance of any exhibitions in the physical galleries.

Online discussion lists, links, and streaming have found themselves fitting into the wider move from top-down didacticism to heteroglossia and "new voices" in museums and with "platforms" at festivals, as discussed in subsequent chapters. However, whereas institutions tend to keep educational events firmly in the interpretation departments, other places keep the roles much more fluid: "The media art curator is not exclusively the 'middle person' between artists and museums or galleries anymore. Curators do not merely organize exhibitions and edit, filter and arrange museum collections. Now, her practice includes facilitating events, screenings, temporary discursive situations, writing/publishing, symposia, conferences, talks, research, the creation of open archives, and mailing lists. Curators become meta-artists. They set up contexts for artists who provide contexts" (Scholz 2006, 198).

New media art curators therefore tend to work across both exhibiting and interpretative events, both online and in real space, working with both content and contexts. Online discussions have not replaced physical conferences; they often involve people who have met in real space at some time and often append to live events. Online discussions tend to work in a slightly different way than the live ones, extending the debate before and after the conference and making it available to a wider geographical audience. Web-streaming of conferences similarly extends the conference time and space into an interpretative "document." New media curators often find themselves working with hybrids of art, event, document, and platform, and it is this basic opportunity to access event space as well as gallery space that proves so useful to new media art, as it did for other marginalized cross-media art forms such as live art. If new media art has few opportunities to appear in galleries, then the work is often first seen at festivals or labs or at hybrid conference events. Those who work in interpretation are perhaps less technophobic than curators who do not and more used to the tension between technology and human contact.[6] Those interpreters who know how to start a discourse are also often highly experienced in introducing new media art to neophytes and in how to interpret "the new."

Interpreting the New

To deliver a new audience, a different kind of audience to the work, rather than just people who are already interested in it, who know where to find it, is important. . . . But it is bringing a critical audience who brings some sort of informed understanding of what the new art is capable of . . . that puts the art to the test!
—Kathy Rae Huffman, in Sarah Cook, "A Conversation Between Kathy Rae Huffman and Julie Lazar," 2001b

Video was once new media. Video curators can now use that knowledge well. Patricia Zimmerman, organizing festivals at Ithaca College in New York State in 2001, described "a kind of repressed horror of the new and the mysterious" and was dealing with two

kinds of newness, for she had to convince college administrators who are scared of both the digital and the political. Despite these challenges, she managed to develop large audiences by starting from strong content (such as a festival of feminist films) and by combining screenings by artists with gallery exhibitions and events such as live DJ remixing of audio and film (Zimmerman 2001). However, as described in the first half of this book, the useful curatorial experience of introducing new video, conceptual, or activist art to an audience isn't always applied when introducing new media art, such as software art. How much, therefore, does the audience need to know? For example, Mark Napier's *Shredder* (1998) shreds any Web page requested into fragments of color, image, and code. Users will probably recognize parts of images from the original, but some curators have seen as a serious deterrent the possibility that users may not recognize the html code as the invisible structure behind Web pages. However, interpreters might see this lack of knowledge as less of a problem: if audiences sometimes need to be informed that a reclining figure is Bacchus, that a painting was made during a period of political change, or that a bronze statue is leaning on a tree trunk because of the engineering limitations of the casting process, then they can surely similarly be made aware of invisible processes or cultural context behind new media art.

The cultural context of new media art does, of course, relate to cultures of technology as well as to cultures of art. *KOP Kingdom of Piracy* (2002–), curated by Shu Lea Cheang, Armin Medosch, and Yukiko Shikata, for example, concerned issues of copyright piracy, Copyleft, and open source software. When exhibited at FACT in Liverpool, the interpretational tactics were very hands on: people could come in and download files from the Internet onto CDs to take away with them (with help available from attendants); the gallery talks included those by activists as well as by artists; the catalog included a free CD of open source software, and the audiences reportedly ranged from novices to young computer programmers with very little "repressed horror of the new." An understanding of the wider cultural context for technology was important for exhibitions such as *Cybernetic Serendipity* in 1968, *Information* in 1970, and *The Art of Participation* in 2008, and all these exhibitions featured considerable interpretational material.

Yet, as Kathy Rae Huffman indicates in the epigraph for this section, in one-off exhibitions in art museums, the audience is often placed at "first-contact" level simply because it is first contact for the curator, interpreters, or the institution. If new media art is to be able to address different critical levels of audience, then regular exhibiting, contact, and audience building will most likely develop a more critical audience. Those working in interpretation in museums will be aware that different kinds of interpretation are suitable for different levels, from worksheets for children to connoisseur essays in catalogs. With new media, it is possible to offer different threads through the same database of material, such as Web sites or educational screen-based media (computer games, after all, are often based on levels of expertise). Curator Michael Connor goes further by advocating installation and staffing choices that offer a range of options for knowledge level, independence, and duration: "With some projects I've done a thing where there

is a facilitated area with a gallery staff person to help on the computer. And then a more easy area where you can just access the projects, and then the advanced use area where you can do it on your own, and not be told what to do. Usually the advanced area will be the most popular area because people will use it for longer periods of time. I like that principle—because technology allows you a way to put different skins onto the same thing" (in C. Jones 2006b).

The "different skins" offered should ideally include options for those who have gained a critical understanding of those kinds of new media art that are much less familiar than video. In discussing "software as art," Dave Franklin questions where the art lies, and looking for it in the elegance of the code itself questions whether, in this case, the audience needs to understand the code. "Code can be elegant and imaginative, it may have clarity, simplicity, strength, energy etc." (Franklin 2001). Andreas Broeckmann, in reply, argues that curators and audiences need not be expert computer users or programmers, but can enjoy the accidental idiosyncrasies; "for me, the oscillation between control and idiosyncrasy in a computer, this supposedly precise machine, is closely linked to the aesthetic experience of a work of software art." He goes on to give examples of the different ways that the work shown might be suitable for different audiences:

How, then, do you "exhibit" a process that runs on a tiny processor? Daniel Garcia Andujar recently printed out the source code of the I-Love-You virus and displayed it on a gallery wall in Dortmund (http://www.irational.org/tttp)—this is obviously just an ironic gesture. . . . In Adrian Ward's *Signwave Auto-Illustrator* (http://www.signwave.co.uk), the best way to experience it is to interact with the program on a regular PC which can but need not be your own. Pieces by JODI are probably best experienced on your own machine because they play with your emotional attachments to what's on it. Whereas the processes involved in a piece like Daniela Plewe's *Ultima Ratio* (http://www.sabonjo.de) need a lot of explanation and its "beauty" might only reveal itself to people who have a deeper understanding of the informatic and logical processes going on in the computer. (2001)[7]

These issues of the level of technical understanding illustrate the difficulty of separating issues of interpretation from issues of display. If, as every good educator knows, people learn by doing, then the audience members need to interact, and if they are to interact, then the interface must be clear. If the curator or exhibition designer changes the interface, then this might change the work's meaning and technological context. How then, is the artwork displayed?

On Display

Can we define where the mediation ends and the experience of an actual encounter with [Net] art occurs? Is it in the wall text, in the catalogue, and the acoustiguides used to explain and illuminate the exhibition? . . . Or, perhaps the mediation is ALL of it—the very inclusion of artists in a big media art show, with the totality of critics and curators and educators that bring it to the public. —Rosanna Flouty, "Re: Big Media Art: March Theme of the Month" (emphasis in the original), 2001

The first half of this book offered examples of the challenges that new media art presents to exhibition and display with respect to its particular behaviors in space, time, and participation. Beyond the particular, however, a range of general issues of display also relates to the roles of the curator, the audience, and the interpreter. As Rosanna Flouty of the Guggenheim Museum in New York suggests, mediation, interpretation, and education are not things tacked on to a finished exhibition, but to "all of it"—the context, the critical response, the selection of the artworks. No mediation is seamless or without values, and the most direct language of mediation for a curator is not the optional leaflet or the catalog essay, but the articulate display of the artwork. This aspect is a large issue for curating any art form, but most of the information and literature available, including that concerning Web sites, is about the design of interpretational displays rather than about the display of artworks.[8] Issues of display, like issues of audience or technical matters, are often regarded as "crafts" to outsource separately from the curatorial role. However, in discussing the distance between the installation, as specified by the artist, and the finished exhibit, Magda Sawon, codirector of the Postmasters gallery in New York, suggests that the fewer intermediaries, the better. "You know, the bigger the institution, the more potential for trouble these things are. The artist and the curator may understand the idea of the piece perfectly, but then comes the bureaucracy and then comes the exhibition designer, etc." (in Joseph-Hunter 2006). The divide between curatorial and technical or exhibition design departments can be seen to reflect a hierarchy between art and design, a hierarchy that the curatorial group digitalcraft.org deliberately rejects. Its members have worked both with interpretational forms, such as an *SMS Museum Guide*, and with meticulously designed exhibitions, such as *I love you* (2003), which explored computer viruses as culture and art. The exhibits allowed people actually to use viruses in confined conditions, and certain screens were interpretative in nature, being log file readers that would "comment" on the progress of the viruses. Lighting and the arrangement of items in space are also deemed crucial because, after all, "curatorial activity demands formal solutions for the displaying of work playing a decisive role in determining the significance of the exhibited 'objects'" (Nori 2003).

Therefore, although the history of art display has a poorly documented critical element, it is prone to firmly held tastes as well as to technical needs and interpretative "position." Even the kinds of exhibition planning tools used tend to affect the success of installation for new media art, where the immaterial factors of sound and light spill are a major challenge, but are sometimes not discovered until the opening night, by which time it is usually too late to remedy the problems.[9] The exhibition *010101* at SFMOMA in 2001, for example, used a low-tech three-dimensional cardboard model of the galleries, with color photocopies of the works. This approach has the advantage that several people can gather around the model at a time, get a literal overview, and move artworks around quickly and easily. A disadvantage is that it is more difficult to get an idea of audience point of view, lighting, or sound issues. In *010101*, some artworks had to be moved

Figure 7.4
Installation view of the touring exhibition *I love you* (2003–) at the Telecommunication Museum in Copenhagen, Denmark, in 2004. Curated by Franziska Nori for digitalcraft.org, opening at the Museum of Applied Art in Frankfurt, Germany. Image courtesy of Franziska Nori.

from the proposed plan when being installed in the gallery because of light or sound spill (Graham 2002a, 34). There is certainly no "one size fits all" answer, however, and the simplest solutions are sometimes the best, even for something as basic as labels.

The panels of text and labels that accompany art exhibitions are subject to the kind of passionate debate that tends to amuse those who are not curators or interpreters. Some institutions have written policies on the subject. In "Death by Wall Label" (2008a), curator Jon Ippolito dissects new media art's disruption of every one of the elements of even the most conventional label, including title (Which version?), artist (How many in a collaborative team?), medium (Do you describe the technology or the interaction or the intent?), and dimension (variable). To summarize very briefly the main issues for new media art in particular, labels must be able to describe the media accurately, but without jargon, and may need to be clear about what "version" or iteration of an artwork is shown. Some exhibitions of interactive artwork have given a rough indication of the time needed to experience the work (as video labels do). In addition to the usual artistic information about the artwork, there may also need to be information on "what to do":

to touch or to refrain from touching, to contribute or not to contribute—which brings labels more into the realm of interpretation.

The potential for new media to offer choices of interpretation material has been grasped in some cases; however, although such complex options might be suitable for a sit-down browse, having them as labels in a gallery can cause problems with respect to legibility. An artwork in the exhibition *Feedback* (2007) showed a more focused approach to using screen "labels" only when necessary to supply something not illustrated by the art itself. Edward Ihnatowicz's *SAM (Sound-Activated Mobile)* (1968) was shown as a valued object in its own right; however, because the piece itself is no longer functioning, its reactive nature, moving fluidly in response to sounds, was illustrated by a small video screen showing filmed documentation. This material added to the experience of the object rather than distracting from it. Like many display solutions for new media art, the best solutions are often the most simple. The solutions often use hybrid media across both old and new technology and emerge from considering not the artwork's specific media, but its behaviors.

The knowledge that informs the display of new media art may come from many sources, including sound art, architecture, and politics.[10] In addition to these understandings of display, it can also be argued that new media has a special relationship with the archive and with how people navigate data and information. The exhibition *Curating Degree Zero Archive* (2003–), described earlier in this chapter, explicitly used display formats from the educational reading room or public archive. The format of display for new media art often crosses over between the library and the "mediatheque" or the lounge. At ZKM in Karlsruhe, for example, the media library has been constructed with great care concerning the means of display. There are two kinds of stations in the public area for long-term examination of media archives: four historic listening booths like enclosed armchairs, designed by Professor Dieter Mankau, and ten individual stations with two seats each, designed by media artist Luc Courchesne in 1997. Courchesne's concern was that the artworks should be viewed as autonomously as possible; any catalog information is therefore shown on a separate screen: "The monitor displaying retrieved titles is reflected by semi-mirrored glass. This effect is similar to a gallery of floating pictures; the work of art is no longer viewed in the usual context of a monitor presentation but as a frameless image, freeing perception from connotations of the television" (Cornwell et al. 2003).

This kind of care taken over ways of displaying and understanding information reflects the key behaviors of new media art, concerning not only time and space, but also interaction and the archive, which leads us to the important question of who is selecting what is displayed in the first place.

Figure 7.5
Edward Ihnatowicz's *SAM (Sound-Activated Mobile)* (1968), showing video "label." Displayed as part of the exhibition *Feedback* (2007) at LABoral, Gijon, Spain. Photograph by Aram Bartholl.

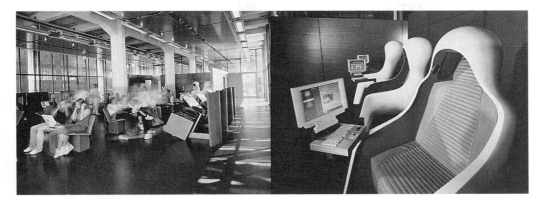

Figure 7.6
Installation views of the ZKM Medialounge in Karlsruhe, Germany, in 2006, showing on the left media seats designed by Canadian media artist Luc Courchesne and on the right historic audio-listening chairs first designed for Documenta 8 in Kassel, Germany, in 1987 by product designer Dieter Mankau. Photographs by Franz Wamhof *(left)* and Bernhard Kroll *(right)*.

Displaying Data—Virtual Galleries or Digital Collections?

In countless venues and on both a major and a minor scale, museums are creating databanks that do not adequately take note of information standards because they are too busy focusing on the multi-media dream of making things more user-friendly. But the more pedagogical these hypertexts and hyper-media-shows become museologically, the more they miss the possibility of joining the electronic network. Visitors too—they especially—should be given access not just to lovingly presorted information but to all available information.
—Friedrich Kittler, "Museums on the Digital Frontier," 1996

Just as interpretative technologies are the default form of new media installation in an art museum, interpretative material also tends to dominate museum Web sites—a factor highlighted by Harwood's project for the Tate (chapter 2). Museums have for some time been digitizing images of artworks in their collections and making this documentation available via their Web sites. This practice has led to a great deal of debate on the confusion between the object and the digitized display of an object. Ross Parry comments that museums have been "recoded by this new technology" (2007, 139). The grammar of displaying information on a computer screen has therefore become established as a means of displaying documentation of paintings, sculptures, or moving images rather than as a means of displaying Net art.[11] Whether the artworks concerned are new media art or not, there is still a choice of ways to display this documentation on a screen. As Friedrich Kittler describes in relation to the display of information, two kinds of approaches are emerging: the pedagogic display of "lovingly presorted information" and the open access to databanks of "all available information." If a comparison is made with the display

of art rather than of information, then there are also two parallel approaches: the "virtual gallery" and the "digital collection." The difference between these two approaches lies in the role of the curator rather than with the role of the "audience" in selecting the information.

The term *virtual gallery* tends to make curators of new media art wince, not only because of its outmoded futurism and the fact that these galleries are mistaken for new media art, but also because of the implication of a desperate clutching at traditional understandings of territories and pedagogy. The excitement over new territories for display, for example, led the Guggenheim Museum to propose a very presorted and literal Virtual Museum, working with Asymptote Architects to "implement a new Guggenheim Museum in cyberspace" (Drutt 1999). The difference between the virtual gallery and the digital collection mirrors the technological move from Web sites being hand edited and presorted in a sequence of pages (like a book) to being "database driven" (single screens may contain text and images that the computer program selects from files of information). Curators might already be familiar with nonpublic museum collection databases: "On an intellectual level, computers can provide curators with the opportunity to interrogate their collections' information in more innovative ways, making connections which could not have been made easily with a manual system" (Fahy 1999, 85). What new media in digital collections offer is the opportunity for "all available information" to be made available to the audience and not just to the curator. The arguments for digitized collections are often based around access to larger collections that may be physically inaccessible because of storage and physical space. However, there is still the fear that this access might be altogether too much for the general audience, who should be allowed access only to "nonsensitive information," and that such mediated experience might detract from the experience of objecthood (Fahy 1999, 88).[12]

In practice, therefore, the audience may not have access to the same range of data that curators do. In 1996, Steve Dietz asked "What becomes a museum Web?" and described a range of tactics before coming to the conclusion that content should be "filtered, with a point of view." Some of the most interesting grammars of online display therefore fall somewhere between "lovingly presorted" and "all available information." In the Web site low-fi Locator, for example, the curators have done a certain amount of preselection and provided a friendly interface to search and filter some works of Net art. Guest curators are asked to choose certain works, but an overall curatorial identity is also discernable in the search terms—it is possible, for example, to search by the keyword *humor.* The Web site is not, however "an exhibition" (the organization does not own the artworks), and it is not a conventional large comprehensive collection of data; it exists, therefore, somewhere between the two models. The example of low-fi Locator suggests both the idea of the "curator as filter" and the question of users filtering the content in online collections (which we come back to again in chapter 10).

Figure 7.7
Screenshot of the low-fi Locator Net art Web site. Courtesy of Luci Eyers.

Audiences

Bill Viola or Gary Hill or anyone working in video can assume what their audience will be like. When you start making work for the Web, you have no idea who your audience is. And in fact, it's almost certain that whoever you think will be your audience, won't be your audience.
—Glenn Lowry, MoMA, in Susan Morris, *Museums and New Media Art*, 2001

Audience is a highly contested word in the field of curating, and for new media art in particular the areas of debate fall into three main issues: first, as Glenn Lowry states, there is the invisible online audience; second, if members of an audience engage with reactive, participative, or data-based art, they are then users, participants, or selectors rather than an audience; third, if the artwork and hence the audience response are about "behaviors," then how much do curators know about those behaviors? All of these issues mark a substantial change in the understanding of audience, and this chapter traces a pattern of issues that cross over between art and interpretation because expectations in each are very different in terms of time and the kinds of experience an audience might expect (Graham 1996). The whole question of audience is one to make any contemporary art curator squirm. Funders tend to apply pressures to increase audience numbers

and to "widen" the audience in terms of class, race, age, and gender. Within institutions, some curators are relieved to dismiss all such information as simplistic bean-counting or dumbing-down and to let the education or marketing department deal with these questions, but passing the buck like this can lead to a lack of knowledge with which to challenge funders' perceptions or to change definitions of audience.

With regard to the basic question of specialist audiences for media-specific art forms, some may question Lowry's claim that video artists such as Bill Viola or Gary Hill can assume what the audience will be like, but his comment does at least establish the idea that, as every good postmodernist knows, there are different audiences rather than a monolithic "audience." As video curators are aware, there are different audiences with different expectations, and it may be necessary to build an audience over time. For curators of new media art in particular, there is the additional problem that cross-media art forms attract very different audiences. For example, an exhibition of new media sound art may introduce a very different art form to a museum and build an audience for it:

I'm speaking here more about the type of viewer who probably won't happen upon a sound event or installation at loft/warehouse/alternative space where this work is more common. It really functions like a domino effect. Sound, when placed within the context of the museum, is automatically afforded a certain deserved validity to an audience that might not necessarily be aware of it otherwise. It generates interest which, in turn, generates more support from the public for more sound programming and installations . . . which generates more interest from the public . . . more sound programming and so on and so on. (Forde 2002)

Audience becomes of particular importance to new media art curators because some art museum directors firmly believe that there is no audience for new media art, a belief based simply on the fact that they themselves have no awareness of such an audience. Although we acknowledge that head counting is a very poor way to define the audience for new media art, some basic findings about audience profiling may be of use to museum directors—patterns identified from comparing two physical exhibitions of contemporary art that included new media art, *010101* (2001) at SFMOMA and *Serious Games* (1996) at the Laing Art Gallery in Newcastle upon Tyne, United Kingdom. The results were very similar, despite the gap of years between them. In terms of total visitor numbers to the galleries, these exhibitions, when compared with other exhibitions at the same venue, attracted fewer people than monographic exhibitions of dead, white, male artists, but more than other contemporary art group exhibitions. Both exhibitions attracted slightly younger people than was usual for those institutions, but beyond that, the demographics were about the same (Graham 1997, 93ff., 2002b). These patterns are reflected across different kinds of institutions. The Edith Russ Haus in Oldenburg, Germany, for example, reports similarly on the youth of the audience and repeat visits: "A measurement of success is the fact that a great part of the visitors are quite young, something found at no other art institution in the area. Outreach is really working when people who would not otherwise take an interest in culture become repeat customers" (Altstatt 2004). The most

obvious reason that ticket sales are not a fit measure of audience for a media arts institution is that the online audience is not acknowledged at all. What is worth noting is that *010101* attracted almost twice the quantity of press coverage than average for SFMOMA shows, and, if the online audience is counted in with the visitor figures, then new media art starts to rival the art of dead white men in terms of head count (Graham 1997, 95ff.). Even if the online audience is acknowledged in mere numbers, however, there is beyond that a need for a critical understanding of online behavior.

Audiences Online

Even in a museum like this [MoMA], where we have had up to 1.8 million visitors, we still started doing better than that on the site, really quite quickly. . . . I don't see the Web site as being a lure for the museum. It's a sporting analogy. Television created entirely new audiences for football or baseball games, and most people who watch football on TV don't go to football games. That's why I talk about a parallel museum.
—Patterson Sims, in Susan Morris, *Museums and New Media Art*, 2001

The online audience for a museum Web site is typically more numerous and more international than the audience in the museum building.[13] Of course, not all of those online visitors are looking at art, but there again, neither are physical visitors (for example, one notable institution includes in the visitor figures those people short-cutting through the public sculpture garden courtyard). Web site tracking software is able to tell Web site managers how many people visit which pages and for how long. In 2007, for example, the average number of visitors for a single Tate Net art commission was about three thousand to nine thousand a month, which is around the same as a physical gallery in Tate Modern such as the Art Now space (Dipple 2007; Rellie 2003). Those who are savvy about statistics can also track how quickly an audience grows once it starts using a resource; for example, use of the Tate Online Events Archive increased by 300 percent between 2004 and 2005, and the archive was shown to be increasingly accessed by international expert users (Zimmer 2007). Curators know that online new media art can attract a large international audience over a long period: General Idea's screensaver for the MoMA Web site reportedly received more hits than any other page on the site for a two-month period in 1998 (London 2001a, 98). As at the Tate, however, it is more typical for the education and marketing pages of an art museum Web site to receive more visits than the Net art pages (should the latter exist). The danger for Net art is that the "visitor figures" are therefore being compared not with the figures for other art exhibitions, but with the figures for interpretation or marketing.[14] This phenomenon can lead to a circular argument for Web site managers: more popular pages get "higher billing" on the home page, whereas the less popular pages get fewer visits because they are more difficult to find, and so on into a feedback loop, making it impossible to do the "audience building" necessary for new art forms. As Net artist Vuk Ćosić states, "When I want to hide or totally remove some stuff in the Web site that still has to be there, but I don't really want anyone to see it, first

I remove the link from the top level page, then I remove it from the secondary link level list or navigation tools, and if at all possible, I give it another label so it doesn't look like the right thing in a third level" (Cook, Graham, and Martin 2002, 78).

While art museums ponder, as Patterson Sims does, whether online audiences are wholly *different* audiences with different needs, the wider field of new media art has been using any means necessary to reach an audience. Different media reach different audiences and serve different functions; blogs such as *we make money not art*, for example, act as critical commentary on new media art and technology, like a magazine, but also arguably have a curatorial remit in the projects covered and linked (Cook 2007). Even those who start from a firm position of exhibiting Net art purely online are not averse to hybrid approaches and hybrid audiences. The low-fi group who work across both areas, have commented:

> The notion of audience is a problematic one from the outset, because low-fi is building a web-based archive with critical commentary, as well as commissioning web-specific and gallery-specific artworks, and the optimism of both of those activities lies not in the hope that they will reach an audience, but the hope that they will become useful, to someone, somewhere. . . . To generalise, our online audience is predominantly people who work in the field of new media (teachers, artists, critics, curators) while our work in physical spaces has been across DIY spaces, institutional and contemporary art galleries and so draws people from both inside and outside of the new media professions. This is not to say there is no cross over, but the relationship is overlapping (a Venn diagram) rather than coincidental or autonomous. (Eyers 2007)

The dominant paradigm, however, is still that of the Web site as a document of or distributor of art. So, in general, the online audience is regarded as something broader (in numbers and location and economic access) and deeper (in duration and repeated visits, something used before or after a live event). However, the online visit is often regarded as peripheral to the "real visit" rather than as an experience of art in itself. Certain curators, therefore, know a great deal about certain audiences, but these large audiences may be literally invisible or "immaterial to" directors of museums, board members of arts institutions, funders, and many others who very rarely use the Internet in art contexts. For those under pressure from funders concerning audience, a neglected Net art site does not impinge on the consciousness as urgently as an echoingly empty lobby does. Directors willing to defend a "difficult" or "new" contemporary artist against simplistic head counting may be less able to defend Net art against the "hit counting" of marketing or education pages simply because they are unfamiliar with conventions of Web site management or with the data. In moving beyond data and numbers, new media has yet another challenge for concepts of audience: What if determining "audience numbers" is not about counting heads or hits, but about measuring the depth and quality of engagement? What if the engagement is not just between the artwork and the audience, but between the audience members?

Audiences as Participants

Participants can be of any kind; presenting, organizing or taking part in the discussion. Whatever one chooses to do. In fact for us there is no distinction between participant and public. We are the public and we are the participants. It's a moebius strip of the inside and outside.
—16 Beaver Group, "Collective Interest," 2006

The heading "Audiences as Participants" marks an intersection of several threads explored in this book. As discussed in chapter 5, new media offers various ways in which the audience can participate in media systems. Creative participation takes time and thought, but a long, deep experience will only show up as one visit on the conventional audience records, whether that visit is online or not. As outlined in chapter 2, however, new media fundamentally challenge notions of authorship, and the network model of new media is not the broadcast model of one to many, but the many-to-many approach of peer-to-peer networking. The roles of the artist, audience, and participant are blurring: the participants sometimes *are* the audience. An audience of peers is excellent for pushing the expertise and critical level within a field, which is why specialist workshops, festivals, and debates are so popular. However, in the consideration of audience, then the Möbius strip analogy works only if no one feels himself to be firmly on the "outside" of a network of participants. In the debate around the NODE.London projects (discussed in chapter 10), there were shared concerns that the events should not just address "insider audiences and participants" (Eyers 2006a). Rudolf Frieling, curator of *The Art of Participation* (2008) also asks, "How, then, can an artwork include not only friends and peers, but also an undefined group of participants? How might the artist address a larger public without becoming simplistic, didactic, or compromised?" (2008, 46).

One relatively neglected solution might be new media's ability to provide platforms for interaction *between* people—a factor that has been used by artists, curators, and educators, but not by museums, which, according to Jemima Rellie, often keep this opportunity at a distance: "few attempts have been made to facilitate communication among online museum visitors. Net artists, with their usual willingness to participate, collaborate, can help kick start community-based activity linked to museum web sites" (2003). As with participation, conventional audience studies have no established way of valuing this kind of active conversation between audience members, apart from counting the number of subscribers to mailing lists. As Rafael Lozano-Hemmer has stated, one of the most exciting characteristics of the behavior of group interaction is that it is largely outside of the artist's or curator's control.

What all of these examples of engagement present are ways in which new media art audiences differ from the conventional audience. These differences are challenges not only to concepts of audience, but also to practical ways of valuing or evaluating audience response. It is obvious that these challenges are not addressed by findings on visitor numbers and demographics; beyond that, however, who might know about audiences

and how they actually behave in relation to new media art, and thus might offer solutions to these challenges?

How Do Audiences Behave?

Even centers and museums designed to encourage more active involvement in issues and collections, and committed to introducing new technologies and the like, often enhance an individual's "interaction" with, and experience of, an exhibit at the cost of co-participation and collaboration. Social interaction in galleries and museums, and the ways in which it informs what people choose to look at, how they examine and experience particular exhibits, and the conclusions they draw, remains a neglected field of study.
—Christian Heath, Dirk vom Lehn, Jon Hindmarsh, and Jason Cleverly, "Crafting Participation: Designing Ecologies, Configuring Experience," 2002

If new media afford new or different roles for the audience, then it would seem sensible to know something about how the audience might behave in these roles. Curators and artists reading this book should at this point resist reaching for the ethical panic button. Testing audiences on what they like or want is unlikely to tell any curator anything useful. However, curators and artists armed with some knowledge of audience behavior are in a much better position to question the received wisdom of experts or to question why, as Christian Heath and his colleagues point out, existing visitor studies may simply not be studying the right thing. The audience studies likely to be of most use to curators of new media art are those on audience behavior and participation (without being simplistically "behaviorist") and those on whether the audience can view or use the artwork effectively. Again, this is not an argument for the uncritical application of the concept of "usability" to art. Artists, of course, should always be free to do the opposite of what the audience expects or to work with antiusability if they choose.[15]

So who knows about how audiences behave? Some anecdotal but perceptive insights are given by those who have most intimate observational knowledge of the relationship between artwork and audience. Gallery attendants, for example, necessarily spend their working lives watching people intently. Attendants and docents at the SFMOMA exhibition *010101* (2001) very succinctly identified how patterns of behavior differed from those in other shows—namely, that the public asked the attendants more questions; that people stayed for longer and returned for repeat visits; and that, above all, people were very uncertain of what to touch and what not to touch (Graham 2002b, 50). Gallery technicians know if things break down, educators know about labels and educational interactives, and exhibit designers are necessarily rigorous about how things work: sterling snippets from the Science Museum in London include "People very rarely read the instructions" (Simmons 1999). Ironically, it is curators who might be in the worst position to know about audiences.

What curators of new media art know about audience behaviors tends to come from experience, and the wider the curator's experience the better, for their observations may

then include fields such as public art, social spaces, and even the kind of private behavior that might be found in a library. There are few substitutes for observation and reflection based on using systems over a period of time. The collaboratively curated project *Do It with Others* (2007) (described more fully in chapter 8), for example, discovered very specific things about what happens when people are given a chance to participate creatively within an online framework: about 4 percent of the audience members were active contributors when the project started, and 25 percent were active a month later (Catlow 2007).

In addition to informal observational and anecdotal findings about audience behavior, formal and academic studies cross the fields of exhibit evaluation, design research, ethnography, cultural studies, and social science, and the methods vary widely, from quantitative product-design surveys to qualitative approaches.[16] In 1997, for example, Beryl Graham drew from exhibition evaluation an approach to observing interactive artworks in art galleries. The findings identified patterns of audience behavior, including extended use times for artworks that facilitated group use, interaction between people, and the way in which an exposed or private viewing position can affect audience use. The research also illuminated how artists were generally good at predicting the duration of use needed for the audience to have a reasonable experience of the artists' work and hence at planning the installation accordingly (Graham 1997, 88; Graham 1999). Since Graham made this study, other curators have also undertaken formal research on audience. Lizzie Muller's valuable work on interactive art (Jones and Muller 2008; Muller 2009) uses a method of working closely with an artist's production process and audiences' recall of their experience of an artwork to explore the artwork's "experiential goals," which then inform her role as a curator when exhibiting artworks. Her method of audience recall, which uses video, has also been applied to the documentation and archiving of interactive art, as in David Rokeby's *Giver of Names* (2002).[17] When artists are engaged in studying audience behavior, they are able to bring their own skills in working with space and time into their research. For example, artist Kazuhiro Jo, together with Yasuhiro Yamamoto and Kumiyo Nakakoji (2006), formally studied *The Sine Wave Orchestra* artworks in public places at festivals. They were able to identify different styles of participation and engagement through "temporal and spatial co-presence" and were very specific about whether the participation was synchronous or asynchronous.[18]

Unfortunately, both the anecdotal and formal knowledge of how audiences behave in response to new media artworks doesn't manage to cross the boundaries between art and art interpretation. Designer Garrick Jones has commented on the fact that "translation" is much needed in making this information accessible across disciplines if research papers are to be at all useful in practice (2007, 24). However, there is a growing awareness that as concepts of audience change, then the understanding of audience behavior may also need to change. As curators grow more familiar with their own experiences when using new media tools, they will become more aware of audience behavior. Above all, they should turn to the artists themselves, who have observed most widely and who

Figure 7.8
Ken Furudate, Kazuhiro Jo, Daisuke Ishida, and Mizuki Noguchi's *The Sine Wave Orchestra* at the International Symposium of Electronic Art 2006 festival. Courtesy of the artists.

have been willing to collaborate with those whose roles may be regarded as educational, design oriented, scientific, or technical. It is the nature of new media art to cross boundaries between technical and behavioral knowledge and hence for its practitioners to be capable of translating across these barriers.

Summary: A Useful Confusion?

It is easier to get an entire museum collection on the Internet than to get a single exhibition of Internet Art in a museum space.
—CONT3XT.net, "Introduction: Extended Curatorial Practices on the Internet," 2007

This chapter has addressed the confusion between interpretation and art that is particular to new media art. Education and interpretation can be a "way in" to an institution for new media art, but the way in may not extend as far as physical exhibition space, and there is the attendant risk of new media art's being confused with interpretational media when assessed in terms of "usability" or audience numbers. Outside the institution, the blur between interpretation and art is well established in the "platforms" and discourse-

building activities of freelance curators, festivals, and participatory events found across the contemporary arts.

In relation to the "curator as . . ." modes discussed in the second half of this book, then the skills to be found in the experience of being an interpreter, educator, context provider, platform provider, and even librarian are all highly relevant skills for curating new media art. These skills can also help address the challenge of "the new."

There are, indeed, audiences for new media art, and those audiences may in some cases be larger than those for other comparable arts. New media art audiences may not behave in the same ways as other audiences, however; they may be online or have very different "roles"—as participant, content provider, and even curator. The particular characteristics of new media art also blur the lines between education, display, and audience. Those who work in art interpretation tend to know not only about technology, but about "the new," discursive structures, participation, display, and audience, all of which directly address new media art behaviors. New media art is characteristically hybrid and, as such, demands flexibility in the way it is exhibited. It will in particular challenge the departmental boundaries of most institutions, as explored in chapter 8.

Notes

1. The word *interpretation* is here used to mean the material or events provided around exhibitions to aid the understanding of and debate on the art itself. The term therefore includes labels, interpretative panels, print materials, Web sites, modes of display, art tours, and debate both online and offline. *Interpretation* is therefore used to cover the role of "context provider"—a role broader than the "education" department of a museum. It refers not to a particular didactic approach to discursive material, but to the full range of contemporary educational strategies, including open discourse. In arts organizations, these interpretational roles are highly variable, ranging from being seen as a kind of marketing concerned with "engagement," to full curatorial roles. See Carbonell 2003, Hein 1998, Hooper-Greenhill 2003, MacLeod 2006, and Ravelli 2006.

2. This issue is expanded on in Graham 2007b and in Graham and Cook 2001.

3. In 2004, a report commissioned by Arts Council England (North West) compared the content of European and North American contemporary curating courses (Graham 2004d).

4. Nina Pope and Karen Guthrie (2001) describe this project from the point of view of "being curated."

5. "Tagging" is an electronic means of labeling an item online to indicate that the item is something the user thinks is worth looking at and wants to share with other people. Tagging can also involve putting items into categories; for example, the Web site del.icio.us is a collection of people's lists and categories of Web site bookmarks. TAGallery by CONT3XT.NET (2006) uses tags on del.icio.us explicitly to curate an exhibition.

6. The notion of an exhibition efficiently transmitting knowledge without human contact is a dated idea, as Julia Noordegraaf states: "In the post-war museum the idea was to fully incorporate

visitor guidance within the displays so as to render human intervention redundant" (2004, 217). Even those artists primarily known for online exhibits are not averse to live interpretation in a gallery—for example, the exhibition *010101* (2001) at SFMOMA, where some Net artists talked through their sites live at the museum. The talks were recorded, and the screen actions were logged, so the exhibition Web site includes a "Sitestreaming" section where the audience can watch the artists clicking through the screens and commenting on the artwork (Graham 2002a, 39).

7. JODI's artworks involve software that often disrupts the appearance of a computer's operating system; for example, the "desktop" screen and widows appear fragmented and move around (see http://wwwwwwwww.jodi.org/). "Netochka Nezvanova," or "nn," is an entity (possibly a group of people) said to have made the software Nato.0+55 used by artists to manipulate sound and images, and is famous for interventions in online discussion lists.

8. David Dernie's 2006 book *Exhibition Design,* for example, does an admirable job in collecting high-quality installation shots of exhibitions, including some using new media, but the commentary moves between examples of interpretation displays ranging from natural-history museums to Lyotard's exhibition *Les Immatériaux* (1985) without analyzing the differences in design that might be demanded for very different exhibition content. Michelle Henning, from a background in cultural studies, is one of the few authors to include examples of new media art (*Cybernetic Serendipity* at the ICA) in her book *Museums, Media, and Cultural Theory* (2006). The CRUMB Web site has gathered together some scattered resources on the display of new media art, and the CRUMB discussion list has discussed the subject on several occasions.

9. A growing body of case studies, however, addresses display strategies—for example, the installation examples on the CRUMB Web site and the detailed comparison of the many versions of Martin Wattenberg and Marek Walczak's *Apartment* (2001–) in Ippolito 2008a and Paul 2007. Tom Cullen (2009) offers advice on the installation of sound works, including the use of directional speakers. Again, like the technical needs of new media, the technical needs of sound may also be invisible to even an experienced visual arts installer. The sound levels required during a busy exhibition opening, for example, will be very different from those required the next day, when artists may not be around to ask for a sound check.

10. The discussion around the theme "curating sound art" on the CRUMB *New-Media-Curating Discussion List* in March 2002 is particularly illuminating with regard to how this knowledge is useful for issues of displaying any immaterial art.

11. There are numerous guides to commercial screen display and guides for successful museum interpretation Web sites. The grammar of screen-based display to some extent works both offline and online; for example, various museum collections were digitized and available in database form offline before they were available online. One interesting finding from an art museum Web site study was that if images were available on a screen, then it didn't appear to be important whether those artworks were on physical display in a building: "The vast majority of visitors want to know what is on view at SFMOMA regardless of whether the artwork is part of our collection or part of a temporary exhibition. . . . The insight: most visitors do not intuitively understand the difference between 'collections' and 'exhibitions' and are confused by those categories as they are presented on the current Web site. While this distinction may be important in the museum world, the majority of our visitors don't know or care about it" (Mitroff 2007).

12. There was a great deal of debate in the 1990s concerning the way in which "virtual" digitized images of art objects might somehow compete with or detract from actual objects (Hoffos 1992; Hoptman 1992; Lees 1993). One of the early accessible digitized collections was the Micro Gallery at the National Gallery in London beginning in 1991, which was seemingly regarded as something to be handled with care: "It is regarded as a facility to help visitors explore the collections through the provision of additional information, but the siting of the Micro Gallery apart from the collections means that it does not detract from the pictures, and visitors must make a conscious decision to visit it" (Fahy 1999, 91).

13. Software can also track where people are logging on (through the suffix ".uk" for the United Kingdom, ".de" for Germany, etc.) and from what kind of institution (through the suffixes ".edu," ".org," ".com," etc.).

14. Again, the analysis of Web site user data in the art world has primarily been for interpretational art sites, and the method focuses on number of visits, number of unique visitors, and duration of visits (Deshpande, Geber, and Timpson 2007, 276). Artists, alternatively, have been at the forefront of understanding and satirizing the kinds of data gathered by Web sites. Christophe Bruno, for example, measures the costs of Google advertising words against the popularity of clicks (*Picasso,* for example, is a much more popular and more expensive word than *Ćosić*), and describes "how 12,000 people saw my 'poems' in 24 hours" (2002).

15. The issues are complex: for example, with the exhibition *010101* (2001) at SFMOMA, there was a case where questions of "usability" were inappropriately applied to a Net art piece (see chapter 8); conversely, although the interpretative Web site for the exhibition won design awards, it was rather difficult to navigate and had to be amended after the launch so that users could more easily find a way in and locate the Net art within the site (Graham 2002b, 34–39). If a Web site is the only venue for Net art, then the usability of that Web site becomes the equivalent of an "accessibility" issue for a building, and the physical equivalent would involve putting the Net art in room with a closed blank door.

16. A broader review of findings from formal audience research is available from Graham (forthcoming a). Debate is currently raging around the crossover between quantitative methods for product design and qualitative methods from the arts and humanities. Bill Gaver's "cultural probes" and "ambiguity as a resource" (Gaver 2006; Gaver, Hooker, and Dunne 2001), for example, sit in contrast to science-based human/computer interaction traditions. As Caroline Schubiger explains, "Interaction design is taught at art colleges, which shows that it is not an exact science based on structured processes and testable methods" (2005, 346).

17. Additionally, ethnographic research on the public artwork *Under Scan* (2006–) by Rafael Lozano-Hemmer emerged with useful findings, including average use times of around twenty-one minutes and interaction patterns that moved from observation to interaction and discussion between participants (Mounajjed 2007; Mounajjed, Peng, and Walker 2007).

18. Formal research on the production of art has been very useful to those working in cross-disciplinary laboratories and collaborative production, as discussed in chapters 9 and 10. In particular, they have succeeded in translating between the designers' traditional prototyping-with-feedback method and the play-test-observe-iteration method more familiar to artists, which in turn affects audience study (Hook, Sengers, and Andersson 2003; Perkel, Shaw, and Niemeyer 2006).

8 Curating in an Art Museum

Since net art has been created to be seen by anyone (provided they have access), anytime, anywhere, it shouldn't just flow above, beneath and around the institution but also through it. Museums/galleries are just one of the possible contexts for this art.
—Christiane Paul, "Re: Showing It: Two Case Studies," 2001b

Museums[1] are, of course, just one of the ways in which curators go about showing new media art, and we describe some other contexts in subsequent chapters. Both Christiane Paul and Barbara London, curators at art museums, see themselves as just part of a network of contexts and ways of working. "I don't think the most important issues facing Web and media art today have to do with large institutions dwarfing smaller ones or larger institutions being closed," states London. "We still need different contexts, which help articulate what Web art is about. We still look for work that goes beyond the technology. People still need each other, for sharing information and adding insights" (2001b).

Other curators, however, may disagree. What we are discussing here are practical issues for contemporary art-exhibiting institutions that are large enough to have several curators who select work, and bureaucratic systems. This chapter therefore examines the ways in which new media art may challenge those systems, whether by crossing departmental boundaries or by changing the timescale of the ways of working.

One obvious role played by art museums is that of historicization, and the previous chapters have suggested a variety of histories for new media art. As Roger Buergel says, any art form should beware "the loss of historical references. For the museum this has dire consequences if you are unwilling to supply these references" (in Buergel et al. 2006, 33). Because the "problem" of collecting new media art is often raised in relation to why institutions don't exhibit new media art, this chapter also includes examples of how collections of new media art have been started, preserved, and exhibited.

Why Would a New Media Artist Want to Exhibit in an Art Museum?

My mum is so proud! [Laughter]. I've had a show in every museum that she's ever heard of!
—Vuk Ćosić, in Sarah Cook, Beryl Graham, and Sarah Martin, eds., *Curating New Media*, 2002

A caricature of an art museum portrays a large institution that is inherently slow, conservative, building-bound, and, well, "institutional," so why would any self-respecting new media artist want to exhibit there?[2] Wouldn't new media art be more comfortable existing in research labs, science museums, festivals, or purely online? As retired Net artist Vuk Ćosić jokes, despite the many good reasons for seeking alternatives, museums are to some extent a "seal of approval." Art museums have large publicity budgets, a wide public (including Vuk Ćosić's mum) has heard of them, and they are where people go to find art. They offer interpretation for both the bemused and the expert, and they also represent a time slot and context for viewing art. They are warm and well lit, and sometimes have free broadband connections and computers that work. Most important, they have publications, documentation, and collections—they are where art history is made. Why *shouldn't* new media art be included in them?

A major problem for new media art is that those in charge of what will and what won't be included and hence historicized are rarely aware of the full range of contemporary artwork. As explored in chapter 2, time still moves slowly within museum structures; many curators are art historians, and so anything new struggles for admittance through the gates: "In the strictest sense, gates represent systems of willful ignorance (by and large) towards that which is not already on the guest list at the door. . . . Artists, producers and curators that find their way through doors/gates successfully on their own, rather than waiting for an invitation, are perhaps the best candidates to be checking the list at the door," states Kathleen Forde (in Fleischmann 2003, 369). Gatekeepers may have the particular problem of identifying new media art *as art* rather than as technology or science in the first place, and once the new media artwork is in an art museum, there is the danger that the history, meaning, and ethics of its original technological context and process may not be understood. In London in 2007, the only new media art permanently exhibited in a physical gallery space resides in the Science Museum,[3] so although the work is exhibited well, there is the reverse danger that art histories and contexts may be lost.

The desire for institutions that understand the meaning of both art and technology has led to a growing number of specialist media art institutions, such as FACT in Liverpool and ZKM in Karlsruhe—the former without and the latter with a collection.[4] Beyond the task of providing buildings with the right facilities for new media, these institutions bear the burden of exhibiting, historicizing, and discussing the critical subdivisions within the field, including the division between video and other new media. A tension between the media specialist and the generalized contemporary art expert, however, still exists. In a parallel situation, more than a century and half after photography's invention, there are still a range of institutional conditions for it: specific photography galleries; institutions that include photographic exhibitions as part of a mixed art program; and contemporary art institutions that do not think photography should be included in art and have never shown it unless as a document of other art. The condi-

tions experienced by new media art mirror those experienced by photography in that it is questionable how many contemporary art curators will visit any media-specific institutions (or media art festivals or events). In theory, contemporary art institutions cover all kinds of contemporary art, but in practice they often don't.

The caricature of the art museum, however, may present more barriers to new media art than the actuality. Museums are changing, albeit slowly. A large amount of curating literature can be condensed as follows: the pressures on the modern museum have moved from traditional gatekeeping connoisseurship, exhaustive collecting, and linear historical displays to responsiveness and inclusiveness, even of a little of the new. According to Karsten Schubert, the movement is "from static-monolithic to the dynamic-temporized" (2000, 135). Museums, via their educational remit, are starting to take on heteroglossia and offer both art and information as a public resource. The characteristics of new media have been identified as being eminently suited to facilitating this dual role: we may now have "a museum that, as in ancient Alexandria, also functions as a library that has not gone through the modern split between texts and images, libraries and galleries" (Kittler 1996, 73). In this context, the eminently dynamic and temporalized field of new media art might even find itself in the middle of the flow, the discourse, or the platform rather than being kept outside by burly gatekeepers.

Even institution insiders sometimes find themselves locked out after they have tried something new. The institutional model in which new media art is included as part of a mixed art program tends to come about because of a particular curator's knowledge rather than because of an institutional decision. As outlined in chapter 6, curators working with institutions can range from the embedded to the adjunct. However, for new media curators in particular, the historical progress has been anything but "static-monolithic," but rather more "involuntarily adjunct": the director of the Jewish Museum lost his job a month after the exhibition *Software* (1970) closed; David Ross left SFMOMA shortly after *010101* (2001); Steve Dietz found himself written out of the Walker Art Center's plans for a new building in 2003; the curator of Live and New Media Art at the ICA in London found her department closed and her job made redundant in 2008.[5] As Julian Stallabrass comments in chapter 2, the peculiar twists and turns of the false dawns and lost histories of new media art mean that there is little opportunity to make the most of what the art museum has to offer—the slow chewing over of art to digest it into history. As contemporary art curator Maria Lind comments, many freelancers welcome the chance to work with the particular rhythms of institutions and to take "a slower, and in that sense maybe more digestive, approach" (in Buergel et al. 2006, 33).

The process of historicization, therefore, is not a smoothly organized monolith, but a hiccupping hype cycle written, as histories are, largely by the victors and depending very much on points of view about what an institution is. Beyond the monolithic concept of an institution, there are the questions of a more immaterial nature—questions of systems rather than buildings and of the software of curators, managements, and ethics rather than the hardware of the venue.

The Building or the Immaterial Systems?

Museums are about real estate—who owns it, who controls it, who shares it, who is allowed in but not made to feel welcome. Anyone who has ever worked inside a museum, particularly on an exhibition, recognizes this essential territoriality. . . . Metaphorically, that is where the virtual museum also resides—squeezed between publications, collections management and education, living on borrowed real estate.
—Selma Thomas in Steve Dietz and Scott Sayre, "The Millennial Museum," special issue of *Spectra (USA)*, 2000

The art museum may have its focus in real estate, but it is also about virtual estate, a factor that is often missed in institutional critique. If not exactly made to feel welcome, new media art has crept in—both in a physical sense and in terms of systems. It is occasionally found in lobbies and corridors (like an interpretative object), in seminar rooms (like an educational event), or via the Web site (like marketing/collections). At BALTIC Centre for Contemporary Art, Gateshead, United Kingdom, stairwells and other sites were for a period named as venues for an "interstitial programme," and, given this limited opportunity, Sarah Cook was able to curate Germaine Koh's *Relay* (2005–) during the Tall Ships Festival in Newcastle and Gateshead. This artwork took SMS text messages from cell phones, converted them into Morse code, and flashed an existing panel of lights on the outside of the building on and off. Small publicity cards informed the passing crowds of the piece, and a screen in the BALTIC building logged the messages as they came in. Physically, the work sat at the interstices of outdoor and indoor spaces, public and private, curating and front of house. It also moved between the junctions of invisible systems: Could an independent electrical circuit be found? Could a computer that usually worked the intra-Net administration systems be used? Who would publicize the work when the communications department was instructed only to publicize shows in the galleries? Above all, where did the project fit in the financial and administrative systems?

These issues are common to many new media art projects in institutions, and the ability to curate the work often lies in the ability to negotiate between systems, people, and sites—with curator as a systems jockey, a networking host, a translator, and a redistributor of institutions' substantial resources to guests. Artist Lisa Jevbratt neatly captures the gaps between the positions of "hosts, guests, and parasites" in describing the position of new media art within an institution: "Each agent (institution, human, computer, system, sub-network, datum, etc.) within a 'network' can be described as a mingler, at any given moment the mingler exists on a continuum of three categories: hosts, guests and parasites. . . . Art occurs in this complex interplay of mingler categories and permissions, i.e., art is the constant motion along the inviter/invitee/non-invitee continuum and the manipulation of permissions" (in Dietz and Sayre 2000, 46). Matthew Fuller has also described the mongrelly nature of living and working in the interstices without becom-

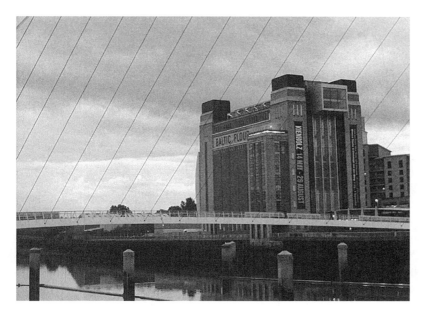

Figure 8.1
Exterior shot of the BALTIC Centre for Contemporary Art, showing Germaine Koh's *Relay* (2005–).
Photograph by Germaine Koh.

ing embedded in the institution: "For artists working via the net to now involve museums as one of the media systems through which their work circulates, what is crucial is . . . to attempt to establish, not a comfy mode of living for the museum on the networks, but a series of prototypes for and chances at something other and more mongrel than both" (2000a).

As discussed in previous chapters, in terms of physical buildings, efforts are being made to experiment with spaces more conducive to the regular appearance of media art, and the time schedule for curators working with process-led new media art may differ from what it was previously. Conceptual systems, however, are taking longer to change, which might mean adjustments to administrative systems for design or for exhibition scheduling. Conceptual systems are also plainly reflected in the names of departments: Barbara London started at MoMA New York in the International Program, then moved to the Department of Prints and Illustrated Books, and then to the Department of Film, which became the Department of Film and Video, then the Department of Media. She is an unusual case in managing departmental change and enjoys the state of flux, while acknowledging that this state may not last long: "Right now the art world is unfocused. Web art and media art are fresh and vital, and artists can take advantage of this open situation. Before too long the Web will probably become more like television, which

means closed. The time is now" (2001b). Her curatorial work is led by her interest in following the art, and as the art evolves, it challenges conceptual categories, as art will. Institutional departments may later come to reflect this evolution, but each new department gradually becomes a closed system, leaving new departmental boundaries to be crossed in order to facilitate the art.

Working across Departments

The whole show had this sense of blur to it, that was really nice in terms of curatorial blur, in terms of chronological blur, in terms of media blur, and in terms of the way pieces were either newly commissioned or loaned. I think that, to me, was the strength of the show; that it developed.
—Kathleen Forde on *010101*, in Beryl Graham, *Curating New Media Art: SFMOMA and 010101*, 2002a

This book has mapped how new media art crosses traditional boundaries of space, time, media, taxonomy, and disciplines. It has also been mentioned that collaborations across disciplines, although exciting, are prone to "the anxiety of interdisciplinarity" (Coles and Defert 1998). Joline Blais and Jon Ippolito identify in their book *At the Edge of Art* (2006) six "functions" of new media art, based on the biological behaviors of antibodies or viruses. Although these functions might engagingly describe the particular behaviors of new media, the crux of the problem with placing new media art in an art museum is that both curators and institutions are notorious for their "boundary issues." Some curators like things neatly in discrete vitrines; some institutions fight internal territorial wars. If new media art behaves like a virus, then many curators will be personally glad to cleanse the foul contagion, and some institutions would be relieved to secure the departmental firewalls before it spreads and hybridizes. There are, of course, exceptions to this tendency, which serve to underline the ways in which new media art can push the boundaries not only between curatorial departments, but also between all departments of an institution.

Example: 010101, *San Francisco Museum of Modern Art*
In a move described as "utopian," SFMOMA director David Ross instigated an exhibition of "art in technological times" to be curated across four curatorial departments: Architecture and Design, Education and Public Programs, Media Arts, and Painting and Sculpture. The exhibition, *010101* (2001), included artworks by John Maeda, Anton Gursky, and Shirley Tse, as well as Net art commissions by Thomson & Craighead and Mark Napier, therefore including both new media and non–new media artworks. In a research study of the differences in institutional structure demanded by this show, when interviewees were asked about their roles, the word that recurred most often in their descriptions was *blur:* they were "exploring how architecture and design was to be integral to this show, exploring the blurring boundaries between the various forms of cultural expressions; making a point about how increasingly difficult it is to delineate," stated the Curator of Media Arts Benjamin Weil

(Graham 2002a, 11). There was no "lead curator"; curatorial staff made some shared re-
search trips; knowledge was shared between the curatorial departments; and the hierarchy
was slightly disrupted by the curatorial associates (including Kathleen Forde) having more
input into selection and events than was usual. Curators commented on and cross-selected
some artworks from other departments, such as video, but there was admittedly less cross-
ing over when it came to Net art, which was the least familiar and least material art form
(Graham 2002a; subsequent page citations in this discussion refer to this source). Weil
commented,

I don't think that my fellow curators were feeling that comfortable with trying to establish criteria for
understanding what kind of (net based) work should be included in the exhibition. We still are toying
with the kind of criteria that we wanted to use in order to understand what we're looking at, and to
start establishing some kind of judgment about it. So I think that they first thought that we could sort
of work on all this together and I could show them things and they can tell me what they think is good
and what they think is bad. Then it gradually became more obvious that there was a time issue, and
there was also something about the fact that yes, I was comfortable with all those things because I had
worked with this long enough and could start instinctively saying what I was interested in and what I
was not interested in. (94)

Blurring occurred not only between curatorial departments, but also between roles and
even between artwork and signage: the Graphic Design Manager commented on a blur
between what was part of the artwork and what was signage (11). In particular, publication
and interpretation involved several personnel: "The line here at SFMOMA has gotten very
blurry between the editing, and the trafficking of content, and the production of the con-
tent. And we've taken on a lot of responsibilities in the wake of this on other shows as well
in kind of participating in that process," stated the Managing Editor of Publications, Chad
Coerver (11).

Because of the SFMOMA Web site's increased role as both interpretation and exhibition
venue for Net art, the temporary additional freelance posts at the museum included a Di-
rector of Web Content. The Web site designers and the exhibition designers were, very un-
usually, the same company, Perimeter Flux, which helped to establish the Web site as not
purely interpretational, but caused some confusion over new departmental relationships.
There was a great deal of debate about the position of the Net art commissions within the
exhibition Web site, and it was decided that those commissions should be omitted from the
Web site terminals in the gallery and should be made available only via the Internet.

Within the museum, departments that were not usually directly involved with exhibitions
at all were now involved because of new media. The Department of Information Systems &
Services was integral in setting up the proposed wireless communication system, but was
omitted in the catalog credits and suffered other communication problems due to their not
being a usual part of the exhibitions system (14). Even the registrar's job was made more com-
plex because of materiality—or lack of it—in the objects being shipped, especially in the case
of different versions of software and in the case of electronic equipment coming from abroad,
which was difficult to clear through customs as art rather than as merchandise (29).

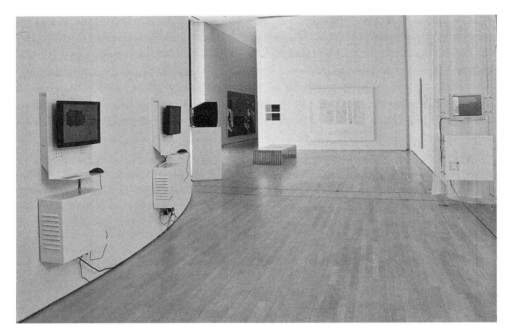

Figure 8.2
Installation view of the exhibition *010101: Art in Technological Times* (2001) at SFMOMA. *From left to right:* two "Web stations"; Euan Macdonald's *Two Planes* (1998) on video monitor; Chris Finley's *Goo Goo Pow Wow* (2000–2001) in far room; Kevin Appel's *House Revision* (2000–2001) on the wall; and a "Think Text" screen. Courtesy of SFMOMA.

The challenges of working across more departments than usual, with more communication needed between more people, fell mostly on the Director of Exhibitions and Project Coordinators. Particular challenges included the event-based or durational nature of some of the new media artworks: inventing administration systems for tasks such as booking appointments for Char Davies's virtual reality artwork and dispensing the video cameras for Janet Cardiff's audio/video walk (17).

Working across curatorial departments demands the sharing of concepts as well as the physical gallery territory—immaterial things such as shared critical vocabulary and, of course, knowledge of the art itself. Working across wider departments, including front of house and building systems, also demands immaterial systems of good communication and development. It is sometimes assumed that being able to show new media art hinges on stacks of hardware. The hardware, however, cannot function without an understanding of the systems. In reality, a building may be immaculately wired and stuffed with kit, but if the systems of people and knowledge are not in place, then all is for naught.

Down in the Technical Department

I am alone as a curator of new media, but we don't have watertight distinctions between curatorial groups at the museum. We work collaboratively quite frequently. There is one technician who is trained in this area, Johan Larje, and he is also responsible for the storage of film and video. And then there are two other AV technicians; one is more focused on computers and the other is more focused on sound.

—Magnus af Petersens in Elna Svenle, "Interview with Magnus af Petersens and Ulf Eriksson," 2006

In the United Kingdom, technical departments of museums are all too often "below stairs," crammed into dank basements, and their staff are rarely encouraged to take up training or development. As with the exhibition design departments already described, technicians may be outsourced rather than accepted as an important institutional responsibility. Certain expert areas may need to be outsourced, but curators will still need to know enough to determine when to outsource and what kind of expert might be needed. Curators with a delicate discrimination between gesso and impasto may lump carpenters, electricians, and audiovisual technicians roughly together in their minds. Otherwise intelligent directors of art museums might fully expect one information technology technician who looks after word-processing PCs also to manage a network, work with artists, program software, and install video projections—simply because of a lack of awareness of the different skills that these tasks demand.[6]

At SFMOMA, the relationship between the technical and other departments has been a good one, building up from a base in video into new media. Both the exhibitions technical manager and the exhibitions design manager have been encouraged to develop new skills and have attended the "Digital Preservation Seminars" and "Tech Archeology" events organized by the conservation department: "Regarding the technical specifics on electronic media, I would say that we defer to our technicians for most of the expertise and, together, we apply the methodological thinking" (SFMOMA head of conservation in Graham 2002a, 54). Even with a well-integrated technical department, however, there are interdisciplinary communication issues to unravel. As stated, an information technology technician is not an audiovisual technician, is not necessarily used to working with exhibition designers or artists, and is often the newest member of exhibition teams. In the interests of "security," the intricacies of network servers, streaming, and IP address numbers may be closely guarded in an institution and often puzzle even the best existing audiovisual staff.

SFMOMA was, of course, not alone in making the jump from video and struggling with starting up invisible systems, but it was unusual in having a curator who knew about servers and networks, Benjamin Weil. Artist Adam Hyde pointed out at a seminar at Tate Modern that the Tate, for all its contemporary architecture and facilities, did not have a dedicated network technician, and he asked how many curators knew what "open source" actually meant (Tate 2001). The crucial question of how much technical knowledge curators need has one answer in particular: if an institution can keep a

well-integrated set of technical staff and invest in training, then curators need not be their own technical experts. Again, exhibiting new media art in an art museum necessitates good communication, cross-disciplinary collaborative teams, and the consideration of departments that are not often considered in relation to curating.

Marketing Departments—Sponsorship or Interpretation?

In the small show that I curated at Tate Britain, *Art and Money Online*, the sponsor, Reuters, insisted on changes to the text in the exhibition booklet to better advertise their involvement, and I was surprised to see at the opening a wall panel, entirely new to me, not only praising the company (which is to be expected) but also putting Reuter's own interpretation of the show (which was blander, more optimistic and more enamored with the wonders of new technology than my own).
—Julian Stallabrass, *Internet Art: The Online Clash of Culture and Commerce*, 2003

As described in the previous chapter, interpretational or commercial new media tend to be confused with new media art, so it is particularly important that interpretational material is clearly just that. As also described in chapter 2, there is an additional crossover with commercial new media, and, as a result, curator Matthew Gansallo found himself wrangling with the Tate marketing department over the use of the institutional Web site for Net art. With immaterial projects such as Net art, each bit of publicity is particularly important for gaining informed audiences and providing context, so it is correspondingly important that marketing departments understand the audiences and the subtle distinctions of the artwork. In the case of curator Julian Stallabrass and Reuters, however, two additional factors are particular to new media art—the cost of the technology (in this case the prohibitive cost of the stock-market data feed used by the *Black Shoals* artwork described in chapter 4) and the meaning of the technology itself. Big institutions put on big shows that tend to need big money. This does not, of course, apply only to new media art: even the most radical exhibition, Harald Szeemann's *When Attitudes Become Form* (1969), was funded by Philip Morris Europe. As Bruce Altshuler wryly notes, it can even be argued that the smoke-filled rooms of avant-garde endeavor were where the medium met the message: "After all, apropos of Philip Morris, they all smoked, and packs of cigarettes were given away at the opening. But if the artists were amused by the fact of corporate support for an exhibition of radical work, in the end the forces of the cultural establishment were to have the last laugh. Works that were deemed noncommercial soon would be sold and resold in a growing international market" (1994, 254–255).

However, with new media art, the technology is the means of production and display, and has a strong cultural meaning all of its own. The big technology companies that produce hardware and software are the military postindustrial complex writ large, which has a political meaning: "elements of the Art World tend to see latent fascist aesthetics in any liaison with giant industries; it is permissible to have your fabrication done by a local sheetmetal shop, but not by Hewlett-Packard" (Burnham 1980, 211). Regina Cornwell is

highly critical about the role of technology in art museums and scathing that former Guggenheim director Thomas Krens should state that "the only way museums can consistently develop and present multimedia and high-technology exhibitions is through collaborations with organizations like Deutsche Telekom which have a broad range of resources and expertise" (in Cornwell 1996, 12). This perceived dependency on the sponsors because of the expense of the equipment of course applies only to certain kinds of new media art—one of the triumphs of Net art is that artists can create it at home on an inexpensive computer. Institutions often seek equipment in kind, but technology companies are jealous gods, and an institution can find itself locked into an exclusive relationship, whereas artists need the option to use any media necessary. In London, the ICA was in a relationship with Sun Microsystems, who—understandably—wished to showcase its high-end PCs, so the incoming media art curator was faced with the task of finding artists who might want to use that particular equipment (Dewdney and Ride 2006, 59–67). Art museum directors seem just as prone as anyone to a bit of technological hype and spectacle, which ironically is a key argument for why museums need more expert new media curators: the more one knows about technology and what artists are doing with it, the less likely one is to believe the hype. Art museums need specialist new media art curators in order to stop the directors or trustees from being persuaded to buy expensive media that have yet to be proven as artistic tools.

The word *expertise* in relation to the Deutsche Telekom case also points to an area of difference. Here, the sponsor is not simply stumping up cash or hardware (a distanced relationship with which museums are familiar); it is offering "expertise," and this offer may be hard to refuse. The SFMOMA exhibition *010101* was not sponsored by Intel, but rather "presented by Intel." Intel had developed a relationship with the Whitney Museum of American Art over some years, producing accomplished interpretational Web sites for exhibitions including the *Bill Viola* (1997) show. The difference with *010101* was that the Web site was the sole venue for the Net art in the exhibition, as well as being the venue for interpretation and publicity. At a meeting that was looking at the Web site, a representative of Intel commented on usability issues. Such comments might have been part of the system of expert comment for an interpretational Web site, but in this case concerned a piece of Net art and hence concerned curatorial and artistic aspects usually outside a sponsor's role. Here, the blurry boundaries of new media art as well as the uncomfortably blurry boundaries between "sponsor" and "expert advisor" caused some confusion (Graham 2002a, 32).

If the role of "expert" is taken to a logical conclusion, then the working models are more like sponsored artists-in-residence at research and development organizations or interdisciplinary "labs," as explored in chapter 9. The trouble with sponsors who are too closely connected with new media systems is that they have opinions about the technology (as in the case of Reuters) or about the interface (as in the case of Intel). Readings of technology change the meaning of the artwork, and changing the interface changes

the artwork, too; hence, institutions showing new media art must take special care to ensure that they are showing the artwork rather than the technology at its best. Back in 1970, Jack Burnham rejected an offer from IBM to pick up the tab for all the software and hardware for the exhibition *Software* (1970) in favor of a collection of smaller in-kind sponsors and a more distantly related major sponsor, American Motors (Burnham 1980, 206). A little more distance in a relationship is perhaps what new media art and its sponsors need.

Documentation and Archiving

Archiving is closely connected to evaluation. This museum practice is what happens generally after works have been exhibited in galleries or online etc. . . . Now museums of modern art archive the processes of contemporary commissioning, presentation and appreciation of the arts too—"as they happen."
—Sarah Thompson, "Re: Curating Critically," 2002

Even if institutions do not have a collection, they usually document past exhibitions in some way, filing away some combination of publicity material, catalogs, press clippings, educational event documentation, installation shots, correspondence, and items without a taxonomical home to go to.[7] The BALTIC Centre for Contemporary Art, for example, has an excellent online public archive that logs textual and audiovisual material from all past events and lists the collection of public material available in the physical library space. The library is a recurring metaphor for new media art. Librarians are excellent at keywords and categories (the "metadata" by which other data are organized) and good at dealing with new or unusual forms of data.[8] Again, however, the lines between departments are blurred when it comes to new media art: with art institutions' Web sites, the choices for public access to documentation are often left in the hands of marketing departments, which usually focus on Web sites purely as a publicity tool, so that only headlining blockbusters tend to get listed under "past exhibitions" and the past is edited to reflect current tastes.

As Sarah Thompson mentions, the whole question of what to document and archive is accelerated by new media, but a useful thing about new media is that in some cases the media can document itself "as it happens" because materials placed on the Internet by users are to a certain extent stored there. As Katie Lips commented concerning the social media *Bold Street Project,* which uses a combination of Web site, blog, and Flickr sites to gather materials by many participants, "It's messy, but it documents itself" (2007). Caitlin Jones (2008) has also pointed out that although the painstaking formal work of a few archivists ensures accuracy, the many people documenting art and performance on Web sites such as Flickr ensures a collection of documents with many points of view, forms a backup if something goes wrong with the official documentation, and makes the substantial time burden of documentation much lighter. The question of how much of the

wider cultural context to archive is a key issue for new media art. The Capturing Unstable Media project at V2_ in Rotterdam took a particular interest in software art, and Sandra Fauconnier comments that

having followed the field of tech-oriented arts for quite some time now, I'm very much convinced that what we "should" try to preserve, are the many diverse histories (plural) and perspectives and the context or cultures in which we are all working now. How can you ensure that (as a random example) it'll be possible to still understand the meaning of a work like *Carnivore* (RSG) within 50 or 100 years or longer? Or the impact of mailing list culture in our field in the late 1990s? This calls for better—open, low-barrier, accessible—archival and documentation strategies. (2005)[9]

The default solution for documentation of context has been to put it into text, whether online or offline, but the tradition of the printed exhibition catalog as the place where documentation is gathered together for posterity presents some problems for new media art. As is often the case for new media art, the final form of a commissioned work is sometimes not available in time to be documented for a catalog. Some institutions have produced post-exhibition publications in order to get around this problem. Other art forms have also struggled to be adequately represented in catalog form; video installation, for example, struggles with the traditional installation still photograph. A good example is the catalog for Eija-Liisa Ahtila's work, which by including detailed installation diagrams gives a much clearer impression of the artwork and how it functioned (Hirvi 2002). The publication about Rafael Lozano-Hemmer's *Under Scan* (2006–), an interactive new media public artwork, goes further in including photographs of work in progress and interviews with audience members and users. The catalog is also unusual in being coedited by the artist and for including moving images on CD or DVD (Lozano-Hemmer 2007). Such tactics can give a much clearer document of many nonstandard art forms, from installation or public art to performative or interactive artwork. Of course, the updatable Web site is another option for a "catalog," but then the Web site itself needs to be available to future researchers.

Concerning the finer detail of what becomes documented in a museum, a problem common to any process-based, event-based, time-based public art or interactive artwork is that of photographic documentation. These photographs are traditionally well lit and composed, and, like some architectural models, are eerily empty of people. For any participative work, this approach means that substantial explanations of the kinds of interaction need to be kept with the images; otherwise, future researchers are left with a puzzle. Take the example of Germaine Koh's *Relay* (2005–), described earlier in this chapter. A photograph of the outside of the BALTIC building would not even communicate the fact of a flashing light, much less indicate Morse code was being used. A video would be able to document the flashing rhythm, but would be able to communicate the interaction only if people were included, sending in text messages from their cell phones and seeing them relayed. Even then, extra documentation would still be necessary to decode the messages and to explain fully the hidden software and systems necessary to install

the piece. New media, however, offers many solutions for combining media to document any artwork fully, even to the extent of reconstructing, reinterpreting, and reenacting an artwork, as Lynn Hershman Leeson did in the three-dimensional graphic world of Second Life, described in chapter 4. The kinds of documentation that most thoroughly address new media art have yet to become standard in art museums, but the convergence of knowledge from librarians, publishers, and educators is starting to find solutions. Again, the new ways of working suggested by new media behaviors is reflected in the crossover between roles, not least of which is the blurring of the line between documentation and collection.

On Collections

Push (senior) curators on this point, and beyond issues of new media art being non-collectible, ephemeral, decontextualized, open ended, and difficult to preserve; beyond frustration with not having the right plug in or the computer being "down" when they were at an exhibition; they will finally admit two things: never having seen new media they thought was really great art, and not knowing anyone who collects (buys) new media art.
—Steve Dietz, "Collecting New Media Art," 2005

Concerning the relationships among documenting, collecting, and displaying new media art, the previous chapter has already outlined a convergence among the database software that can be used for all three. New media art can therefore be regarded in some ways as a "natural" for collecting, but, as Steve Dietz comments, collecting it is for some reason regarded as a mysteriously insurmountable obstacle. Nevertheless, people do go out and buy the "noncollectible." In the case of commercial galleries, Postmasters in New York has been selling new media artworks alongside other contemporary artworks since 1996. The exhibition *On and Off* (2006) at the Bryce Wolkowitz Gallery in New York included work by Vuk Ćosić and Thomson & Craighead, and sold almost every artwork (in short-run editions), despite versions of those artworks being freely available on the Internet. The gallery also sold works to major collectors at the SCOPE art fair in Miami. Buying new media art is therefore slowly entering the mainstream markets (C. Jones 2007). In fact, artists have recognized the Internet's marketing potential for some time: Cory Arcangel, for example, gives code away free, but also uses his Web site to sell versions as editions and sells posters cheaply (C. Jones 2005a, 11). New media art probably doesn't sell as well as painting in the global economy—then, neither does video—but that doesn't mean it can't sell at all. Private collectors such as Pamela and Richard Kramlich, for example, have purchased major video artworks that are installed around their home and have often lent them to art museums (Riley 1999).

Art museums are largely defined by their collections, but many have yet to start creating a collection of new media art. Steve Dietz points out that art museum collections have plenty of artworks that are conceptual, ephemeral, instruction-based, or perishable, yet these collections still don't include new media. He identifies two steps by which

the shock of the new might be chewed for a while before it is digested and illustrates how new media can radically question exactly how much context is documented and collected:

There was a two-step process for collecting new-media art at the Walker. It could be acquired for the Digital Arts Study Collection and then later accessioned into the permanent collection. This allowed me to collect work that I felt strongly about but which the institution was not necessarily fully equipped to deal with at that point. More important, however, the Study Collection allowed me to preserve work that provided a context for the artwork I was collecting, such as the *Art Dirt* webcasts, which included interviews with many of the artists in the digital art collection. (2005, 95)

Dietz's suggestion is one way of starting a collection, via documentation and a library metaphor. Another way of starting is by commissioning works for collection. In a report titled *Museums and New Media Art*, Susan Morris comments that museums were using three models for commissioning artwork and that these models tended to inform the contracts and purchasing agreements for the artwork: "1) an original, unique work of art, 2) an edition, or 3) a performance" (2001, 9). Thus, museums might purchase a whole installation (such as a Nam June Paik set of monitors and videotape), one of an edition (such as a videotape or a copy of software or a set of instructions), or a performance (which might range from buying the performance right for a Matthew Barney film to running a Web site for a certain length of time to paying for a live artist to appear). Institutions, therefore, already have variable methods for buying artworks and can adapt those methods to new media art accordingly.

Once a collection of new media art is started, then questions arise that are common to all "new" art forms. Barbara London has described how the MoMA's original collections policy had an "upgrade agenda" whereby artworks would at some point cease to be modern and would be deaccessioned, enabling the collection to "move through time like a torpedo." However, this policy failed to take into account the wider perspective of cultural context: "This prescription for change turned out to be inappropriate. The collection that came together at the Museum was more like a living organism than a torpedo. An appendage lopped off a growing body cannot be replaced by attaching something else. Only if the Museum bestowed the whole Modernist collection as one complete unit could the torpedo formula work. The transfer would have to include curators, literature and ancillary documentation—everything that reflects on the collection" (2001a, 98).

Museums are increasingly looking to develop "deep" holdings of artists' work from all stages of their careers. Individual curators often over time develop an interest in a particular artist's work and become specialists in that artist. This approach obviously presents a problem for new media art in relation to "the new": the artists are often younger and may change medium and hence be shifted from one museum department and curator to another. Curators with a special interest in new media may become, as described earlier in this chapter, "involuntarily adjunct." The relative lack of critical response, monographic shows, and provenance through collecting also conspire against "deep"

holdings. In addition, museums as well as private collectors have a sharp eye on the collection as a financial investment, and new media artists' works have generally not yet had the opportunity to accrue value through changing hands between collectors. Starting a collection is therefore not straightforward for new media art, but it has been done, and positive examples exist of how to provide both the collection and the context. Once such a collection is started and established, however, how then have curators exhibited artworks from it?

Exhibiting from a Collection

Having worked within a public art institution in Canada, I have seen how works from permanent collections are exhibited over and over within different contexts and how this process allows for a build up of critical and perceived economic "value" and layering of meaning.
—Rachelle Knowles, " Re: Curating Critically," 2002

Rachelle Knowles outlines how collections can explore depths of context and meaning, and context is of particular importance to new media art. Although working from collections is a traditional curatorial skill in art museums, these skills of layering are rarely called upon for new media art because of the lack of collections; nevertheless, interesting examples do exist. In curating historical exhibitions, new media curators have often used other approaches. For example, the exhibition *The Art Formerly Known as New Media* (2005) (described in chapter 1), curated to celebrate the Banff New Media Institute's tenth anniversary, did not comprise a retrospective of collected artworks specifically produced there, but instead highlighted new artworks by artists who had participated in previous Banff programs, drawn from a vast archive of documentation.

In 2005, Steve Dietz compared three collections and identified three different approaches to collecting and documenting: the Guggenheim Museum in New York, which has conscientiously researched a wide range of "variable media" across the art forms; the American Museum of the Moving Image, which has taken a media-object-based approach; and the Walker Art Center, which has integrated artwork collections with interpretational collections of context. These approaches tend to be repeated at other organizations, and if the institution is big enough, sometimes different parts of the institution use different approaches. At ZKM in Karlsruhe, there is a very interesting relationship between the Media Museum with its collection of interactive media art, and the nearby Museum of Contemporary Art with its collection of contemporary art. The collection of interactive media art is shown both in physical gallery spaces in a media-object-based approach and via documentation in the media library (as described in chapter 7), some of which is also available online via the Web site, along with interpretation. The Museum of Contemporary Art is the one physical space that also offers "selected works from private collections." Clearly, therefore, media art collections can be exhibited in both material and immaterial forms, but there are still differences in how collections are accessed and treated.

While curator of media arts at SFMOMA, Benjamin Weil was one of the few institutional curators to have negotiated a regular physical gallery space in a mixed art museum to show media art from its collection. At SFMOMA, two adjacent smallish gallery rooms showed both work from the collection and new works, such as those by Nick Crowe and Gary Hill, as "double features" (Graham 2002a, 10). For example, the exhibition *Double Feature: Paul Kos and Nam June Paik* (2001) featured two works from the permanent collection—Kos's *Tokyo Rose* (1975–1976) and Paik's *Egg Grows* (1984–1989). These two installation-based works usefully highlighted some historical time differences within media art, the two works being around ten years apart. Given this kind of opportunity, curators can begin not only to present comparisons across the history of new media art, but also to compare different kinds of new media art rather than present the single-artist show or the never-to-be-repeated blockbuster. Only in this way can the

Figure 8.3
From the exhibition *Double Feature: Paul Kos and Nam June Paik* (2001) at SFMOMA, Nam June Paik's *Egg Grows* (1984–1989) included eight video monitors, video camera, and an egg. San Francisco Museum of Modern Art, Accessions Committee Fund: gift of Elaine McKeon, Byron R. Meyer, Madeleine Haas Russell, and Mr. and Mrs. Robert A. Swanson. © Estate of Nam June Paik.

"layering of meaning" start to happen and the content of the new media artwork escape from the practicalities of time and collection. For this purpose, Weil considers that a hybrid approach is most useful and that small spaces are not necessarily a drawback: "I've started thinking of it from the standpoint of a much more experimental environment. So rather than saying 'I would like to curate large monographic exhibitions that will take place on the whole fourth floor of the museum' (which doesn't mean that I exclude that forever), it means that the core of my interest is a 'project' approach to things. . . . What I end up doing is not only using these two spaces but also using the web and the theater" (in Graham 2002a, 98).

Weil's successor at SFMOMA, Rudolf Frieling, has carried on making the most of a collection that includes new media and old media. His exhibition *The Art of Participation* (2008), for example, included at least two pieces from the collection: Janet Cardiff's *The Telephone Call* (2001), a video/audio walk originally commissioned for the exhibition *010101,* and Felix Gonzalez-Torres's *Untitled* (1992–1993), an endless stack of printed posters. The permanent collection acquired by SFMOMA's media arts department, like that of many institutions, is primarily of film and video. In 2001, it included around ninety artworks by approximately sixty artists—including Matthew Barney, Jim Campbell, Fischli and Weiss, Julia Scher, and Bill Viola. Unlike the curators of many institutions, however, the SFMOMA architecture and design curator Aaron Betsky also started collecting well-designed Web sites: thus, in 2000, e.space was launched—a section of the SFMOMA Web site that exhibited the Web sites acquired on CDs for the permanent collection. When Benjamin Weil joined the organization later that year, the project developed: by 2002, e.space had been redesigned under the aegis of the media arts and architecture and design departments to include the design Web sites and the new Net art selected by Weil; by October 2006, e.space had changed to include *only* the Net art. In 2007, the design Web sites could be found by searching the collections database of the Web site, but the Net art could not. These kinds of interdepartmental issues are typical of new media, as are the overlapping relationships between collection, online exhibition of the collection, and the physical display of a collection (as noted in chapter 7). The kinds of preservation issues raised by the display of Paul Kos and Nam June Paik artworks from the SFMOMA collection also signal another area of overlap—the conservation of a collection.

Conserving a Collection

Conservators have little choice but to accept variability as another aspect of their jobs, as most museum collections have vast holdings of installation-based works, film and video, and conceptual art—all of which are as variable and immaterial as any new media artwork.
—Caitlin Jones, "Re: Rhizome Opportunity," 2005b

Just as the purchase and collection of new media art are seen as problems, institutions also give the "problem" of conserving new media art as a reason for not engaging with

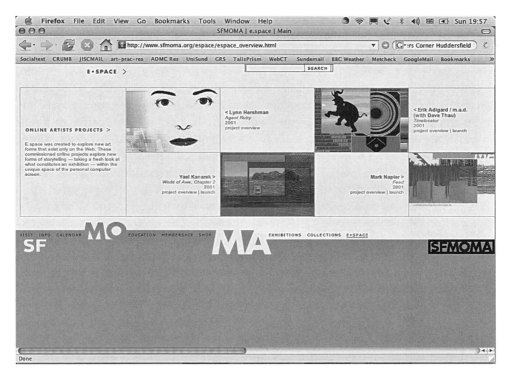

Figure 8.4
Screenshot from SFMOMA's e.space collection Web site, taken in 2007. Courtesy of SFMOMA.

new media at all. However, as Caitlin Jones points out, conservators are used to facing up to problems, and new media art *is* preserved.[10] The debate around the preservation of new media art has been crucial for the development of such art, not because everyone needs to be a preservation expert, but because the artwork, in order to be collected, also needs to be preserved and classified, and its most essential characteristics need to be discussed. These tasks are very much within the purview of the curator in an art museum, but an independent curator may not be trained to handle them. All of this imposes systemic changes on institutions: conservators need to talk to curators, artists, technicians, interpreters, documentors, and registrars; the very metadata of collection-management systems shift. As Richard Rinehart warns, "We could confuse 'preserving the past' with preserving our own past ways of doing things" (in Dietz and Sayre 2000, 69).

Most important of all, collections are where new media art might sit alongside other contemporary art. Members of the Variable Media[11] network in particular have been careful in their choice of words to make common ground in the preservation issues between,

say, Dan Flavin's fluorescent tubes and Mark Napier's Net art made from html code. Crucially, they consider not only the traditional "medium" factors, but also the "medium-independent behaviors" of the artworks that are reproduced, duplicated, interacted with, encoded, or networked. In considering the "preservation" of artworks, Ippolito describes four flexible options: *store, emulate, migrate,* or *reinterpret* (Ippolito 2003, 48–51). This range of options has been successfully applied to a wide range of contemporary arts and is able to deal with the characteristic new media habit of appearing in highly variable software versions and interface options; for example, the artwork *Apartment* (2000–) by Martin Wattenberg, Marek Walczak, and Jonathan Feinberg appeared in more than twenty variations in an eighteen-month period, including single or multiuser interfaces, on the Web, and in the gallery (Ippolito 2006, 2008a; Paul 2007).

Curator Caitlin Jones has perceived the "occupationally independent" nature of the preservation skills needed as well as the medium-independent behaviors of the artworks (2003, 61). Her Guggenheim exhibition *Seeing Double: Emulation in Theory and Practice* (2004) crossed the boundary between exhibition and collection, and her own role crossed the line between curator and archivist. The exhibition included artworks using highly variable old software that were successfully emulated using newer operating systems. The functions of hardware, too, can be emulated: *The Erl King* (1982–1985) by Grahame Weinbren and Roberta Friedman, originally used analog video laserdisks for a reactive screen-based narrative, but was lovingly re-created to run on digital hard drives, even down to emulating the leisurely response time of the original laserdisks.

Although many things can be emulated, it is sometimes necessary to resort to text. To reference issues that predate new media, "A Sol LeWitt wall drawing is re-created with new material each time it is exhibited. Each version is a unique 'performance' of the work that will vary from showing to showing within the parameters set by the artist. The materials may be unique, variable, or replaceable, but in all cases it is the artist's instructions that are the constant, conservable core of the work" (R. Perry 1999, 44). The Variable Media network includes a paper questionnaire as a means of gathering information from the artists themselves about the characteristics of the work that they think are the most crucial to preserve should "reinterpretation" be necessary. These factors are particularly important with regard to the invisible dynamics of interactive artworks. Conservators may be used to dealing with the immateriality of conceptual art and the variability of materials, but the documentation of interactivity is a particular challenge. The Variable Media questionnaire goes into some detail to obtain an accurate record of the artist's intent for interactive or participative artwork. For example, if audience members leave evidence of their participation, such as the notes on the wall of Ritsuko Taho's artwork, or on a Web site in the case of *Learning to Love You More* (both discussed in chapter 5), then should that evidence remain in the next exhibition? "Among the important questions for interactive behavior is whether traces of previous visitors should be erased or retained in future exhibitions of the work" (Ippolito 2003, 50).

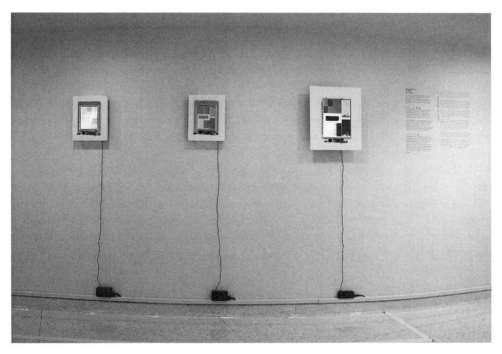

Figure 8.5
Installation view of John F. Simon Jr.'s *Color Panel v1.0.1,* part of the exhibition *Seeing Double: Emulation in Theory and Practice* (2004), Solomon R. Guggenheim Museum, New York. Photograph by David Heald. © the Solomon R. Guggenheim Foundation, New York.

The occupationally independent nature of knowledge about preservation has meant that solutions may be found in the wider world of contemporary art. The preservation of video work, including video installation, is now well documented, and museums are starting to build on this knowledge in the context of new fields. After years of regarding new media as exclusively video, the Centre Pompidou has started to include Net art, and a report on Net art in particular recommends a "hybrid" approach that is somewhere between library and art metaphors (Laforet 2004). The performing arts have also been dealing with variability in musical scores and dance notation, and performance art has been facing issues of documentation and reenactment.[12] Richard Rinehart (2005) of the Berkeley Art Museum and Pacific Film Archive, has developed a highly detailed method for preservation based on the metaphor of a "score."[13] He has developed a system that works on two levels: first, a basic level functions as a record of the work; at a second level is a more complex machine-processable score that functions as a representation of the work. This awareness of record versus representation reflects the debate on documentation or conservation already outlined in this chapter: Are we talking about

the documentation of a context or the preservation of an object? This typical blurring in new media art is again reflected in the case of the role of registrar: "In my experience as a museum registrar—when a museum exhibits something of this ilk—particularly something still owned by the artist—it is necessary to anticipate its acquisition. Thus it is critical that either, the artist supply what I would call an 'installation manual,' or the institution itself must thoroughly document the installation of a work. And/or the artist (who, also in my experience, is present and participating in the installation) must be interviewed as the process unfolds. Document it all!" (Quigley 2006) .

The crossover between issues of what is documented, what is collected, and what is exhibited brings us right back to the crossovers between interpretation and display explored in the previous chapter. New media systems are often used for all of these tasks: as Howard Besser says, "collection management systems start to look like exhibition systems" (in Dietz and Sayre 2000, 17). The pattern of crossover behavior is reiterated via the methods and the technology. Although "problems" of preservation are often quoted as reasons not to collect new media art, there are actually increasing numbers of well-documented case studies of how it can be done successfully. As the Variable Media project found, the lessons learned can profitably be applied to a great range of contemporary artworks, not just to new media. Once in collections, new media art can then benefit from the deeper exploration and historicization of new media artwork in general.

Summary: Networking the Museum

Where are the sought-after gates and doors supposed to lead? To the Valhalla of media art where the Gods are in each other's company? Is it not rather about introducing media art and its influence on society to a larger audience in order to enable ongoing discussion and personal experience?
—Monika Fleischmann, "How Gate-Keeping Systems Work in the New Media Arts," 2003

What art museums offer new media artists—that is, if these artists want to appear in an art museum—is an audience who go to look at art, interpretation, resources, and historicization via catalogs, documentation, and collection. How well museums do this will depend on how well they understand the behaviors of new media art, how well they network in order to understand the ongoing discussion, and how well they document, collect, and show from that collection in order to facilitate the layers of meaning that accrue over time. The inclusion of new media art within the art museum and hence the majestic flow of historicization have so far offered a few choppy episodes for new media art, even though the behaviors of new media converge in several midstream cross-departmental flows. As described here, the kind of cross-departmental communication and networking needed to understand and facilitate new media art may be something fundamentally at the center of the museum infrastructure, rather than a novel and seasonal sidestream. Curators of new media art need to access all areas of an institution, including the marketing and technical departments, in order to make that art happen. Rather than joining a ready-made Valhalla of the art gods and becoming a rather pale and ghostly version of its

former avant-garde self, new media art can potentially change the institutional systems of Valhalla into something more fluid, albeit perhaps more messy in terms of archive.

What appears to have worked well for introducing new media art to collections has been starting a collection via a broad approach to documentation, including self-documentation, and in commissioning artworks that are then collected. Once the artworks are collected, the issues of conservation can be addressed by making common ground with other "variable media." The historicization of new media can be aided by the iterative and comparative exhibition of works from a collection rather than by the occasional "blockbuster."

Museums are not monoliths: they can and do change, and curators working in museums are also highly variable. For every curator who believes that new media should flow through institutions as well as around them, as does Christiane Paul, there are others who would rather be big fishes in small, separate ponds than dabble in such muddy waters. For every curator who believes, as Barbara London does, that curators should be "sharing information and adding insights," there are others who would rather use "networking" as a means of promoting their solo gatekeeping skills. Whether a museum is networked in the fullest sense—networked between departments and with the wider world—tends to depend on curatorial taste and institutional values. The level of integration of new media art into contemporary art museums will depend not so much on having a specialist new media art curator in every institution, but more on institutions being open to new ways of working. As Christiane Paul outlines, what is novel to institutional colleagues is not so much the new media, but the new ways of working, in which the curator is only part of a team or network (Graham 2006, 213). What tends to work well for new media art in museums is often a good network as well as a mixed approach to "embedded" or "adjunct" curatorial strategies. The next two chapters explore these "ways of working" for curators and examine the flow of new media art that occurs outside the large art museums. These modes of curating draw their ways of working from diverse influences, including festivals, publishing, broadcast, and labs. As curator Maria Lind emphasizes, size is important in terms of embedding artworks in history, but other, more mobile means of historicization, such as publishing or research, draw on other ways of working: "I think the size is important. I think MoMA, Tate Modern, and some other institutions have more in common with big media companies like Channel 4 or something like that in how they operate, while small institutions like the Kunstvereine would have more in common with a little publisher or a little record label or a little research institute somewhere" (in Buergel et al. 2006, 39).

Notes

1. In North America, an "art museum" is a major institution defined by having an art collection that can be historical or contemporary, whereas a "gallery" is a much smaller place, often in the privately funded or commercial sector. In the United Kingdom, the nomenclature differs: "museums"

tend to be historical, whereas "galleries" or art centers can include very large, publicly funded institutions, but which may or may not have a collection. In this chapter, the term *art museum* stands for any sizable publicly or privately funded art institution with more than one curator.

2. The literature of curating contemporary art has in the past few decades been informed by a standpoint of institutional critique, criticizing the art museum in terms of hierarchy, gatekeeping, and a highly problematic relationship to "the other" (whether concerning art form, race, or gender). In the 1960s and 1970s, the critique often came from artists themselves (as evinced in Christian Kravagna and Kunsthaus Bregenz's 1976 collection of essays *The Museum as Arena: Artists on Institutional Critique*, Bruce Altshuler's 1994 book *The Avant Garde in Exhibition,* and AA Bronson and Peggy Gale's 1983 collection *Museums by Artists*). More contemporary critiques of the museum are informed by a postmodern range of theories of culture, audience, and politics (Bennet 1995; Crimp 1993; Ferguson, Greenberg, and Nairne 1996). The arguments concerning whether museums offer anything to new media art or not are complex and still ongoing on discussion lists such as CRUMB, Nettime, and others. As explored in chapter 2, there are arguments for whether new media artists want to be collected in order to become part of a "canon" or not. The arguments briefly go as follows. Museums are seen to be incompatible with the aims of Net art because the Net is its own means of distribution, because of immateriality, because of the gift economy, because of open source issues, and because certain histories are activist rather than art historical. Above all, the ways of working for a curator of new media art are often positioned to be well outside of the "curator as gatekeeper" model.

3. The Wellcome Wing at the Science Museum (at http://www.sciencemuseum.org.uk) features work by artists including Tessa Elliott and Jonathan Jones-Morris, Gary Hill, Christian Möller, David Rokeby, and Scanner.

4. The histories and structures of such large organizations are starting to be well documented online and in print, including substantial catalogs and histories—for example, *Hardware-Software-Artware: Confluence of Art and Technology. Art Practice at the ZKM Institute for Visual Media 1992–1997* (ZKM and Morse 1998) and FACT's *FACTOR* series covering the years since 1989 (Doherty 2003). Many smaller new media organizations working in other modes are less well documented and so are described more frequently in this book, including the Edith Russ Haus (chapter 7), Eyebeam (chapter 9), and the Media Centre, Huddersfield (chapter 5).

5. These departures are referenced in Burnham 1980, 207; Eastman 2002; Halbreich 2003; and Wellsby 2008.

6. There is admittedly a dearth of material on the technical side of curating new media art for curators or nonexpert technicians, so the CRUMB publication *CRUMB Technical Guide for Exhibiting New Media Art* (Cullen 2009) aims to fill this gap at least partially.

7. In this book, issues of documentation, in particular the relationship between art and document, are informed by the practices of conceptual art, performance art, and socially engaged art (Alberro and Norvell 2001; R. Perry 1999). The question of what kinds of documentation are most suitable for new media art recurs on the CRUMB *New-Media-Curating Discussion List,* particularly in May 2007. The CRUMB Web site has an extensive set of links and references for both documentation/archiving and collecting/conservation.

8. As mentioned in chapter 1 concerning taxonomies, online archives of documentation of new media art such as the Database of Virtual Art and the Centre for Research and Documentation at

the Daniel Langlois Foundation for Art, Science, and Technology have been able to display documentation of most types of media and have been instrumental in developing keywords and metadata structure.

9. RSG stands for Radical Software Group, and *Carnivore* is software art that deliberately mirrors the surveillance software DCS1000 (nicknamed "Carnivore") that was reportedly introduced by the FBI onto systems such as Hotmail to identify "terrorist" material on the Internet. The software therefore refers directly to wider cultural and political contexts (Galloway and RSG 2002).

10. Christiane Paul (2007) nicely summarizes the debates around conservation, so we have tried to use some different examples here.

11. Variable Media (at http://www.variablemedia.net) is a network of those individuals involved in the preservation of contemporary art. The book *Permanence Through Change: The Variable Media Approach* (Depocas, Ippolito, and Jones 2003) includes a collection of detailed case studies.

12. See also chapter 4 on time. Johannes Goebel has noted that the way of documenting and recording performing arts via a score or a script might usefully apply to the problems of documenting new media art: "in the theater world, one actually goes so far as to edit the piece, cut text, add text etc. and it is still 'Shakespeare'" (2006).

13. Rinehart drew on methods from Preservation and Archiving of Newmedia and Interactive Collections (PANIC), Capturing Unstable Media Conceptual Model (CMCM), and the Digital Music Library Data Model Specification.

9 Other Modes of Curating

Perhaps we are already uncomfortably aware that the physical space within which we are exhibiting will deaden the vitality of anything we might put into it, or that the form of presentation possible within the exhibiting environment is itself at odds with the nature of the work.
—Renee Baert, "Provisional Practices," 1996

The title of this chapter suggests that there are modes of curating that are "other," but "other" to what? The preceding chapter addressed the contemporary art museum and argued how new media art may or may not be at odds with that curated space. However, other curatorial spaces do have a better fit with new media art. Those that differ from the contemporary art museum in the most familiar ways are the noncollecting exhibition spaces *(Kunsthallen)* with remits specifically devoted to the contemporary arts. These form a small network, still young but considered venerable for their longstanding efforts to sustain real estate devoted to new and emerging art practices. For example, both Cornerhouse in Manchester and the ICA in London are aligned with cinemas but since the 1970s have also been identified as independent spaces for contemporary art. Although these noncollecting organizations are certainly not all of one kind, they do have similarities. They have typically been quicker to take on new media art. Since the 1980s and the institutional acceptance of video art practice, what were once avant-garde fringe venues devoted to new art and technology experiments beyond video as well as to events rather than objects have become institutions at the heart of new media art practice. FACT in Liverpool started its life as a festival, Videopositive, and is now is a successful building with cinemas and exhibition space. Other organizations cited in this book, including V2_ in Rotterdam, Eyebeam in New York, and Edith Russ Haus in Oldenburg, Germany, are themselves hybrids of *Kunsthalle,* gallery, festival, and laboratory, created purposefully to deal with the behaviors of new media art.[1]

What follows in this chapter is not an investigation of all noncollecting spaces, but instead a further definition of the landscape of the exhibition of new media art that teases out some of the distinctions between spaces and systems. It explores how the alternative models of exhibition offered by types of cultural organizations other than galleries can offer various opportunities particularly suited to the way in which new media art's

production and distribution are interlinked.[2] Therefore, for our purposes, this "otherness" is distinguished by organizations whose curators are perhaps less engaged in questions of display, collection, and audiences (the driving force of the conventional museum or gallery), and more engaged with the realization of the project—its production and distribution. The modes described here demonstrate a concentration on hybrid means, starting from the familiar and progressing to the more unfamiliar.

Festivals—New, Hybrid, and (Upwardly?) Mobile

Are conferences, media art festivals or art + technology spaces such as Transmediale, the Subtle Technologies Festival, the Inter-Society for the Electronic Arts . . . or the Beall Center at University of California Irvine the only venues in which computer-mediated artworks can rock out, isolated from the rest of the art world? Or do "new media" simply need new venues?
—Trebor Scholz and Judith Rodenbeck, "Whitney Biennial 06," 2006

The landscape of contemporary art includes, in addition to its exhibitions in museums and galleries, a vast array of non-museum-based periodic exhibitions. By contrast, the new media art world often has some of the latter, but not always the former. Nonmuseum exhibition events for contemporary art might take the form of annual or biannual festivals, blockbusters, prize exhibitions (some of which do take place in museums, such as the Turner Prize at the Tate), and regular citywide specialist events. These international events—temporary, often site specific, well attended, and seen to influence the curatorial selection of works for museum exhibitions for years to come—have specific histories. They are on the one hand global in scope and on the other intensely local in impact. In the process of curating a festival, organizers tend to seek out and show new artists, sometimes as a result of the desire to be inclusive of art production from a wide range of countries or regions. Festivals have come to represent the rise of the curator as author, the globetrotting arbiter of taste and culture, and the curator's role has expanded to producer as well as selector (Oguibe 2001, 131; Marincola 2002). Due to these events' size and global reach, the curating is often shared among a committee of very public, easily identified curators.

A major benefit of festival-inflected exhibitions is their emphasis on newness—on showing the latest art—although in the past few decades the emphasis has been on the latest art idea or trends (such as documentary practices) rather than on techniques, media or emergent art forms. Artists working with specialist and minority art forms, such as performance art, have developed and produced festivals to gather critical attention around their activities—which may previously have been perceived as having a kind of "curatorial invisibility." New media art is no different, having spawned many regular periodic events including, for example, Transmediale, the AV Festival, and Lovebytes.[3] Many of these events started out as strictly video art festivals—technology based and focused on the moving image—and grew to include other forms of new media art, such as

Net-based art projects, if only for a limited time before returning to their specialist roots as the field became more widely recognized.[4] Some forms of new media art are suited to festivals for medium-specific reasons such as the ease of distribution; early festivals of video art were greatly facilitated by the possibility of mailing tapes from one city and cinema to another.[5] Few cities are as well attuned as Rotterdam to the way in which artists want to present their moving-image material, architecture, or design. This city hosts the substantial International Film Festival and the separate Dutch Electronic Art Festival (DEAF)—video practice seems to live almost equally in both as single-channel screenings and multiscreen installations.

And yet mainstream "mixed" visual arts festival/biennials, such as Documenta, still struggle to represent new media art as one of the contemporary arts. On the one hand, it appears that new media art has had a relatively long history of inclusion in mainstream visual arts festivals. On the other hand, there has been little real integration or consistency: the 1986 Venice Biennale had a focus on art and science and, as part of the section on *Art, Technology, and Informatics,* presented the *Planetary Network and Laboratory Ubiqua* (Braun 2005, 81); Nam June Paik represented Germany alongside Hans Haacke in 1993, and together they won the prize for best pavilion; the 2007 fifty-second edition of the Venice Biennale had several national pavilions exhibiting new media artists, such as Rafael Lozano-Hemmer and his interactive installations on behalf of his home country, Mexico. In the next section, we consider the example of Vuk Ćosić's work and see some of the bumps along the road that has led to the inclusion of new media art in a mixed-media festival.

Internationalism, Commercialism, Carnivalesque?

Many major art events receive state subsidies precisely in order to make a place attractive and put it on the map for potential investors. Linz and the Ars Electronica festival exemplify the digital version of this kind of sponsorship strategy. With the launching of the Ars Electronica festival in the late 70s, the former steel industry town has tried to publicly mark its transition into an information age town and service industry center.
—Armin Medosch, "The Economy of Art in the Information Age," 1998

Like world fairs before them, festivals and biennials were often first founded as a way to demonstrate to the world the unique and original cultural production of a country.[6] The oldest biennials and festivals, such as those in São Paulo and Venice, were tied to histories of colonialism, with pavilions for different "nations." This model seems outdated for new media art, which through its inherent connectedness can represent both the local and the global at once. The economic valuing of art inherent to the international art fairs has also seemed at odds with new media art, which often takes the form of a direct challenge to the idea of the commodifiable art object.[7] New media art fairs do exist, but are understood to be marketplaces for the tools of art making—software packages, hardware systems—as much as for the art itself. The Special Interest Group for Computer

Graphics (SIGGRAPH)[8] thus has an important art gallery exhibition and conference strand within the framework of a commercially driven professional trade fair, which critics Jay David Bolter and Diane Gromala have likened to a "a carnival for the twenty-first century." Rather than "people crowded into a muddy town marketplace to gawk at tables of exotic goods," however, "the delights of SIGGRAPH 2000 were more high tech; there were no dancing bears." They observe that "the whole gallery [of art projects] functions as a counterexhibit to the carnivalesque commercial exhibits" (2003, 10, 144).

New media art events, such as SIGGRAPH or the International Symposium on Electronic Art (ISEA), are significantly different from mainstream art biennials in that they are a chance to "demonstrate" rather than necessarily to "exhibit" a prototype—an early, research-led version of what may later become a substantial work of new media art (robotic projects, for example). This approach has meant that festivals of new media art have come in for criticism for their emphasis on not just the new, but also the not-yet-finished. However, showing your research through a fair such as SIGGRAPH's gives companies, technologists, and even university research centers and labs a chance to "buy in" to the work's later production stages.

Festivals are also an important part of the curatorial landscape for new media art because they are places to demonstrate work in progress *and* to meet possible collaborators, even if the artist has sent his or her work over the Internet. Julian Stallabrass writes: "As computer networking began to flourish, new media artists had a way of sharing their work without attending exhibitions or festivals—though many did so simply to meet those people with whom they had corresponded online" (2003, 112). The social networking aspect of the industry trade show and art biennial is significant. Generating cultural discourse around artwork via events and platforms (discussed in chapter 7) has become a mainstay of the art "Grand Tour." For instance, the platforms of Documenta 11, a series of talks and conferences in cities around the world, culminated in an exhibition in Kassel, Germany, though the exhibition itself was considered the last but not necessarily the most important platform for exchange of ideas about globalization. Documenta serves as an example of a strategy adopted by curators to deal with the increased workload and the increased demand that the international art event be truly global in relevance. It can be argued that the art biennials and fairs have adopted some of the social networking traits of the field of new media art, as the example of Vuk Ćosić's work shows.

Example: Vuk Ćosić, Documenta Done *and* Net.art per me

In 1997, Documenta, in its tenth incarnation, included for the first time works of Web-based art. Curated by Catherine David in collaboration with Simon Lamunière, a dozen projects by artists (many working in collaborations) such as JODI, Heath Bunting, Muntadas, and Jordan Crandall were presented. Some of the works were developed especially for Documenta. The works were installed on computers, all grouped in one room. They were divided into categories—surfaces and territories, cities and networks, groups and interpretation, in and

out—and were displayed online alongside forums, links to other arts institutions, and other Web sites both by the invited artists and other "invited guests."

Installation aesthetics aside (the room was described as a classroom, with a big IBM logo on the wall), the initiative was a success; those who logged on were doubtless exposed to new forms of cultural production. The only drawback was that the art world system had fundamentally misunderstood the nature of networked art production. The Documenta organizers issued a press release saying they would take the Documenta Web site offline at the end of the exhibition and release it for purchase on a CD-ROM. This misguided attempt to apply an art fair mentality (of turning an artwork into a commodity or documentary publication after the actual event is over) nevertheless caused the creation of another great work of Net art. Artist Vuk Ćosić, whose colleagues were among those included in the exhibition, decided to "steal" the Documenta Web site; he copied it whole (or as near to whole as possible) and posted it on his own server, issuing a press release to the effect that it would be freely available there for as long as people wanted it (it is still there today).

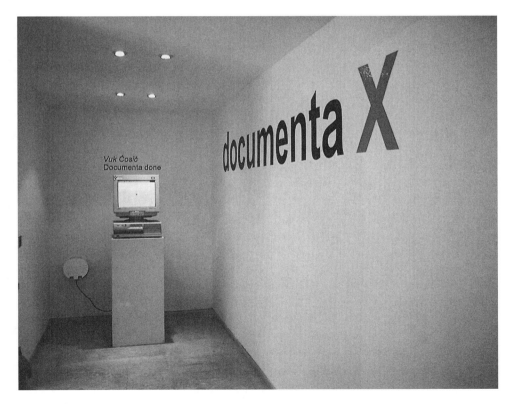

Figure 9.1
Installation view of Vuk Ćosić's exhibition *Net.art per me* at the Slovenian Pavilion of the Venice Biennale (2001), showing the project *Documenta Done* (2000). Courtesy of the artist.

When a few years later, in 2001, Vuk Ćosić had the opportunity to "represent" his home country of Slovenia in the Venice Biennale, he again appropriated and rechanneled the power of the international art festival—exhibiting *Documenta Done* (as his version had become known) in his presentation *Net.art per me*. He writes, "I have exhibited my net.art pieces in a variety of venues, and in very many different settings. Sometimes the display was reminiscent of the office, sometimes the work was shown offline, and sometimes technologically complex and expensive setups were created to host net.art. And rarely did it work. Possibly the problematic detail is that whatever you do in a gallery in order to show net.art pieces (already this expression is thoroughly wrong) you will de-contextualize it, and lose the spontaneity of free browsing" (2001b).

In fact, in the Slovenian pavilion, the exhibition titled *Absolute One* included three artists: Vuk Ćosić, 0100101110101101.org, and Tadej Pogacar. Aurora Fonda curated the exhibition, deliberately choosing works that find their home on the Web and have a disdain or lack of need for actual exhibition space and hence for actual museum or art world institutional structures. Ćosić questioned the validity of Fonda's political gesture, suggesting that

Figure 9.2
Installation view from the untitled exhibition curated by Vuk Ćosić for his Temporary Autonomous Pavilion at the Venice Biennale, 2001. The artwork shown is *Model 71 Measuring Device* (1998) by Tom Jennings. The exhibition also featured works by JODI, Vinyl Video, irational, and others. Photograph by Vuk Ćosić.

it did not actually speak to the real politics at work in the selection process.[9] In Venice during the Biennale, having an allocated space, time frame, and budget for installation and publication (marketing and documentation) was the best way to ensure that a work would be seen. Ćosić therefore personally invested a year's salary in advance to curate an exhibition of Net art in Venice, separate from the exhibition in the Slovenian Pavilion, to contextualize his work. Part of the larger project *Net.art per me*, the deliberately untitled exhibition was based on the theme of "New Low Tech Media" and held in what Ćosić called a Temporary Autonomous Pavilion. In addition to Ćosić, the untitled exhibition included 0100101110101101 .org, Heath Bunting, Tom Jennings, Vinyl Video, JODI, and RTMark. Furthermore, Ćosić published an English catalog comprising three sections—documentation of the group exhibition, a reader on issues of the exhibition of Net art edited by Sarah Cook, and a Nettime reader edited by Ted Byfield (Ćosić 2001b).

The example of Vuk Ćosić's projects for the 2001 Venice Biennale demonstrates the potential success of new media programming strands within mixed-media biennials and festivals. Ćosić's idea was that in the case of Net-based art practice that distributes itself, an artist doesn't need the official sanction of the art system in order to be included and noticed by the art world. Instead, he or she can define and set his or her own criteria, depending on how large a loan can be secured and how many favors can be pulled in to realize a project.

Lessons Learned from Festivals

What I find very strange is that some large media festivals (in Europe) think they do not even have to inform the artist if their work is in their exhibition and catalogue (or even press releases). . . . There is a general tendency to treat media artists as if they were immaterial themselves. They often do not get invited to openings or physical openings are not organized (there are not many online openings (in chat or so) either) and they seem to get less attention of the PR department in general. I think we are really missing an opportunity when media art gets separated from the real (flesh) world.
—Josephine Bosma, "Curating Critically," 2002

Festivals, art fairs, and biennials are, as we have seen, international, commercial, and carnivalesque events. Once the excitement and hype have died down, festivals come in for their share of criticism, often around these three issues. New media art is globally networked and doesn't lend itself to the easy reception of an exhibition based on national representation by single art makers. Instead of being commercially oriented, new media art festivals are prone to a kind of financial volunteerism, expecting artists to come and present their work on their own budgets in order to secure future funding and future collaborators. New media art festivals are also seen as either too carnivalesque (everything is interactive, plugs in, breaks down) or not materially visible enough (the common vision of a cultural festival being that of banners and bunting on the streets, fire eaters, and outdoor food concessions). If new media art festivals have been modeled after trade fairs, academic conferences, or social networking events (rather than after

exhibitions), complete with talks, skill-sharing sessions, and professional development opportunities, then it is no wonder that they don't look like either biennials to the art world or festivals to the general public of the city in which they are held. So what are the lessons learned and the benefits of producing and distributing new media artworks through the format of the festival?

Hybrid Platforms The first benefit is that festivals are a hybrid of different forms of exhibition and presentation: new media art festivals tend to showcase the hybrid nature of new media work by including time-based events, screenings, and performances at set times, as well as more static exhibitions of art with set opening hours. The AV Festival—which takes place every two years across three cities in the United Kingdom, Newcastle, Sunderland, and Middlesbrough—includes a traditional film festival at the cinema, exhibitions in partner galleries, outdoor installations, and performances in concert halls. This hybridity has an immediate value in that the audience members can choose their own time of engagement in relation both to the format of the festival itself and, where possible, to the hybrid nature of the new media artworks distributed through it.

Within such a structure, it is possible to include projects that themselves cross the boundaries between art, art making, interaction, learning, sharing, and performing, which the AV Festival does by including conferences and workshops at the universities, artist-run centers, and labs. Unlike commercial art fairs, new media art festivals tend to emphasize skill sharing over sales of discrete artworks. This inclusion of discourse with display also works in reverse, where academic conferences devoted to new media art often include an exhibition stand or at least "poster sessions" as a way of demonstrating and discussing work in progress.

Because of this multiform approach, curators of festivals often find themselves working in a similar way to arts agency curators (described later in this chapter): acting as a networker among artworks, modes of display and discourse, and a variety of host venues—demonstrating the "curator as matchmaker" metaphor, perhaps. The advantage of having a festival that makes use of (or is hosted or programmed by) different kinds of venues across a geographic area is that each project can then cater to a different audience with unique marketing strategies or outreach opportunities, dependent on both the skills of the host organizations' curators and their local expertise—thus, a "modular" mode of curating, perhaps, as described in chapter 6.

Time and Money Some works of new media art can be technologically difficult and financially prohibitive to sustain for a month or more, which is why a ten-day festival is so appealing and such a widely adopted format. Audiences can enjoy the live contact with artists, who may be there to install and maintain their works technically for the duration of their exhibition. For example, "When the public started accessing the Expoforum, [in] the biggest room at the MACAY (Museum of Contemporary Art Yucatan),

the artists were able to give a real performance. Because of the technical difficulties, they were fixing computers, bringing down software from the Internet and figuring out the digital projection as the audience arrived, giving the public the chance to see the artists at work. Contrary to the expectation that work be 'finished,' ready to be displayed and shown, the public interaction with the artists at work created a unique perspective, forcing spectators to re-evaluate the nature of the museum in relation to new media arts" (Ferrera-Balanquet 2002). At the AV Festival in 2006 at the Sunderland Museum & Winter Gardens (a mainstream council-run museum), the artist Ken Rinaldo installed his *Autotelematic Spider Bots* responsive, robotic sculptures. The partnership between the artist and the museum was ideally managed within the format of the festival in that the project was installed for only a short period of time rather than the usual museum exhibition run of six weeks. As a result, the museum could afford an appropriate volunteer and technical team to sustain the work. The shorter run of a festival also makes it possible for artists to present prototypes of their work for audience engagement and then to go back to the studio and develop the work further for an exhibition presentation later on. Festivals are perfect for this purpose because, as exhibition presentations, they are short term but also regular; an artist can return the following year with a new

Figure 9.3
Installation view of Ken Rinaldo's (with Matt Howard, Ross Baldwin, and Kate Jones) *Autotelematic Spider Bots,* exhibited in Sunderland Museum & Winter Gardens as part of the AV Festival in 2006. Photograph by Mark Pinder.

iteration of the work and secure funding with this concrete presentation in mind. This approach is invaluable for the curator, too, who can then document a development or trend over time.[10]

The downside of the short-term nature of festivals is that they depend heavily on the strength of their volunteer team and the time commitments from the artists presenting, whose costs are rarely covered.[11] Another problem for audiences is the limited amount of time available to view a large amount of work, much of which might be durational. Thus, Documenta 11 was criticized (albeit tongue in cheek) for the manner in which the copious amounts of video work were installed: "The quantity of work depending on the projected, moving image requires an inordinate degree of audience commitment and stamina. . . . It cannot be given full attention in this context, unless one moves to Kassel for a week" (Searle 2002).

Overall, as this investigation of the festival model has shown, although showing work in such a multidisciplinary context has benefits to new media artists, it has drawbacks as well. These drawbacks are often economic, relating to the space, place, time, and technology needed to participate. The questions of the local versus global impact on the artist's career and on the city in which the festival or biennial takes place are still being debated. Festivals *are* different with new media art: they have a shorter run, which is more conducive to complicated technological setups; and they allow for a fluid and iterative process, including the presentation of prototypes or work still under production rather than just distribution of the finished product. Festivals are also naturally hybrid, which matches the nature of new media work; in a festival you can have it all—public art, exhibitions, and talks.

Arts Agencies and Public Art—Located, Engaged, and Flexible

1. Promoting interaction to the fearless confrontation and contact with strangers.
2. Promoting the formation of a public sphere by criticism, discussion, reflection on the society.
3. Promotion of social interaction and integration in the local neighborhood.
4. Perception of current developments, by technology reflecting sensual system experiences.
5. Activating conscious participation in the creation of public space.
—Mirjam Struppek, "Interactionfield—Public Space," 2002

In listing the characteristics identified in a set of examples of new media as public art, Mirjam Struppek neatly summarizes the major issues of location, audience, and participation. Arts agencies—those fast-moving, office-based organizations that arrange arts commissions and events—have extensive experience in the process of making art happen in venues outside of conventional arts spaces, using any media necessary, from sculpture to socially engaged educational events. Above all, they commission new works for specific contexts and systems, and can respond quickly to "the new" because they are small organizations: "Although cash flow is always a concern . . . with careful planning, amaz-

ing things can and do happen. These are accomplished without board approval, trustee budget approval, or the mandatory wait of two+ years to work into a pre-scheduled calendar. . . . What we are able to do in this environment is to respond rapidly to artists' initiatives and funding possibilities" (Huffman 2001).

Each project is likely to be individually funded, which allows for great flexibility, but conversely can make it difficult to facilitate projects that involve the new media behavior of long-term evolution over time and can also privilege projects with a concrete, fixed outcome. Arts agencies, however, are able to access the kinds of funding that work across disciplines and that support experimental process rather than just product. Arts Catalyst in the United Kingdom, for example, specializes in art and science projects, and has been able to focus and develop those interests. The joy of commissioning in this context is that agencies can network to bring together artists and facilities in highly experimental ways, such as negotiating artists' work with weightless environments, wind tunnels, radio towers, medical labs, police stations, or broadcasters. Concerning organizational systems, for new media art the advantage of the curator's working within an agency is primarily that the organization can to a limited degree re-form itself from scratch and rebuild itself anew with each new commission, each new project. The context of each location is different, and thus the invisible systems of the organization as well as the physical resources have to be flexible. Agencies are familiar not only with the immateriality of not having a permanent exhibition space or gallery, but also with not having a production lab or workshop. New media projects therefore benefit from the ability to be allocated the most appropriate technology or equipment—whether hired, borrowed, leased, or purchased—each time.

Another useful skill related to agency and public art curating is the heightened awareness of location and place beyond the glamour of internationalism or nomadism so prevalent in festivals. Curators are perhaps more likely to know the social meaning of their local areas and to be familiar with the cultural meaning of popular technologies. Creative Time in New York, for example, used technologies of public display early on, including the Times Square electronic billboards for video art. More recently, it installed Jim Campbell's *Primal Graphics* (2002) outdoors in Battery Park, which matched the more social location to the more delicate human scale and content of the artwork, although the LED technology used was similar to the Times Square billboards. Creative Time, in collaboration with the artists, has thus taken the conceptual and technical challenges of new media in its stride, and it considers each different work's characteristics in the context of scale, location, and public interaction, even as it manipulates other media such as art on paper cups or sky writing by airplanes (Stenakas 2001). The experience of curating contemporary art in an agency, therefore, demands several skill bases useful to the characteristics of new media art, so it comes as little surprise that such agencies have been among the first to integrate new media art into their range of commissioning and exhibiting.

Figure 9.4
Jim Campbell's *Primal Graphics* (2002). Installation at Battery Park, New York, presented by Creative Time and the Ritz-Carlton New York, Battery Park. Courtesy of the artist.

Systems and Public Interaction

The public site is all about addressing an audience that have not chosen to be addressed. They are passers-by. The psychological differences between a proactive and passer-by audience have to be considered when creating a work for either context. In the case of interactive work this is immediately of concern to the artist (and the curator) in that they are premising their work explicitly on some sort of active relationship between audience and work.
—Simon Biggs, "Sites," 2001b

Public-art audiences are rigorously unforgiving of artworks being "parachuted" into an unsuspecting community and of insensitivity to local cultures (Finkelpearl 2000; Jacob 1995). Specific audience needs should be fully worked into the processes of social and architectural systems, as opposed to, for example, the "percent for art" schemes tacked onto buildings and often seen, as Vito Acconci says, "clinging on like a leech" (in Finkelpearl 2000, 176).

For the new San Jose Airport, the approach taken by Barbara Goldstein, the public-art officer for the city of San Jose, was to try to integrate the art within the system by

appointing an artist to the Airport Activation Committee to develop a framework for the inclusion of art in the airport's development. The architectural team of Gorbet + Banerjee was determined to negotiate to the center of the invisible systems of the building, using the communications networks as well as the physical building as a venue for art. Architect and artist Matt Gorbet considers platforms and "human systems" to be highly important, and Susan Gorbet has examined how architects "ride the line between art and design" in having access to research on how people behave and interact within buildings. These approaches are therefore able to draw from the skills of public art, arts agency commissioning, architecture, and user research. Architect Banny Banerjee wisely cautions that architects, despite their control over architectural materials, have very little control over people and that there is often a large gulf between the intent and the actuality (Gorbet and Banerjee in Goldstein 2006a). This mode of public-art commissioning is necessarily deeply embroiled in a long-term process, which can offer a rethinking of modes of curating for new media art. Public-art agencies and artists tend to have at least some understanding of the complexities of interaction between artwork and audience as well as essentially of the interaction between audience members that an artwork might facilitate. Media-specialist agencies such as New Media Scotland in Edinburgh have also been able to use this flexibility, mobility, and connectivity.

Example: New Media Scotland

Founded in 1999 by Chris Byrne, the new media art office-based organization New Media Scotland commissions and distributes artworks from short videos to Net art and public-art projects. Commissioning new art is always a challenging experiment, and curator Iliyana Nedkova, who joined the organization in 2001, has wittily discussed solutions to feelings of "curatorial inadequacy" when dealing with new technology as well as art (Nedkova 2001). "There is not just a love of experimenting," she says, "but a lust for blind-dating technology" (2000, 126).

Although the agency is based in Edinburgh, a founding intent was to use the distributive qualities of new media to link geographically remote areas of Scotland—including many outlying islands. For example, the commission of Colin Andrews's *Geist* (2000) linked four traditionally "haunted" locations across Scotland via the Internet, which fed data such as changes in temperature and fluctuations in electromagnetic radiation to the Pier Arts Centre in the Orkney Islands, where it was used to feed an audio installation of ghostly voices. Iliyana Nedkova is originally from Sofia in Bulgaria, and her experience of commissioning cross-national and cross-cultural new media production projects, including the *Crossing Over* and *Blind Dating Technology* projects, reflects on the multitasking nature of the mode of agency curating. "The shortage of infrastructure resources and junctions in Bulgaria—and by and large in other Eastern European countries—means that most projects are managed on the line of 'reinventing the wheel' by well-rounded curators often disguised as miracle workers, matchmakers, plumbers, babysitters, B & B owners or interior designers" (Nedkova 2000, 125).

New Media Scotland's program has illustrated the flexible nature of commissioning in an office-based agency: the artwork has ranged not only in geography, but also in media, including the touring short film program *Desktop Icons*, the Host online art collection, and artist Cavan Convery's residency work with schoolchildren, which included tying webcams to rockets. Agencies can place each iteration of the art in a context suitable for that culture and can specialize without remaining in a "ghetto." As Chris Byrne states, "Net art has some things in common with the art world and with certain sub-cultures within broader popular culture. Like other technologically-determined forms I guess: sound art and video art spring to mind. Is this a problem? Not necessarily" (2002).

The agency's history also reflects the relatively unstable nature of funding for arts agencies; local government funders tend to be much more concerned about continuing revenue funding if there is the risk of a visible, boarded-up, public arts building. After a period of controversy and funding instability, New Media Scotland is now run by different curators, and its program reflects different aspects of agency work, including putting on the public-art-oriented projects *[murmur] Edinburgh* and *Community Green,* as well as hosting discursive social events and being an active member of peer networks such as Dorkbot and Upgrade!

Figure 9.5
Installation view of a detail from Colin Andrews's *Geist* (2000) at the Pier Arts Centre in the Orkney Islands. Photograph by Colin Andrews.

More recently, New Media Scotland has also offered a project space for both the production and the exhibition of artwork. The agency is therefore able to work across the systems of public art, commissioning, and social interaction by using connective networks in a way that typifies the mobile yet located methods of agency curating.

Lessons Learned from Art Agencies and Public Art

As flexible as our design strives to be, it has been very important to remember and communicate through this process that the airport is an airport, not a gallery: its primary purpose is not the artwork that's in there, and the artwork has to be appropriate for the experience of the people who will encounter it. This was actually a theme we found that we needed to articulate often to technology artists, who in general we found are used to being able to do gallery artworks that are far less constrained than typical public art. There aren't many technology artists who have faced the constraints of public art (which incidentally apply to all public art—the genre is simply far more restrictive than gallery art).
—Matt Gorbet, "Re: Permanence and Public Art," 2006

The curatorial skills developed for public-art and agency commissioning offer useful lessons for the connective and participative characteristics of new media art and can work in a way that is integrated into the systems of buildings or locations. However, although agencies may move faster than museums when it comes to new systems or engaging new audiences, a certain amount of lag in awareness of new media art still occurs. Barbara Goldstein has commented that the field is still catching up with the artists and that more established organizations with more experience in the many political skills concerning site and audience for public art means that more new media artworks get commissioned, whereas the less experienced "tend to commission timid work" (2006b).

One particular challenge for new media art has been in considering the long-term nature of some traditional public art, which isn't the case for publicly sited works in the context of festivals, as we have seen. Solutions and alternatives for these preservation and maintenance challenges do exist, however. Mirjam Struppek suggested one possible solution: that new media appear as a series of art projects rather than as a long-term installation (Interactionfield 2006). On a digital billboard, for example, a series of different artworks might appear over time, as has happened with the Times Square NBC Astrovision, where the fifty-ninth minute of each hour of commercial material is used by Creative Time for artists' works.

As with the other modes for curating new media art outlined in this chapter, documentation of new media artwork becomes very important because of its temporary nature. Arts agencies often use publishing to gather together a series of art projects into a coherent whole, both for posterity and for funding bodies. Public-art agencies publish because of process and posterity, and because, even if an artwork is permanent, an audience might well not be able to get to Idaho to see it. But can publishing itself be a mode for the production and distribution of new media art?

Publishing and Broadcast—Distributed, Reproducible, and Networked

So you are a video artist. And yeah, its 2006, . . . and your videos are short, like 2–3 minutes long. So what do you do with them? Do you screen them on public access? Do you upload them to YouTube? Do you sell them in limited editions in a gallery? Do you make music videos for bands? Do you enter them in underground video/film festivals? . . . And that's just for video, imagine what a headache you'd have if you made other forms of media art as well.
—Cory Arcangel, in "The Art, Technology, and Culture Colloquium of UC Berkeley's Center for New Media," publicity material, 2006

Distribution is an inherent characteristic of new media art (as discussed in chapter 3). For Internet art, the system that is used in the production of the art—the Web—is the same as that used for its distribution, and in that way it differs from other "distributed" art forms such as mail art. This access to the means of distribution has always been important: The artist group Mongrel has used cheap print materials such as newspaper, referencing the chapbooks and hand-distributed songsheets of eighteenth-century England and even co-opting William Blake's printed poetry sheets into their software code for their project *Lungs-London.pl* (2004).[12] The tradition of artists' books is well known, where limited edition artworks are produced in printed form. They become an interesting "boundary subject" in terms of distribution (distributed like books or sold like artists' multiples?), exhibition (shown in a closed vitrine or on a table for browsing through?), and collection (kept by the library of an institution or in the museum's main art collection?). As explored in the exhibition *Broadcast Yourself* (2008),[13] in the 1970s the debate about artists' access to television showed that it was the problem of access to the commercial means of distribution and broadcast rather than access to cheap video cameras that emerged as the crucial factor (Ross 1996; Youngblood 1986). The Internet can indeed work as a less expensive and more accessible version of international broadcast, but video artists who once may have been wary of handing over their work to commercial distribution are now reveling in the gamut of formal and informal distribution and publicity options online. The Internet exists within—and, some would argue, has created—a new media world of cutting and pasting, copying, hypertext linking, sampling, file sharing, hacking, mashing, changing, and reproducing. New media therefore offers various modes of broadcast, narrowcast, tagging, filtering, blogging, reblogging, and hybrids of all the above. Commercial understandings of broadcast, however, do not fully fit new media art. Those involved in the study of commercial new media describe the impact of the Internet and networked computing on mass media primarily in terms of consumer "choice" or a tokenistic level of feedback or both (Lister et al. 2003, 20–21).

This range of modes of publishing and broadcast can be confusing, but it may help clarify things to consider the structure of the distribution in terms of the different kinds of networks described in chapter 2. If looked at historically, the technological progression from the centralized (one-to-many) to the distributed (many-to-many) network has

not always been smooth: the rollercoaster of radio's history, for example, has included the early many-to-many system of ham radio, the dominance of centralized broadcast, and the more recent growth of Internet audio and video streaming.

Artists have of course been early adopters of hybrid understandings of broadcast and provide useful articulations of their position in a network. Artist Simon Pope, for example, worked on the BBC's online digital archive of publicly accessible broadcast material (television shows, radio transmissions, and Web pages). *Charade* (2005–) took the form of live events, where volunteers "performed" items from the digital archive in regions across the United Kingdom. It asked how we would be able to remember the broadcast heritage of our nation were the digitized files to be corrupted or lost, and it demonstrated this challenge by inviting volunteers to form a network in an attempt to "become" a TV or radio program, play, book, film, piece of music, and so on. Volunteers gathered at workshops to learn or memorize part of one of these digital assets and then met up with the others in the network to go for a walk and recite or retell the material. Pope has described how the network structure varied between a centralized network with himself as the traditional art star at the hub, and a many-to-many (or peer-to-peer) network, ironically stimulated by the need for every participant to take responsibility for use of copyright material with a contractual "peering agreement" (S. Pope 2005). Authorship, ownership, and the shape of distribution networks are therefore key to considering modes of curating in relation to publishing and broadcast.

How to Digest Your Peers

Mute: Ceci n'est pas un magazine.
—Pauline van Mourik Broekman, "*Mute:* Ceci n'est pas un magazine," 2004

Those who use new media technologies are rarely purist about using only new media and often use different modes of distribution for different purposes. Those who use online discussion lists value the peer-to-peer open-ended debate, but also appreciate a more digestible form of the mass of their peers—Sarai and Nettime lists have also published digested, themed, and edited versions of these debates in print form. The print versions are of course different in nature and serve a different function, being more readable, more digested, and more linear. Books are still more thoroughly archived than Web sites; they are listed in bibliographies and appear on the library shelves of institutions, including universities, for the edification of future generations. If we are considering the publishing and distribution of texts, then the academic world also has an obvious interest in this field. ThoughtMesh online repository is an interesting new media approach to the idea of a peer-to-peer network of texts and indeed is a source of references used in this book. This distributed network stands as a fundamental challenge to the hierarchical and centralized system traditionally applied to valuing academic knowledge, even down to challenging the system of how publications are valued in academia (Ippolito 2008b).

In stating that *Mute* "n'est pas un magazine," Pauline van Mourik Broekman poses, in surrealist fashion, the quandary that although *Mute* may look like a magazine, it has in fact used very different tactics, moving between print and the Internet, and questioning whether it acts as a network. The print magazine started as just that—a regular periodical concerning a wide take on new media culture, with articles and reviews on art, culture, and literature from very varied writers. As the Web site Metamute grew to include discussions and wider modular contributions, it took over, leaving the print embodiment as more of an occasional specialist publication or a print-on-demand thematic reader. Thus, peer-to-peer methods, both online and face to face, help to develop ideas, but *Mute* then also publishes tightly edited print documents as a kind of digest. It has had to adopt various funding models to sustain its activities, such as selling advertising space online and having readers pay for the printed end product.[14] The variability of the publishing modes for *Mute* relate to the variability of what has become a widely discussed curatorial mode—that of curator as editor. This mode is usually discussed in relation to the curator being a basic "filter," editing down the mass of material on the Internet, but there are also the finer distinctions of editorial roles to consider: the role of managing editor (curator as producer); the useful skills of arranging material for sense and clarity, which can apply to making an exhibition; or the role of stylistic editor wherein the distinction between editor and author can become blurred. In some modes, the curator might also be acting as a translator rather than as an editor (Graham and Gfader 2008).

The clearest technical innovation of new media is the streaming of sound and images over the Internet, which means less expensive and more accessible broadcast in the traditional sense. Artists' stations such as *tenantspin* can narrowcast to specialist-interest audiences internationally, as opposed to broadcasting to a small geographic area, like analog pirate radio. Artists sometimes use hybrid tactics—for example, irational's *Radio90*, which is based in Banff, Canada, and streams on the Web as well as on FM broadcast, or r a d i o q u a l i a's *Frequency Clock* (1998–), which is software to download for listening to streamed content online, therefore enabling users to edit and select their own schedules for listening. Successful streaming still requires a degree of technical knowledge and server access, but bodies such as Superchannel aim to make the process easier. There are hybrid models galore in the understanding of how new media now relates to mainstream television. In Sheffield, United Kingdom, for example, b.tv (Bastard Television), an independent production company, collaborated with Arts Council England and the BBC to produce *Shooting Live Artists* (2001). Documented on the BBC Web site, this project both commissioned and documented the practices of live artists and new media artists. The work of Kate Rich, however, epitomizes a wider range of hybrid tactics for distribution, which makes important parallels between physical modes of distribution and those afforded by new media.

Example: Kate Rich

Kate Rich's art projects have included numerous collaborations and have been highly mobile in both production and distribution, using means of distribution and broadcast that vary from the online to the very low tech and physical. Rich has often worked anonymously, for example with Bureau of Inverse Technology (BIT) (discussed in chapter 3) and Hostexe, helping with and hosting projects in a fluid way and acting as part of an informal international network (both online and in person) of friends and colleagues.

BITplane (1997), for example, featured a remote control toy plane fixed with a video camera, which gleefully recorded images while flying over Silicon Valley, a place where the technology companies have very strict rules banning photography. The later work *Broadbandit Highway* (2001) was improvised around distribution technology already available, such as the internal television network channel of the Great Eastern Hotel in London. There, Hostexe improvised a live soundtrack to go with images taken from traffic surveillance webcams on international Web sites and that played in the hotel's bedrooms and social spaces. The *Flat of Culture* (2001) project involved audio webcasting from a council flat in a tower

Figure 9.6
Kate Rich, *Feral Trade* (2003–). Screenshot from the project Web site. Courtesy of the artist.

block in Newcastle upon Tyne, with forty-nine hours of continuous broadcasting of visual images from Slovenia, Croatia, and Bristol, as well as an Internet chat line on which people sent typed messages from thousands of miles away and from neighboring flats. The audio artworks included one inspired by Morse code.

Rich has traveled widely for work and personal reasons, which has informed the project *Feral Trade* (2003–) in its hand distribution of trade products such as coffee from a collective in El Salvador and sweets from Iran through informal friendship networks. This project is a very literal and critical take on systems of distribution in a globalized world of trade and works primarily face to face, using new media such as Web sites and e-mail only where it is useful for making links with informal couriers and publicizing the wares.

Lessons Learned from Publishing and Broadcast

I think my only talent is that I'm a good "vulgarisatrice." It is a French word that can be used in a positive or unflattering light; it means that I can make things easier to understand for a bigger number of people. I make media art more pop. By doing so I give it more visibility but as I mentioned earlier there's always the danger of making it look like something just cool and shallow.
—Régine Debatty, in Sarah Cook, "An Interview with Régine Debatty," 2007

Now that artists have access to the international distribution facilities of the Internet, there is still a debate about who gets the most publicity, what kind of publicity, and whether the curator still has an editorial role, with all the attendant responsibilities of fully digesting one's peers. As the Internet is increasingly geared toward Web 2.0 applications, producing and distributing content are certainly much easier, yet often trapped within the structures or templates that the commercial enterprises provide, such as the Flickr site for sharing photographs. Commercial broadcast and publishing bodies are understandably interested in the technological "convergence" of the means of distribution; equally understandably, artists are worried that the Internet's promise to offer a much less controlled system of distribution will be crushed by these interests. However, commercial media predominantly means simple choices and a network that is still centralized, whereas art projects have been exploring the wilder shores of peer-to-peer networks, participation, and hybrid distribution from localized broadcast to international feral trading. As Simon Pope describes in this chapter, it is the ideology of production methods and processes that differs from the mainstream, as is the case with many examples of "other modes" or artist-led ways of working. So from curator as editor, filterer, or digester, yet another mode for new media art emerges, one that is at the heart of issues of production: the "gallery" as research lab.

The Lab—Experimental, Interdisciplinary, and Research-Led

This dialectic between new spaces and new art became critical as a creative blur frequently occurred between the making and the exhibiting of work: the spectator was self-consciously drawn into the

making of the art, or at least into the making of its meaning. This was reflected in the play between three adopted concepts for the exhibiting gallery: the studio, the warehouse (or factory) and the laboratory.
—Sandy Nairne, "The Institutionalisation of Dissent," 1996

Art galleries, musical venues, and theaters have all used the word *laboratory* to indicate an alternative approach that can deal with process rather than object, with participant rather than audience, or with production rather than exhibition. Even in high modernist times, Alfred Barr was describing MoMA as a laboratory. Since then, curators, including Hans Ulrich Obrist (2000), have also used the term to stress the importance of research and to imply that the gallery can be a place of experimental methods of display, perhaps with a more active audience, whereas others have used the term *factory* to emphasize production beyond traditional art authorship (Diaz 2007). However, sustaining an active production program in any exhibiting organization demands effective technical systems and funding, with the latter often being prioritized to the more visible urgencies of public exhibition.

The art world has a tendency to take up words and models without entirely thinking through how they work in practical terms. If a studio is a place of experiment and production, then it is arguably akin to a laboratory or a factory, but a studio has rules of experiment and production that differ greatly from either of these domains. What studios, laboratories, and factories have in common, however, is that they don't often have an audience standing there and watching. Claire Bishop makes a point that arts organizations, excited about a laboratory metaphor, often fail to consider "what the viewer is supposed to garner from such an 'experience' of creativity, which is essentially institutionalized studio activity" (2004, 52). Labs in art galleries, therefore, have often been placed in servicing roles—either facilitating the production of commissions or, if understood as interpretation, making visible to an audience at least some of the processes behind the artwork. Artists-in-residence have sometimes found themselves working in an open "lab" in a gallery space, but this approach tends to be very much about display—often of the artists' creative process—rather than about production or experiment. A real scientific laboratory may be dangerous and messy, as well as nonvisual. It may also require a degree of expertise for a visitor to participate in or gain from the visit. Critical Art Ensemble's *GenTerra* in the exhibition *Clean Rooms* (2002) was one of the few examples of a literal scientific laboratory used as an integral part of an artwork. It was challenged with the actuality of being presented to a nonexpert audience in nonlab conditions: there was a necessity for careful negotiation of health and safety regulations, careful scheduling of live workshop events with the artists, and human assistance at other times to help in understanding what was displayed (Graham 2003a).

Liane Davison, whose background happens to include science and technology as well as art, curates one of the few current examples of an integrated production lab and exhibition area. Surrey Art Gallery is a mixed art form gallery with a nonexpert audience;

Davison has therefore used artists-in-residence as a means of making the new media art—and the processes—visible and accessible. Next door to and communicating with the gallery space is TechLab, a flexible space where artists work and that can be both a real production space and a real exhibition space. Davison explains:

We look at the residency program as a means to address not only the challenge of our institution staying current, just like media artists. If we can assist artists producing work, there's a positive reciprocal for us. In a residency, we ask the artist to do three things: make art on site; help build audiences for new media; and third, assist the Gallery to anticipate media art and artists' needs in the future. . . . Every artist gives us feedback on what has worked and what hasn't and we use this knowledge. . . . The artists-in-residence always give fabulous answers to questions. (in Graham 2004c)

This triple role of artist, educator, and researcher-technician reflects the range of skills demanded by new media and the need to work across departmental boundaries, as described in the previous chapter. If serious production is really taking place in addition to exhibition, then the science lab or art studio metaphor can have definite effects on the building's structure and the curator's mindset, and can demand definitions beyond the vague art world use of the terminology.[15]

Figure 9.7
Installation view of TechLab at Surrey Art Gallery, Surrey, Canada, showing M. Simon Levin's installation. Photograph by Cameron Heryet.

Models of Labs

The definitions [of terms such as *research*] are different in Canada, i.e. in a university [it] is . . . clearly pre-commercialization. There are disclosure agreements with private companies regarding development of projects/software. But at the same time you need to maintain an open source network with the artists. How do you walk that line?
—Sara Diamond, presentation at the 2001 "Momentum" forum, 2001

If art has borrowed methods from science that it fails to implement fully, then it has been argued that new media art, with an inherent interdisciplinarity between technology and art, is eminently suited for the lab format. These modes of working with new media art that include lab and workshop can certainly offer ways of working that are process oriented, non–object centered, and open to experiment. However, Lev Manovich cites the lab factor as one of the key divisions between Duchamp-land and Turing-land: "Duchamp-land wants art, not research into new esthetic possibilities of new media" (1996).[16] Conversely, artists who might want to be admitted to Turing-land still struggle to be recognized as research professionals (Burgess n.d.). Labs have their very own gatekeepers, who may be reluctant to let real, live, "free-range" artists in to play with the labs' equipment. Therefore, if these models are the *only* ones offered to new media art by the gatekeepers of fine art institutions, then we don't necessarily have the answer to how new media art might usefully be curated into the art world. As Sara Diamond illustrates, there is a tension between art and labs, but it is important to differentiate whether that tension is between art and the modes of production, pure research, or commerce. Broadly, three kinds of models can be identified.

Production: Workshops Factories and workshops are about producing products, and many "art labs" are also about producing art products. In the United Kingdom, the history of "community media workshops" made means of production available to non-artists. Artec, a computer arts workshop organization in London where Graham Harwood of Mongrel once worked, was founded on such issues of access, but through funding changes became more about training and hence moved into the "creative industries" (Bassett 1999; Haskel 2004).

Research: Laboratories The conventional scientific research laboratory is about process. Experimental activities occur, things and ideas are tested, and sometimes they fail. A "pure research" laboratory is still sometimes found in academia, although research is often funded by short-term research grants, so "product" is still eventually measured in some way, but that product is often information.

Research and Development Research and development activities are sometimes called "labs," but usually lie somewhere between research and production, as the name implies. The model is primarily a commercial model, and interdisciplinarity is encouraged in as much as it is functional: for example, the report *Beyond Productivity* specifically asks what art and design can do for computer science and vice versa (Mitchell, Inouye, and

Blumenthal 2003). Michael Naimark summed up the tensions within this model in the title of his 2003 report about labs, *Truth, Beauty, Freedom, and Money*.

The tensions of working within any of these three models of a lab are therefore not necessarily just between the disciplines of art and science, art and engineering, or art and computing, but rather, as Diamond indicates, between art and commerce. In *Art and Innovation* (Harris 1999), the book about the Xerox Parc Artist-in-Residence Program, for example, the recurring issues between the artists and the scientists were the corporate issues of scheduling, confidentiality, and intellectual property rather than cross-disciplinary difference. Organizations often mix their metaphors about labs and workshops even though these modes have quite different relationships to product. It is therefore interesting to see how new media lab models have dealt with the tensions between production and research.

Example: V2_, Rotterdam

Anne Nigten was for many years the manager of V2_Lab, part of the V2_ organization that also has departments to undertake activities that result in publications, events, an online repository, the KnowledgeBase, DEAF, a store, and an archive. The lab itself comprises projects, research (including the project *Capturing Unstable Media*), a residency program (for researchers, technicians, curators), and artists-in-residence. According to Nigten, it

> is mainly involved in software/hardware-based art and software to support artistic development, following two collaboration models, based respectively on a multidisciplinary approach and an interdisciplinary approach. Although "multidisciplinary" and "interdisciplinary" are often used synonymously, I refer here to the definition of these terms provided by the dictionary: "multi" is defined as "many" and "inter" as "between, among, mutually, reciprocally." . . . I refer to these two approaches and not to the outcomes of the processes, since different artistic qualities derive from both approaches, and these work processes are referred to as indicators of quality or importance. (Nigten 2002)

V2_ often organizes inter- and multidisciplinary public events and seminars such as "Understanding Media Art Research" in 2004. Founder Alex Adriaansens has described V2_ as a "connection machine" (in Graham 2004a). This concentration on invisible networks and systems of working is key to the lab's approach: as manager of the lab, Nigten saw to the publication of the organization's findings in *A Guide to Good Practice in Collaborative Working Methods and New Media Tools Creation* (Goodman and Milton 2004) and participates in similar research at SMARTlab in London as well as in the international Research and Development Informed by Creative Arts Labs (RADICAL) project.

In terms of curatorial modes, Nigten has described herself not as a curator, but as a manager who consults with curators and technicians because she is not herself an engineer. The lab itself is an architect-designed space, featuring areas defined by zipped, clear, plastic curtains and a substantial, mobile, equipment base. The lab works on both hardware and software projects, with the artists-in-residence and the resulting projects often the result of creative cross-fertilization.

The main funding comes from the Netherlands Ministry of Culture and the City of Rotterdam, but this source specifically excludes funding for exhibiting, so for the distribution of art production V2_ needs to work online or with arts organizations—primarily local organizations with galleries in Amsterdam, such as the Netherlands Media Art Institute (formerly Montevideo) and Steim, often using guest curators or cocuratorial modes. Curatorial interns have also used the substantial V2_ archives to research new media art for publishing and exhibition. As outlined in this chapter, festivals can offer appropriate venues for showing artworks and works in progress; in this case, DEAF forms an important platform for exhibition, co-commission, and debate. Publishing is also an important outlet for production and debate on process. Although arts organizations in the Netherlands don't have a specifically educational responsibility, nevertheless V2_ has been voluntarily involved with several universities, including Goldsmiths College, London, UK, and Piet Zwart Academy in Rotterdam. Projects have included running external modules for the universities of Amsterdam, Utrecht, and Leiden.

The individual research projects do not aim to make a profit but seek to cover their costs, usually by forming a consortium with other organizations and raising money from bodies such as the Ministry of Science, the Daniel Langlois Foundation for Art and Technology, and

Figure 9.8
The production area at the opening of V2_Lab, Rotterdam, the Netherlands, in 1998, showing clear, zipped, plastic room dividers. Photograph by Jan Sprij.

the Mondriaan Foundation. Some projects involve in-kind support from commercial companies such as Phillips, but V2_ has not been involved to a great extent in "research and development" models.

The V2_ model of a lab serves to highlight a certain relationship between production and distribution. For new media art, examples exist of all three kinds of labs (production workshop, research lab, and research and development facility). The workshop model, for example, has explicit industrial references in the Redundant Technology Initiative (RTI), an artist-run lab in Sheffield, United Kingdom. It deliberately uses the language of postindustrial depression to foreground its ethics of using discarded technology and open source software and of providing a free drop-in lab for the local community. For a place so concerned with process, it is interesting that the project has also shown artwork in exhibitions at venues including Tate Britain. The "research lab" mode of formal research has examples at many universities as well as at Sarai in Delhi, India, where the labs are supported both by the Urban Cultures and Politics Programme at the Centre for the Study of Developing Societies and by Sarai's cofounder, the artist group Raqs Media Collective. The labs therefore have both a university humanities research and a media workshop agenda. In India, computer programming is an important cultural and political issue, so software has become very important for Sarai, which has produced FLOSS software in Indian languages (Raqs Media Collective 2003). Research and development cover a wide range of practice, from the Xerox Parc research mentioned in this chapter to media arts centers such as the Banff New Media Institute, which is predominantly art oriented and experimental, but also does some more commercially oriented development work.

As is typical of new media, however, there are hybrid examples such as Eyebeam in New York, which includes both conventional artists-in-residence programs and a research lab with longer-term research fellows who release their work either though open source software or instructions into the public domain. The building has a large, warehouse-type performance and exhibition area, which, being in Chelsea, situates the venue right in the center of the conventional commercial art distribution modes, while presenting a very different approach to distribution. If we are considering open source software practice in particular, as all of these examples do, then it can be argued that the space follows a workshop, research, *and* development model because, after all, open source software is being developed there as a product, albeit a free one.

New media labs have therefore developed several different models for dealing with the production of artwork or with process-based research, which can usefully inform the more uncertain use of the terminology by contemporary art in general. However, the question remains: How much of this artwork is communicated to those in the world of contemporary art?

Lessons Learned from Labs

This might be where the departure between traditional art and art/research occurs as in most fine art contexts (even digital interactive art to some degree)[;] simply justifying the work by creating it and providing a theoretical grounding . . . is often sufficient. In the research hybrid it's less about the concept and framing of the work and more about the feedback, analysis, and user studies from people either using the work or experiencing it over time.
—Jonah Brucker-Cohen, "Formal Research: Response," 2003

Working the boundaries between art and research as well as between research and production, new media artists and curators have had a great deal of useful experience of what works and what is just rhetoric. One lesson learned from new media is that curators and institutions shouldn't be led by the technology, especially if this choice locks them into an uncomfortable long-term relationship. Another obvious factor (also identified in chapter 8 on museums) is the importance of technical staff: the Banff Centre, for example, had state-of-the-art technology for virtual reality for some years and did facilitate important work, but it struggled in the long term to fund the programming expertise to assist the artists.

There are many pitfalls for any research or production project quite apart from the challenges that many forget—those of making good art. In the spirit of practical research identified by artist Jonah Brucker-Cohen, however, many useful reports are willing to be analytical and to identify patterns of factors for success. Michael Century, who ran the early virtual reality experiments at the Banff Centre, suggests looking at a thirty-year time frame (including consideration of long gestation periods) to appreciate the long-term benefits of research, the importance of working with distinguished artists, and the possible multiple outcomes for different audiences (1999a, 23). What several reports identify is that the factors for success are not so much about hardware as about the immaterial systems and relationships.[17] Establishing the rules for these relationships is key to sustaining them.

For interdisciplinary production in particular, many new media labs can offer useful solutions to important questions. Are the scientific and technical staff servicing the artists, or are the artists merely content providers? Are art/science projects merely "illustrating" scientific ideas or visualizing someone else's data?[18] At the Banff New Media Institute (BNMI) at the Banff Centre, the thrust of the research has been to define successful systems for interdisciplinary production, and this goal has been discussed at a series of discursive events and workshops. Hernani Dimantas, for example, shared useful experience from the MetaReciclagem project in São Paulo, Brazil. Specifically, he illustrated how through the use of new media and hacker ethics, the "easy conversation" of the local markets and "survival craft" of favela living can "join everybody's ego trips to create a collaboration" (2004).[19] Sara Diamond has identified key issues from a series of these BNMI events, conferences, and consortia, including her art project, *Code Zebra*,

which used an unusual but highly entertaining method of interdisciplinary "collision" by placing pairs of artists and scientists together in beautiful, but closed room spaces for twenty-four-hour periods (Nigten 2004). Diamond's analyses amount to a codification of interdisciplinary production that identifies parallel and conjoined methods of collaborative research and an ethics of mutual respect.[20]

All of the examples in this section offer different models of how to deal with the tension among research, production, and distribution.[21] Labs, therefore, certainly offer the kind of facilities and knowledge for multidisciplinary production that suits the needs of new media art. However, with regard to the products of these labs, for each champion of the research mode there are others who object to the commercial incompatibilities of such modes and who fear that they will be labeled as residing in Turing-land. As described more fully in chapter 11, however, labs and the modes of research they support can be regarded as a unique strength of new media art.

Summary: From Production to Distribution and Beyond

[P]rovisionality . . . admits and allows the curator to be a learner, to be enacting a process-in-process.
—Renee Baert, "Provisional Practices," 1996

Curator Renee Baert has described the "provisional practices" of curating as fundamentally experimental processes that may fail and may expose a curator to "learning in public." However, if curators are able to learn from the experience of other fields, they may be able to apply a mode of working to another field completely—for example, apply lab modes to any cross-disciplinary artwork or festival modes to short-term hybrid platforms. Utilizing these other modes may be much less painful than forcing museum modes to fit or reinventing modes and having to learn in public.

Curators are thus offered a number of other modes of working that might fit new media behaviors and that encompass both production and distribution, both process and object. In all the modes discussed in this chapter, the role of the curator includes being involved in the production of the work of art, and the question is how this new commission might encounter its audience. This chapter has addressed other possibilities not only for showing new media art, but also, crucially, for making it—from the placelessness of the citywide mobile festival back to the actual space of the lab.

Both festival and lab curators have to deal with the tensions between art and the commercial world—the commercial art fair, the trade fair, the funding structures with an eye on development or regeneration. Does new media art deal well with this tension because it is more closely tied to developments in culture—the technological possibilities of making and distributing engaging content from the artist's desk to the world? Or because new media art is sometimes at a greater distance from the commercial (art fair) world because of its natural emphasis on process over product? Or because it simply challenges

the established format of the exhibition, preferring the more hybrid forms in keeping with its variable, connected, distributed nature?

From the specific challenges of curating public new media art from within an art agency to the matching of medium to context in the case of publishing and broadcast, curators are discovering that distribution means more than just display. Getting their hands dirty in the lab alongside the artist is one way of enjoying this new mode and learning more about the process. As Baert says, curators need to be learners if they are to rethink curating. Although the modes discussed in this chapter move away from the conventional art museum, they are still relatively familiar in method. In the next chapter, we move away from the lab to the studio and to artist-led and collaborative modes of working.

Notes

1. Indeed, an attempt to write a time line of the distribution modes available to the newest of new media art from 1960 to 2000 might demonstrate a trajectory from new media art's inclusion in gallery-based exhibitions in the late 1960s and early 1970s (such as *Software* at the Jewish Museum and *Information* at MOMA, both in New York in 1970) to its inclusion in newly founded festivals (such as the World Wide Video Festival) to the creation of explicit platforms for its presentation, such as servers and lists (The Thing, Rhizome), and then again to its inclusion in museum exhibitions (such as *010101* in 2001 or the *Whitney Biennial* in 2002) (Cook 2004b). After 2000, we find new media art distributed in any number of these and other ways.

2. As established in chapter 3, in the case of Net art the media used for production is often the same as that used for distribution, and the connectivity is a key behavior of new media.

3. In fact, the histories of these media-specific festivals are often intertwined (it was video festivals that first showed Internet-based art and that were crucial early adopters of new practice and developers of new types of exhibition).

4. As outlined in chapter 4, there are conceptual and media differences between film and video, and they are reflected in festivals: video art festivals are not necessarily even very closely tied to film festivals—and, indeed, old film cooperatives were initially very hostile to the users of the early video production facilities. These territorial divisions between artists, which have arisen over each group's particular approach to its chosen medium, seem at odds with the tendency for a museum's departments of film and video to be considered one and the same department, with a single curator responsible for both fields (although increasingly this is no longer the case; MoMA has just created a department for media that includes video, but not film, which remains its own department programming the cinema).

5. In fact, the *Whitney Biennial* exhibition has included a curated video art component, which was distributed separately—loaned out to smaller regional galleries and cinemas for presentation.

6. Documenta was explicitly developed as a way to recoup the wartime devastation of Germany. The first Documenta exhibition was initiated by the painter and educator Arnold Bode and took place from 16 July to 18 September 1955. Not only did it include many artists whose work had been in the *Degenerate* exhibition of the National Socialist regime (which opened in Munich in 1937), but

it also was deliberately held right in the middle of the country, in a city nearly destroyed by Allied bombing, Kassel. See http://en.wikipedia.org/wiki/Documenta_1.

7. Indeed, the financial implications of such global events also have a detrimental side; they favor those who have the budgets to travel to them. This favoritism creates a curatorial trap, where, as Barbara London says, well-funded curators dance "the novelty hustle," trying to get home in time to be the first to show the latest great artist seen in the international fair.

8. SIGGRAPH is an annual conference on computer graphics and interactive techniques, first held in 1974. For further information, see http://www.siggraph.org.

9. Ćosić wryly pointed out: "While it would be truly polite to congratulate ourselves for the inclusion in the Biennale . . . the fact that net.art has become part of the official history of the Biennale is a consequence of the art-political vacuum in Slovenia. The previous selection of artists for this show have raised so much bad blood (mauvais sang) that the key institutions have de facto boycotted the selection process staged by the culture ministry" (2001). Ćosić's point is that as locally responsive and internationally inclusive biennials and festivals may try to be, there are always politics and economics to consider.

10. A good example of this model of repeated events is the Ars Electronica Festival, documented in the book *Ars Electronica: Facing the Future,* edited by Timothy Druckrey with Ars Electronica (1999).

11. This lack of funding then adds to the significance of the prizes awarded: as Julian Bleecker quipped when winning the Peoples' Choice award at ZeroOne San Jose, "Thank you, now I can pay my hotel bill." In fact, ISEA 2006 and 01SJ had two tiers—those artists whose work was curated into the formal exhibition at the San Jose Museum of Art, who were paid fees, and those whose work was selected by an international jury and shown in the temporary exhibition hall, who were not paid but received in-kind, limited, technological support.

12. Mongrel's project *Lungs-London.pl* (2004) is a perl code software "poem" that, like William Blake's poem "London" (1794), calculates the loss of life, for children mostly, caused by poor working conditions and their resulting ill health. With the help of a mortality records database, the perl code calculates lost lung capacity and "breathes" the total amount through the interface of a speaker (placed on a school desk).

13. The international group-exhibition *Broadcast Yourself: Artists' Interventions into Television and Strategies for Self-Broadcasting from the 1970s to Today* was co-curated by Sarah Cook and Kathy Rae Huffman for AV Festival 08: Broadcast. It was on view at the Hatton Gallery at the University of Newcastle from February 28 to April 5, 2008, and at Cornerhouse Manchester from June 13 to August 10, 2008. Further information can be found in the online catalogue, http://www.broadcast yourself.net.

14. Portable document formats (PDFs) signal another recent development for publishing: the commercial sector now sells PDFs online and can enable print on demand for short-run publishing, whereas academic and art organizations usually make them freely available. It remains to be seen whether new media art publications will adopt those economic models now in use by newspapers, which include the cheap printing of "lite" free evening versions of the following morning's full edition, and ask visitors to their Web sites to pay subscription fees for archived content—akin to buying a book.

15. As Claire Bishop has pointed out, production in the gallery has become formalized to a point where "related to the project-based 'laboratory' tendency is the trend toward inviting contemporary artists to design or troubleshoot amenities within the museum" (2004, 52). Bishop gives as an example Liam Gillick, who has designed screens, walls, tables, and benches intended as formalist interaction spaces at institutions such as the Tate. European media agencies and labs have been termed *platforms* for several years (Murschetz 1999)—a word used elsewhere in this book to describe the way that curators host events, discourse, or exhibitions, although more usually in relation to distribution than production.

16. Turing-land and Duchamp-land are described in chapter 1.

17. Michael Century (1999b) categorizes his examples of labs by "style of teamwork"; Pamela Jennings talks of "building capacity and community" in her 2000 report; and James Leach in 2007 considered that "value lies in the relationships established."

18. These issues are explored in Arends and Thackara 2003; Cook 2001c; and Kemp and Schultz 2000, 101.

19. In this book, the open source and FLOSS systems are introduced in chapter 5. MetaReciclagem in particular uses FLOSS, including MetaLinux, Komain, Drupal, Nucleus, Xoops, and Moodle. It is in these kinds of workshops that the rhetoric of open source software becomes most real, and the year 2006 saw the Brazilian government's announcement that most software used by most public institutions in Brazil would be open source.

20. These comments come from the documentation of the summit "Participate/Collaborate: Reciprocity, Design, and Social Networks" (2004) and Diamond 2002, 3–4.

21. In addition, Ele Carpenter, through her work on projects such as *LabCulture* and the *RISK Academy* (2002), has written about the tensions arising from the time it takes to learn and understand software in new media art labs and the pressing desires for art production and exhibition (Carpenter 2008; PVA Medialab 2005). One solution to this tension has been to put the emphasis on training, specific skills, and manageable short-term outputs, such as Lisa Haskel's (2002) London-based "Tech_nicks" series of touring workshops specifically on streaming media online.

10 Collaboration in Curating

Net-based culture holds out an even more challenging possibility; to force us to rethink the conventional identity of the artist as someone who develops projects or works that are then administered to a receptive viewer.
—Grant Kester, "Subject: From Grant Kester," 2001

The previous chapter looked toward hybrid modes of working outside the museum but within the landscapes of contemporary art and digital culture, from the biennial to the blog to the lab. The examples suggest that a separation in the curatorial process between production and distribution or exhibition of art is increasingly hard to maintain with new media art. This is all the more so with artists who are self-curating their projects and using new technologies as both tools of art making and methods of exhibition, as is often the case on the Web. This chapter addresses these collaborative hybrid models borne of artists' practice. Many of the examples discussed foreground the process of collaboration, and the chapter elaborates a critique of "collaborative in name only" projects,[1] the ambiguity inherent in online "collaboration," and the difficulties of finding the right balance between control and authority in open and shared projects. By starting with examples of artist-led activity and moving to audience-led activity, this chapter traces the move in curating from being all about the curator to there seemingly being no curator at all.

Artist-Run—Alternative Spaces and Independent Organizations

If there are actual "alternatives," they are to be found at the very edges of the system or hidden in the cracks and crevices at the centre.
—Sandy Nairne, "The Institutionalisation of Dissent," 1996

In 1996, Sandy Nairne considered alternatives to the white cube museum and gallery space in terms of politics, experiment, space, place, and economy. He concluded that in some way all possible alternatives still existed in relation to the predominant system of art. As Ruth Claxton has written, "the overwhelmingly predominant model is the clean, white cube gallery space, run by a committee of artists and often with a longstanding director, mimicking the structures and organisation of the institution" (2005, 4).

In fact, it is now possible to discern a wider diversity of spaces for showing art, each with its own well-documented history.[2] Categories of artist-led spaces and places (Carpenter 2008) might include:

- An artist-run organization
- An organization run by an artist where an artist is the director (which, as Claxton indicates, is not so different from an institution)
- A cooperative, which is a legal entity like a gallery or museum, but which is owned and controlled by members
- A collective, which may be a similar model to a gallery, but is collectively run by a number of staff people with no distinct hierarchy in their roles
- A studio collective of artists practicing within a gallery, perhaps without a formal exhibition space (a design workshop for instance)

Collectives and cooperatives are different under a prosperous economy than under a depressed economy, and networked technology makes collaborative working much more fluid. Nairne points out, however, that both models "rely on a degree of liberal egalitarianism which contrasts greatly with the curatorial, directorial and trustee hierarchy of most larger art museums" (1996, 398). We can thus continue the list with:

- A community interest company, which in legal and financial terms sits between a profit-making company and a not-for-profit charity
- A charitable organization "staffed" by volunteers
- An artist's network, which might exist for the sake of communication rather than production, distribution, display, and exhibition of art; for instance, networks of artists developing around a particular project and then devolving when the project ends

Any or all of these models might have exhibition spaces or not. They all are possible alternatives to the civic, regional, national, or international museum or gallery. They might have their own "alternative" audience and hence their own way of legitimating their activities among their peers. Artist-run publications, for instance, are now well-established parts of the art system.[3] In the end, it may be an organization's political outlook or focus on experimentation or its physical manifestation (in a closet, in a pocket, in a warehouse) or its financial backing that distinguishes it from the more traditional museum or gallery. In that sense, it might be right to call itself independent—but independent from what is the question. From the private sector? From public government funding? From the pressure of exhibition? What is the difference between being an alternative and being independent?[4]

Avant-garde movements are littered with home grown institutions. Let's be clear about this: alternative spaces, artist-run galleries and artist-led art magazines are institutions. When [Alexander] Alberro laments the institutionalisation of artist-run galleries he obscures the fact that they were institutionalised all along. The same is true of the Cabaret Voltaire, the Judson Dance theatre, Art Language magazine, Artist Placement Group, Variant magazine, Bank space, and the Copenhagen

Free University: without such institutions the Avant Garde would be stillborn. Critique, if it is to have a transformative effect, needs to build alternative institutions. If critical culture is not to be converted into mainstream culture without remainder then it needs to institutionalise its alternative values. (Beech 2006, 10)

Artist and critic David Beech nicely surmises the tension between being alternative and being institutionalized. It bears remembering that even non-artist-run organizations that engage with new art and new models of exhibition practice can find themselves tripped up by following too closely the artists' desires to be outside, avant-garde, and alternative. "The ICA was often split internally, and attempted to occupy both official and unofficial positions in the cultural life of London. . . . Despite occasional outrages and clashes the ICA was a very official alternative; for all its independence, a site of controlled experiment" (Nairne 1996, 393–394). How do today's alternative, artist-led projects help us to rethink the role of the curator?

Learning from Artist-Led Ways of Working

The alternate space is the equivalent of "dressing down," wearing jeans and knowing what's in, intellectually, aesthetically, politically—in the sense of artworld politics. Money is nowhere to be seen. . . . The dinginess or long climb on creaking stairs to the clean white space, the unexpected content: government office building, broken down loft, business district, etc., proves sincerity.
—May Stevens, "Is the Alternative Space a True Alternative?" 1980

In the previous chapter, the distinctions between labs and exhibition spaces was addressed. Another hybrid example is the Star and Shadow Cinema in Newcastle upon Tyne, United Kingdom—a warehouse with a cinema, gallery, studio, lab, social space, bar, and meeting rooms.[5] Founded by film enthusiasts, this venue is a community interest company, but it is entirely volunteer run and collective in its approach to everything from budget planning to programming. It exists to show all kinds of moving-image work—from Bollywood cinema to anarchist and radical films to socially engaged documentaries—as well as art, live performance, music, and other intermedia from artists such as Cory Arcangel.[6] It is programmed by committee (interested volunteers using a consensus form of decision making), and there is no hierarchical structure to get acquainted with: if you come to an openly advertised organizational meeting and have the enthusiasm to make something happen, almost nothing other than scheduling it, getting permissions from the makers, and finding funding for it, if needed, will stand in your way. Ele Carpenter, one of the founders of the Star and Shadow Cinema, writes of the uniqueness of this way of working, situating it within a context of socially engaged and activist practice of art making:

As film has become digitised its accessibility and affordability have created opportunities for both artists and activists to utilise the media, creating their own independent hubs for production and distribution. . . . This convergence of ethics and technologies is carefully negotiated by art-activist screening venues such as the Star and Shadow Cinema and Cube Cinema, whose non-hierarchical

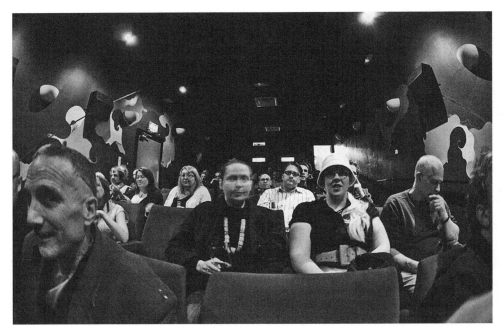

Figure 10.1
The Star and Shadow Cinema in Newcastle, United Kingdom, which fosters an artist-led, collabora-
tive, volunteer spirit for the production, distribution, and reception of moving-image work in any
format. This documentation shot shows the audience at the Music and Film event by Suzy Man-
gion, 20 September 2008. Photograph by Conor Lawless.

commitment to all forms of film technology (analogue, print and digital) situate them within the
tactical media rather than conventional media culture. (2008, 50)

The Star and Shadow Cinema is a radical new bricks-and-mortar manifestation of an
old impetus: creating communities around the shared experience of viewing moving-
image art. This new venue, like others before it, arose out of a need to show work that
wasn't getting seen otherwise—the "freedom to create and publish ideas and images that
are not merely alternate but unacceptable" (Nairne 1996, 406). Throughout this book,
we have described some of the distinctions between the kind of work that is acceptable
to the art world and the kind accepted by the new media art "ghetto." Although there
is today nothing particularly "unacceptable" about moving-image work itself, there is
definitely something alternative about the way it is programmed at the Star and Shadow
Cinema. Media art in particular—due to the behaviors of its medium, such as connectiv-
ity in the case of Web-based art—was quick to point out new possibilities for program-
ming and how it needed an alternative to the traditional gallery setup in order to be
seen. But "alternative" to the mainstream doesn't have to mean unacceptable in me-

dium only. New media art is inherently networked and distributed, so "alternate" might today imply the kind of user-generated content filtering of the Star and Shadow Cinema rather than the hierarchical programming model of the museum. The incentives for artists to work within such a collective are multiplied with respect to new media technologies: experimental spaces and seemingly open systems allow for network-centric art practices to flourish and provide a different kind of institutional validation for cultural production than is the norm with more hierarchically based and centralized organizations. As Skawennati Tricia Fragnito writes,

"artist-run culture" [is the term used to describe] our publicly funded gallery and production spaces whose boards are made up (usually) entirely by artists, or at least artsy-fartsies. When I (with Ryan Rice, Eric Robertson and lots of support from others) co-founded Nation 2 Nation, a First Nations (Aboriginal) artist collective, one of our goals was to make exhibitions happen for ourselves. It seemed only natural and right when we started thematicizing (I hope you will accept the new verb) and grouping artists, formats and ideas together. (2002)

Clearly, there are benefits to filling a gap, conceptually or physically, in your own local art culture. But now that the line between alternative culture and official culture is muddier still (with mainstream arts venues showing exhibitions of graffiti and street culture, for instance), the question bears asking: If artist-run centers are seen to be adequately addressing a new or emergent field of practice, does that excuse other more established and mainstream organizations within the art landscape from showing these art forms also and thus leading to these art forms' further ghettoization? (Inke Arns in Cook 2006b). It is clear that legitimation starts as peer support, and in an artist-run model that is bound to be the case (as it certainly is for Net art also). Yet legitimation of new practice (new forms of art making) can also be extended through how that practice is supported by new institutions, just as new forms of curatorial practice or event or exhibition organizing (of which the Star and Shadow Cinema is a multidisciplinary example) are legitimated by their new organizations.

In general, artist-run centers may be lauded for their capacity to respond quickly to developments in the field (their space is usually but a short step from the studio), but how are their legitimating activities actually shaping the field? In 2000, large physical installations of new media art seemed to be becoming "the 'preserve' of big museums, and net.art the preserve of artist-run spaces (mostly because of resources)" (Graham 2001b). These technical and practical considerations regarding the production and distribution of art need to be taken into account alongside the more theoretical concerns of working the terrain of the alternative. What starts out as an alternative way of working for practical reasons—as Patti Astor commented, "I just wanted a place to show art and didn't want to bother to fill out the grant forms" (in Nairne 1996, 404)—can soon become an alternative way of working for theoretical reasons, and vice versa. If new media art is itself a kind of alternative or other and unacceptable system to contemporary art, and if the artist-led model is posited as an alternative to the gallery system, then new media artist-led

activity is seemingly doubly alternative. In fact, it is impossible to argue that new media art, like any other form of emerging practice, has ever been anything but artist led.

For new media art, there are clear benefits to the artist-led way of working, often evident in the practicalities of how things are curated and organized: team working makes more sense with new media projects, which are fluid in their approach to finished product; collaboration between parties is often made more simple (across distances, across time zones) with the kind of teamwork inherent in the technological field. Furthermore, when it comes to the production and distribution of new work, overheads are lighter and more mobile when dealing with seemingly immaterial and placeless new media artwork (such as Net art), and the means of production and distribution are more accessible.

The danger of the artist-run model is tied to questions of sustainability and access to resources—not necessarily specifically in relation to new media. If the choice is to show works that technically don't require great resource allocation, there are still all the attendant activities that require financial investment—from the opening party to the documentation. Just as the incentive for documenting this self-organized activity is often just to try to maintain as irreductive a version of the art's history as possible, so it is also true that creating something outside the system is the surest way to get yourself pulled into it. Chris Byrne, writing about the cycle of development for an emerging art form to be accepted into the mainstream, commented that "we have moved from . . . artists as curators in the developmental stage to a relatively professionalised infrastructure emerging now, where museums and institutions feel more confident about getting to grips with the technologies. . . . [T]he [new media] art world is now equivalent to artist-led initiatives in other [more established] media" (2002).

As a result, there appears to be a precariousness at the heart of alternative and artist-led activity, as much as there is a deadening in becoming institutionalized and in finding that more than half of a curator's working time is spent sustaining the institution and not the activity taking place within it. The latter issues were addressed in an exchange between artist Karen Guthrie and a funding officer at a seminar in 2001 when the funding officer asked if the artist struggled to remain an individual in her work and not become an organization or production company by dint of her collaborations with other artists. Guthrie replied: "I think there are lots of artists in our position who want some of the hassle taken off their hands—they want the professional status that helps them do what they want to do creatively, but haven't done business studies. . . . We want to be flexible. We want to move quickly. We don't want to get bogged down with a building and a programme" (in Pope and Guthrie 2001).

The questions of funding and sustainability are at the heart of artist-led activity, but the artist-run, collective, and volunteer-led mode of distributing and presenting art (as exemplified by both the Star and Shadow Cinema and NODE.London, discussed later in this chapter) poses other dangers. Within the culture of new media, with its mixed economy of voluntary and paid activities, time does equal money, so those individuals

who are well funded, efficient, organized, and good at documentation and who have a wealth of time may conceivably, at the very least, dominate the program, if not turn the activity into a mainstream institution of the kind Ruth Claxton describes or, at the most, use the activity to write the history of the field. This outcome is particularly evident when considering open systems of collaboration in creating artist-led activity. At play in any collaborative project is a hierarchy of time: he who has the most time (to sustain his involvement in the inevitably long meetings that result from multiparty discussions) has the most power.[7] Just as with new media tools, he who holds the key (passwords or technical knowledge) to the filing system can determine what gets seen and what gets buried.

In new media art, which for many in the art world still remains an illegitimate (or unlegitimated) form of cultural production, the critical scrutiny of artist-run projects should be just as harsh when they fail and just as supportive when they are successful. As Saul Albert writes, "It's clear that in the Arts, as in all areas of society, there is an ever-increasing imperative from central government and industry for greater accountability, evaluation and evidence of 'success.' This comes along with a pervasive management culture that is anathema to unwieldy, risky, genuinely subversive or non-hierarchical forms of cultural organisation" (2006a).

Swapping Roles—Artists as Curators

If in these instances the artist has strayed into the terrain once traditionally accorded the curator, then this has been at her invitation, at her behest. This is, and should remain, a one-way process: the curator should no more flirt with the notion of becoming an artist than fancy herself in the shoes of the patron. Instead, through such a collaboration, she may gain a partner who, like herself, also wishes to play by other rules—and to devise other paradigms.
—Lynne Cooke "In Lieu of Higher Ground," 2007

Whether there is a "felt need" for an exhibition, festival, or whole new organization devoted to a given emergent medium or field of practice or not, artists have long toyed with possibly giving up their (poorly paid) activities for the powerful possibilities of working within the institutions of art. (Does change happen on the inside or from without?) After all, a number of artists work in institutions, anyway—as part-time technicians or exhibition assistants—and so have insider, firsthand knowledge of the system, which inevitably affects their practice. Thus, we have the familiar sight of artists populating the numerous university degree programs in curatorial studies. But much still depends on the successful legitimation of their chosen medium within the wider sphere of cultural production. In the case of new media art (and Web-based work in particular), where process rather than objects is prioritized, it would appear that little is to be gained by moving one's activities into an institution that is built around the static object. Although artists might be best placed to curate an emergent medium (because they work with it,

they know the most about it), it is entirely possible that in a self-organized mode of working, the end result will be a project that either preaches to the converted or speaks only to an audience of peers. This section examines some of the strategies artists employ when acting as curators in the system of art and what the incentives of doing so are.

Activist, Oppositional, and Interventionist

Daniel Joseph Martinez objects to being identified as an artist . . . and has invented his own job title. He prefers to be known as a Tactical Media Strategist. The "tactics" and "strategies" he employs fall into two categories: Martinez defies rules, and he disrupts conventions. These methods are designed to expose insidious concentrations of social, political, and economic power. Open discussion is a prerequisite for social change. Martinez succeeds when his methods stimulate dialogue among those who are in control and those who are controlled.
—Linda Weintraub, "Political Success—Diffusing Concentrations of Power: Daniel Joseph Martinez," 2003

A good example of artists acting as curators in an activist or oppositional mode is a project relating to the *Whitney Biennial*. As inclusive as the biennial has tried to be in its presentation of media art,[8] from the get-go it was co-opted by its more new media savvy cousin, Whitneybiennial.com—a collaboration among artists Miltos Manetas, Patrick Lichty, and Michael Rees. The idea behind Whitneybiennial.com was not just to divert Web traffic searching for the museum's exhibition, but to "create an 'exhibition' concurrent with the opening night of the *Whitney Biennial* consisting of U-Haul trucks that would circle the museum showing projected Flash-based snippets . . .via rear-projection screens. The idea would be to question the relevance of shows like the *Whitney Biennial*, the material gallery and like strategies by recontextualizing such cultural spaces in light of online art" (Lichty 2004a). Within the online art community, the project generated a debate around artists' use of Flash, a proprietary software coding language commonly used in the field of Web design. Was design being elevated to the status of art, or was the entire project a conceptual breaking of boundaries between the virtual and real? When on opening night the U-Haul vans never materialized, but more *New York Times* column inches had been devoted to Whitneybiennial.com than to the Whitney's exhibition, it seemed the latter was more likely the case (Lichty 2004a). This instance of outsider intervention can be read simply as an artist's project, but the upshot—that it addressed a debate in the field of production as a whole—links it to debates about the role of artists as curators, as legitimators of artistic practice. "This activist role requires some of the best practices of curators, while coming up against the pressures to quickly create genres in an immature medium, or set of media. This creates friction with value structures and validation through the traditional means of the institutions of art. In new media curatorial practice, there is often a mix-up between the role of the curator as a creator and interpreter of the exhibition space and the role of the artist as creator" (Diamond 2003, 157).

Functionally and Practically Alternative

> I too have been straddling the line between artist and curator for some time now—feeling more comfortable with the title "artist" mainly because I did not study Art History and became a curator in "guerilla" mode, thinking up shows that my co-curators (friends, kindred spirits, etc) and I believed needed to be seen.
> —Skawennati Tricia Fragnito, "Curational Models," 2003

Independent projects sometimes arise out of a need to represent emergent art activity that other organizations are not taking on, in which case the artist assumes the role of catalyst as well as project manager—curating both his or her own work and that of friends and colleagues. An example of this functionally alternative form of curatorial practice can be found in the work of Nina Pope and Karen Guthrie, such as *TV Swansong* (2002).

TV Swansong, a single-day webcast of programmed content, both live and prerecorded, included the work of eight artists who, in addition to Pope and Guthrie, created works about sites or events made famous by television.[9] It bucked a trend prevalent in the early 2000s toward "media convergence," premised on the Internet as a medium more advanced than television, even if the experience of watching a Web broadcast was at the time often less rewarding than watching television. *TV Swansong* is an interesting model of collaborative curatorial practice: Is it a single project with nine components, or are nine projects subsumed under one structure? It is both live and archived, and it challenges the separation between the structure (the context) and the works embedded within that structure. Pope and Guthrie have worked collaboratively in adopting the roles of curators simply as a practical way to realize their research-led projects. As Guthrie has commented:

> You can probably guess the challenges faced by those who commission us: perhaps the initial horror for a curator is that our work is expensive—in terms of time—our work always evolves from extensive periods of research. . . . It's also expensive because there are 2 of us to pay from a project, and lastly, because the media we use can be very costly to access and costly to "present"—by that we mean that a piece may not be suitable for 6 weeks in a gallery and be destined to be shown once, in public. This can require heavy, i.e. expensive, marketing to target audiences. (in Cook, Graham, and Martin 2002, 160.)

For *TV Swansong* and other projects, therefore, Pope and Guthrie took on the role of commissioner themselves, adopting an "artist-centered" management structure that enabled them to share their skills.[10]

There are a number of incentives for an artist to take on the role of curator; from a pragmatic point of view, the artist can control how her project is being realized and presented, and can hire the staff necessary to deliver the components she can't take care of herself. Artists are often seen to be doing it themselves because others aren't as good at it (that's not just an ego trip, and when it comes to writing a press release for an

Figure 10.2
Screenshot of the streaming Web portal for the collaborative artist-led project *TV Swansong* by Nina Pope and Karen Guthrie (2003), showing Giorgio Sadotti's *Virtual Bootleg* artwork, using cameras attached to ballroom dancers. Courtesy of the artists.

experimental or challenging project, it might be no surprise—marketers rarely spend as much time researching a work as artists do in the process of making it). Pope and Guthrie (2001) have noted that commissioners have increasingly wanted to work with them on the basis of their success at curating their own work and their ability to manage themselves effectively, from writing marketing copy to running a budget meeting. Yet, most of all, it seems that being an artist (who is usually tasked with making artwork) makes the process of being a commissioner easier because the artist can imagine the project from the other side (as we saw with the model of publishing and the task of "digesting your peers" in chapter 9).

One of drawbacks of the practical "artists doing it themselves" approach is that funders or the audience might interpret the activity "as artists colonizing a space (i.e. degree show in a warehouse)" and thus will merely watch from a distance, sometimes just to see if it works, rather than engage in the collaborative potential that such ways of working permit (Pope and Guthrie 2002b). The Star and Shadow Cinema example suggests

that this holding back on the part of funders and audience can be both good and bad. Nonhierarchical and peer-to-peer artist-led projects require that the collaborators meet regularly while the work is being created, thus maintaining transparent operations and evoking a shared responsibility for the project. However, having funders and audiences watch from a distance means that artists end up doing more than their share of the work in establishing the new venues, new frameworks, and new networks for the presentation of new forms of art, and if they're not careful, they burn themselves out in the process. Another similar and all too familiar scenario is that the artists' activities become the first step toward gentrification of a neighborhood: once property developers move into the warehouse next door, the artists soon get priced out. These caveats suggest that as functionally and practically alternative as the artist-run model is, there needs to be a time limit both to ensure project success and to avoid the pitfalls of either burnout or institutionalization.

Hybrid Platforms: Temporary Autonomous Zones

The idea of the platform also suits as an image of what has been going on, not only in the art world, but in society as a whole, with the network economy, new technology based on non-hierarchical functions (the web), and even the way we have professionalized the act of meeting new people through the concept of net-working.
—Pernille Albrethsen "Platform Formalism," 2004

The event structures of new media (discussed in chapter 7), many of which have emerged from festivals and other modes of working (discussed in chapter 9), show how new media artists have adopted a curatorial methodology that sees them organizing their own "temporary mediation systems" around the art form they are working in, outside of art institutional structures. These temporarily created structures (or *sarai*) are an example of artists' responses to the more formal structures of control within the system for making and showing art.[11] Perhaps as a result of having been trained in art school with its methodology of open studio "crits," these projects are programmed with events to gather critical mass around the demonstration and exhibition of new art; much of the language around these platforms comes from theorist Hakim Bey's description of a temporary autonomous zone (TAZ): "In the formation of a TAZ, Bey argues that information becomes a key tool that sneaks into the cracks of formal procedures. A new territory of the moment is created that is on the boundary line of established regions. Any attempt at permanence, that goes beyond the moment, deteriorates to a structured system that inevitably stifles individual creativity. It is this chance at creativity that is real empowerment" *(Wikipedia).*

An artist-initiated TAZ may simply consist of artists organizing their own time-limited, special-interest networks within the wider community of artists.[12] This hybrid mode of curating might sit within the exhibition landscape about halfway between a bake sale and a trade fair, with an emphasis on the short-term exhibition of finished artworks

alongside a series of talks, presentations or demos, and tea or coffee. In many ways, these experimental exhibitions (from the "Secret net.art Conf" meetings [1997] to "Expo Destructo: Post Media Pressure" [1999], a meeting of activists complete with their own flea market) physically manifest activity that has long been the norm on the mostly atemporal online listservs. For instance, Vuk Ćosić, who was quite deliberate in describing his untitled exhibition as part of his *Net.art per me* project (for the Venice Biennale, discussed in chapter 9) as taking place within a TAZ, hosted the original Net art meeting in Trieste, Italy, (called *net.art per se* [1996]) so that the participants could meet in person, talk, and eat ice cream. This mode of presenting work within a temporary time frame and with the artists on hand that has emerged from the new media art environment is truly hybrid: neither a festival nor an exhibition nor a conference. As Eugene Thacker comments, the importance of the TAZ is in its timeliness: "A TAZ is by necessity ephemeral: gather, set up, act, disassemble, move on. Its ephemeral nature serves to frustrate the recuperative machinations of capital. The TAZ nomad is gone before the cultural and political mainstream knows what happened. This raises the issue of efficacy. The TAZ wages the risk of an efficacy that is invisible, de-presented, an efficacy whose traces are more important than the event itself. (Is this distributed efficacy?)" (Galloway and Thacker 2007, 137–138).

The idea of the TAZ's distributed efficacy is an interesting one if the model of iterative exhibitions can be applied to it: rather than create artist-run initiatives that burn out volunteer members or become institutionalized (or are consumed by the capitalist economy), what if artists continually decamped to the most conducive context for their work? In other words, what would an iterative form of a TAZ look like and how would it work? Upgrade! and Dorkbot ("people doing strange things with electricity") are monthly or quarterly meetings (events or peer networks) of artists and producers that are organized locally along a standard international format or brand and that take advantage of opportunities presented by visiting artists. These showcases serve dual purposes; they function as educational, promotional, and professional development opportunities as well as social networking events. Each is a discrete event, which leaves an internationally networked trace. "Instead of the term 'platform,' the art world could as well have come up with an expression along the lines of 'net-something,'" writes Albrethsen (2004).[13]

Yet TAZs, by definition, operate unlike the platforms Albrethsen describes within the more formal curatorial spaces of exhibitions in that they might include a collaborative goal, a task to accomplish, beyond just "networking." Another difference when new media tools are introduced to such zones is that collaboration is more readily encouraged and supported by the technical skills the participants bring to the project.[14]

There are a number of pros and cons to this particular artist-led mode of curatorial practice, not least that hybrid platform-based projects question the role of the curator as one who *shows* art to an audience. The boundary between who is the producer and who is the consumer is blurred. The activities that might take place within a TAZ are often vibrant for how they engage with a community of makers on a specific timeline, but that

engagement is often peer led and gone before dawn, so to speak, making the activities inaccessible, both intellectually and socially, to a wider public. Artists don't necessarily perceive this as a problem because they maintain that "where you get your collaborators is the same place you get your audience" (Pope and Guthrie 2002b). The idea of the TAZ suggests both the temporary nature of such systems and an autonomy that actually might not exist. With Net-based practices, there is a perceived autonomy from the structures that usually show and distribute art, such as the museum (one can do it oneself on the Web). Yet on the Net, as with most new media art, one is for the most part still working with a new medium that is on the edge of gentrification (Albert 2007). Thus, as art activist and theorist Geert Lovink (2002) notes, artist-led "digital commons" projects of the kind that a TAZ would facilitate exist in a third space between state interests and market forces. The projects that result from such frameworks are not always commodifiable and distributable in the way art is usually circulated; their success is conditioned by their users, not by an observant audience, so they operate in a kind of middle ground. In this sense, all artist-led curatorial projects are indeed hybrids, never fully independent or autonomous from an existing system, no matter how temporary. "In the new curatorial rhetoric the emphasis is on flexibility, temporality, mobility, interactivity, performativity and connectivity. This newfound urgency to seek a common language is exemplified by the number of international curators who have treated [exhibitions and biennials] as a collective activity, using them as a means to explore the processes of art production through temporary mediation systems rather than presenting art and its exhibition as a finished product" (O'Neill 2005, 7).

Temporary artist-led projects, with their public-funding investment, seem inevitably to lead either toward other more "institutionalized" and gentrified forms of exhibition making or toward collapse and rebirth (again, as we will see later with the example of NODE.London).

Self-Institutionalization

The taboo on institutionalisation in art is effectively the refusal to underwrite alternative practices with the institutions that they need and deserve in order to thrive. We do not need to avoid institutionalisation, we need fuller, wider, and more diverse forms of institutionalisation. Institutionalisation for the few needs to be replaced by institutionalisation for all.
—David Beech, "Institutionalisation for All," 2006

Artists as curators have adopted a number of modes to produce and promote their own and others' new media art, ranging from activist interventions to more hybrid temporary event structures. All these modes are, for the most part, instances of artists curating art because they have felt a strong need to do so or have benefited from doing so: more participants means more chance at learning a new skill, sharing authorship, or extending a network of contacts to create communities of discourse. New media art projects often require collaboration and skill sharing, and, indeed, they engender these approaches

through tools such as wikis and e-mailing lists. As Maria Lind has written, "Many of today's collaborations in art contexts operate horizontally and consist of agents from different fields; very often these collaborations lie on the border between activist, artistic and curatorial activities and they tend to be self-organised" (2007, 27). Does it then follow that curating is also an activity that results in self-institutionalization?

Self-institutionalization is a muddy field to slip into not only because institutions and their controlling infrastructures are often the reason artists want to curate their own work in the first place, but also because artists are likely to create any number of kinds of collectives with their own unique and complex characteristics. In fact, self-institutionalization as an artistic strategy has a long history of being a "copy and paste" tactic of adopting other models, particularly against the dominance of the mainstream media (as discussed in chapter 2). The artist-led models described in the first half of this chapter are based predominantly on a space or place, even if temporary. Self-institutionalization as a mode of practice within the field of new media art differs from self-institutionalization in the field of contemporary art in that the institutions that artists create for themselves are not always physically bound and the range of institutions they can emulate is so much more varied. For instance, the *University of Openess* (discussed in chapter 7) is a self-institutionalized research facility modeled on a higher-education establishment. An artist can become an institution as big as a festival or as placeless and seemingly spaceless as a Web server.[15] As the idea of the TAZ suggests, just about anything can *look* like an institution. In this sense, self-institutionalization is a bit like being an avatar or a clone—allowing for the possible syndication (or simultaneous distribution or publishing) of yourself, your artistic identity, or your projects (as discussed in chapter 9 in relation to "digesting your peers" in the instance of Kate Rich and her work). Artists groups that are not quite as fully fledged as collectives (their projects are more individual than collaborative) or that have a charismatic leader (in the style of a cult) are also more prone to be viewed as self-institutionalized formations.[16]

Clearly, artist-led-curating has benefits similar to those of self-institutionalization; however, it is tricky to distinguish how one artist-led activity seems like self-institutionalization, but another seems simply collaborative or open to others' participation. The levels of participation in the institution vary enormously (as we have seen in questions about social engagement and new media in chapter 4 on participatory systems).

Example: NODE.London

NODE.London (NODE standing for Networked Open Distributed Events) was a self-organized event in March 2005 committed to building the infrastructure and raising the visibility of media art practice in London.[17] It included a number of events, exhibitions, and conferences, some of which—such as DorkFest, Open Congress, World Information Summit on Free Information Infrastructures, and Future Wireless—took place in advance of the

Figure 10.3
Faculty of Taxonomy Web site wiki as part of the *University of Openess*. Courtesy of Saul Albert and
Sarah Cook.

"season" in October 2004. An accompanying reader produced as a result of the October
conferences, "engages in debates in FLOSS (Free, Libre, Open Source Software), media arts
and activism, collaborative practice and the political economy of cultural production in the
present day" (Vishmidt et al. 2006, back cover). In total, more than 250 artists, curators,
and practitioners participated in more than sixty exhibitions, events, workshops, and talks
organized by nearly eighty "nodes" over the course of the month.

Tim Jones, the coordinator of NODE.London (one of only two paid positions in this
volunteer-run initiative), referred to it as more akin to a "hydra headed network" rather
than to the usual art world model of a project whose sole goal is a demonstration of "star
power" (2006). The essence of NODE.London's organizational strategy, Jones commented,
was that it sought "equitable participation." This goal was reflected in the distributed net-
work structure: "a mediation organisation between artists, organisations and the public"
(T. Jones 2006), without a centralized hierarchy. According to Saul Albert, "The remit was
basically to get loads more new people involved—small agencies, individuals, funders and
sponsors, institutions, curators . . . *everyone*" (2006b).

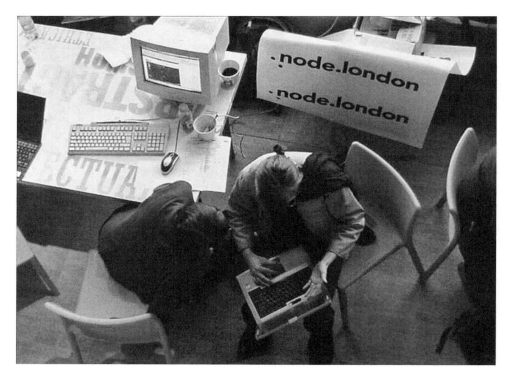

Figure 10.4
Participants at Limehouse Town Hall preparing for a NODE.London event in 2005. Photograph by
Mark Simpkins.

 NODE.London is widely discussed and has entered the new media canon as a "no-
curator" model of curatorial practice, but that is not entirely the case. It was an experi-
ment. Nodes, or organizations, interested in participating were not advised what to show
or present in their "strands" of programming, so long as it was media art. They also had
the chance to apply for "seed funding"—small resource grants—to enable them to build
up their infrastructure so that they would be technically equipped to show new media art
projects. The criteria of what fitted the bill and who got the funding were openly discussed
at voluntary organizer meetings as well as on the NODE.London wiki. In this sense, the
event was consciously noncuratorial (Garrett 2006b), though each node could curate as it
liked. As one voluntary organizer described the process, "[There was a] backlog of projects
in London that needed to be seen but didn't have the venues at the time [and others] who
wanted to be involved [with new media art] but didn't know how to show it. . . . The cu-
ratorial process was inviting people to join in to NODE.London. And [what was] interesting

Figure 10.5
The online map of London showing the "nodes" as part of the artist-led collaborative "Season of Media Arts," NODE.London, March 2006. Courtesy of NODE.London.

about that was that those people didn't have a connection to a network and it helped them to align and see themselves in relation to that network" (Garrett 2006b).

The key areas of debate in the evaluation of NODE.London concerned the idea of openness and the practical questions of how it might have been better organized in terms of time and scale given the enormous variety of projects contained within the structure—from workshops to screenings to talks to exhibitions (questions that afflict any artist-led or curated project, no matter what the focus).[18] One of the difficulties of any experimental open curatorial system, whether oriented around new media art or not, is that participants will have different ideas of openness.[19]

> There was the idea that everyone was asking more people to join in, and encouraging each other. This was a way of shaping the programme. There are things in the structure of *Node London* that look a certain way and it is tempting to talk them up, like the transparency and the openness. But in fact this is not [entirely] true. We were invited. We didn't just see something on the net. There was a lot of word of mouth and personal contact. . . . [And] the language used is naturally exclusive to some kinds of people. (Catlow 2006)

Individuals were central to the success of NODE.London, and their place as "nodes" served to shape the network as a whole. Institutions as large as the Science Museum in London or the Tate ("we're a gnat on their windscreen," commented the event's coordinator about these institutions) or as small as e:vent gallery or Furtherfield potentially had equal billing. In some instances, this egalitarianism shifted the power balance within the nodes themselves. "NODE.London brought together practitioners irrespective of their organisation, allowing them to present themselves above and beyond their organisations" (Redler

2006). In the case of larger institutions such as the Tate, this result is significant; working in partnership with NODE.London thus might have enabled an embedded curator to do more in an adjunct style and to have a greater visibility for his program than was possible within his institution alone.

Although the "open" voluntary organizer meetings were excellent for information sharing, they relied on a consensus decision-making process, which may have been problematic because everyone has a different definition of consensus (even if that process is documented in public). This kind of openness—based on who has time for long meetings or the will to engage in the systems of information exchange—meant that organizational nodes reacted differently to the initiative's structure. "The structure creates endless circularity and can slow things down," commented Tim Jones (2006). Thus, the time demands placed upon the volunteers were extreme, and "burnout" was widely reported. Volunteers who became overburdened with tasks (which they may have agreed to do in a moment of enthusiasm) and then "fell away" from their commitments jeopardized the project if they were not able to deliver on time.[20] So although NODE.London may have been networked, it wasn't entirely "modular" as a model of exhibition practice (as outlined in chapter 6). "The process of [developing] NODE.London was like reinventing the wheel, so it couldn't fit into systems that were already in place" (Garrett 2006b).

Pros and Cons of Artist-Led Modes of Curating

I had to depend primarily upon listening to others, to the public: I had to work with communities not my own but also outside the contemporary art world to become educated. This was a big shift from picking artists, artworks, and telling audiences about art. As curator, I was not the authority; at best I could become a conduit for ideas of others, translated and transformed by the artist. In the process, I had to reveal that "I didn't know"—about a place or a community, about what the art would look like in the exhibition or what its thesis would finally be.
—Mary Jane Jacob, "Making Space For Art," 2007

The lessons learned from the example of NODE.London reflect further on the other ways of working for artists as curators—interventionist, practically alternative, hybrid, temporary, and self-institutionalized—and they beg the question, Does NODE.London stand up as a curatorial model? Marc Garrett described it as a "big curious lateral thing" but emphasized its importance as a model of curatorial practice by saying, "Culturally, more than often, we are left to our own devices as curators and we are forging new territories, problematic and interesting at the same time. We need to figure out how NODE.London can be distributed as a working model (recreated according to content and context)" (2006b).

In this sense, Garrett is arguing for NODE.London to continue to exist as an iterative model, which remains to be seen.[21] In many ways, this event and other practically alternative artist-curated projects, such as those proposed by Nina Pope and Karen Guthrie, are modular because they have "distributed" the curatorial remit to partner organiza-

tions (or nodes in the network). This description does raise the question of where exactly legitimation or the curator's "quality-control" activity comes in. Organizer Luci Eyers comments:

NODE.London was definitely not an attempt to curate where there was no curation. I would have liked more discussion about projects and how they related, what connections were emerging and what parameters [the nodes were] working with. For the catalogue we only included projects which were definitely going to happen, which were credible. On the website other projects were added which seemed more tenuously linked, and there was no discussion about that at all. . . . If anything could have been collectively curated, I would have liked to have seen more discussion about . . . why things were connected in the way they were. (2006b)

The issues of time and scale are the same in any open curatorial project, regardless of whether it involves new media art or not. Yet the use of the tools for organizing (wikis and the like) and the distribution of the curatorial activity to the nodes did change the nature of the curators' engagement and allowed for a more flat and less hierarchical collaboration over all. There are drawbacks to the artist-as-curator mode, and not only when it is confusing as to whether the curator is the artist or vice versa. These drawbacks are often at the level of ethical questions as well as practical ones: Who is getting the credit? Who is getting paid to do what by whom? As Marc Garret has pointed out, with respect to new media art there is a blur not only between the curator and the artist, but also between those two and the technician (where the latter sees the former as an "enemy" because she or he isn't always fairly considered a creative professional, but rather as a gun for hire) (Garrett 2006b). But what is important to remember is that "the curatorial role is a function not a person. Roles are fluid and multiple" (Dietz 2002b).

Thus, those seemingly invisible skills in which curators are trained or experienced—such as being the interface to the quite formal structures of how art is marketed or interpreted—are all the more important. Curators have highly tuned critical and social skills and can act as interpreters for artistic activity using any one of a number of languages depending on whom they are talking to (wealthy art collectors or first-grade school children). Even if new media artists have highly developed social networks, they are not always aware of or concerned with these things that a curator does, focused as they are on the work itself. So although, for instance, the hybrid example of being practically alternative might show artists' strengths in terms of production (of art or of activity around art), perhaps it also shows their weaknesses in terms of distribution or long-term commitment.

Being able to tell "who is behind what" isn't of course crucial to a meaningful engagement with art, but in a field where the named author of a project can be as important as the project itself and is a curatorial method for assigning value, then the challenges of open and collaborative curating via a platform or TAZ are brought to the foreground. Self-institutionalization or interventionist activity does raise a theoretical question about how emerging art practices are legitimated, which is probably the biggest reason for artists to work as curators in these modes. Patrick Lichty writes:

What is interesting to me is the relationship between the aspects of legitimation, generation, and distribution (among others), that this combination of practical strategies entails. The nature and timbre of each mode of engagement is fascinating. . . . One has to look at the curator, institutional context, and the whole cultural matrix in order to get a handle on the relations. . . . In New Media, perhaps the distinctions are less inertial. One can move more quickly from role to role, or even play multiple parts simultaneously. (2002)

Collaborative Practices—Networks and Audiences

Read more articles about consensus decision-making or you'll always be voted down.
Martyr yourself immediately. No one will notice but it may offer some small consolation.
Stop looking at your inbox, and pick up the phone instead.
You're a perfect collaborator. It's everyone else's fault.
Almost there, but shorter sentences in offline meetings would be useful.
You're giving too much. Much more than you know. Selfishness is the answer.
Give way to your inner dictator! The others need bossing around!
You place far too much trust in wikis (+ others to create them for you).
—workshop participant, in Beryl Graham, "Openness and Collaboration: Fortune Telling Game Fortunes," 2007c

These "fortunes" were submitted by a participant in a workshop about collaboration in curating new media art led by CRUMB at a festival of new media art in Cambridge, United Kingdom, in 2007. They make up another entry in a long bibliography of writing about the nature of collaboration within the fields of art history (Bishop 2006b; Green 2001), sociology, and new media theory (Friedman 2006). In this section, we attempt not to reiterate those fortunes and findings, but to bring them together and ask how collaboration differs in new media art projects (as introduced in chapter 7). We open up the artist-led modes of working further to include the question of what happens when the audience acts as the curator.

Not all collaborations are of the same kind. In some, the production of the art might be an offshoot of another research process, whereas in other collaborations participants might swap positions within the network all to further the production of the work (as described by Anne Nigten in the discussion on labs in chapter 9). The Banff New Media Institute has undertaken research concerning the nature of online collaboration, using wikis, file-sharing systems, video chat, and supercomputing or grid computing networks. They have found that online collaboration differs from offline collaboration not only due to the roles people take on in each environment, but also due to the tools used: tables and pens differ from tablet screens and phones in the kind of interaction they encourage (Diamond 2004b, 2008).

Art institutions focused on new media art, such as FACT in Liverpool or Eyebeam in New York, have encompassed "collaboration" within their curatorial remit, beyond the audience engagement with their program that the more traditional education department would be responsible for, and often through commissioning new "community-oriented"

projects. Artists swapping roles with the curator might take any number of strategic approaches to the realization of their projects—from being activists-interventionists to creating a hybrid and temporary space for exchange. In many artist-led projects, the collaborative strategies are most concerned with putting the audience first, even if that audience is composed of the artists' peers. Curator Maria Lind writes of a distinction between "single" and "double" collaboration, although her distinction doesn't come close to addressing where the audience sits: "In the former, the author remains alone and contributions of others are towards the realisation of an idea, which is already more or less formulated. In the latter, collaboration takes place both on the level of the author, with the formulation of an idea, and also in the realisation of the work. . . . 'Triple' collaboration would then refer to the cases where the subject of the work, the theme itself, is collaboration" (2007, 27). In this section, we look at collaboration within new media practice from the perspective not just of the curator, but also of the artist and the audience.

Collaboration within Networks

Whatever sector you operate within, there is a choice to make: whether to have your personal relations industrialized; or . . . your industrial relations personalized. . . . [W]e should vigorously assert our agency here, in choosing the model appropriate at any moment—for any of the work we make. If we require peer-to-peer development, production, distribution and evaluation, then the new media sector prefigures ways-of-working which will satisfy. If we need external validation, sales and hard-sell, then perhaps older ways of doing business are better-suited.
—Simon Pope, "RE: A comment on artistic and curatorial practice," 2006

Collaborative projects inevitably start with the questions of who is the initiator and who is the collaborator. Each different instance of collaboration has varying degrees of success. One way to look at collaboration is to consider the shape of the network within which it takes place and where within that network the artist, the audience, and the curator sit. These networks, as discussed in chapter 3, can be hierarchical and centralized, decentralized, or distributed. Curator Francis McKee has suggested that the usual triangulation of curating—with the curator, the audience, and the artist at the poles—should be flattened into a spectrum, with the "curator, audience, and artist all standing on one side looking at the work, and you can't tell between them who is who" (in Cook 2006b).

The shape of the network, even if it has just three nodes—curator, audience, and artist—determines the hierarchy of the players within it. Thus, within a collaborative team of people responsible for realizing a project (be it an artwork or an exhibition), it may be possible to distinguish who is at the center and who is out on the periphery. The distributed network is most commonly aligned to the way the Internet works, so it is the goal of new models of new media art curatorial practice (such as NODE.London), with each "entity" in the network perceived (or enabled) as autonomous. The distributed network maps well onto the model of "modular curating" because it presupposes this autonomy.

Alex Galloway's adage that "if one route is blocked, another will do just as well" (2004, 35) is reflected in the modular approach that if one element of the program can't be realized, it can be dropped without affecting the whole.

Yet "decentralized network" thinking is not always easily adopted when it comes to event organizing and curatorial practice:

I always find it extraordinary that festivals relating to networked cultural practices persist in linear formats. . . . [S]urely there are more network-centric forms of crowd control than the auditorium model. / Some of the things I loved about [Tech 2] were: —The format was very open. Impromptu presentations and conversations were happening all the time /—There was enough time in the schedule for relaxed socialising—the place where most work gets done at festivals anyway. /—There were enough connections and computer facilities for everyone, or tools and support for people to make them. / Also, the ridiculous and often irritating "inner circle" mentality had been thrown out. Whoever was interested in joining in evening events . . . came along and were made welcome. (Albert 2001)

Truly peer-to-peer methods of curating evidenced in the examples of artist-led practice given here are less likely to happen explicitly in institutions, which are not as used to being an active part of the network beyond their own walls.

With the recent development of online projects made with user-generated content (file-sharing sites such as Flickr), the question of the distributed network model's success is again raised because it impacts on the question of management. If you are a curator producing a project that involves the active collaboration of the audience members within a system, are you managing the content or the users? If each "node" or user is autonomous, your role is apparently merely functionary, and there are a number of examples of this relationship, as we shall see in the discussion of allowing the audience to become the curator.

There Is No Curator in This Network (the Audience Is the Curator)

Artists often embrace new technologies as a means in itself rather than a means to an end . . . [T]hey tend to fool themselves by the seemingly limitless possibilities of new techniques instead of focussing on the results, which are often embarrassing. Taken too seriously the immaterial qualities of a medium may result in yet more alienation from the physical environment. . . . Unwillingly, artists and curators provided the avant-garde for a neo-liberal life-style, which pretends to free capitalism from the curse of oppression and bureaucratic routine but only introduces more subtle regimes of power that are not organised as pyramids but as networks.
—Eva Grubinger, "'C@C': Computer Aided Curating (1993–1995) Revisited," 2006

The need for friendships, for collaborative models, for alliances within the new media art world, begs the question, if the content or the data is the king, who is the emperor? Is it the form or is it the audience? Is it the interface or is it the user?
—Iliyana Nedkova, in Sarah Cook, Beryl Graham, and Sarah Martin, *Curating New Media*, 2002

Does a decentralized or distributed network, which includes the audience as autonomous agents and flattens the hierarchy between curator and artist, create alternative

ways to legitimate practice? Or, put more simply, if NODE.London suggests that such a network-based project is not anticurator, are there other modes of curating new media art that similarly eschew the traditional curatorial role in favor of letting the audience take the reins? Two places to look for this model of practice are festivals and events curated by artists or by a group or filtered by fans, visitors, or subscribers.

Asking your audience to take on the curatorial role of selector raises the opportunity for curating to be completely automated and outsourced (as is speculated in Anne-Marie Schleiner's [2003] metaphor of the curator as "filter feeder," mentioned in chapter 2). Here we can start to see different degrees of collaboration—between artist and curator, between artist and audience—within the networks that produce, distribute, and support new media art.

Some of the least collaborative but still laudable examples of audience as curator come from gallery-based exhibitions where the structure and content for the exhibition is already in place, such as the Netherlands Media Art Institute's *Curator for One Day* exhibition, which showcased online video from the institute's collection as selected by visitors each day. *Your Show Here* (2002) at the Massachusetts Museum of Contemporary Art allowed visitors to use computer software to browse a database of images of works of art, choose up to five, write a curatorial statement, and title the show. The images of the work were then projected onto the wall at the same scale as the original works, until the next "curator" arrived to make his or her show (printouts of the shows were also collected on a bulletin board in the space) (Paul 2002).[22] In both of these cases, audiences were invited to filter "all available information" (Kittler 1996, 73) given the materials already preselected by the organization's curators.

A more collaborative but also more mainstream example is that of the music festival All Tomorrow's Parties (United Kingdom, 2007), which asked its fans (paid-up ticket holders) to propose and vote on acts to book for the gigs. This kind of populist voting system, where the collective weight of numbers determines the curatorial scope of the project, allows for collective authorship of the event, thus seeming more collaborative in terms of affecting the outcome. Here, the *your* in "your show here" is plural.

More collaborative still would be new media art projects that allow not only for consensus and voting systems, but also for the individual perspectives that opening up selection to audiences allows. Projects that employ collective tagging and keywording to change the taxonomy and structure of the project fall into this category. A few examples are worth noting here for the ways in which they outsource and automate not only the curatorial process in terms of selection, but also the other less visible curatorial roles such as coproducing and commissioning the work and establishing the critical framework for its reception.

As with the Rhizome Artbase, founded in 1999 and widely accepted as one of the first and most rigorous collaboratively created online collections of Net-based art, runme.org (founded 2003) is an online file repository, but it is solely concerned with software art—

namely, projects that may have no formal physical manifestation and may exist solely as media or code held in files on the Internet.[23] Artists and programmers upload their projects to the database, and then other users can search them by keywords or category; categories are often just the most relevant or commonly used keywords. A team of experts regularly reviews the projects and their classifications. As they write, "Authors here perform the active role of context developers, and not the passive role of acting as objects of classification, description, and curation. That is why those categories that don't get many remarkable entries might be deleted (not the projects they contain!), those that are not appropriately named will be renamed, and new ones will be created according to the needs of software art community."[24]

Kurator (founded in 2004) is a similar ongoing research initiative that in some ways grew out of Eva Grubinger's *C@C—Computer Aided Curating*,[25] an online project that ran from 1993 to 1995 (in the very early days of the World Wide Web) and allowed artists both to create online works without needing prior programming knowledge and to curate the works of others online. Like *C@C* and runme.org, Kurator investigates software code as art, but from the perspective of the curator, facilitating the development of software for curating code and code-based projects. Kurator members also undertake code research and work on the programming of software for new forms of wiki-enabled collaboration.[26]

What all these projects share is a commitment to allowing their "audience" (composed predominantly of other curators and artists) to be involved in not only the selection, but also the underlying structure of the online collections: the audience provides the content and helps form the "folksonomy" for cataloging these emerging forms of art. Such projects' collaborative nature also raises further questions about authorship and ownership in informal and distributed networks and on user-generated content sites. Asking your audience to distinguish and curate the data and metadata of seemingly immaterial works such as Net-based art or software art is slightly more tricky than letting them loose in your gallery with paintings and sculptures. Sound artist Douglas Kahn, who is known for "sampling" the sounds of the universe (for instance, listening to the radiation emitted from stars), has played devil's advocate regarding Kenneth Goldsmith's radical proposition that media on the Internet should be

free or naked, stripped bare of the normative external signifiers that tend to give as much meaning to an artwork as the contents of the artwork itself. Unadorned with branding or scholarly liner notes, emanating from no authoritative source, these objects are nude, not clothed. Thrown into open peer-to-peer distribution systems, nude media files often lose even their historical significance and blur into free-floating sound works, travelling in circles that they would not normally reach if clad in their conventional clothing. (Kahn 2005)

Kahn also poses the opposite question as to whether this unattributed system can also lead to "historical amnesia, social or ecological decontextualization, lack of attribution, cultural theft and imperialism." The trouble with the Internet, as with the noise of the

universe itself in Kahn's reckoning, is that unless the curator who is "feeding the filter" (reblogging the blog post or creating the list of links) is also taking on the duties normally held by the museum registrar, creating the metadata about the artwork, and tying it to the artwork (i.e., tagging the nude media file), the two positions are virtually indistinguishable![27] In the systems of online curating, which rely on audience-user input and folksonomical structures, the curator's role as registrar—analyzing data and checking references—is in fact quite important.

Last and seemingly most collaborative is the example of the exhibition *Do It with Others* (2007) at http Gallery. *Do It with Others* was modeled on a mail art network for the e-mail generation, where all messages sent to the e-mail list were considered individual works of art and part of the collective creation of a work.[28] This example demonstrates group collaboration on one show, illustrating a hybrid model of curating where all discussion is considered and all contributions are included, facilitated by the use of online tools such as mailing lists and wikis.

In all of these seemingly "no-curator projects," no matter how automated the system or outsourced each of the nodes, there still needs to be an administrator or dedicated group of users, gardening the wiki for weeds (spam), filtering out inappropriate content, updating user accounts, and the like. Here we discover in fact that the curator might be the system administrator or the programmer, controlling access to the network and use of the system.

The examples described here tend to be difficult to define clearly as being either artworks or interpretational initiatives or curatorial projects, and for that reason it is difficult to pinpoint exactly where in the network the curating happens. With new social software, is it indeed the case that there is no curator or that in fact everyone is acting in some kind of curatorial role? These projects obviously question the skills of curating and whether the audience has those skills or not, but considering the popularity of collecting anything from music to Barbie Dolls and the selection opportunities offered by Web sites such as YouTube, then it can be argued that blogging, linking, and bookmarks are the raw starting materials of "selection."

Of course there are good and bad curators. One therefore needs to ask what the function of the curator is in this context (a good subject for this list). It could be observed that the role of the curator here could have been to establish a vision of this terrain and to articulate that within a questioning critique such that it would be evident to an observing public just what it is that is happening in London with new media art and artists. . . . As a self organising non-curated phenomenon it is probable it will reveal more about the nature of certain practices, involving certain media and modes, in certain places than a curated show would have. (Biggs 2006)

So although the audience may be good at fulfilling the selector's role, what if it isn't equipped for the other more subtle roles within curatorial practice, such as collaborative coproducer, commissioner, or interpreter? It can be argued that *Do It with Others* had an already informed audience of artists and curators who were members of the discussion list, which guaranteed the project's success.

The no-curator or audience-as-curator models of practice are not always about giving the audience what they want (in a reality TV voting kind of way, as in the All Tomorrow's Parties example), but rather about allowing individual audience members to be the users and makers in collaboration with the artist, the institution, or other audience members. Nevertheless, curators are still hesitant to give up to the public all the control over selection, and sometimes that is a good thing. As artist Jon Thomson writes, "I for one, would far rather see all the myriad strands of contemporary art practice (sound included) curated and combined with personal vision and less often by committee" (2002).

Informal Networks and "Flat Collaboration"

There's an argument going around which says that informal networks are more inherently democratic and collectively intelligent than the curator/institution model, and that they support artists much more effectively. hmm, I'll buy that.
—Michael Connor, "Re: Curatorial Models: What Good Are They?" 2003

Quite aside from the question of what shape the network of collaborators might take is the question of how the network is established in the first place. Taking a network (of any sort) as the basis for a curatorial model can be seen to be adapted from the ways in which artists have always worked—by including their peers in an exchange that contributes to the development of their projects.[29] Are you on the inside or the outside of the network? In the field of new media art and on the Internet, working within a network is both a practical fact (the tool) and a theoretical construct (the methodology), as seen, for example, in the *Life Sharing* (2000–2003) project of artists' group 0100101110101101.org, which, in a deliberate challenge to the popular idea of file sharing, encouraged people to leave access to their computers open for others to use over a network.

Iliyana Nedkova has posited a networked model of curatorial practice that is based on friendship. She argues that working with a network of friends (particularly across borders) is one way to overcome curatorial inadequacies and cultural misunderstandings where new technologies are concerned. She states, "With institutions focused on outreach, to an extent that collaborative practice and open source channels are desirable—and the Internet is great at facilitating the process—the curator's role is to make media art communicable, meditative and manageable" (in Cook, Graham, and Martin 2002, 103). Like the modular models of curating, this practice is potentially self-effacing, making the curator but one more collaborator in the network of friends working toward the realization of a project. Another way of thinking of such self-effacement is as generosity and trust. This model is not market or economy driven (or even politically led), so it is more akin to the way artists have worked since the early community arts projects of the 1980s. This model also has a history in activist practice: "If we read between the lines of the European Commission guidelines, knowing your cross-border partners is just a step away from making friends," Nedkova points out. "So I think we're being very timid here, not to confess to this. We have to be really honest that this is what drives curatorial prac-

tice. We all need to make our own little alliances in order to manage and deliver a project, and we're also trying to put all sorts of grandiose titles to something that may be just another instance of extended friendship" (in Cook, Graham, and Martin 2002, 107).

Problems with the informal network model of curating new media art are significant: the network of collaborators can quickly close down and thus exclude new partners who are unknown to the core circle of friends, leading to a difficulty in bringing new people in to the network (if, for instance, one is lacking a particular skill among one's group of collaborators). Moreover, because institutions handle public funds, working with a small group of friends is not always perceived as fair and equal business practice. A gift economy presupposes only exchange value and not market value, and so is premised on volunteerism (one might not pay one's friend if he is doing a favor). It is hard to move new media projects created within this model into the mainstream market-driven art world and to ensure that all collaborators are adequately compensated. More problematically, the informal network model might have no clear project manager, no hierarchical structure, which makes it all the more imperative for the collaborators to know who ultimately they are answering to or working for. Otherwise, problems may arise, such as debates over intellectual property, complete disintegration of the project if partners develop irreconcilable differences, and confusion if some people believe they are functioning in a "gift economy" and others do not think they are.

The informal network model of practice has its problems, but they may be compensated for by the possibility of pooling resources to deliver a project with the help of likeminded people—the true benefit of collaboration.

When I first started "guerrilla curating," it was obvious to me that friends and other people in my circle, my community, would be invited to contribute their art to a particular show. They knew me, trusted me and we spoke the same language. I got nervous only later on, when I started to learn about "real" curators, for whom this was a conflict of interest (as was being an artist at the same time as being a curator). But I've gotten over that. The people in your circle always have friends in their own circle, and pretty immediately you are working with someone new, who is contributing something fabulous to your production of meaning (the exhibition, archive, site, project). (Fragnito 2003)

We have seen that even within distributed network models of practice, there are still subtle divisions or indicators as to where power lies within them. We are not interested in propagating the idea that curating is a power trip, but within every network-oriented collaboration, some form of "gatekeeping" or control mechanism will define the project's limits.

Thomas L. Friedman's book about globalization, *The World is Flat* (2006), describes workflow software, including open source and online software, as one of the great "flatteners" that has leveled the global playing field. Artists, especially those who use online software, have taken on this idea to describe collaborations based on "thinking cultures," small groups of like-minded developers, each group having an individual leader, but all

helping the others and sharing as they work toward their common goal (Pollice, 2007). As artist Adam Somlai-Fischer describes his interdisciplinary practice of working with architects and social scientists, "We do need to be informed by the understanding of other thinking cultures about issues related to social space, identity, and so on. So the best way to go was to set up a tight team of great innovative people, from different disciplines, and share the whole process. This way most do put in tremendous amounts of energy as the project really belongs to all of us" (in Debatty 2006a). The idea of "flattening" the collaboration is akin to flattening the triangle of a spectrum, which McKee posited, or flattening the pyramid-shaped hierarchy of the institution, which Grubinger referenced.

Others have questioned how the models of collaboration emerging from the field of open source software development and new media art production can be usefully applied to curatorial practice (Paul 2002; Pearce, Diamond, and Beam 2001). Interest in this study has increased in part because museums have often downplayed the collaborative process behind the making of media art and its built-in distribution mechanisms, and have tried to establish authorship as singular and the work of art as unique. Writing of the results of collaborations in art and technology and in particular of new media art "that cannot be collected," Sara Diamond comments, "The value of such art is often correlated to the individual artist, which can create challenges for collaborative teams, which may have to struggle to give credit to all the team members in the context of a traditional art exhibition, especially when not all the collaborators are artists" (in Pearce, Diamond, and Beam 2001).

This "attribution" problem is exacerbated by the fact that many new media artists deliberately blur the boundaries of their own "original" artistic practice by using tools and methodologies that sample or borrow or manipulate other existing media structures (see chapter 2). In a process-led project involving numerous participants in the work's creation, who ultimately is the author? Who retains the intellectual property rights? Nina Pope and Karen Guthrie write: "In some collaborations each party clearly owns a part of the work, in others the work is impossible to separate. Music can be separated from image but written word spoken by actors cannot. Communication and distribution of the work can lead to problems where authorship is concerned" (2002c).

Collaboration tends to become a method of working within technological fields simply because of need—for instance, artists making works for the Web need either to learn computer programming (or how to use proprietary software) or to collaborate with a programmer. By extension, in order to determine the best environment for exhibiting a work, curators also need to collaborate with the artist, the partners in the exhibition, the venue of presentation, and the audience. The flexibility of a team of people all working together toward the realization of a single project is crucial. Denise Delgado, a new media curator within a small art museum, writes: "[I consider] my role to be that of catalysing activity and curating processes as opposed to discrete works of art or art-as-objects. I feel more comfortable when my relationship to other artists in the production/presentation

of work/actions is collaborative and centers around dialogue. Other curatorial models often seem to carry an implicit hierarchical relationship, which . . . seems at odds with the emphasis on process and exchange in community-based or activist art" (2001).

Curators also need to ask themselves all the aforementioned questions regarding practice when dealing with collaborative new media works—most of all, what is the sustainability of collaborative work in the long term? In collaborations, the different partners often have differing timelines. The artists might be thinking in "iterative" terms that each stage in the process is a "launch" or "event," whereas the institution might be thinking of a single long-term presentation. Are both parties able to agree whether the work ends or begins on the day it launches? If, as in the case of most new media art projects, the artist's work is to change over time, to be subject to a multiplicity of interpretations and experiences, to remain dynamic and interconnected, and if other institutions or organizations are contributing to that evolution, then curators need to create a space wherein both the artist's expertise and the audience's interest are present. As Luci Eyers commented with regard to NODE.London, "In some instances people were coming back [a month after the meeting and] saying 'why didn't you do this' instead of 'why haven't we got this done.' Some people didn't ever grasp the fact that they had to buy-in in order for things to happen. [They were] acting as consultants instead of collaborators" (2006b).

Summary: Artist-Led or Audience-Led?

Art needs curators like the web needs Google. I don't like using Google for various reasons, but I do, all day, every day.
—Saul Albert, "Re: Some Personal Thoughts on NODE.London," 2006b

Through this chapter, we have looked at artist-led initiatives within the curating of new media art. We now return again to the question of incentives: Why are these people doing it? In some instances, they have pragmatic reasons, such as establishing financial security, assuring control over the quality of the work presented, raising awareness, or wanting to contribute, however fleetingly, to the emergence and potential legitimation of the field of practice. As Saul Albert has commented, some of these artist-led activities and initiatives, however experimental, are borne into existence as a way of maintaining as irreducible a version of art history as possible. "Legitimation starts as peer support—but extends through the institutional life of a practice . . . and perhaps the network legitimates somewhat differently" (2007).

Paul O'Neill writes, "The curatorial voice is too often perceived as separate from that of the artist; artists are deemed to speak on their own behalf, the curator on behalf of some abstract notion of culture" (2005, 10). Yet the perception is perhaps different in new media art, which already speaks on behalf of interconnected, networked culture, and where artist-curators can more readily (or, online, more sneakily than in bricks-and-mortar institutions) ape, adopt, or spoof this "authoritative" or "legitimating" voice.

Some of the lessons learned from artist-led practice include a much greater emphasis on collaboration and, with it, a consideration of the level of engagement required by the audience. These elements add a new responsibility to the role of the curator: ensuring that the artist-led projects are actually being open to the participation of audiences and responsive to their needs especially when the emphasis is on process, not end product.[30] Artist and writer Liam Gillick (2005) has suggested the work of art is in a process of "becoming" with the audience rather than being received by them. To enable the experience of art to emerge in tandem with audience engagement does demand a different format of "exhibition" or "presentation," which may be the biggest incentive of artist-led activity or the greatest impetus for artists to act as curators. Many artist-led projects allow the artist to engage with the audience more directly, more functionally, more collaboratively than the traditional exhibition-presentation mode does. As Ruth Catlow of Furtherfield and http Gallery said of NODE.London, "It hasn't changed what we do at all, just provided a strong and nice context to continue doing what we do, and disseminate and think and critique more of our own process. Between curator and artist, artist and technician, artwork and audience" (2006). Artists working in the sphere of new media are aware that the content of the work is inseparable from its context, that its context informs the process of making that generates the content. In the examples described in this chapter, such as NODE.London, there is minimal interference from an institutional curatorial structure, and the artists' own methodologies can best be demonstrated by the work itself.[31]

So what happens when there is no curator? As these artist-led examples show, each person takes on more roles, swaps hats more often, and learns new skills along the way. This multitasking might make the individual nodes in the network either more valuable or more dispensable. If everyone in this new flat world that Thomas L. Friedman posits is "outsourced," then that too has an effect on collaboration because people not only have to relinquish authorship, but also have to give up the power that goes with it.

From these examples, it is apparent that collaboration with partner organizations (the artist, the institution, the audience, the press, the funder, other theorists, and curators) is paramount. The nature of and impetus behind collaboration needs addressing. Is it sufficient to say collaboration resulted from a simple practical need or a desire to create an alternative? Along with this recognition of need comes a recognition of skills and knowledge: the artists and technicians and theorists and historians and critics may well have bodies of knowledge that the curator doesn't, and through their work they can present ideas about curating new media art that a curator might not have.

Dear all, I have been following this discussion somewhat remotely but I feel there is a point that needs to be stressed that I think wasn't about curating and the positioning of the curator in relation to artists and artworks. The curator, of course is a person but this person has intellectual inclination, curiosity, preoccupation, and the work of artists, artworks, thus become a cognitive object so to

speak, an object to make you think. So the curator is the one who develops a discourse through the selection of works. That the artwork (not the artist) serves his or her purpose in terms of discourse is fine with me. But in my experience as Curator of Media Arts at the National Gallery of Canada, in the end, good works of art always exceed what the curator wanted this work to say or intend it to demonstrate in a selection of works, and what makes good exhibition interesting, is when the curator's discourse is overwhelmed or enhanced, as you wish. (Gagnon 2002)

The fact that there are a greater number of artist collectives than of curator collectives is indicative that some people might be better at sharing and relinquishing control than others are. Thus, we find that the same conclusion applies here as with other modes of curating: follow the artists, share your skills, and collaborate.

Notes

1. Also addressed in Sarah Cook's chapter in Christiane Paul's book *New Media in the White Cube and Beyond* (Cook 2008; Paul 2008).

2. The history of the artist-run space and network in Canada, the United States, and Australia is well documented in magazines such as *Parallelogramme*. See http://www.rcaaq.org.

3. For instance, *Parallelogramme* was first published by the Association of National Non Profit Artists' Centres in Canada, but later became *MIX,* a magazine of "creative independence" that is more commercially produced.

4. Being an "independent curator" has a specific connotation, as discussed in chapter 6 of the book.

5. See http://www.starandshadow.org.uk. The cinema opened on the Stepney Bank of Newcastle in November 2006 (having programmed films for four years prior to that in a hired venue on the Side, Newcastle).

6. Recent media arts programs have varied from Guy Sherwin sixteen-millimeter film performances to Simone Bennett DVD film presentations to democratic "plug and play" nights devoted to digital culture featuring Web designers such as Myron Campbell alongside open source art makers such as Dominic Smith. Smith is part of Polytechnic, an artists' group about sharing open source software knowledge and based at the Star and Shadow Cinema. See http://www.ptechnic.org.

7. Tim Jones, the NODE.London coordinator, writes: "The structure of NODE.London is such that the project coordinator could TAKE OVER and no one would notice for 3 months" (2006).

8. The *Whitney Biennial* first showed Web art in 2000, quite controversially, as discussed in chapter 3 on space.

9. *TV Swansong* also included a postevent conference and a book. See http://www.swansong.tv.

10. Admittedly, *TV Swansong* was a well-funded, well-resourced project, which enabled the artists to hire a project manager to deal with the details they didn't want to or were not as good at doing themselves. There remain debates about whether the artists involved felt as rewarded during the process as with the outcomes, and, certainly, on the day of the broadcast itself there were technical problems that seemed to hamper its successful realization.

11. "The word *sarai,* or *caravansarai,* common to many Central Asian and Indian languages, refers to the shelters for travellers, sometimes large and extravagant, often modest and improvised, that traditionally dotted the cities and highways of that part of the world, facilitating travel, pilgrimage, commerce and adventure but also enabling the creation of rich, hybrid languages and cultures and the exchange of stories, concepts and ideas across large distances" *(Wikipedia).*

12. As such, TAZs are tied to a much longer history in art—that of the salon. Artists' groups working with the Net who have initiated a TAZ include I/O/D, Furtherfield, Mongrel, bak.spc, and the Institute of Applied Autonomy.

13. Albrethsen continues, "There is reason to believe that the notion of platform came to the art world with Gilles Deleuze's & Felix Guattari's 'Mille Plateaux' (1980), which surely played a vital part in forming the vocabulary of early 1990s art and art criticism. No doubt, the notion of deterritorialization in terms of rhizomes, nomads and the like, influenced a fair amount of the art writing of the 1990s."

14. Collaborative software programming events such as "Hack-Day London" (2007) sponsored by Yahoo and the BBC include "chill-out" zones and playful social events for computer hackers. See http://www.hackday.org.

15. As we have seen with the work of irational.org or the ongoing activities of Furtherfield. See http://www.furtherfield.org.

16. An example artists often cite is the work of Stewart Home and the idea of "neoism"—the loose "movement" derived from early mail art networks: "Neosim refers both to a specific subcultural network of artistic performance and media experimentalists and more generally to a practical underground philosophy. It operates with collectively shared pseudonyms and identities, pranks, paradoxes, plagiarism and fakes, and has created multiple contradicting definitions of itself in order to defy categorization and historization"*(Wikipedia).*

17. Built upon the legacy of the DMZ, a two-day exhibition-festival-TAZ held at Limehouse Town Hall in 2003, substantially funded by the Arts Council of England to increase networking for artists in East End London. Disclosure: Sarah Cook was named as an instigator of NODE.London on the original application for funding to the Arts Council of England. She helped conceptualize the structure and participated in early planning meetings. Once the system was loosely in place, she did not participate further because she felt (rightly or wrongly) that her identification as a curator and as someone not based in London would potentially be detrimental to the development and understanding of the project.

18. For more about the NODE.London evaluation, cleverly titled the "NoDevaluation," see the exhibition Web site at http://eval.nodel.org. Rigorous evaluation was a criteria of funding from the Arts Council of England, and it was widely discussed on blogs such as Furtherfield's and mailing lists such as CRUMB's. NODE.London was also evaluated as a potential model for organizing similar events in other cities such as Linz, Austria, and São Paolo, Brazil.

19. Different ideas of openness were in evidence in a project undertaken by the ICA in London in 2005, when its in-house curator invited six other guest curators to initiate two-week-long exhibitions on the subject of the art scene in the city of London. "By giving over curatorial reins . . . the ICA declared itself open; but in fact it hid the institutional process involved in selecting these spe-

cific six curators at the expense of placing the curatorial responsibility on the invitees" (O'Neill 2005, 8).

20. This lack of completion was the case with the database and the software for resource sharing and wireless networking across London. See http://blog.furtherfield.org/?q=NODE.London_Malmoe.

21. A "burning of NODE.London party" was planned, no doubt to allow the project to rise, phoenix-like, in a new incarnation with new volunteers. (At the time of writing, there has been another successful edition of NODE.London that took place in Spring 2008 and there continue to be ongoing meetings concerning the Web site development, the formation of a constitution and applications for further funding.)

22. Other examples include Steve Dietz's online curatorial project *Fair Assembly* for the ZKM exhibition *Making Things Public* (2005) (see http://makingthingspublic.zkm.de/fairassembly); Andrew Renton's *Browser* (1997) (Hiller and Martin 2002, 14ff.); and Walker Art Center's ArtsConnectEd (see http://www.artsconnected.org).

23. The Web site states that runme.org was developed by Amy Alexander, Florian Cramer, Matthew Fuller, Olga Goriunova, Thomas Kaulmann, Alex McLean, Pit Schultz, Alexei Shulgin, and the Yes Men. Hans Bernhard and Alessandro Ludovico are also members of the expert team. See http://runme.org/about.tt2.

24. See FAQ at http://www.runme.org.

25. The project was designed by artist Eva Grubinger in collaboration with the software developer Thomas Kaulmann and supported by Kunst-Werke Berlin.

26. For more information on Kurator, see the Web site at http://www.kurator.org.

27. This is what the software Kurator does for software-based art: search metadata and distinguish code about the software from the code of the software itself.

28. Ruth Catlow writes: "we initiated the DIWO E-Mail-Art project so that 'subscribers' to the Net-Behaviour email list and the technologies they deploy are ALL artistic contributors to the project. . . . The idea deliberately draws on the tradition of earlier Mail Art exhibitions in that the project started with an open-call and every post to the list, between 1st February and 1st April, is considered a work—or part of a larger, collaboratively created artwork. I can even imagine arguing that lurkers are also contributors" (2007).

29. Similarly, curators have sometimes been criticized for their "old boy network" mentality, showing only those artists they know personally. This approach is perhaps due to the lack of openness in their selection procedure.

30. Iliyana Nedkova expands on this idea in Cook, Graham, and Martin 2002, 103.

31. This attempted mode of curating—in essence, adopting the methodology of the work of art as the methodology for curating the exhibition—is well suited to a demonstration of the process-led nature of new media work, but it demands extensive consideration of the structures of a traditional gallery (because a gallery setting favors static presentations of fixed objects).

III Conclusions

11 Conclusions: Histories, Vocabularies, Modes

Once you've curated new media art you're unlikely to curate anything else the same way again.
—CRUMB, "CRUMB biography," 2008

We know that artists have for some time now been turning the gallery into a discotheque or a lounge or restaurant or school, confusing barriers and functionalities, inviting confusion and instability. Indeterminacy becomes an inherent part of the artistic experience.
—Rudolf Frieling, in Suzanne Stein, "Interview: Rudolf Frieling on the Art of Participation," 2008

New media art presents the opportunity for a complete rethink of curatorial practice, from how art is legitimated and how museum departments are founded to how curators engage with the production of artwork and how they set about the many tasks within the process of showing that art to an audience. The productive indeterminacy curators encounter when faced with a work of new media art and what methodology to adopt in response are informed by many different kinds of cultural reference points beyond the traditional museum exhibition. The modes of curating engendered by working with new media art can be more widely applied to any art that may be process oriented, time based or live, networked or connected, conceptual or participative. As Steve Dietz noted, new media art is like other contemporary art, "only different." The conclusions we come to in this book therefore involve not only the context of contemporary art, but also the wider cultural context—"curating art after new media" rather than "curating new media art."

There are three key arguments in this book. First, the history needed for the understanding of any artwork is in fact a set of histories, and for new media art this set includes technological histories, which are essentially interdisciplinary and patchily documented. Second, these histories have informed the development of a set of critical vocabularies for the fluid and overlapping characteristics of new media art, which can now be best understood in terms of the behaviors of the work of art—for instance, Is it time based or participatory? Third, the artworks' behaviors demand different modes of curating in response. These three arguments are of course interrelated, and this book attempts to offer helpful solutions from practical experience for those curators who are coming to grips with the technological history, the artworks' behaviors, and the practice of curating new media art all at once.

These interrelated arguments are woven through the book in a rather complex way, but it may be helpful to describe them in a more linear fashion, following the chapters through in order. New media art is in an almost constant state of emergence because of its use of new technologies, leading it to be described as "new" or "avant-garde." The challenge of curating emerging art might be addressed by the passage of time: once the peak of inflated expectations on the hype cycle has been passed, then the long-term effects of new art forms, media, and methods upon the world of contemporary art are open for consideration. However, the time lag for arts organizations to catch up with the avant-garde has meant that vital historical, documentation, and collection work occurs too late. The description of new media art in terms of systems and the way in which these systems function materially—over time, in space, and through interaction—marks key areas in which new media art can be seen to present an opportunity to rethink curating. New media artworks challenge these systems to be "open." A critical vocabulary of how "open" or how "participatory" these systems are may be drawn from politics, new media, and aesthetics.

Concerning the wider landscape of curating as a whole, it then becomes clear that the most promising and successful solutions come from a hybrid way of working. The second half of the book describes different modes of working for curators, whether in institutional systems or in other kinds of collaborations. This adjustment includes rethinking the fundamental roles of artist, curator, and audience. The issues of display for new media art are inextricably interlinked with issues of how new media technologies are used for interpretation, discourse, and communication, whether offline or online. New media function in the context of the wider social body, and the audience may encounter new media artworks in the form of, for example, online collections, cell phones, and digital audio players. The contexts of presentation beyond the static exhibition—the interface for new media art, if you like—may include "other" modes such as festivals, commissions for public spaces, publishing and broadcast, research and production laboratories, and any hybrid of these modes. Changing the interface to a new media artwork will always change the meaning of the piece; therefore, the challenges for display are not just practical ones.

The context for new media art as it is understood by audiences often extends into social spaces and popular culture. The audience's role is a key thread of investigation into collaborative ways of curating because one of the logical endpoints of the development of interfaces for new media art is that the curator can let audience members do their own selecting, filtering, naming, and collecting. Collaboration within the process of curating can also help to address the multiple roles that may be demanded of a curator and can help to build up expertise or pool a range of different skills. Dialogue and role swapping between artists and curators can greatly enhance the kind of hybrid collaborations essential for curating new media art.

This concluding chapter explores the book's three key arguments in turn. In doing so, it draws again from practical curatorial experience sited firmly in the context of con-

temporary art. In our research into curatorial practice, we have come across statements from contemporary art curators as to why new media art lies outside their area of interest, and we use these statements as subheads for the chapter, such as "But is it art?" Curators should, of course, always be free to show what they want to show, but the stated objections to new media art can be contradictory and may be borne of lack of awareness about the conceptual and practical issues that new media art presents. Our conclusions therefore also question the stated reasons for not curating new media art, uncover the real challenges behind those reasons, and offer possible solutions to these challenges drawn from new modes of curating.

A Set of Histories

The problem with net.art is that it's old hat. The problem with net.art is that it's too new.
—Steve Dietz, "Why Have There Been No Great Net Artists?" 1999

In 2008, a reason given for the discontinuation of the Department of Live & Media Arts at the ICA in London, the venue for the 1968 exhibition *Cybernetic Serendipity,* was that "in the main, the art form lacks the depth and cultural urgency to justify the ICA's continued and significant investment."[1] New media art suffers from this particular quandary: it is an art form where the "new" dates quickly, and both the hype and the work disappear before full critical understanding of the work is reached. That said, no matter what the new form of art, there is a "lag" in the time between an artwork's emergence and its acceptance by arts institutions. Art curators are often led by provenance and precedence, and those curators in publicly funded arts organizations, for example, may wait until others have approved the art before risking anything that might be seen as an opportunistic "flash in the pan." Some institutions, however, are not averse if the flash is bright enough, and curators are actually under pressure to do the "novelty hustle," as Barbara London has put it.

Some organizations are indeed led by fashion or by theory and hence might also be led by technology to exhibit art made only with the latest thing or to exhibit the latest postfeminist or postmedia tendency before the wider public has had time to chew over the issues. The shape of history for new media art can be described as a series of peaks and troughs—curators may leave organizations (or be pushed) and take their expertise with them, just as freelancers might have only a limited time to realize risky, forward-thinking projects. If an institution held a hastily organized technology-led exhibition in the 1990s, it may have been a disappointing experience that the institution is not keen to repeat, or it may consider that it has ticked that particular box and doesn't need to do so again.

This strange rollercoaster of time has had problematic effects on the development of the field of new media art. Those art museums that historicize art may have had the odd art-and-technology blockbuster, but have not subsequently developed their engagement

with the practice of new media artists, meaning that new media art has been doomed to remain at "first contact" level, its subsequent development ignored altogether. If histories are lost, then a repeated cycle of "first contacts" means that there is no time to digest critically the varied emerging forms of new media art, and audiences do not get the chance to develop their understanding and appreciation of these forms. There is also the important factor, explored later in this chapter, that if new media art is not collected, then the base from which to write the history is also lost.

Which Histories?

For example, the most cursory comparison between the history of post-war art and the Tate's holdings will demonstrate that, for all its intentions to represent, as best it is able, art of that period, there are many forms of practice it has failed to engage with completely or at best only partially or belatedly. These include: Cybernetic Art, Robotic Art, Kinetic Art, Telematic Art, Computer Art and net.art. . . . It is not, of course, that Tate is deliberately following a policy of exclusion in terms of the above. It is rather that an institution founded in and for the very different conditions of art production and reception of the late nineteenth century, simply is not properly equipped to show such work, or at least not as it is presently constituted.
—Charlie Gere, "New Media Art and the Gallery in the Digital Age," 2004

Those involved in new media art bear the burden of having to explain that there is a history and context to this work that will enhance understanding of it. There is also then, however, a choice of which history to include and the fact that there is a history of technology as well as a history of art. As Charlie Gere suggests, institutions may not be "equipped" in a systemic sense to collect and hence historicize certain kinds of art, but curators can equip themselves with historical knowledge that might help, such as knowledge of the differences between new media and older forms of art.

The book has identified lessons from history that can be applied to different varieties of new media art. Hence, the histories of the avant-garde and postmodernism are useful in considering postmediality, ready-mades, appropriation, and critical issues of authorship, all of which were explored with regard to the 1985 exhibition *Les Immatériaux*. However, new media art demands some further detail in order to be able to articulate fully the concepts of cut and paste, hacking, and modification, as evidenced in the example of Harwood@Mongrel's *Uncomfortable Proximity* commission for the Tate in 2000. One conclusion is that with respect to new media art, attribution is more of a problem than authorship.

Histories of conceptual art—in particular, how mail art, Hans Haacke, and Fluxus artists dealt with issues of space, immateriality, and systems—are of obvious relevance to new media art. The historical examples of Seth Siegelaub's curatorial practice and the 1970 *Software* exhibition curated by Jack Burnham can be seen to inform how Net art in particular has been exhibited, and the difference between the located and the locative is evident in the artwork of Thomson & Craighead. The related histories of "time" ac-

knowledge the obvious debt to video and live art, and in particular identify tools for considering mediation, reenactment, and degrees of "liveness" in video and performance art practice. Alexei Shulgin's "performative" software, and the *Art, Technology, and Informatics* event for the 1986 Venice Biennale are both examples where "real time" new media temporalities differ from the temporalities of other art forms.

The consideration of participative systems offers lessons from the histories of socially engaged and political art and media, such as Arnstein's "Ladder of Citizen Participation," which helps to distinguish interaction from participation and collaboration. The examples from the *Information* exhibition of 1970 and Robert Morris's ill-fated 1971 sculpture exhibition at the Tate highlight certain contemporary institutional and critical attitudes to participation, which center on issues of control and authorship.

This historicization in itself helps to sidestep the problem of new media art's being understood only in terms of "newness." The press hype about "upgrade culture" need not be a curatorial anxiety: if curators make exhibitions based on histories, behaviors, content, themes, and context rather than based on the latest technology, then they can avoid dancing the "novelty hustle." Exhibitions discussed in this book, including *Database Imaginary, Generator,* and *Seeing Double,* include artworks from different histories that are not "new," but that does not make them "old hat." In answer to the question "Which histories?" we can therefore say that several different art histories have useful lessons to offer to curators of new media art, depending on the artwork's exact behaviors or characteristics. The history most often omitted from art education, however, is technological history.

Technological Histories, Technological Presents?

MTAA recently had our worst fears realized when speaking to some traditional art world types about a new piece we're developing with RSG [Radical Software Group]. We were told bluntly that phrases like "peer-to-peer" and "file-sharing" are jargon. . . . What we find interesting and exciting culturally about this technology needs to be expressed to folks in the present that may be ignorant of it or fail to understand it. We also need to communicate to people in the future that may have no idea what happened in the late 90s/early 00s.
—T. Whid, "New Media Art Shouldn't Suck," 2006

Although ignorance of technological histories is starting to be addressed by publishing, self-documentation, and translation across the varied vocabularies of new media, useful histories of technology in art are often offered in vain, as in the case of the conceptual art exhibition *Open Systems* (2005) (described in chapter 2), which missed an opportunity to include computer-based artworks along with nontechnological systems-based work of the 1960s and 1970s, and hence the opportunity to compare across systems, including open systems from recent history.

New media histories are much wider than art histories, and curators therefore need to understand a certain amount about "life in technological times" rather than just "art

in technological times." Negative attitudes to technology are deeply linked to humanist and political historical positions. Curators are hardly likely to admit publicly that they fear and loathe (or don't understand) technology, so they tend to present their objections in terms of reduced artistic quality or the "dumbing down" of art. It can be argued, however, that "life in technological times" has had more of an effect on arts institutions than all the lobbying by new media arts specialists has: if contemporary arts curators take pleasure in using a cell phone to SMS their loved ones, if their colleagues show them quirky things on the Web, or if their institution has wireless networking in the café, then they are much more likely to know how these technologies can be made to work for art. For example, Germaine Koh's artwork *Relay* (2005–) (described in chapter 8) used the existing lighting and Internet systems of an art institution for its presentation. If curators do not use, understand, or like new media, then they'll probably not like new media art. Unlike the reading of art theory, where a distanced point of view is possible, to understand how certain types of software, such as wikis, work and to gain a critical view of them, curators would actually have to use them. Technology is, let's face it, often a source of everyday irritation; however, many art critics tend to take out their annoyance with "life in technological times" on new media art (as explored in chapter 5).

Educators are great sources of solutions in this respect, introducing "the new" to a range of audiences from neophyte to expert (as described in chapter 7). Technology is not everything, however: an arts venue may have all the technological infrastructure in the world, but if the staff don't know how to work the systems or if they hold technology in disdain, then new media art will not be shown in that venue (as described in chapter 8).

The need to understand this range of interdisciplinary histories, coupled with the practical issues of time, again links to conclusions reached in the second half of the book about the need for alternative, modular, and collaborative modes of curating. There also may be a need for a certain amount of translation, as the artist T. Whid acknowledges at the start of this section. Ways of translating the expert knowledge of new media are to some extent being addressed by the ongoing development of histories of technology.

Critical Vocabularies—Which Verbs, Which Systems?

What has kept the art world out of the loop? There are many issues, but the most disturbing one is laziness. Not the physical kind—there are plenty of curators who jet back and forth from Kwangju to Kassel studiously trolling for biennale *Wunderkinder* and art-school stars-in-training. No, what's holding the art world back is a philosophical laziness: a disinterest in or—worse—a refusal to rethink their definitions of the art they spend so much of their time trying to scare up.
—Joline Blais and Jon Ippolito, *At the Edge of Art*, 2006

New media art can be regarded as contemporary art only if it can find a place in the category of art, and can develop a critical vocabulary only if it can define itself accurately.

One of the key challenges for curating new media art lies in the description of its seemingly immaterial or conceptual processes given curators' usual material and aesthetic concerns.

The vocabularies offered in this book can be used to describe the behaviors of new media art—such as *interactivity, connectivity,* and *computability,* the terms Steve Dietz proposes to describe what the art does. There are also adjectives to describe the different kinds of network systems: *centralized, decentralized,* and *distributed.* Differentiating these networks is particularly important because new media art circulates within these networks, using the systems for both production and distribution. Armed with an understanding of these terms, a curator is better equipped to identify different possible ways of working with new media art.

New media art projects invite a rethinking of levels of openness in systems of production and distribution. The vocabularies of openness and participation as well as the new media theories of interaction offered here include the metaphor of conversation to express the power relationships between those involved in a network of exchange. New media art in turn offers even more exact categories to distinguish who is interacting with what and why (the specific participative model of open source software production is a good example).

Some contemporary art museums genuinely wishing to include new media art have started from a familiar category and tried to squeeze new media art into it. As explored in the chapters in the first half of this book, more familiar kinds of art—such as conceptual art, video or performance art, and socially engaged art—have some similarity of behavior, but each has dissimilarities to new media art, too. A curator may be familiar with the immateriality of conceptual art, for example, but be all at sea if the work is participative. Although the art histories may inform, they may also not quite suit the full range of work made under the banner of "new media"; or, to put it another way, the coat made from such remnants of history may have a comfortingly familiar feel, but is an awkward fit. New media art can certainly offer sophisticated vocabularies for its technological media, its behaviors, and its systems. However, it has to be admitted that for some contemporary arts institutions, the questions start from a much more basic understanding.

"But Is It Art?" A Challenge to Categories

If you want to be really heretic you could claim that [your work] is media art and [has] its specific contemporaneity. . . . [T]hat makes the ideas dealt with more contemporary than the ones contemporary visual art is dealing with.
—Inke Arns, in Inke Arns, Diederichsen, and Druckrey, "Media Art Undone," panel presentation, 2007

As posited in chapter 1, new media art starts from the problematic taxonomic starting point of being labeled "not art" because it is identified as popular culture or activism or science or design or technology. A knowledge of the histories of process-based, socially

engaged, conceptual, and performance art can help curators establish that the varia-
tions on these forms within the field of new media are in fact Art (even if they remain
"hyphenated" forms of art not quite in the center of the art world's hierarchy). The key
question for new media artists is whether they would *rather* be considered designers or
activists because being so considered would help the understanding and the reception
of their work and would sidestep the problems that the art world has with multiple au-
thorship, the aesthetics of activism, the exhibiting of process instead of product, and
audience interaction. There are in general two usual solutions for disagreements about
inclusions and exclusions from categories: one is to make your own separate category
and risk making an autonomous ghetto where no one else understands your terminol-
ogy; the other is to lobby for integration into the dominant category. Tim Druckrey ar-
gues that for new media art, the answer lies somewhere between these solutions: "we
are neither autonomous nor assimilated without pardon" (in Arns, Diederichsen, and
Druckrey 2007). He reasons that new media technologies have now become so ubiqui-
tous that they are simply in the atmosphere of the culture rather than being a subset of
art. Inke Arns goes even further to suggest that the relationship is that of leading by ex-
ample rather than becoming just a subset of contemporary visual art.

What Arns is querying in the epigraph to this section is why these engaging projects we
know and love should be considered "media art" rather than art in general, and whether
that consideration would change if new media art sought to "emancipat[e] itself from
the 'compulsion' to use media/technologies" (Arns in Arns, Diederichsen, and Druckrey
2007). Is it just a case of mistaken naming? Works of new media art are often mistaken
for video art (simply because they might be projected or on the same exhibition format
of DVD), and owing to the shifting nomenclature of new media art, this mistake is a rela-
tively easy one to make. Hence, the New Media Collection of the Centre Pompidou is in
fact very dominantly video art, and new media projects often disappear into media art
departments and remain below the surface of the collection. Even those organizations
specializing in new media art—such as FACT in Liverpool and ZKM in Karlsruhe with
its Media Museum—have their own internal debates as to how much video art domi-
nates the program. Certain skills from curating video art are highly relevant to curat-
ing new media art, in particular those used in dealing with time-based work and with
questions of installation, conservation, and mediation, but these skills are not the only
ones needed (as discussed in chapter 4). Some video art curators fought for video as "the
new" some years ago, but are now highly reluctant to let new media art into the terri-
tory they fought for—a land now fully occupied, it seems, with the canon of big video
installation.

Arts organizations are sometimes under the impression that they already "do" new
media art because their collections are online on their Web sites. New media art can
quite often be confused with education and interpretation technologies (as discussed in
chapter 7). This confusion is sometimes productive, as the example of Tate Media shows,

but it also raises problems of definition: if museum curators can safely delegate responsibility for new media art to an education department, then they do not have to deal with it themselves.

Possible solutions to these basic confusions are relatively straightforward. A general improvement in the definition of categories has occurred, and some events have attempted to "bring on" curators of film and video into more detailed knowledge of new media, such as the Tate "Moving Image as Art" seminar (described later in this chapter). Nevertheless, other than working in teams that involve both art curators and education workers, curators have only a limited number of events where they can learn from the use of educational technologies and differentiate their role as curators of new media art (a possible area for development). Of course, hidden under this simple confusion regarding nomenclature is a larger issue concerning the position of new media art in relation to the contemporary arts in general.

"We Deal with Contemporary Art, Not Media-Specific Art"

It's not something I would want to vulcanize in a department. Because art doesn't exist that way.
—Max Anderson, Whitney Museum of American Art, in Susan Morris, *Museums and New Media Art*, 2001

That contemporary art should be treated as art regardless of the media used is an excellent argument. We are, after all, post-postmodern and possibly living in a postmedia condition (as discussed in chapter 2). The medium is seldom as important as the content or context, and funding bodies or museums are increasingly claiming to be, as Susan Morris puts it, "departmentally blind" (2001, 15). Treating the work of new media art as any other form of contemporary art is surely the solution to the problem of catering to all the medium-independent behaviors of new media art. Many of the organizations that most passionately advocate this solution, however, have never actually shown any works of new media art.

As the quotation from Susan Hazan (2004) in chapter 1 illustrates, many museums' departments would struggle to cope with an artwork that is even mildly networked. For example, Adrianne Wortzel's robotic sculpture *Camouflage Town* (2001) is controlled by viewers over the Internet and when exhibited showed an amusing tendency to cross the boundaries of the museum by following visitors from the lobby into the elevator. Perhaps related to this history, defining art by medium has become unfashionable, and areas such as installation art or socially engaged art have never been defined by medium. Artists will justifiably resist being pigeonholed by the media that they use, even if they use those media expertly. Above all, some curators are so highly aware that the media specific has become unfashionable that they have become not only "departmentally blind," but also media blind: during an opening of a monographic exhibition by an artist using immersive sound and mobile digital video, the gallery director was heard explaining that the gallery had never shown new media art—simply because the artist was not identified

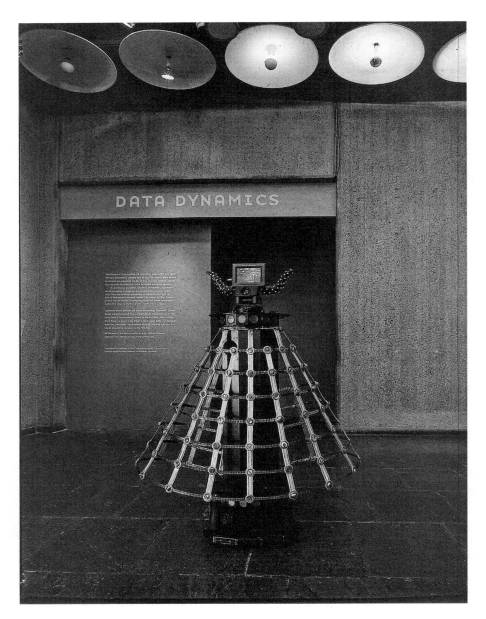

Figure 11.1
From the exhibition *Data Dynamics* (2001) at the Whitney Museum of American Art, New York: Adrianne Wortzel's *Camouflage Town* (2001), a networked robot that responded to visitors and moved around the galleries and lobby, occasionally following visitors into the elevators. Photograph by Becket Logan.

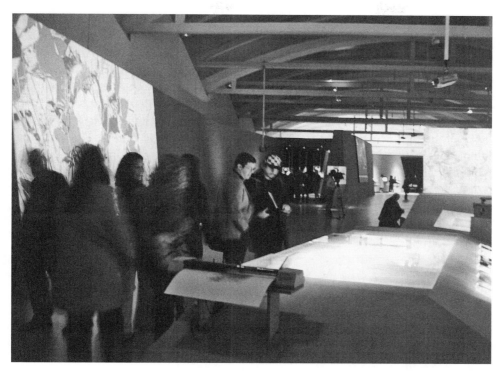

Figure 11.2
Installation shot of the exhibition *Feedback* (2007) at LABoral, Gijon, Spain, showing Roman Verostko's *Untitled Page* (1991) and *Untitled* (1989) in the foreground. Photograph by Beryl Graham.

as a new media artist or because the director didn't know that *new media art* was a term that accurately described that artist's work. The problem is, therefore, not one simply of names or categories, but of political "position." Curators who know about new media art are in a catch-22 situation: if they acknowledge specialist knowledge of the behaviors specific to new media art, then they risk being seen as media-specific evangelists or even too specialist for the wide world of art. If curators in a departmentally blind institution are simply expected to know about all kinds of art and all kinds of media, then they are caught between being understandably reluctant to admit that they don't and not having the time to inform themselves even if they want to.

The most obvious solution is for those working with new media art to consistently challenge the specific inclusions and exclusions of the "non-media-specific" rhetoric of arts institutions, funders, and contemporary curating courses. "Curating by example" is a tactic already in use: exhibitions cited in this book—such as *Database Imaginary, Serious Games, Feedback, Risk,* and *The Art of Participation*—are reflective of all "necessary media"

and histories in the wide field of contemporary art. However, art using new media is seldom included in even highly relevant art exhibitions, so perhaps the reciprocal position is still in development.

The reason why new media art is not included is often a simple lack of familiarity with the art. New media art might be "new," but it's not that new. One of the solutions explored by art museums has been to admit their lack of familiarity and to look at adjunct or short-term research tactics. Once a level of familiarity and expertise is reached, however, curators are then back in the catch-22 situation. Experts in new media art are often assumed to be utopian, uncritical, and technology led, when in fact the opposite is usually the case. One solution seems to lie in the opposite of Ippolito's "philosophical laziness" mentioned at the start of this chapter—taking on the challenging activities of defining meaningful working categories independent of media and of questioning established categories.

Figure 11.3
Installation view from the exhibition *Database Imaginary* (2004) at e-space, University of Toronto, Mississauga, Canada, showing projects by Heath Bunting from irational, Cheryl L'Hirondelle, MobileScout, and Preemptive Media. Curated by Sarah Cook, Steve Dietz, and Anthony Kiendl. Photograph by Sarah Cook. See http://databaseimaginary.banff.org.

The most radical categorical definition for the philosophically hyperactive, therefore, might lie in the consideration of new media art not as a media-specific subset of contemporary art, but as the convergence of a set of issues common to contemporary art. If the common issues of curating contemporary art are considered, then there is a similar convergence. The approach taken in the book *Curating with Light Luggage* (Gillick and Lind 2005), for example, is optimally suited to new media art, and O'Neill's recent book *Curating Subjects* (2007) is full of the language of mediation, distribution, and audience as producer. When Hans Ulrich Obrist talks of the need for venues that change and exhibitions that evolve, and of the fast/slow nature of audience response, he points to key issues considered by those curating new media art (as stated in chapter 4). Art critics and curators often use software, systems, and relationality metaphors, but without referring to new media art (as discussed in chapter 5).

The search for curatorial new media bliss in relation to the larger field of contemporary art therefore remains a knotty challenge because it involves radically restructuring the categories of art. The common interests that new media art and contemporary art share concerning process, participation, and audiences, however, can form a bridge that links new media systems to art systems. Bliss might be attained through adopting a hybrid working method: sharing skills, collaborating, and taking time to think and explore new art and new contexts.

"Is It Great Art?" A Critical Base of Aesthetics

The problem with net art is that it is so opaque. The problem with net art is that it is so obvious. . . . The problem is that there is no great net art.
—Steve Dietz, "Why Have There Been No Great Net Artists?" 1999

In answering the question "Why have there been no great net artists?" Steve Dietz (1999) deliberately makes a parallel with the arguments of feminist art histories concerning documentation and aesthetics, and states that, obviously, a response depends on what you mean by "great" and which histories. Many new media art curators will have had the experience of having a contemporary art curator explain to them with great sincerity that they would love to be showing new media art if only they'd seen any that was good enough. Sometimes the subtext to this explanation is that new media art won't fit into their category of art or that they haven't seen any at all or that they don't like technology. Sometimes, however, it is a genuine difficulty with aesthetics or with critical provenance.

The trouble with conventional art aesthetics is that it's all about how it looks, and new media art is more about what it *does* and about the wider cultural context. This is why, as Lev Manovich (2002, 2007) points out, some Net art has been described as "abstract" when it fact it is representative of code. If we are casting around for other markers of artistic value, then even the craft value connected to "the hand of the artist" doesn't fit new media, as demonstrated by the generative work of Cornelia Sollfrank. If considering "truth to materials," then it is perhaps the nature of computers to be glitchy or

irritating; Josephine Berry has even argued that the "aura" of new media art using code is in its glitchiness, as in JODI's work (Berry 2001). It's difficult to establish the aesthetics of technology if, as described in this book, the histories of technology are missing from art education, resulting in a patchy aesthetics of process, systems, and simulation; if the existing aesthetics of space and time are useful, but not always fully adequate; and if the aesthetics of interaction or participation is undertheorized, although the histories of political ethics are useful. You get the picture (although not, perhaps, the process): existing aesthetic frameworks simply don't quite fit.

The trouble with new media art is that even if we are just considering how it looks, then to an art curator it might look strange and incomprehensible. The screen graphics might look messy if you're used to commercial design; the installation might look too minimal and cold if you're used to busy textural installation art; or the trailing cables might look wrong if you like minimal art. How the artwork is installed is highly variable, but curators tend to judge the first impressions of the installation rather than the artwork itself. Curators have very definite opinions on how things are installed, especially if beanbag chairs might be involved. The only real solution in this case is to listen to the artist's expertise and to recognize the artwork's individuality.

With regard to issues of critical provenance, it should be mentioned that in the traditional art world, the provenance—the identity and status of who has previously owned the artwork and where it has been seen—is the key to the value of the art when resold. In terms of critical provenance, if important people have said in print that the artwork is good, then such a statement is key to the definition of "good art." Both of these factors put new media art at a disadvantage in the "good art" stakes. They involve a circular self-fulfilling prophecy for new media art: if there is no aesthetic structure, then it is difficult for critics to write an informed review, and there is little to feed into critical or catalog essays; if there are few catalogs and sparse documentation, then the historical criticism does not build up; and if there is no collecting, then there is no provenance.

"You Can't Collect It . . ."

Each section of a museum building should contain two groups of galleries; one for the exhibition of selected objects in a way to promote their appreciation, the other for the installation of remaining objects in a way to facilitate their investigation.
—Benjamin Ives Gilman, "Aims and Principles of the Construction and Management of Museums of Fine Art," [1909] 2003

In 1909, Benjamin Ives Gilman was quite clear that, once collected, art can be appreciated, investigated, reinterpreted, and otherwise form part of a continuing critical base. It is therefore important that all kinds of art are collected. The short answer to the excuse "you can't collect new media art" is therefore "yes, of course you can," and this book gives examples of how. Private domestic buyers and art museums have already done so successfully, sometimes by starting their collections via documentation, which chal-

lenges both what is documented and what is collected. As Caitlin Jones points out, a possible solution to the problem of the huge range of cultural context that should be documented alongside an artwork is the fact that huge amounts of self-documentation, including informal documentation by audiences, is already happening online. In some ways, it can be argued that because new media art shares media with collections databases and interpretational Web sites, it is "a natural" for both collection and self-documentation. It has even been instrumental in changing the ways that collections can be accessed, investigated, interpreted, and taxonomized—for example, through online collections or "virtual galleries" and through the treatment of the audience as curator. Again, new media art challenges the boundaries between the roles of curator, documentor, conservator, and audience.

Yet the problem of aesthetics and critical response gets more complicated still: if there are no criteria for the evaluation of new media, then funding councils find it difficult to determine their funding criteria and to write policy or make reports. If there are few catalogs, reports, or press reviews, then art historians find it difficult to do research. For new media art in particular, even the early stages of getting an art press review can be a challenge.

From a Review to a Critical Base

What I feel is seriously lacking in a lot of new media rhetoric is any attention to the history of esthetics and philosophy of art, in particular in the gee-whiz newspaper articles. Most often, in this context, the writer starts with something inane like "Are rapidly blinking colors or role-playing styling interactive systems art?" and ends with the question "Is it art?" and leaves it at that. The issue is never picked up.
—Saul Anton, "I'll Make a Go," 2003

The press coverage of new media art has suffered from being too often at the "first contact" level that usually has a "gee whiz" attitude about the technology involved. In the minds of some journalists, technology seems inextricably linked with "fun for kids": in 1968, *Cybernetic Serendipity* was described as "guaranteed to fascinate anyone from toddling age to the grave"; in 1970, the *Software* exhibition gave gleeful satisfaction to a press obsessed with malfunctioning technology; and for the exhibition *Serious Games* in 1996, press response still appeared to be at the level of first contact.[2] One solution to this problem has been for curators simply to write press releases themselves, very carefully, or for curators to temper any gee-whiz impulses in their institution's communications and marketing department. The excitement about technology should be an opportunity rather than a problem: the exhibition *010101* at SFMOMA gained almost twice the press coverage of other shows in the museum, and the well-informed press department employed several good tactics, including having two different press releases written for the art press and the technology press, and personally sitting with art journalists to talk them through the Net art commissions.

Figure 11.4
Installation view from the entrance of the *Cybernetic Serendipity* exhibition, ICA, London, 2 August to 20 October 1968. The work suspended from the ceiling is James Seawright's *Scanner.* Courtesy of Jasia Reichardt.

A slightly different challenge to that of the technology is the fact that new media art projects often involve different media and can be more in tune with contemporary issues in the fields of design, politics, and science, so the press do not know which journalist to send (and don't have a new media art specialist). Journalists, like curators, usually start from more familiar forms of art, and the solution to this conundrum lies in the rather large task of critically developing the understood categories of art. One shorter-term solution is cleverly elegant: artist Lynn Hershmann Leeson admits that in the early days of her cross-media performance work, she simply wrote and published reviews of her own work under aliases (Finkel 2005). If a newspaper can't supply a subject specialist, then it can't find anyone more specialist than the artist herself. Those involved in socially engaged art have also found themselves documenting, reviewing, and criticizing art from a position of embodied knowledge.

This tactic of taking on more than one role is the starting point for a set of solutions: "While art professors typically divide clearly into critical (Art History) and creative (Studio Art) faculties, new media's brief history often requires its practitioners to develop a critical context for their own creative work. This is why so many pre-eminent new media artists are also critics or curators" (Ippolito 2007). Artists are sometimes also curators *and* critics and take on those additional roles with the interests of wider criticism and

the development of the field in mind. The do-it-yourself ethic is here repeated: members of the Furtherfield artist-run organization also solicit reviews of new media art for their Web site. Although the critical roles may be blurred, it is important that the critical argument of the practice—whether art practice or curating practice—is clearly articulated.

The relationship between critical vocabularies brings us back to an interrelated set of arguments and even to vicious cycles: if new media art isn't exhibited, it can't be reviewed; if there isn't the demand for reviews, then there won't be specialist reviewers; if there is no critical base, then reviewers cannot inform themselves in order to write better reviews; if there is poor awareness of histories, then there will be poor critical base; if art isn't exhibited and hence collected, then documentation, archiving, and collections will be poor, and art research to inform the critical and historical base will be hampered. With artists, curators, and critics taking on hybrid roles, the solution to these vicious cycles lies not only in expanding our critical vocabularies but also in developing different modes of curating.

Beyond Novelty—Curatorial Modes

Subject to many of the same pressures that have produced what is termed an "experience economy," institutions too are ever more committed to the staging of a series of interconnected leisure attractions which supplement and enhance the exhibition experience. As if in self-protection, curators, when faced with such potential constraints on their areas of competence, have appropriated methodologies employed by artists . . . and compete with them in delving into the social/institutional domain in order to construct experiences.
—Lynne Cooke, "In Lieu of Higher Ground," 2007

The most radical differences between new media art and other contemporary arts are perhaps not in the art itself or in the critical vocabulary, but in the process of curatorial practice—in the verbs of how things are done rather than in the nouns of categorization. This book is centered on modes of practice not as modish new enthusiasms for, say, collaboration or social networking, but as solid practical knowledge based in history and drawn from a range of disciplines. The working practices of networks, how audiences participate in them, and how collaboration happens, after all, come as much from politics and the culture of work as from art, and as much from interpretation as from curating.

The solutions to the historical and categorical challenges already outlined are as much about ways of working as about kinds of art. Even with something as familiar as adjunct versus embedded curatorial roles, there are some interesting examples of how this approach has been used to deal with the specialist knowledge demanded by new media art. Solutions for the valuing of new media expertise include not only the obvious new-media-specific organizations such as FACT in Liverpool and Eyebeam in New York, but

also even some galleries that specialize in certain behaviors, such as interactive art. Some organizations, for example, invite more specialist curators in for short periods, such as in the case of Matthew Gansallo and Julian Stallabrass at the Tate, where visiting curators have been able to spend research time, cross established institutional boundaries, and help plant a marker for future development. The obvious disadvantages of being in an adjunct position include the lack of a power base, continuity, and historicization. How curators are to become more familiar with new media art is another key question, and it is notable that several curators have indicated lack of research time as a major problem. Other curators have chosen to make themselves as familiar with the art as possible by making public the creative processes of the art—for example, the Surrey Art Gallery's small, public artists-in-residence series in the gallery or full lab-production models.

In considering "other modes" of curating, then, it is clear that, outside of the art museum, certain ways of working tend to suit certain behaviors of new media art. Festivals, for example, can deal with emerging work and the short, sharp exposure of prototypes and works in progress, and arts agencies have a useful history of responding quickly and commissioning for a wide range of public contexts and audiences. Art publishing and broadcast modes have a preexisting grasp of one-to-many versus many-to-many distribution networks and an understanding of the importance of self-documenting projects. Of the many modes available, however, labs and collaborative production seem to cater most fully to the behaviors of new media art by illuminating the whole process of production and distribution.

On Process and Collaboration

There's something in the field of media art that is impossible to . . . sub-categorise under the existing structures or categories of contemporary art. That's, I would say, in some cases a really very deep, very intense experimentation with technology which still makes it very different from contemporary art. This kind of involvement or experimentation is just not being taken seriously in the field of contemporary art.
—Inke Arns, in Inke Arns, Diedrich Diederichsen, and Timothy Druckrey, "Media Art Undone" panel presentation, 2007

If process rather than object is becoming more important for contemporary art, then the curatorial mode of the lab has much to offer in terms of production as well as distribution. As posed in chapter 1, what might be viewed as a divide between new media and contemporary art can also be viewed as a fundamental strength of new media—the actual practice of production labs offering modes far in advance of somewhat vague art world understandings of "the lab," in particular for cross-disciplinary work. Curator Inke Arns values the deep experimentation as differing from the realm of art, and Joline Blais and Jon Ippolito also see the process and research elements in relation to artistic "genre" and as fundamental strengths of new media art: "In order for research to become genre, exposure to that medium or movement must expand outside the subcul-

ture that birthed it. This destiny will only befall a subset of artistic research. . . . Generally speaking, only works that were valuable originally as research retain a strong sense of originality once they have been accepted as genre. . . . Research draws original and non-intuitive connections often among disparate fields, while the focus of genre is more internal than external" (2006, 239). Art and technology labs do not of course have a monopoly on research or experimentation, but they can offer to curators working models of production that allow for deep research on new phenomena, understandings of complex systems, and the time and inclination necessary for cross-disciplinary work. If work is cross-disciplinary, then it is also often collaborative.

One of the most apt curatorial solutions described in this book is one copied from artists—that of collaborative teamwork, the sharing of expertise and skills. As described in the second half of the book, a number of curators (and artists) may together work in "modular" or more tightly collaborative groupings. Even within conservative institutions, small teams of curators have successfully worked across departments on exhibitions such as *010101*. Using hybrid approaches, a team made up of embedded, adjunct and independent curators worked on *Database Imaginary*.

Farther outside the traditional organizational landscape of curating, artist-led practices facilitated by new media, including that of "self-institutionalization," suggest new modes for curators. Attempts at open systems of curating are becoming increasingly prevalent, both in the field of new media art and in contemporary art in general. The seemingly "no curator" mode of the NODE.London season appears as a flashpoint for this development, but actually is far more curatorially minded compared to the trendy goal of devolving curatorial gatekeeping to allowing all participants—curators, artists, and audiences—to be involved in selection, production, and presentation.

Audience—Last But Not Least?

The viewer—poor creature . . .
—Vuk Ćosić, in Régine Debatty, "Interview of Vuk Ćosić," 2006b

The viewers of new media art, poor creatures, find themselves at the center of a flux: first, they are redefined as users, participants, producers, and even curators; then they find themselves wondering what it is and how much of their time to invest; and finally, their very existence is questioned. Whether contemporary art curators can see the new media art audience at all, especially if the audience is online or is a participant, is a big question (see chapter 7). When online audience figures for new media art are examined, they risk being compared with audience figures for educational Web sites or for mass media such as YouTube rather than being compared with audience figures for other art.

Definitions of audience are absolutely crucial to what is new about new media art and what is different about its behaviors (this issue is addressed in every chapter of this book, from the question of the death of the author in chapter 2 to the audience as curator in

chapter 10). A contemporary art curator might fail to recognize viewers of new media art *as* an audience for the following reasons: they are a science audience; they are producers; they are in a lounge not a gallery; they are participants; they are a performer or activist; they are at an event, not an exhibition; they are at a festival, in a public space receiving broadcasts, or in a lab; or they are in a collaborative team.

New media art fundamentally disrupts a curator's and an audience member's understanding of the stages of production, distribution, and consumption of a work of art. Much of the valuable working knowledge of the behavior of new media artworks comes from interpretation, and much of the knowledge of audience behavior comes from design disciplines of one kind or another. With new media art, artists have opened up opportunities for the audience to be participants—as curator, documentor, tagger, and collector. As such, the modes used by curators in rethinking their roles in relation to this challenge must involve being able to work collaboratively, across the boundaries of disciplines, including the highly hierarchical boundaries between art and design.

The Task at Hand—Translation

The curatorial process of most of my colleagues still seems to radically differ from mine . . . when I follow models that are common practice in new media curation (particularly networked and distributed practice). Needless to say that can make it difficult to work with each other because there is a lot of "translation" required on both ends and you need to be committed and enthusiastic about the art to have a basis for collaboration.
—Christiane Paul, in Beryl Graham, "Edits from a CRUMB Discussion List Theme," 2006

The branching issues within the field of curating new media art intersect on the questions of behaviors, systems, audiences, and modes of practice. But other fields often use different vocabularies drawn from different histories for discussing these questions. Despite the convergence of common themes, there is sometimes still a danger that new media art is categorized as "not art" or that only the kind of new media art that looks most like more familiar art gets considered. As Christiane Paul points out, there is still an obvious need for "translation" between contemporary art and new media art, certainly in respect to aspects of new media art's behavior and medium. For instance, computer code—which can be unfamiliar to a curator—is certainly a set of other languages, but by using the vocabularies of systems, networks, or protocols that are expressive of how computers work, these behaviors might be more understandable to curators who are not coders. Some types of software illustrated in this book, such as Kurator or digitalcraft.org's virus log, are tools designed specifically to help curators and audiences identify certain patterns within software languages—providing a handy phrase book, as it were, rather than demanding that they learn a whole new language. In a similar way, the language of political participation, from tokenism to empowerment, can be mapped onto vocabularies of art interaction.

These translation exercises are crucial to the further development of the practice of curating new media art, especially if the delicate process of collaboration needs to take place. With enthusiasm for the art itself and commitment, steps are being made toward offering useful translations between working knowledge bases. For example, Sarah Cook's diagram maps Steve Dietz's notions of interactivity, connectivity, and computability onto art's characteristics of being collaborative, distributed, and variable (see chapter 1). A recurring metaphor for translating networks or systems and for defining the power relations between parts of these networks is "dialogue" or "conversation." Is there space for argument, or is the conversation one-sided? Are some nodes in the network equal, or are some more equal than others? Who is collaborating, connecting, interacting, conversing with what or whom? Likewise, arts agencies might translate "location" into "locative," and broadcasters might distinguish the phone-in voting system from the user-generated content. Not every individual will speak every language—hence the need for collaborative multilingual teams who can translate from immateriality to distributed networks. This requirement demands from contemporary art curators that they look beyond the traditional art hierarchy into the fields of technology, design, and popular culture. It also demands that they take collaborative practices seriously and understand them from the inside; collaboration is not for everyone, but this book offers a range of collaborative modes, from modular exhibitions to flat collaborations. The most challenging mode of all for art curators is where the audience-users-participants are part of the network by acting as authors or selectors and by helping to define the curating and the vocabularies themselves. In using such common-language critical vocabularies, curators can find their way around a field that is rather too fond of neologism.

There are reasons to be cheerful about the translations between contemporary art and new media art, particularly around a shared understanding of systems. Artist Jeanne van Heeswijk, for example, has worked for many years on systems-based and often socially engaged collaborative projects, using any media from games to furniture. In *Works 1993–2004, Typologies and Capacities* (2004), she worked with programmer Maurits de Bruijn to create a map of the relationships between the many different people involved in her projects. She chose to represent that map in three dimensions using the witty device of different varieties of potatoes joined with wires (you'll be interested to know that curators were Mentor variety, whereas social workers were Berber). According to the artist, "During the exhibition the work changed: under the influence of time, air and moisture the potatoes started to sprout, developing their own network" (in van Heeswijk, Lapp, and Lutz 2007, 401). Along these lines, we hope that this book offers the seeds from which new networks may sprout, rather than a ready-made dish or a fixed recipe for success.

In reflecting on the systems of new media art and how these systems can be translated, this book ends where it began: with the art. Our conclusion is that the only way to determine how best to curate—to produce, present, disseminate, distribute, know, explain, historicize—a work of art is to know its characteristics and its behaviors, rather

than imposing a theory on the art. The motivation for making the extra effort and commitment to cross the boundaries of vocabulary, discipline, department, and art form lies in the stimulation of the art itself. New media art refuses any kind of philosophical (or, indeed, practical) laziness, and it will always challenge the existing boundaries between disciplines. That's why we like it.

Notes

1. This quote is a statement made by the ICA and cited in Wellsby 2008. The debate concerning the inclusion of new media arts in contemporary art institutions was discussed extensively on the CRUMB list in November 2008 around the ICA decision and is also well explored in Lovink 2008.

2. See Burnham 1980, 206, and Usselmann 2003, 390. These issues are also discussed in chapter 5 on participatory systems.

Figure 11.5
Installation view of *Works (1993–2004), Typologies, and Capacities* by Jeanne van Heeswijk with Maurits de Bruijn, in the exhibition *Tätig Sein* at Neue Gesellschaft fur Bildende Kunst, Berlin, 2004. Courtesy of the artist.

References

After the first reference for the *New-Media-Curating Discussion List*, references are in a shortened form without the URL, http://www.jiscmail.ac.uk/lists/new-media-curating.html.

16 Beaver Group, in conversation with Tone Hansen and Trude Iversen. 2006. "Collective Interest." In Nina Möntmann, ed., *Art and Its Institutions: Current Conflicts, Critique, and Collaborations,* 180–187. London: Black Dog.

Alberro, Alexander, and Patricia Norvell. 2001. *Recording Conceptual Art.* Berkeley and Los Angeles: University of California Press.

Albert, Saul. 2007. E-mail to S. Cook. 2 June. Available by e-mail at sarah.e.cook@sunderland.ac.uk.

Albert, Saul. 2006a. *Bankrupcy in the Gift Economy: Learning from the Productive Failures of NODE.London.* Available at http://twenteenthcentury.com/saul/bankrupcy_in_the_gift_economy.xhtml.

Albert, Saul. 2006b. "Re: Some Personal Thoughts on NODE.London." *New-Media-Curating Discussion List,* 14 February. Available at http://www.jiscmail.ac.uk/lists/new-media-curating.html.

Albert, Saul. 2001. "Re: Theme of the Month: Curating Festivals." *New-Media-Curating Discussion List,* 26 September.

Albrethsen, Pernille. 2004. "Platform Formalism." *NU-E—FROM: The Nordic Art Review* (16 April). Available at http://www.nu-e.nu/nue.asp.

Alloway, Lawrence. 1996. "The Great Curatorial Dim-Out." In Bruce W. Ferguson, Reesa Greenberg, and Sandy Nairne, eds., *Thinking about Exhibitions,* 221–230. London: Routledge.

Altshuler, Bruce. 1994. *The Avant Garde in Exhibition: New Art in the 20th Century.* Berkeley and Los Angeles: University of California Press.

Altstatt, Rosanne. 2004. "How to Get a Local Audience to Take an Interest in International Media Art—A User's Guide." *Netzspannung.* Available at http://netzspannung.org/cat/servlet/CatServlet/$files/272658/altstatt_engl.pdf.

Anderson, Steve. 2006. "Aporias of the Digital Avant-Garde." *Intelligent Agent* 6 (2). Special issue, proceedings of the 2006 International Symposium on Electronic Art. Available at http://www.intelligentagent.com.

Anton, Saul. 2003. "I'll Make a Go." *New-Media-Curating Discussion List,* 8 May.

Arends, Bergit, and Davina Thackara. 2003. *Experiment: Conversations in Art and Science.* London: Wellcome Trust.

Arns, Inke. 2005. *Dispersed Moments of Concentration.* Available at http://www.hmkv.de/dyn/d.

Arns, Inke. 2004. "Read_me, run_me, execute_me: Software and Its Discontents, or: It's the Performativity of Code, Stupid." Available at http://www.runme.org/project/+executeme.

Arns, Inke, Diedrich Diederichsen, and Timothy Druckrey. 2007. "Media Art Undone." Panel presentation at the Transmediale.07 conference, Berlin, 3 February. Available at http://www.mikro.in-berlin.de/wiki/tiki-index.php?page=MAU.

Arnstein, Sherry R. 1969. "A Ladder of Citizen Participation." *Journal of the American Institute of Planners* 35 (4): 216–224. Available at http://lithgow-schmidt.dk/sherry-arnstein/ladder-of-citizen-participation.html.

"The Art, Technology, and Culture Colloquium of UC Berkeley's Center for New Media." Publicity material, 16 October. Available at http://atc.berkeley.edu/bio/Cory-Arcangel/.

Ascott, Roy. 1967. "Behaviourist Art and Cybernetic Vision ii." *Cybernetica* 9 (1): 247–264, and 10 (1): 25–26.

Atkinson, Karen. 1996. "Gathering Voices: Some Curatorial Perspectives." In Peter White, ed., *Naming a Practice: Curatorial Strategies for the Future,* 122–130. Banff, Canada: Banff Centre Press.

Baert, Renee. 1996. "Provisional Practices." In Peter White, ed., *Naming a Practice: Curatorial Strategies for the Future,* 116–121. Banff, Canada: Banff Centre Press.

Baran, Paul. 1964. *On Distributed Communications Memorandum RM-3420-PR.* Santa Monica, Calif.: RAND Corporation, August.

Bar-Joseph, Ittai. 2001. "Re: Baltic New Media Curating Seminar." *New-Media-Curating Discussion List,* 17 May.

Barker, Emma. 1999. *Contemporary Cultures of Display.* New Haven, Conn.: Yale University Press.

Bassett, Caroline. 1999. "The Sweet Hereafter? The Work of Artec." In Frank Boyd, Cathy Brickwood, Adreas Broekmann, Lisa Haskel, Eric Kluitenberg, and Marleen Stikker, eds., *New Media Culture in Europe,* 53–54. Amsterdam: Uitgeverij De Balie.

Batchen, Geoffrey, Rachel Greene, and Lev Manovich. 2002. "Voiceover." *Afterimage* (January–February). Available at http://findarticles.com/p/articles/mi_m2479/is_4_29/ai_82626348.

Baumgartel, Tilman. 2002. *[Net.art 2.0]: Neue Materialien zur Netzkunst / New Materials Towards Net Art.* Nürnberg: Institut für Moderne Kunst.

Baumgartel, Tilman. 1997. "Interview with Jodi." Nettime, Sun, 31 Aug 1997. Available at http://www.nettime.org/Lists-Archives/nettime-l-9708/msg00112.html.

Beech, David. 2006. "Institutionalisation for All." *Art Monthly* 294: 7–10.

Bell, S. C. D. 1991. "Participatory Art and Computers: Identifying, Analysing, and Composing the Characteristics of Works of Participatory Art That Use Computer Technology." Ph.D. diss., Loughborough University.

Bennett, Tony. 1995. *The Birth of the Museum: History, Theory, Politics.* London: Routledge.

Berry, Josephine. 2001. "The Thematics of Site Specific Art on the Net." Ph.D. diss., University of Manchester. Available at http://www.metamute.com/mfiles/mcontent/josie_thesis.htm.

Beuys, Joseph, and Dirk Schwarze. 2006. "Report on a Day's Proceedings at the Bureau for Direct Democracy // 1972." In Claire Bishop, ed., *Participation (Documents of Contemporary Art),* 120–124. Cambridge, Mass.: MIT Press.

Biemann, Ursula. 1998. "Re: <eyebeam><blast> Art and Media." E-mail to eyebeam@list.thing.net. Available at http://www.thing.net/eyebeam/msg00329.html.

Biggs, Simon. 2006. "Re: Some Personal Thoughts on NODE.London." *New-Media-Curating Discussion List,* 14 February.

Biggs, Simon. 2001a. "Subject: Re: <thingist> immaterial semiotics." *Thingist,* 4 June.

Biggs, Simon. 2001b. "Sites." *New-Media-Curating Discussion List,* 15 March.

Bird, Jon. 2000. "Minding the Body: Robert Morris's 1971 Tate Gallery Retrospective." In Peter Wollen, Michael Newman, and Jon Bird, eds., *Rewriting Conceptual Art,* 88–106. London: Reaktion Books.

Bishop, Claire, ed. 2006a. *Participation (Documents of Contemporary Art).* Cambridge, Mass.: MIT Press.

Bishop, Claire. 2006b. "The Social Turn: Collaboration and Its Discontents." *Artforum* (February): 178–183.

Bishop, Claire. 2004. "Antagonism and Relational Aesthetics." *October* 110 (Fall): 51–79. Available at http://www.mitpressjournals.org/doi/abs/10.1162/0162287042379810.

Blais, Joline, and Jon Ippolito. 2006. *At the Edge of Art.* London: Thames and Hudson.

Blank, Joachim. 1996. "What Is Netart;-)?" Presentation at the exhibition *(History of) Mailart in Eastern Europe* in the Staatliches Museum, Schwerin, Germany. Available at http://www.irational.org/cern/netart.txt.

Blaswick, Iwona. 2007. "Temple/White Cube/Laboratory." In Paula Marincola, ed., *What Makes a Great Exhibition?* 118–133. Chicago: University of Chicago Press.

Bolter, Jay David, and Diane Gromala. 2003. *Windows and Mirrors.* Cambridge, Mass.: MIT Press.

Bolter, Jay David, and Richard Grusin. 2000. *Remediation: Understanding New Media.* Cambridge, Mass.: MIT Press.

Bosma, Josephine. 2006. "Art as Experience: Meet the Active Audience." In Tom Corby, ed., *Network Art: Practices and Positions,* 24–39. London: Routledge.

Bosma, Josephine. 2002. "Curating Critically." *New-Media-Curating Discussion List,* 10 February.

Bosma, Josephine. 2000. "Interview with Steve Dietz." Nettime, 18 January. Available at http://www .nettime.org/Lists-Archives/nettime-l-0001/msg00092.html.

Bourriaud, Nicolas. 2002. *Relational Aesthetics*. English ed. Dijon: Les Presses du Réel.

Braun, Reinhard. 2005. "From Representation to Networks: Interplays of Visualities, Apparatuses, Discourses, Territories, and Bodies." In Annmarie Chandler and Norie Neumark, eds., *At a Distance: Precursors to Art and Activism on the Internet,* 72–87. Cambridge, Mass.: MIT Press.

Brickwood, Cathy, Bronac Ferran, David Garcia, and Tim Putnam, eds. 2007. *(Un)Common Ground: Creative Encounters across Sectors and Disciplines*. Amsterdam: BIS.

Broeckmann, Andreas. 2005. "Discussing 'Media Art.'" *New-Media-Curating Discussion List,* 16 April.

Broeckmann, Andreas. 2001. "Re: Software as Art." *New-Media-Curating Discussion List,* 4 July.

Bronson, AA, and Peggy Gale, eds. 1983. *Museums by Artists.* Toronto: Art Metropole.

Brucker-Cohen, Jonah. 2003. "Formal Research: Response." *New-Media-Curating Discussion List,* 3 July.

Bruno, Christophe. 2002. *The Google AdWords Happening.* Available at http://www.iterature.com/ adwords.

Buchmann, Sabeth. 2006. "From Systems-Oriented Art to Biopolitical Art Practice." In Marina Vish-midt with Mary Anne Francis, Jo Walsh, and Lewis Sykes, eds., *Media Mutandis: A NODE.London Reader: Surveying Art, Technologies, and Politics,* 51–60. London: NODE, Mute.

Buergel, Roger M., Anselm Franke, Maria Lind, and Nina Möntmann. 2006. "Curating with Institu-tional Visions (Roundtable Talk)." In Nina Möntmann, ed., *Art and Its Institutions: Current Conflicts, Critique, and Collaborations,* 28–59. London: Black Dog.

Burgess, Marilyn. n.d. "Support for New Media Arts in Canada: What Place for Artists?" *Sidestreet.* Available at http://www.sidestreet.org/sitestreet/burgess/burgess1.html. Site last visited 12 June 2000.

Burnett, Craig. 2005. "The Invisible Curator." *Art Monthly* 291 (November): 1–4.

Burnham, Jack. 1980. "Art and Technology: The Panacea That Failed." In Kathleen Woodward, ed., *The Myths of Information: Technology and Post-industrial Culture,* 205–215. Bloomington: Indiana Uni-versity Press.

Burnham, Jack. 1968a. *Beyond Modern Sculpture.* London: Penguin Press.

Burnham, Jack. 1968b. "Systems Esthetics." *Artforum* 7 (1) (September): 30–35.

Burnham, Judith, ed. 1970. *Software, Information Technology: Its New Meaning for Art.* New York: The Jewish Museum.

Byrne, Chris. 2002. "Re: February's Topic: Artist/Critic/Curator." *New-Media-Curating Discussion List,* 5 February.

Byrne, Chris. 2001. "Re: Baltic New Media Curating Seminar." *New-Media-Curating Discussion List,* 18 May.

Caldwell, John, and Anna Everett, eds. 2003. *New Media: Practices of Digitextuality.* New York: Routledge.

Carbonell, Bettina Messias, ed. 2003. *Museum Studies: An Anthology of Contexts.* Oxford, U.K.: Blackwell.

Carpenter, Ele. 2008. "Politicized Socially Engaged Art and New Media Art." Ph.D. diss., University of Sunderland.

Carpenter, Ele. 2004a. "Gregory Sholette and Nato Thompson." Available at the CRUMB Web site, http://www.crumbweb.org/getInterviewDetail.php?id=26.

Carpenter, Ele. 2004b. "Re: Curating a Symposium." *New-Media-Curating Discussion List,* 9 June.

Catlow, Ruth. 2007. "Do It with Others (DIWO) E-mail-Art at HTTP Gallery." *New-Media-Curating Discussion List,* 4 March.

Catlow, Ruth. 2006. Unpublished interview with Sarah Cook. 30 March. Notes by Sarah Cook.

Century, Michael. 1999a. "Cultural Laboratories." In Frank Boyd, Cathy Brickwood, Andreas Broekmann, Lisa Haskel, Eric Kluitenberg, and Marleen Stikker, eds., *New Media Culture in Europe,* 20–23. Amsterdam: Uitgeverij De Balie.

Century, Michael. 1999b. *Pathways to Innovation in Digital Culture.* Report for the Centre for Research on Canadian Cultural Industries and Institutions, Next Century Consultants. New York: Rockefeller Foundation. Available at http://www.rockfound.org/display.asp?context=3&SectionTypeID =16&DocID=528.

Chandler, Annmarie, and Norie Neumark, eds. 2005. *At a Distance: Precursors to Art and Activism on the Internet.* Cambridge, Mass.: MIT Press.

Claxton, Ruth. 2005. "Trading Places." In John Beagles and Paul Stone, eds., *Shifting Practice: a-n Collections July 2005,* 4–7. London: a-n. Available at http://www.a.-n.cvo.uk/publications/article/ 235993.

Coleman, A. D. 1994. "Letter from New York." *Photo Metro* (January): 28–29.

Coles, A., and A. Defert, eds. 1998. *The Anxiety of Interdisciplinarity.* De-, dis-, ex-. Interdisciplinarity: Art|Architecture|Theory series, vol. 2. London: BACKless Books and Black Dog.

Connor, Michael. 2003. "Re: Curatorial Models: What Good Are They?" *New-Media-Curating Discussion List,* 17 March.

CONT3XT.NET. 2007. "Introduction: Extended Curatorial Practices on the Internet." In CONT3XT. NET, eds., *Circulating Contexts: Curating Media/Net/Art,* 6–19. Norderstedt, Germany: Books on Demand GmbH.

Cook, Sarah. 2008. "Immateriality and Its Discontents." In Christiane Paul, ed., *New Media in the White Cube and Beyond: Curatorial Models for Digital Art,* 26–49. Berkeley and Los Angeles: University of California Press.

Cook, Sarah. 2007. "An Interview with Régine Debatty." Available at the CRUMB Web site, http:// www.crumbweb.org/getInterviewDetail.php?id=28.

Cook, Sarah. 2006a. "The Art of Re-enactment: Curating Real-Time Presence." In Joan Gibbons and Kaye Winwood, eds., *Hothaus Papers: Perspectives and Paradigms in Media Arts,* 193–200. Fremantle, Australia: VIVID/Article Press.

Cook, Sarah. 2006b. Notes from a panel presentation/discussion at "Art-Place-Technology: International Symposium on Curating New Media Art," 30 March–1 April, Liverpool School of Art & Design and FACT Centre.

Cook, Sarah. 2004a. "Re: Curating a Symposium." *New-Media-Curating Discussion List,* 8 June.

Cook, Sarah. 2004b. "The Search for a Third Way of Curating New Media Art: Balancing Content and Context in and out of the Institution." Ph.D. diss., University of Sunderland.

Cook, Sarah. 2001a. "Ars Electronica Festival—Prize Debate." Reposting Peter von Brandenberg and Joy Garnett. *New-Media-Curating Discussion List,* 3 September.

Cook, Sarah. 2001b. "A Conversation Between Kathy Rae Huffman and Julie Lazar." Available at the CRUMB Web site, http://www.crumbweb.org/getInterviewDetail.php?id=2.

Cook, Sarah. 2001c. "An Interview with Christiane Paul." Available at the CRUMB Web site, http://www.crumbweb.org/getInterviewDetail.php?id=10.

Cook, Sarah. 2001d. "An Interview with Matthew Gansallo." Available at the CRUMB Web site, http://www.crumbweb.org/getInterviewDetail.php?id=1.

Cook, Sarah. 2001e. "Multi-multi-media: An Interview with Barbara London." Available at the CRUMB Web site, http://www.crumbweb.org/getInterviewDetail.php?id=12.

Cook, Sarah, and Beryl Graham. 2004. "Curating New Media Art: Models and Challenges." In Lucy Kimbell, ed., *New Media Art: Practice and Context in the UK 1994–2004,* 84–91. London: Arts Council of England.

Cook, Sarah, Beryl Graham, and Sarah Martin, eds. 2002. *Curating New Media.* Transcript of the CRUMB seminar "Curating New Media," 10–12 May 2001. B.Read/Six. Gateshead, U.K.: BALTIC.

Cooke, Lynne. 2007. "In Lieu of Higher Ground." In Paula Marincola, ed., *What Makes a Great Exhibition?* 32–43. Chicago: University of Chicago Press

Corby, Tom. 2004. "Re: Art." *New-Media-Curating Discussion List,* 13 September.

Cornock, Stroud. 1977. "Art and Interaction." Unpublished manuscript, Leicester Polytechnic.

Cornock, Stroud, and Ernest Edmonds. 1973. "The Creative Process Where the Artist Is Amplified or Superseded by the Computer." *Leonardo* 6 (11): 11–15.

Cornwell, Peter, Juergen Enge, and Hartmut Joerg. 2003. *Implementing Conservation-Quality Digital Media Systems and Distributed Archives.* International Conference on Hypermedia and Interactivity in Museums (ICHIM), Paris. Available at http://www.ichim.org/ichim03/PDF/128C.pdf.

Cornwell, Regina. 1996. "Artists and Interactivity: Fun or Funambulist?" In Carol Brown and Beryl Graham, eds., *Serious Games,* 10–16. London: Barbican Art Gallery and Tyne and Wear Museums. Also available at http://www.crumbweb.org/serious/rcessay.htm.

Cornwell, Regina. 1992. "Interactive Art: Touching the 'Body in the Mind.'" *Discourse* 14 (2) (Spring): 203–221.

Ćosić, Vuk. 2001a. "Curating New Media Art: Welcome and Introductions." Presentation at the seminar "Curating New Media," 10–12 May, Gateshead, U.K. Available at http://www.crumbweb .org/getPresentation.php?presID=1&semID=1&id=1&op=4&ts=1240224343&sublink=8.

Ćosić, Vuk, ed. 2001b. *Net.art per me.* Ljubljana, Slovenia: MGLC. Available at http://absoluteone .ljudmila.org.

Cox, Geoff, Joasia Krysa, and Anya Lewin, eds. 2004. *Economising Culture.* Data Browser 01. London: Autonomedia.

Crimp, Douglas. 1993. *On the Museum's Ruins.* Cambridge, Mass.: MIT Press.

Cubitt, Sean. 2005. "From Internationalism to Transnations: Networked Art and Activism." In Annmarie Chandler and Norie Neumark, eds., *At a Distance: Precursors to Art and Activism on the Internet,* 424–437. Cambridge, Mass.: MIT Press.

Cullen, Tom. 2009. *CRUMB Technical Guide for Exhibiting New Media Art.* 1st ed. Sunderland, U.K.: CRUMB, University of Sunderland. Available at http://www.crumbweb.org.

CRUMB. 2008. "CRUMB biography." Sunderland, U.K.: CRUMB, University of Sunderland. Available at http://www.crumbweb.org/getBiosContacts.php?id=4&sublink=3.

Czegledy, Nina. 2002. "Trickster: The Myth and Mischief Maker." In Catherine Thomas, ed., *The Edge of Everything: Reflections on Curatorial Practice (Naming a Practice),* 109–119. Banff, Canada: Banff Centre Press.

Darke, Chris. 2003. "Tall Ships (Slight Return): Gary Hill: *Tall Ships.*" In Claire Doherty, ed., *FACTOR 1993,* unpaginated. Liverpool: Foundation for Art and Creative Technology (FACT).

DEAF07. 2007. *DEAF07 "Interact or Die" Seminar Reader.* Available at http://www.deaf07.nl/index .php?option=com_content&id=49&task=view&Itemid=7.

Debatty, Régine. 2006a. "Interview of Adam Somlai-Fischer." 28 August. Available at the *we make money not art* Web site, http://www.we-make-money-not-art.com/archives/008893.php.

Debatty, Régine. 2006b. "Interview of Vuk Ćosić." 17 February. Available at the *we make money not art* Web site, http://www.we-make-money-not-art.com/archives/008056.php.

Delgado, Denise. 2001. "Re: April Theme of the Month—the Poetics of Art Activism." *New-Media-Curating Discussion List,* 23 April.

Depocas, Alain, Jon Ippolito, and Caitlin Jones, eds. 2003. *Permanence Through Change: The Variable Media Approach.* New York: Guggenheim Museum. Also available at http://www.variablemedia.net/ e/preserving/html/var_pub_index.html.

Dernie, David. 2006. *Exhibition Design.* London: Laurence King.

Deshpande, Suhas, Kati Geber, and Corey Timpson. 2007. "Engaged Dialogism in Virtual Space: An Exploration of Research Strategies for Virtual Museums." In Fiona Cameron and Sarah Kenderdine, eds., *Theorizing Digital Cultural Heritage: A Critical Discourse,* 261–279. Cambridge, Mass.: MIT Press.

Dewdney, Andrew, and Peter Ride. 2006. *The New Media Handbook*. Abingdon, U.K.: Routledge.

Diamond, Sara. 2008. "Participation, Flow, and the Redistribution of Authorship: The Challenges of Collaborative Exchange and New Media Curatorial Practice." In Christiane Paul, ed., *New Media in the White Cube and Beyond: Curatorial Models for Digital Art,* 135–162. Berkeley and Los Angeles: University of California Press.

Diamond, Sara. 2004a. "Aesthetics of Collaboration Panel." Paper presented at the International Symposium on Electronic Art 2004, 17 August, Tallinn, Estonia.

Diamond, Sara, chair. 2004b. "Introduction, 1st October" at the summit "Participate/Collaborate: Reciprocity, Design, and Social Networks," 30 September–3 October, Banff Centre for the Arts, Banff New Media Institute, Banff, Canada.

Diamond, Sara. 2003. "Silicon to Carbon." In Melanie Townsend, ed., *Beyond the Box: Diverging Curatorial Practices,* 141–168. Banff, Canda: Banff Centre Press.

Diamond, Sara. 2002. *Bridges Consortium II—New Media Symposium: Searching for New Metaphors, New Practices*. Banff, Canada: Banff New Media Institute, 4–6 October. Available at http://www.banffcentre.ca/bnmi/bridges.

Diamond, Sara. 2001. Presentation at the forum "Momentum," 19–21 April, Watershed Media Centre, Bristol. Notes by Sarah Cook.

Diamond, Sara. 2000. Panel discussion at the conference "Sins of Change: Media Arts in Transition," 6–8 April, Walker Art Center, Minneapolis. Transcription by Sarah Cook.

Diaz, Eva, ed. 2007. "Futures: Experiment and the Tests of Tomorrow." In Paul O'Neill, ed., *Curating Subjects,* 92–99. Amsterdam and London: De Appel and Open Editions.

Dietz, Steve. 2005. "Collecting New Media Art: Just Like Anything Else, Only Different." In Bruce Altshuler, ed., *Collecting the New: Museums and Contemporary Art,* 85–101. Princeton, N.J.: Princeton University Press. Also available at http://www.yproductions.com/writing/archives/000764.html.

Dietz, Steve. 2004a. "Was It All Robert Morris's Fault?" *Yproductions: WebWalkAbout* (19 December). Available at http://www.yproductions.com/WebWalkAbout/archives/000612.html.

Dietz, Steve. 2004b. "British New Media Art" *Yproductions* (3 April). Available at http://www.yproductions.com/writing/archives/british_new_media_art.html.

Dietz, Steve. 2003. "Interfacing the Digital." Paper presented at the conference Museums and the Web 2003, 19–22 March, Charlotte, N.C. Available at http://www.archimuse.com/mw2003/papers/dietz/dietz.html.

Dietz, Steve. 2002a. "Re: Curating Critically." *New-Media-Curating Discussion,* 12 February.

Dietz, Steve. 2002b. "Re: Curating Critically." *New-Media-Curating Discussion,* 13 February.

Dietz, Steve. 2000a. "Curating New Media." *Yproductions* 25 August. Available at http://www.yproductions.com/writing/archives/curating_new_media>html.

Dietz, Steve. 2000b. "Signal or Noise? The Network Museum." *Webwalker* no. 20, Art Entertainment Network. Available at http://www.walkerart.org/gallery9/webwalker/ww_032300_main.html.

Dietz, Steve. 1999. "Why Have There Been No Great Net Artists?" Paper presented in the "Critical Texts" portion of the exhibition *Through the Looking Glass,* 15–30 April. Available at http://www .voyd.com/ttlg/textual/dietz.htm.

Dietz, Steve. 1998. *Beyond Interface: Net Art and Art on the Net.* Minneapolis: Walker Art Center. Available at http://www.archimuse.com/mw98/beyondinterface/dietz_pencilmedia.html.

Dietz, Steve. 1996. "What Becomes a Museum Web?" *Yproductions* (28 October). Available at http:// www.yproductions.com/writing/archives/what_becomes_a_museum_web.html.

Dietz, Steve, and Scott Sayre, guest eds. 2000. *Spectra (USA)* 27 (1, special issue) "The Millennial Museum." Available at the Museum Computer Network, http://www.artsconnected.org/ millennialmuseum.

Dimantas, Hernani. 2004. "Democratic Systems for Collaboration: Public Projects, Building an Open Source Culture, Private Space and Access." Panel discussion at the summit "Participate/Collaborate: Reciprocity, Design and Social Networks," 30 September–3 October, Banff Centre for the Arts, Banff New Media Institute, Banff, Canada.

Dipple, Kelli. 2007. "Some Perspectives on the Chapter." E-mail to B. Graham, 19 June. Available by e-mail at beryl.graham@sunderland.ac.uk.

Doherty, Claire, ed. 2003. *FACTOR 2000.* Liverpool: Foundation for Art and Creative Technology (FACT).

Drabble, Barnaby. 2005. Presentation at the seminar "Curating: Can Be Learned, but Can It Be Taught?" 19 May, Northern Gallery for Contemporary Art, Sunderland, U.K.

Drabble, Barnaby. 2003. "Fw: March Theme." *New-Media-Curating Discussion List,* 25 March.

Druckrey, Timothy, with Ars Electronica, eds. 1999. *Ars Electronica: Facing the Future.* Cambridge, Mass.: MIT Press.

Drutt, Matthew. 1999. *Guggenheim Museum—Virtual Museum.* Available at http://www.guggenheim .org/exhibitions/virtual/virtual_museum.html.

Dunn, Alan. 2003. "*Tenantspin*—Simple Complexity." In Emma Posey, ed., *Remote: Creativity, Technology, and Remoteness,* 54–60. Gladestry: Bloc Press.

Eastman, Dale. 2002. "The David Ross Affair." *San Francisco* (January): 34–45.

Ebner, Jorn. 2004 . "Locative." *New-Media-Curating Discussion List,* 7 April.

Esche, Charles. 1996. "Video Installation, Conceptual Practice, and New Media in the 1990s." In Julia Knight, ed., *Diverse Practices: A Critical Reader on British Video Art,* 195–206. London: Arts Council of England, John Libbey.

Eyers, Luci (for the low-fi group). 2007. "Re: Is There an Audience for New Media Art?" E-mail to B. Graham, 20 April. Available by e-mail at beryl.graham@sunderland.ac.uk.

Eyers, Luci. 2006a. "Re: Some Personal Thoughts on NODE.London." *New-Media-Curating Discussion List,* 14 February.

Eyers, Luci. 2006b. Unpublished interview with Sarah Cook. Notes by Sarah Cook.

Fahy, Ann. 1999. "New Technologies for Museum Communication." In Eilean Hooper-Greenhill, ed., *Museum, Media, Message,* 82–96. London: Routledge.

Fauconnier, Sandra. 2005. "Re: Let It Go." *New-Media-Curating Discussion List,* 21 February.

Ferguson, Bruce W., Reesa Greenberg, and Sandy Nairne, eds. 1996. *Thinking about Exhibitions.* London: Routledge.

Ferrera-Balanquet, Raul. 2002. *Curating New Media Art in a Latin American Context.* Available at http://www.artsmanagement.net.

Finkel, Jori. 2005. "Pardon Me, but the Art Is Mouthing Off." *New York Times,* 27 November. Available at http://www.nytimes.com/2005/11/27/arts/design/27fink.html?.

Finkelpearl, Tom. 2000. *Dialogues in Public Art.* Cambridge, Mass.: MIT Press.

Fleischmann, Monika. 2003. "How Gate-Keeping Systems Work in the New Media Arts." In *Culture Gates: Exposing Professional Gatekeeping Processes in Music and New Media Arts,* 361–395. Bonn: ERICArts.

Fletcher, Harrell. 2004. *Digital Happy Hour.* New York: The Kitchen.

Flouty, Rosanna. 2001. "Re: Big Media Art: March Theme of the Month." *New-Media-Curating Discussion List,* 28 March.

Forde, Kathleen. 2002. "Sound Art: March Theme of the Month." *New-Media-Curating Discussion List,* 18 March.

Foster, Hal. 2006. "Chat Rooms // 2004." In Claire Bishop, ed., *Participation (Documents of Contemporary Art),* 190–195. Cambridge, Mass.: MIT Press.

Fragnito, Skawennati Tricia. 2003. "Curational Models." *New-Media-Curating Discussion List,* 25 March.

Fragnito, Skawennati Tricia. 2002. "New Media Courses." *New-Media-Curating Discussion List,* 6 November.

Fragnito, Skawennati Tricia. 2001. "Distribution: A Curator Discusses Distribution and Participation Projects Including CyberPowWow." Paper presented at the conference "Curating New Media Art / La mise en espace des arts mediatiques," 2 December, Ottawa Art Gallery, Ottawa, Canada. Available at http://crumbweb.org/getPresentation.php?presID=17.

Francis, Mary Anne. 2006. "Open Source Fine Art: Infinities of Meaning for an Age of Finite Means." In Marina Vishmidt with Mary Anne Francis, Jo Walsh, and Lewis Sykes, eds., *Media Mutandis: A NODE.London Reader: Surveying Art, Technologies, and Politics,* 197–205. London: NODE, Mute.

Franklin, Dave. 2001. "Re: Software as Art: Jul/Aug 'Theme of the Month." *New-Media-Curating Discussion List,* 3 July.

Friedman, Ken. 1971. *The Distance From This Sentence To Your Eye Is My Sculpture.* VII Paris Biennale.

Friedman, Thomas. 2006. *The World Is Flat: The Globalized World in the Twenty-First Century.* London: Penguin Books.

Frieling, Rudolf. 2008. "Toward Participation in Art." In Rudolf Frieling, ed., *The Art of Participation,* 32–49. San Francisco: San Francisco Museum of Modern Art, Thames and Hudson.

Frieling, Rudolf, 2004. "Form Follows Format: Tensions, Museums, Media Technology, and Media Art." Available at the Media Art Net Web site, http://www.medienkunstnetz.de/themes/overview _of_media_art/museum/1.

Frieling, Rudolf, and Dieter Daniels, eds. 2000. *Media Art Interaction: The 1980s and 1990s in Germany.* Vienna: Springer.

Frieling, Rudolf, and Dieter Daniels, eds. 1997. *Media Art Action: The 1960s and 1970s in Germany.* Vienna: Springer.

Frohne, Ursula. 2005. "The Artwork as Temporal Form." In Ursula Frohne, Mona Schieren, and Jean-Francois Guiton, eds., *Present Continuous Past(s): Media Art: Strategies of Presentation, Mediation, and Dissemination,* 25–35. Vienna: Springer.

Frohne, Ursula. 1999. "Old Art and New Media: The Contemporary Museum." *Afterimage* (September–October): 9–11.

Frohne, Ursula, Mona Schieren, and Jean-Francois Guiton, eds. 2005. *Present Continuous Past(s): Media Art: Strategies of Presentation, Mediation, and Dissemination.* Vienna: Springer.

Fuller, Matthew. 2005. "Fractures / History / Cheang, Plus Cut and Pasted Conceptualism." *New-Media-Curating Discussion List,* 10 October.

Fuller, Matthew. 2000a. "Art Meet Net, Net Meet Art." Available at the Tate Web site, http://www .tate.org.uk/intermediaart/entry15618.shtm.

Fuller, Matthew. 2000b. "Breach the Pieces." Available at the Tate Web site, http://www.tate.org.uk/ intermediaart/entry15470.shtm.

Fuller, Matthew. 1998. "A Means of Mutation." Available at http://bak.spc.org/iod/mutation.html.

Fuller, Matthew. 1994. Presentation at the Institute of Contemporary Arts "Terminal Futures" conference, October, London.

Gablik, Suzy. 1995. "Connective Aesthetics: Art after Individualism." In Suzanne Lacy, ed., *Mapping the Terrain: New Genre Public Art,* 74–87. Seattle: Bay Press.

Gagnon, Jean. 2002. "Re: Curating Critically." *New-Media-Curating Discussion List,* 21 February.

Galloway, Alexander R. 2006. "Charlie Puts NMA's Down." *Rhizome Digest,* 8 September. Available at digest@rhizome.org.

Galloway, Alexander R. 2004. *Protocol: How Control Exists after Decentralization.* Cambridge, Mass.: MIT Press.

Galloway, Alexander R., and Radical Software Group (RSG). 2002. "How We Made Our Own 'Carnivore.'" Available at the Ars Electronica Archive Web site, http://www.aec.at/en/archives/festival _archive/festival_catalogs/festival_artikel.asp?iProjectID=11800.

Galloway, Alexander R., and Eugene Thacker. 2007. *The Exploit: A Theory of Networks*. Minneapolis: University of Minnesota Press.

Gammon, Ben. 1999. "Everything We Currently Know about Making Visitor-Friendly Mechanical Interactives, or 28 Painful Lessons Learnt." Available at the British Interactive Group Web site, http://www.big.uk.com/knowledgebase/exhibits/mech_interactives_v1.htm.

Garrett, Marc. 2006a. "Charlie Puts NMA's Down." *Rhizome Digest,* 18 August. Available at digest@rhizome.org.

Garrett, Marc. 2006b. Unpublished interview with Sarah Cook. 29 March. Notes by Sarah Cook.

Garrett, Marc. 2004. "Curatorial: Cultural Tagging." *New-Media-Curating Discussion List,* 9 June.

Gaskin, Vivian. 2004. "Space and Time: Live." Paper presented at the CRUMB seminar "Curating in Space and Time," 7 September. Northern Gallery for Contemporary Art, Sunderland, U.K. Available at http://crumbweb.org/getPresentation.php?presID=32.

Gaver, Bill [William]. 2006. "Probes and Commentators: Placing Interpretation at the Heart of Design." In Ernest Edmonds, Lizzie Muller, and Deborah Turnbull, eds., *ENGAGE: Interaction, Art, and Audience Experience. CCS/ACID Symposium,* 8–9. Sydney: Creativity and Cognition Studios Press, University of Technology.

Gaver, William, Ben Hooker, and Anthony Dunne. 2001. *The Presence Project.* London: Royal College of Art.

Gere, Charlie. 2006a. *Art, Time, and Technology*. London: Berg.

Gere, Charlie. 2006b. "The History of Networked Art." In Tom Corby, ed., *Network Art: Practices and Positions,* 11–23. London: Routledge.

Gere, Charlie. 2006c. Keynote address at the conference "Art-Place-Technology: International Symposium on Curating New Media Art," 30 March–1 April, Liverpool School of Art & Design and Foundation for Art and Creative Technology (FACT) Centre.

Gere, Charlie. 2004. "New Media Art and the Gallery in the Digital Age." *Tate Papers*, Autumn. London: Tate. Available at http://www.tate.org.uk/research/tateresearch/tatepapers/04autumn/gere.htm.

Gere, Charlie. 2002. *Digital Culture.* London: Reaktion Books.

Gillick, Liam, and Maria Lind, eds. 2005. *Curating with Light Luggage.* Frankfurt: Revolver, Kunstverein Munchen.

Gillman, Clive. 2001. Presentation at the "I'll Show You Mine If You Show Me Yours" workshop on new media spaces, 13 October, the Media Centre, Huddersfield, U.K. Available at http://www.crumbweb.org/getPresentation.php?presID=8.

Gladwell, Malcolm. 2007. "Chris Anderson." *The People Who Shape Our World—The TIME 100,* special issue of *Time* magazine. Available at http://www.time.com/time/specials/2007/time100/article/0,28804,1595326_1595329_1616107,00.html.

Goebel, Johannes. 2006. "Re: Self-emulation—from Jon Ippolito." *New-Media-Curating Discussion List,* 16 September.

Goebel, Johannes. 2004. "Re: Definitions." *New-Media-Curating Discussion List,* 5 September.

Goldstein, Barbara, moderator. 2006a. "City of San Jose Public Art: Matt Gorbet, Susan Gorbet, Banny Banerjee, Ben Rubin." Panel presentation at the International Symposium on Electronic Art (ISEA06), 10 August, San Jose. Notes by Beryl Graham.

Goldstein, Barbara. 2006b. "Re: Permanence and Public Art—Recap and Then . . ." *New-Media-Curating Discussion List,* 21 July.

Goodman, Lizbeth, and Katherine Milton, eds. 2004. *A Guide to Good Practice in Collaborative Working Methods and New Media Tools Creation (by and for Artists and the Cultural Sector).* Arts and Humanities Data Service (AHDS) Guides to Good Practice. London: AHDS. Available at http://ahds.ac.uk/creating/guides/new-media-tools/index.htm.

Gorbet, Matt. 2006. "Re: Permanence and Public Art." *New-Media-Curating Discussion List,* 12 July.

Graham, Beryl. Forthcoming a. "Audience Research: What Curators of New Media Art Should Know." To be available at the CRUMB Web site, http://www.crumbweb.org/.

Graham, Beryl. Forthcoming b. "What Kind of Participative System? Critical Vocabularies from New Media Art." In Anna Dezeuze, ed., *The Do-it-Yourself Artwork: Spectator Participation in Contemporary Art* [working title]. Manchester, U.K.: Manchester University Press.

Graham, Beryl. 2009. "The Ironic Heirs of Serendipity: British New Media Art 1960s to Now." In Paul Brown, Charlie Gere, Nick Lambert, and Catherine Mason, eds., *White Heat and Cold Logic: British Computer Arts 1960–1980,* 401–420. Cambridge, Mass.: MIT Press.

Graham, Beryl. 2008. "Serious Games—Case Study." In Christiane Paul, ed., *New Media in the White Cube and Beyond: Curatorial Models for Digital Art,* 191–206. Berkeley and Los Angeles: University of California Press.

Graham, Beryl. 2007a. "Interaction/Participation: Disembodied Performance in New Media Art." In Jonathan Harris, ed., *Dead History, Live Art? Spectacle, Subjectivity, and Subversion in Visual Culture since the 1960s,* 241–263. Tate Liverpool Critical Forum, vol. 9. Liverpool: Liverpool University Press and Tate Liverpool.

Graham, Beryl. 2007b. "Redefining Digital Art: Disrupting Borders." In Fiona Cameron and Sarah Kenderdine, eds., *Theorizing Digital Cultural Heritage: A Critical Discourse,* 93–112. Cambridge, Mass.: MIT Press.

Graham, Beryl. 2007c. *Openness and Collaboration: Fortune Telling Game Fortunes.* Available at http://www.sunderland.ac.uk/~as0bgr/coot/cambridge.htm.

Graham, Beryl. 2006. "Edits from a CRUMB Discussion List Theme." In Joasia Krysa, ed., *Curating Immateriality: The Work of the Curator in the Age of Network Systems,* 209–220. Data Browser 03. London: Autonomedia.

Graham, Beryl. 2004a. "February Theme of the Month: Formal Research 2." *New-Media-Curating Discussion List,* 9 February.

Graham, Beryl. 2004b. "A Dialogue with an Idiot? Some Interactive Computer-Based Art." In Finn Bostad, Craig Brandist, Lars Sigfred Evensen, and Hege Charlotte Faber, eds., *Bakhtinian Perspectives on Language and Culture: Meaning in Language, Art, and New Media,* 217–232. London: Macmillan.

Graham, Beryl. 2004c. "An Interview with Liane Davison." Available at the CRUMB Web site, http://www.crumbweb.org/getInterviewDetail.php?id=24.

Graham, Beryl. 2004d. "Research Report: An MA in Curating New Media Art?" Unpublished consultancy report for Arts Council England (ACE, North West), Liverpool.

Graham, Beryl. 2004e. *A Table of Categories of Digital Art*. Available at http://www.crumbweb.org/crumb/phase3/append/taxontab.htm.

Graham, Beryl. 2003a. *Critical Commentaries: Clean Rooms, Polaria, and Gastarbyter*. Play Garden. London: Arts Council of England. Available at http://www.newaudiences.org.uk/playgarden/projects/cleanrooms/essay3.htm.

Graham, Beryl. 2003b. "Subject: Curatorial Models: March Theme." *New-Media-Curating Discussion List,* 31 March.

Graham, Beryl. 2002a. *Curating New Media Art: SFMOMA and 010101*. Available at the CRUMB Web site, http://www.crumbweb.org/getCRUMBReports.php?&sublink=2.

Graham, Beryl. 2002b. "An Interview with Benjamin Weil." Available at the CRUMB Web site, http://www.crumbweb.org/getInterviewDetail.php?id=13.

Graham, Beryl. 2001a. "'New Media,' 'Community Art,' and Net.art Activism: Interviews with Natalie Bookchin and Brendan Jackson." Available at the CRUMB Web site, http://www.crumbweb.org/getInterviewDetail.php?id=3.

Graham, Beryl. 2001b. "Re: Big Media Art: March Theme of the Month." *New-Media-Curating Discussion List,* 27 March.

Graham, Beryl. 1999. "A Study of Audience Relationships with Interactive Computer-Based Visual Artworks." *Leonardo* 32 (4): 326–328.

Graham, Beryl. 1997. "A Study of Audience Relationships with Interactive Computer-Based Visual Artworks in Gallery Settings, Through Observation, Art Practice, and Curation." Ph.D. diss., University of Sunderland. Available at http://www.sunderland.ac.uk/~as0bgr/cv/sub/phd.htm.

Graham, Beryl. 1996. "Playing with Yourself: Pleasure and Interactive Art." In Jon Dovey, ed., *Fractal Dreams,* 154–179. London: Lawrence and Wishart.

Graham, Beryl, and Sarah Cook. 2001. "A Curatorial Resource for Upstart Media Bliss." In David Bearman and Jennifer Trant, eds., *Museums and the Web 2001: Selected Papers from an International Conference,* 197–208. Pittsburgh: Archives & Museum Informatics. Also available at http://www.archimuse.com/mw2001/papers/graham/graham.html.

Graham, Beryl, and Verina Gfader. 2008. "Curator as editor, translator or god? Edited CRUMB discussion list theme." In: Sabine Hochrieser, Michael Kargl (carlos katastrofsky), Franz Thalmair (eds.) *CUREDITING—TRANSLATIONAL ONLINE WORK*. Available at http://vagueterrain.net/journal11/crumb/01

Grau, Oliver, ed. 2007. *MediaArtHistories*. Cambridge, Mass.: MIT Press.

Green, Charles. 2001. *The Third Hand: Collaboration in Art from Conceptualism to Postmodernism*. New South Wales, Australia: University of New South Wales Press.

Grubinger, Eva. 2006. "'C@C': Computer-aided Curating (1993-1995) Revisited." In Joasia Krysa, ed., *Curating Immateriality: The Work of the Curator in the Age of Network Systems*, 103–110. Data Browser 03. London: Autonomedia..

Grzinic, Marina. 2000. "Exposure Time, the Aura, and Telerobotics." In Ken Goldberg, ed., *The Robot in the Garden: Telerobotics and Telepistemology in the Age of the Internet,* 214–225. Cambridge, Mass.: MIT Press.

Halbreich, K. 2003. *Halbreich Letter.* Available at http://www.mteww.com/walker_letter/halbreich _letter.html.

Hall, Doug, and Sally Jo Fifer, eds. 1991. *Illuminating Video.* New York: Aperture.

Hanhardt, John G. 1987. *Video Culture: A Critical Investigation.* London: Gibbs Smith.

Hansen, Mark B. N. 2006. *New Philosophy for New Media.* Cambridge, Mass.: MIT Press.

Harding, Anna. 2003. *"Republicart*—Interview on Interference, with Raimund Minichbauer." *Republicart* (July). Available at http://republicart.net/art/concept/interview-harding_en.htm.

Harkrader, Lauren. 2003a. "Interview with Rirkrit Tiravanija." In Linda Weintraub, *Making Contemporary Art: How Today's Artists Think and Work,* 102–109. London: Thames and Hudson.

Harkrader, Lauren. 2003b. "Interview with Victoria Vesna." In Linda Weintraub, *Making Contemporary Art: How Today's Artists Think and Work,* 287-291. London: Thames and Hudson.

Harris, Craig, ed. 1999. *Art and Innovation: The Xerox Parc Artist-in-Residence Program.* Cambridge, Mass.: MIT Press.

Haskel, Lisa. 2005. "Re: XX Years since *Cybernetic Serendipity.*" E-mail to B. Graham, 27 May. Available by e-mail at beryl.graham@sunderland.ac.uk.

Haskel, Lisa. 2004. "Selling Out—Buying In: Art vs. Design in UK Media Culture." In Lucy Kimbell, ed., *New Media Art: Practice and Context in the UK 1994–2004,* 120–125. London: Arts Council of England.

Haskel, Lisa. 2002. *MAP Media Arts Projects.* Available at http://mediaartprojects.org.uk/index.html.

Hayles, N. Katherine. 1995. "Embodied Virtuality: Or How to Put Bodies Back into the Picture." In Mary Anne Moser and Doug McCleod, eds., *Immersed in Technology: Art and Virtual Environments,* 1–28. Cambridge, Mass.: MIT Press.

Hayward, Philip. 1996. "Video Installation, Conceptual Practice, and New Media in the 1990s." In Julia Knight, ed., *Diverse Practices: A Critical Reader on British Video Art,* 209–215. London: Arts Council of England, John Libbey.

Hayward, Philip, ed. 1991. *Culture, Technology, and Creativity in the Late Twentieth Century.* London: John Libbey, Arts Council England.

Hazan, Susan. 2004. "Re: February Theme of the Month: Formal Research 2—Resisting the Canon." *New-Media-Curating Discussion List,* 6 February.

Heath, Christian, Dirk vom Lehn, Jon Hindmarsh, and Jason Cleverly. 2002. "Crafting Participation: Designing Ecologies, Configuring Experience." *Visual Communication* 1 (1): 9–34.

Heidegger, Martin. [1953] 1993. *The Question Concerning Technology*. In David Farrell Krell, ed., *Martin Heidegger: Basic Writings from "Being and Time" (1927) to "The Task of Thinking" (1964)*, 283–317. San Francisco: Routledge.

Heidegger, Martin. [1935] 1993. *The Origin of The Work of Art*. In David Farrell Krell, ed., *Martin Heidegger: Basic Writings from "Being and Time" (1927) to "The Task of Thinking" (1964)*, 143–187. San Francisco: Routledge.

Hein, George E. 1998. *Learning in the Museum*. London: Routledge.

Held, John. 2005. "The Mail Art Exhibition." In Annmarie Chandler and Norie Neumark, eds., *At a Distance: Precursors to Art and Activism on the Internet*, 88–115. Cambridge, Mass.: MIT Press.

Henning, Michelle. 2006. *Museums, Media, and Cultural Theory*. Milton Keynes, U.K.: Open University Press.

Hiller, Susan, and Sarah Martin, eds. 2002. *The Producers: Contemporary Curators in Conversation (5)*. B. Read/Eight. Gateshead, U.K.: BALTIC.

Hirschhorn, Thomas. 2004. "Bataille Monument." In Claire Doherty, ed., *Contemporary Art: From Studio to Situation*, 133–148. London: Black Dog.

Hirvi, Maria, ed. 2002. *Eija-Liisa Ahtila: Fantasized Persons and Taped Conversations*. Helsinki: Kiasma Museum of Contemporary Art.

Hoffos, Signe. 1992. *Multimedia and the Interactive Display in Museums, Exhibitions, and Libraries*. Library and Information Research Report no. 87. London: British Library.

Holley, Tom. 2006. Audience discussion at "Art-Place-Technology: International Symposium on Curating New Media Art," 30 March–1 April, Liverpool School of Art & Design and FACT Centre.

Hook, Kristina, Phoebe Sengers, and Gerd Andersson, eds. 2003. "Sense and Sensibility: Evaluation and Interactive Art." In *Proceedings of the SIGCHI Conference on Human Factors in Computing Systems*, 241–248. Toronto: ACM Press. Also available at http://portal.acm.org.

Hooper-Greenhill, Eilean. 2003. "Changing Values in the Art Museum: Rethinking Communication and Learning." In Bettina Messias Carbonell, ed., *Museum Studies: An Anthology of Contexts*, 556–575. Oxford, U.K.: Blackwell.

Hooper-Greenhill, Eilean, ed. 1999. *Museum, Media, Message*. London: Routledge.

Hoptman, Glen. 1992. "The Virtual Museum and Related Epistemological Concerns." In Edward Barrett, ed., *Sociomedia: Multimedia, Hypermedia, and the Social Construction of Knowledge*, 141–160. Cambridge, Mass.: MIT Press.

Hor-Chung Lau, Joyce. 2005. "Now in Hong Kong, an Interactive Display by Rafael Lozano-Hemmer." *International Herald Tribune*, 15 November. Available at http://www.iht.com/articles/2006/11/15/opinion/HKART.php.

Huffman, Kathy Rae. 2004. "Space and Time: Audience." Paper presented at the CRUMB seminar "Curating in Space and Time," 7 September, Northern Gallery for Contemporary Art, Sunderland, U.K. Available at http://crumbweb.org/getPresentation.php?presID=33.

Huffman, Kathy Rae. 2001. "Re: April Discussion." *New-Media-Curating Discussion List,* 3 April.

Huffman, Kathy Rae. 2000. "A Conversation Between Kathy Rae Huffman and Julie Lazar." Available at the CRUMB Web site, http://www.crumbweb.org/getInterviewDetail.php?id=2.

Interactionfield [Mirjam Struppek]. 2006. "Permanence and Public Art—Lots of Thoughts." *New-Media-Curating Discussion List,* 6 August.

Ippolito, Jon. 2008a. "Death by Wall Label." In Christiane Paul, ed., *New Media in the White Cube and Beyond: Curatorial Models for Digital Art,* 106–132. Berkeley and Los Angeles: University of California Press. Also available at http://three.org/ippolito/writing/death_by_wall_label@m.html.

Ippolito, Jon. 2008b. "Re: [NEW-MEDIA-CURATING] Exclusivity and Heresy | Alternative academic criteria." *New-Media-Curating Discussion List,* 16 September.

Ippolito, Jon. 2007. *Standards of Recognition.* Available at http://cordova.asap.um.maine.edu/wiki/index.php/Standards_of_Recognition.

Ippolito, Jon. 2006. "Self-Emulation—from Jon Ippolito." *New-Media-Curating Discussion List,* 16 September.

Ippolito, Jon. 2003. "Accommodating the Unpredictable: The Variable Media Questionnaire." In Alain Depocas, Jon Ippolito, and Caitlin Jones, eds., *Permanence Through Change: The Variable Media Approach,* 47–54. New York: Guggenheim Museum. Also available at http://www.variablemedia.net/e/preserving/html/var_pub_index.html.

Ippolito, Jon. 1999. "Answers and Questions about Digital Collaboration." *Afterimage* (November–December): 8.

Ives Gilman, Benjamin. 2003. "Aims and Principles of the Construction and Management of Museums of Fine Art." In Bettina Messias Carbonell, ed., *Museum Studies: An Anthology of Contexts,* 419–429. Oxford, U.K.: Blackwell.

Jacob, Mary Jane. 2007. "Making Space for Art" In Paula Marincola, ed., *What Makes a Great Exhibition?* 131–141. Chicago: University of Chicago Press.

Jacob, Mary Jane. 1995. "Outside the Loop." In Mary Jane Jacob, ed., *Culture in Action: A Public Art Program of Sculpture Chicago,* 50–61. Seattle: Bay Press.

Jennings, Pamela. 2000. *New Media Arts / New Funding Models.* New York: Rockefeller Foundation. Available at http://www.rockfound.org/display.asp?context=3&SectionTypeID=16&DocID=528.

Jeremijenko, Natalie, and Perry Hoberman. 2001. "Bar Codes and a Really Clumsy Mouse: A Conversation Between Natalie Jeremijenko and Perry Hoberman." In Timothy Druckrey, Perry Hoberman, Siegfried Zielinski, Christian Viveros-Faune, *Symptomatic: Recent Works by Perry Hoberman,* 54–60. Bradford, U.K.: National Museum of Photography, Film, & Television.

Jo, Kazuhiro, Yasuhiro Yamamoto, and Kumiyo Nakakoji. 2006. "Styles of Participation and Engagement in Collective Sound Performance Projects." In Ernest Edmonds, Lizzie Muller, and Deborah Turnbull, eds., *ENGAGE: Interaction, Art, and Audience Experience. CCS/ACID Symposium,* 110–119. Sydney: Creativity and Cognition Studios Press, University of Technology.

Jones, Caitlin. 2008. *Documenting New Media Art Seminar*. Newcastle, U.K.: CRUMB, 5 March. Available at http://www.crumbweb.org/getPresentation.php?presID=44.

Jones, Caitlin, 2007. "Re: Bryce Wolkowitz Show." E-mail to Beryl Graham, 23 January. Available by e-mail at beryl.graham@sunderland.ac.uk.

Jones, Caitlin. 2006a. "Conversation with CRUMB's Sarah Cook & Beryl Graham." *EAI Online Resource Guide for Exhibiting, Collecting, & Preserving Media Art.* Available at http://resourceguide.eai .org/exhibition/computer/interview_crumb.html.

Jones, Caitlin. 2006b. "Conversation with Michael Connor." *EAI Online Resource Guide for Exhibiting, Collecting, & Preserving Media Art.* Available at http://resourceguide.eai.org.

Jones, Caitlin. 2005a. "My Art World Is Bigger Than Your Art World." *The Believer* 3 (10): 3–13.

Jones, Caitlin. 2005b. "Re: Rhizome Opportunity." *New-Media-Curating Discussion List,* 21 February.

Jones, Caitlin. 2003. "Reality Check: A Year with Variable Media." In Alain Depocas, Jon Ippolito, and Caitlin Jones, eds., *Permanence Through Change: The Variable Media Approach,* 61–64. New York: Guggenheim Museum. Also available at http://www.variablemedia.net/e/preserving/html/var_pub _index.html.

Jones, Caitlin, and Lizzie Muller. 2008. "Between Real and Ideal: Documenting New Media Art." *Leonardo* 41 (4): 418–419.

Jones, Garrick. 2007. "Experiences of Academic/Business Interdisciplinary Work—Two Cases and a Framework." In Cathy Brickwood, Bronac Ferran, David Garcia, and Tim Putnam, eds., *(Un)Common Ground: Creative Encounters across Sectors and Disciplines,* 16–27. Amsterdam: BIS.

Jones, Tim. 2006. Unpublished "Interview with Sarah Cook." 21 March. Notes by Sarah Cook.

Joseph-Hunter, Galen. 2006. "Conversation with Magda Sawon." *EAI Online Resource Guide for Exhibiting, Collecting, & Preserving Media Art.* Available at http://resourceguide.eai.org.

Kahn, Douglas. 2005. "Re: Re: Re: Collaboration or Participation?" In the Tate online forum "The Politics of Sound / The Culture of Exchange," 31 January to 23 March. Available at http://www.tate .org.uk/forums/category.jspa?categoryID=8.

Kahn, Douglas. 1999. *Noise, Water, Meat: A History of Voice, Sound, and Aurality in the Arts.* Cambridge, Mass.: MIT Press.

Kanarinka. 2004. "Re: Definitions." *New-Media-Curating Discussion List,* 6 September.

Kelley, Paul, and Alan Dunn, eds. 2005. *Tenantspin Workbook.* Liverpool: Foundation for Art and Creative Technology (FACT).

Kemp, Martin, and Deborah Schultz. 2000. "Us and Them, This and That, Here and There, Now and Then: Collecting, Classifying, Creating." In Siân Ede, ed., *Strange and Charmed: Science and the Contemporary Visual Arts,* 84–103. London: Calouste Gulbenkian Foundation.

Kester, Grant. 2004. *Conversation Pieces.* Berkeley and Los Angeles: University of California Press.

Kester, Grant. 2001. "Subject: From Grant Kester." *New-Media-Curating Discussion List.* 8 April.

Kittler, Friedrich. 1996. "Museums on the Digital Frontier." In John Hanhardt, ed., *The End(s) of the Museum,* 67–80. Barcelona: Fondacio Antoni Tapies.

Kleiner, Dmytri, and Brian Wyrick. 2007. "InfoEnclosure 2.0." *Mute Magazine: Culture and Politics after the Net,* 29 January. Available at http://www.metamute.org/en/InfoEnclosure-2.0.

Knowles, Rachelle. 2002. " Re: Curating Critically." *New-Media-Curating Discussion List,* 12 February.

Krauss, Rosalind. 2000. *A Voyage on the North Sea: Art in the Age of the Post-medium Condition.* London: Thames and Hudson.

Krauss, Rosalind E. 1986. *The Originality of the Avant-Garde and Other Modernist Myths.* Cambridge, Mass.: MIT Press.

Krauss, Rosalind. 1978. "Video: The Aesthetics of Narcissism." In Gregory Battcock, ed., *New Artist's Video,* 43–64. New York: E. P. Dutton.

Kravagna, Christian. 1998. "Working on the Community: Models of Participatory Practice." Available at the Republicart Web site, http://www.republicart.net/disc/aap/kravagna01_en.htm.

Kravagna, Christian, and Kunsthaus Bregenz, eds. 1976. *The Museum as Arena: Artists on Institutional Critique.* Cologne: Walter Konig.

Krysa, Joasia. 2006. "Curating Immateriality: The Work of the Curator in the Age of Network Systems." In Joasia Krysa, ed., *Curating Immateriality: The Work of the Curator in the Age of Network Systems,* 7–26. Data Browser 03. London: Autonomedia.

Kuoni, Carin, ed. 2001. *Words of Wisdom: A Curator's Vade Mecum.* New York: Independent Curators International.

Kwastek, Katya. 2008. "Interactivity—a Word on Process." In Christa Sommerer, Lakhmi C. Jain, and Laurent Mignonneau, eds., *The Art and Science of Interface and Interaction Design,* 15–26. Vienna: Springer.

Lacy, Suzanne, ed. 1995. *Mapping the Terrain: New Genre Public Art.* Seattle: Bay Press.

Laforet, Anne. 2004. *Net art et institutions artistiques et muséales: Problèmatiques et pratiques de la conservation.* Paris: Ministère de la Culture et de la Communication Délégation aux Arts Plastiques, Bureau de la Recherche et de l'Innovation Université d'Avignon, et des Pays de Vaucluse Laboratoire Culture et Communication. Available at http://www.sakasama.net/conservationnetart.

Laniado, Joe. 1997. "Serious Games." *Frieze* 36: 98–99.

Leach, James. 2007. *Extending Contexts, Making Possibilities.* London: Arts and Humanities Research Council, Arts Council of England. Available at http://www.artsactive.net/files_reports/EXTENDING CONTEXTS_JamesLeach_sept2003.pdf.

Lees, Diane, ed. 1993. *Museums and Interactive Multimedia: Proceedings of the Sixth International Conference of the MDA, and the 2nd International Conference on Hypermedia and Interactivity in Museums (ICHIM '93).* Cambridge, U.K.: Museum Documentation Association, Archives and Museums Informatics.

Lialina, Olia. 1998. "Cheap.art." *Rhizome,* 19 January. Available at http://rhizome.org/object.rhiz ?1026.

Lichty, Patrick. 2004a. "CONFESSIONS OF A WHITNEYBIENNIAL.COM CURATOR." Available at http://subsol.c3.hu/subsol_2/contributors3/lichtytext.html.

Lichty, Patrick. 2004b. "Re: Definitions." *New-Media-Curating Discussion List,* 6 September.

Lichty, Patrick. 2002. "Re: Curating Critically." *New-Media-Curating Discussion List,* 13 February.

Lichty, Patrick. 2001. "The Gallery as Serious Space." *New-Media-Curating Discussion List,* 12 May.

Lind, Maria. 2007. "The collaborative turn." In Johanna Billing, Maria Lind and Lars Nilsson (eds.) *Taking the Matter into Common Hands: On Contemporary Art and Collaborative Practices*, 15–31. London: Black Dog Publishing.

Lind, Maria. 2005. "Telling Histories: Archive/Spatial Situation/Case Studies/Talk Shows/Symposium." In Liam Gillick and Maria Lind, eds., *Curating with Light Luggage,* 91–106. Frankfurt: Revolver, Kunstverein Munchen.

Lippard, Lucy. 2008. "Lucy Lippard." In Hans Ulrich Obrist *A Brief History of Curating,* 196–233. Zurich: JRP Ringier & Les Presses Du Réel.

Lippard, Lucy, ed. 1973. *Six Years: The Dematerialisation of the Art Object from 1966 to 1972*. Berkeley and Los Angeles: University of California Press.

Lips, Katie. 2007. "Bold Street Project." Paper presented at the "Had To Be There Symposium," 16 October, Foundation for Creative Art and Technology (FACT), Liverpool.

Lister, Martin, Jon Dovey, Seth Giddings, Iain Grant, and Kieran Kelly, eds. 2003. *New Media: A Critical Introduction*. London: Routledge.

Locke, Matt. 2003. "Tim Etchells, Surrender Control." *Test,* 14 July. Available at http://www.test.org .uk/archives/000617.html.

Locke, Matt. 2001a. Presentation at the "I'll Show You Mine If You Show Me Yours . . . " workshop on new media spaces, 13 October, the Media Centre, Huddersfield, U.K. Available at http://www .crumbweb.org/getPresentation.php?presID=7.

Locke, Matt. 2001b. "Re: Baltic New Media Curating Seminar." *New-Media-Curating Discussion List,* 15 May.

London, Barbara. 2001a. "Digital Art Takes Shape at MoMA." *Leonardo* 34 (2): 95–99.

London, Barbara. 2001b. "Re: Software as Art: July/August 'Theme of the Month.'" Posted by Beryl Graham. *New-Media-Curating Discussion List,* 27 March.

Lovejoy, Margot. 2004. *Digital Currents: Art in the Electronic Age*. 3rd ed. London: Routledge.

Lovink, Geert. 2008. *Zero Comments: Blogging and Critical Internet Culture*. London: Routledge.

Lovink, Geert. 2007. "Theses on Wiki Politics: An exchange with Pavlos Hatzopoulos for *Re-public*." Available at the Republicart Web site, http://www.republicart.net/disc/aap/kravagna01_en.htm.

Lovink, Geert. 2005. *The Principle of Notworking—Concepts in Critical Internet Culture.* Paris: American University of Paris. Available at http://www.hva.nl/lectoraten/documenten/ol09–050224–lovink.pdf.

Lovink, Geert. 2002. Presentation at the conference "Digital Commons: Documenta 11," July, Kassel, Germany.

Lovink, Geert. 2000. "Interview with Rafael Lozano-Hemmer." Nettime, 26 June. Available by e-mail at nettime-l@bbs.thing.net.

Lovink, Geert, and Sabine Niederer, eds. 2008. *The Video Vortex Reader: Responses to YouTube.* Amsterdam: Institute of Network Cultures.

Lozano-Hemmer, Rafael. 2007. *Under Scan.* Edited by David Hill. Nottingham, U.K.: East Midlands Development Agency.

Lozano-Hemmer, Rafael. 2001a. Presentation at the "Interventions: Reframing the Interface" conference, 20 October, National Museum of Photography, Film, & Television, Bradford, U.K.

Lozano-Hemmer, Rafael. 2001b. "Too Interactive (Belated)." *New-Media-Curating Discussion List,* 6 December.

Lunenfeld, Peter 2003. "Space Invaders: Thoughts on Technology and the Production of Culture." In John Caldwell and Anna Everett, eds., *New Media: Practices of Digitextuality,* 63–74. New York: Routledge.

Lyotard, Jean-Francois. 1996. *"Les Immatériaux."* In Bruce W. Ferguson, Reesa Greenberg, and Sandy Nairne, eds., *Thinking about Exhibitions,* 159–174. London: Routledge.

MacLeod, Suzanne. 2006. *Reshaping Museum Space: Architecture, Design, Exhibitions.* London: Routledge.

Maleuvre, Didier. 1999. *Museum Memories: History, Technology, Art.* Stanford, Calif.: Stanford University Press.

Manovich, Lev. 2008. "Art After Web 2.0." In Rudolf Frieling, ed., *The Art of Participation,* 66–80. San Francisco: San Francisco Museum of Modern Art, Thames and Hudson.

Manovich, Lev. 2007. "Abstraction and Complexity." In Oliver Grau, ed., *MediaArtHistories,* 339–354. Cambridge, Mass.: MIT Press.

Manovich, Lev. 2003a. "New Media from Borges to HTML." In Noah Wardrip-Fruin and Nick Montfort, eds., *The New Media Reader,* 13–25. Cambridge, Mass.: MIT Press.

Manovich, Lev. 2003b. "The Poetics of Augmented Space." In John Caldwell and Anna Everett, eds., *New Media: Practices of Digitextuality,* 75–92. New York: Routledge.

Manovich, Lev. 2002. "Data Visualisation, New Media, and Anti-Sublime." Lecture in the "Remote Forum" lecture series, 18 November, Fruitmarket Gallery, New Media Scotland, Edinburgh.

Manovich, Lev. 2001a. *The Language of New Media.* Cambridge, Mass.: MIT Press.

Manovich, Lev. 2001b. "Post-media Aesthetics." In Zentrum für Kunst und Medientechnologie (ZKM), ed., *(Dis)locations.* DVD-ROM. Ostfildern, Germany: Hatje Cantz. Also available at http://www.manovich.net.

Manovich, Lev. 1996. *The Death of Computer Art.* Available at http://www.thenetnet.com/schmeb/schmeb12.html.

Manovich, Lev, and Andreas Kratky. 2005. *Soft Cinema: Navigating the Database.* Cambridge, Mass.: MIT Press.

Marincola, Paula. 2007. *What Makes A Great Exhibition?* Chicago: University of Chicago Press.

Marincola, Paula. 2002. *Curating Now: Imaginative Practice/Public Responsibility.* Philadelphia: Philadelphia Exhibitions Initiative.

Marshall, Stuart. 1996. "Video: From Art to Independence. A Short History of a New Technology." In Julia Knight, ed., *Diverse Practices: A Critical Reader on British Video Art,* 59–70. London: Arts Council of England, John Libbey.

Mastai, Judith. 1996. "Oh Heck! High Tech: Art Galleries, Ideologies of Practice, and Shifting Paradigms of Knowledge." In Peter White, ed., *Naming a Practice: Curatorial Strategies for the Future,* 146–153. Banff, Canada: Banff Centre Press.

McDonald Crowley, Amanda. 2006. Keynote presentation at "Art-Place-Technology: International Symposium on Curating New Media Art," 30 March to 1 April, Liverpool School of Art & Design and Foundation for Art and Creative Technology (FACT) Centre.

McGarry, Kevin. 2005. "Database Imaginary: Sarah Cook, Steve Dietz, and Anthony Kiendl Interviewed by Kevin McGarry." *Rhizome Digest,* 1 August. Available from digest@rhizome.org.

Medosch, Armin. 2006. "Meshing in the Future: The Free Configuration of Everything and Everyone with Hive Networks." In Marina Vishmidt with Mary Anne Francis, Jo Walsh, and Lewis Sykes, eds., *Media Mutandis: A NODE.London Reader. Surveying Art, Technologies, and Politics,* 234–245. London: NODE, Mute.

Medosch, Armin. 2002a. "Art for Networks." Presentation at the exhibition *Art for Networks,* November, Chapter Arts, Cardiff, U.K.

Medosch, Armin. 2002b. "Network 404." In Hannah Firth and Simon Pope, eds., *Art for Networks,* 13–18. Cardiff, U.K.: Chapter Arts. Also available at http://amsterdam.nettime.org/Lists-Archives/nettime-l-0211/msg00057.html

Medosch, Armin. 1998. "The Economy of Art in the Information Age." Available at http://www.medialounge.net/lounge/workspace/crashhtml/es/4.htm.

Mellor, Adrian. 1991. "Enterprise and Heritage in the Dock." In John Corner and Sylvia Harvey, eds., *Enterprise and Heritage: Crosscurrents in National Culture,* 93–115. London: Routledge.

Miessen, Markus, and Shumon Basar. 2006. *Did Someone Say Participate? An Atlas of Spatial Practice.* Cambridge, Mass.: MIT Press.

Miessen, Markus, and Chantal Mouffe. 2007. "Articulated Power Relations." In Markus Miessen, ed., *The Violence of Participation,* 37–48. New York: Sternberg.

Miranda Zuniga, Ricardo. 2002. The Work of Artists in a Databased Society: Net.Art as Online Activism." *Afterimage* (March–April): 7–9.

Mirapaul, Matthew. 2001. "O.K., It's Art, but Do You View It at Home or in Public?" *New York Times,* 19 March.

Mitchell, William J., Alan S. Inouye, and Marjory S. Blumenthal, eds. 2003. *Beyond Productivity: Information Technology, Innovation, and Creativity.* New York: National Academies.

Mitroff, Dana. 2007. "Do You Know Who Your Users Are? The Role of Research in Redesigning sfmoma.org." Paper presented at the conference Museums and the Web 2007, 11–14 April, San Francisco. Available at http://www.archimuse.com/mw2007/papers/mitroff/mitroff.html.

Möntmann, Nina, ed. 2006. *Art and Its Institutions: Current Conflicts, Critique, and Collaborations.* London: Black Dog.

Morris, Susan. 2001. *Museums and New Media Art.* Research report. New York: Rockefeller Foundation. Also available at http://www.rockfound.org/display.asp?context=3&collection=0&subcollection=0&DocID=528.

Morse, Margaret. 1998. *Virtualities: Television, Media Art, and Cyberculture.* Bloomington: Indiana University Press.

Mounajjed, Nadja. 2007. "Interviews with the Public." In Rafael Lozano-Hemmer, *Under Scan,* edited by David Hill, 91–105. Nottingham, U.K.: East Midlands Development Agency.

Mounajjed, Nadia, Chengzhi Peng, and Stephen Walker. 2007. "Ethnographic Interventions: A Strategy and Experiments in Mapping Sociospatial Practices." *Human Technology* 3 (1). Available at http://www.humantechnology.jyu.fi/articles/volume3/2007/mounajjed-peng-walker.pdf.

Muir, Gregor. 2002. "Past, Present, and Future Tense." Paper presented at the New York Digital Salon Tenth Anniversary exhibition *Vectors: Digital Art of Our Time.* Reprinted in *Leonardo,* October (Vol. 35, No. 5), 499–508. Available at http://www.mitpressjournals.org/doi/pdf/10.1162/002409402320774321.

Muller, Elizabeth. 2009. "The Experience of Interactive Art: A Curatorial Study." Ph.D. diss., University of Technology, Sydney.

Munster, Anna. 2005. "Re: Fractures / History /Cheang, Plus Cut and Pasted Conceptualism." *New-Media-Curating Discussion List,* 11 October.

Murphy, Rob. 2003. "Re: [Thingist]. Barney at the Gug." *Thingist,* 26 February. Available at http://www.thing.net.

Murschetz, Paul. 1999. *Digital Culture in Europe: A Selective Inventory of Centres of Innovation in the Arts and New Technologies.* Strasbourg: Council of Europe.

Naimark, Michael. 2003. *Truth, Beauty, Freedom, and Money: Technology-Based Art and the Dynamics of Sustainability.* A report for *Leonardo.* New York: Rockefeller Foundation. Available at http://www.artslab.net.

Nairne, Sandy. 1999. "Exhibitions of Contemporary Art." In Emma Barker, ed., *Contemporary Cultures of Display,* 105–126. New Haven, Conn.: Yale University Press.

Nairne, Sandy. 1996. "The Institutionalisation of Dissent." In Bruce W. Ferguson, Reesa Greenberg, and Sandy Nairne, eds., *Thinking about Exhibitions,* 387–410. London: Routledge.

Nash, Mark. 2007. "Questions of Practice." In Paula Marincola, ed., *What Makes a Great Exhibition?* 142–153. Chicago: University of Chicago Press.

Nedkova, Iliyana. 2001. "Consolations for Curatorial Inadequacy." Presentation at the seminar "Curating New Media," 10–12 May, Gateshead, U.K. Available at http://www.crumbweb.org.

Nedkova, Iliyana. 2000. "Ultracurating—the Holistic Nutrition for a Time-Starved World." In Gavin Wade, ed., *Curating in the 21st Century,* 123–130. Wolverhampton, U.K.: New Art Gallery, Wallsall, and University of Wolverhampton.

Nelson, Theodor H. [1965] 2003. "A File Structure for the Complex, the Changing and the Indeterminate." In Noah Wardrip-Fruin and Nick Montfort, eds., *The New Media Reader,* 133–146. Cambridge, Mass.: MIT Press.

Nesbit, Molly, Hans Ulrich Obrist, and Rirkrit Tiravanija. 2006. "What Is a Station // 2003." In Claire Bishop, ed., *Participation (Documents of Contemporary Art),* 184–189. Cambridge, Mass., and London: MIT Press and Whitechapel.

"Nicolas Bourriaud and Karen Moss." 2003. *Stretcher,* 25 February. Available at http://www.stretcher .org/archives/i1_a/2003_02_25_i1_archive.php.

Nigten, Anne. 2004. *Tunnels and Collisions.* Available at http://archive.v2.nl/v2_lab/papers_general/ 2004_nigten_tunnels.pdf.

Nigten, Anne. 2002. *Human Factors in Artistic Research and Development in Multi- and Interdisciplinary Collaborations.* Available at http://archive.v2.nl/v2_lab/papers_general/2002_nigten_human factors.pdf.

Noordegraaf, Julia. 2004. *Strategies of Display: Museum Presentation in Nineteenth and Twentieth Century Visual Culture.* Rotterdam: NAI Publishers.

Nori, Franziska. 2003. "Management of Meanings—Annotations on the Curatorial Work Realized by *Digitalcraft.org.*" Available at the digitalcraft.org Web site, http://www.digitalcraft.org/ ?artikel_id=552.

Obrist, Hans Ulrich. 2005. "Shifts, Expansions, and Uncertainties: The Example of Cedric Price." In Liam Gillick and Maria Lind, eds., *Curating with Light Luggage,* 62–76. Frankfurt: Revolver and Kunstverein Munchen.

Obrist, Hans Ulrich. 2001a. "Battery, Kraftwerk, and Laboratory (Alexander Dorner Revisited)." In Carin Kuoni, ed., *Words of Wisdom: A Curator's Vade Mecum,* 127–130. New York: Independent Curators International.

Obrist, Hans Ulrich. 2001b. "Evolutional Exhibitions." *The Happy Face of Globalisation* (Biennial of Ceramics in Contemporary Art), Albisola, Italy. Available at http://www.attese.it/attese1/article13/ index.html.

Obrist, Hans Ulrich. 2000. "Kraftwerk, Time Storage, Laboratory." In Gavin Wade, ed., *Curating in the 21st Century,* 45–59. Wolverhampton, U.K.: New Art Gallery, Wallsall, and University of Wolverhampton.

O'Doherty, Brian. 1986. *Inside the White Cube: The Ideology of the Gallery Space*. San Francisco: Lapis Press.

Oguibe, Ole. 2001. "The Curator's Calling." In Kuoni, Carin (ed.) *Words of wisdom: A Curator's Vade Mecum*, 131–133. New York: ICI/Independent Curators International.

O'Neill, Paul, ed. 2007. *Curating Subjects*. Amsterdam and London: De Appel and Open Editions.

O'Neill, Paul. 2005. "The Co-dependent Curator." *Art Monthly* 291 (November): 7–10.

Packer, Randall. 2006. "Where Art Thou Net.Art? Conference report on Zero One / ISEA 2006." *Rhizome*, 25 August. Available at http://rhizome.org/thread.rhiz?thread=22736&page=1#43853.

Packer, Randall, and Ken Jordan, eds. 2001. *Multimedia: from Wagner to Virtual Reality*. New York: Norton.

Parry, Ross. 2007. *Recoding the Museum*. London: Routledge.

Pask, Gordon. 1976. *Conversation Theory, Applications in Education, and Epistemology*. Amsterdam: Elsevier.

Paul, Christiane, ed. 2008. *New Media in the White Cube and Beyond: Curatorial Models for Digital Art*. Berkeley and Los Angeles: University of California Press.

Paul, Christiane. 2007. "The Myth of Immateriality: Presenting and Preserving New Media." In Oliver Grau, ed., *MediaArtHistories*, 251–274. Cambridge, Mass.: MIT Press.

Paul, Christiane. 2006. "Flexible Contexts, Democratic Filtering and Computer-Aided Curating." In Joasia Krysa, ed., *Curating Immateriality: The Work of the Curator in the Age of Network Systems*, 81–102. Data Browser 03. London: Autonomedia.

Paul, Christiane. 2005a. "Public Forum and Openness." *Tate Online Events: COdE Of Practice: Online Panel Discussion June 13–July 18, 2005*, 23 June. Available at http://www.tate.org.uk/contact/forums/onlineevents.

Paul, Christiane. 2005b. "Time Aesthetics and Open Systems." *Tate Online Events: COdE Of Practice: Online Panel Discussion June 13–July 18, 2005*, 15 July. Available at http://www.tate.org.uk/contact/forums/onlineevents.

Paul, Christiane. 2003. *Digital Art*. London: Thames and Hudson.

Paul, Christiane. 2002. "Collaborative Curatorial Models and Public Curation." *Switch* (17). Available at http://switch.sjsu.edu/nextswitch/switch_engine/front/front.php?cat=27.

Paul, Christiane, curator. 2001a. *Data Dynamics*. Exhibition, 22 March to 10 June, Whitney Museum of American Art, New York: Information available at http://whitney.org/datadynamics.

Paul, Christiane. 2001b. "Re: Showing It: Two Case Studies." *New-Media-Curating Discussion List*, 3 May.

Pearce, Celia, Sara Diamond, and Mark Beam. 2001. "Summary Report of the First Annual Summit 2001 BRIDGES: International Consortium on Collaboration in Art & Technology." *Leonardo* 36 (2). Available at http://www.mitpressjournals.org/doi/pdf/10.1162/002409403321554189.

Penny, Simon. 1995. "Consumer Culture and the Technological Imperative: The Artist in Dataspace." In Simon Penny, ed., *Critical Issues in Electronic Media,* 47–74. New York: State University of New York Press.

Perkel, Dan, Ryan Shaw, and Greg Niemeyer. 2006. "Learning to Play Together: Crossing Boundaries in Art and Design." In Pamela Jennings, Elisa Giaccardi, and Magda Wesolkowska, eds., *About Face—Interface: Creative Engagement in New Media Arts and HCI.* Available at http://studio416.cfa.cmu.edu/CHI06workshop_AboutFace.

Perry, Grayson. 2006. "Is the World Wide Web Art's Final Frontier?" *The Times* (London), 9 August. Available at http://entertainment.timesonline.co.uk/tol/arts_and_entertainment/article603212.ece.

Perry, Roy A. 1999. "Present and Future: Caring for Contemporary Art at the Tate Gallery." In Miguel Angel Corzo, ed., *Mortality Immortality? The Legacy of 20th-Century Art,* 41–44. Los Angeles: Getty Conservation Institute.

Pirrie Adams, Kathleen. 2000. Unpublished notes from a conversation with Sarah Cook.

Pollice, Gary. 2007. "Collaboration in a flat world, part one: Collaboration development tools." *The Rational Edge,* 15 April. Available at http://www.ibm.com/developerworks/rational/rationaledge/.

Pope, Nina, and Karen Guthrie, hosts. 2002a. "Theme: TVSS as a Curatorial/Commissioning Model." In *TV Swansong.* Available at http://www.swansong.tv/symposium/curate.htm.

Pope, Nina, and Karen Guthrie. 2002b. "*TV Swansong* Symposium." 27 July, BALTIC Center for Contemporary Art, Gateshead, U.K. Notes by Sarah Cook.

Pope, Nina, and Karen Guthrie, hosts. 2002c. "Theme: Collaboration." In *TV Swansong.* Available at http://www.swansong.tv/symposium/collaboration.htm.

Pope, Nina, and Karen Guthrie. 2001. "On Being Curated—a Critical Response." Presentation at the seminar "Curating New Media," 10–12 May, Gateshead, U.K. Available at http://www.crumbweb.org/getPresentation.php?presID=37&semID=1&id=1&op=4&ts=1228234380&sublink=7.

Pope, Simon. 2006. Re: A comment on artistic and curatorial practice." *New-Media-Curating Discusison List,* 30 March.

Pope, Simon. 2005. "Re: Exhibiting Re-enactment and Documentary-Based Art: December 05 theme." *New-Media-Curating Discussion List,* 8 December.

Pope, Simon, curator. 2002. *Art for Networks.* Exhibition, Chapter Arts, Cardiff. Documentation available at http://irational.org/artfornetworks.

Popper, Frank. 1993. "The Place of High-Technology Art in the Contemporary Art Scene." *Leonardo* 26 (1): 63–69.

Popper, Frank. 1975. *Art: Action and Participation.* London: Studio Vista.

Powers, David. 1998. *Loebner Prize Competition.* Available at http://www.cs.flinders.edu.au/research/AI/LoebnerPrize.

Purves, Ted. 2006. "Maria Lind—Tactical/Agnostic Artist—Ted Purves 4/26/2006." Available at the Leisurearts Web site, http://leisurearts.blogspot.com/2006/04/maria-lind-tacticalagnostic-artist-ted.html.

PVA Medialab. 2005. *LabCulture Report 2004/05*. Bridport, U.K.: PVA Medialab. Available at http://www.pva.org.uk.

Quaranta, Domenico. 2006. "The Last Avant-Garde: Interview with Mark Tribe & Reena Jana." *Thingist,* 30 October. Available at http://www.nettime.org/Lists-Archives/nettime-l-0610/msg00087 .html.

Quigley, Suzanne. 2006. "Re: July/August 06 Theme: Permanence and Public Art." *New-Media-Curating Discussion List,* 13 July.

Randolph, Sal. 2008. *Notes on Social Architectures as Art Forms.* Available at http://thoughtmesh.net/publish/231.php#.

Ranzenbacher, Heimo. 2001. "Metaphors of Participation: Rafael Lozano-Hemmer Interviewed by Heimo Ranzenbacher." Paper for Ars Electronica Festival 2001. Available at http://www.aec.at/festival2001/texte/lozano_e.html.

Raqs Media Collective. 2003. "A Concise Lexicon of/for the Digital Commons." In *Sarai, Sarai Reader 03: Shaping Technologies,* 357–365. Delhi: Sarai and De Waag.

Ravelli, Louise. 2006. *Museum Texts: Communication Frameworks*. London: Routledge.

Raven, Arlene. 1989. *Art in the Public Interest*. Ann Arbor, Mich.: UMI Research Press.

Redler, Hannah. 2006. Unpublished interview with Sarah Cook. 21 March. Notes by Sarah Cook.

Redler, Hannah. 2001. "Hannah Redler: C-Plex, Sandwell." Paper presented at the "I'll Show You Mine If You Show Me Yours . . ." workshop on new media spaces, 13 October, the Media Centre, Huddersfield, U.K. Available at http://www.crumbweb.org/getPresentation.php?presID=2.

Rellie, Jemima. 2004. "One Site Fits All: Balancing Priorities at Tate Online." In David Bearman and Jennifer Trant, eds., *Museums and the Web 2004: Proceedings*. Arlington, Va.: Archives & Museum Informatics. Available at http://www.archimuse.com/mw2004/papers/rellie/rellie.html.

Rellie, Jemima. 2003. "Intervention and Subvention." *Olats Artmedia* 8. Available at http://www .olats.org/projetpart/artmedia/2002eng/te_jRellie.html.

Rieser, Martin, and Andrea Zapp, eds. 2001. *New Screen Media: Cinema, Art, Narrative*. London: BFI.

Riley, Robert R. 1999. *Seeing Time: Selections from the Pamela and Richard Kramlich Collection of Media Art*. San Francisco: San Francisco Museum of Modern Art.

Rinehart, Richard. 2005. "A System of Formal Notation for Scoring Works of Digital and Variable Media Art." In *Media Art Histories Archive Refresh! Presentations*. Available at http://hdl.handle.net/10002/307.

Rokeby, David. 1995. "Transforming Mirrors: Subjectivity and Control in Interactive Media." In Simon Penny, ed., *Critical Issues in Electronic Media,* 133–158. New York: State University of New York Press.

Rollig, Stella. 2004. "Not Yet Mutually Reconciled: The Museum and Media Art." Available in the Ars Electronica Archive at http://www.aec.at/en/archiv_files/20041/FE_2004_rollig_en.pdf.

Ross, David A. 1999a. "Net Art in the Age of Digital Reproduction." *Camerawork* 26 (1): 4–9.

Ross, David A. 1999b. "Transcription of Lecture by David Ross, San Jose State University, March 2, 1999." *Switch* 5 (1). Available at http://switch.sjsu.edu/web/v5n1/ross/index.html.

Ross, David A. 1996. "Radical Software Redux." In Lynn Hershman Leeson, ed., *Clicking In: Hot Links to a Digital Culture,* 344–348. Seattle: Bay Press.

Rugg, Judith, and Michèle Sedgewick, eds. 2007. *Issues in Curating Contemporary Art and Performance.* London: Intellect Press.

Rush, Michael. 1999. *New Media in Late 20th-Century Art.* London: Thames and Hudson.

Sack, Warren. 2005. "Discourse Architecture and Very Large-Scale Conversations." In Robert Latham and Saskia Sassen, eds., *Digital Formations,* 242–282. Princeton, N.J.: Princeton University Press. Also available at http://hybrid.ucsc.edu/SocialComputingLab/Publications/wsack-discourse-paper.doc.

Saper, Craig J. 2001. *Networked Art.* St. Paul: University of Minnesota Press.

Schleiner, Anne-Marie. 2003. "Curation Fluidities and Oppositions among Curators, Filter Feeders, and Future Artists." *Intelligent Agent* 3 (1). Available at http://www.intelligentagent.com/archive/Vol3_No1_curation_schleiner.html.

Scholz, Trebor. 2006. "The Participatory Challenge." In Joasia Krysa, ed., *Curating Immateriality: The Work of the Curator in the Age of Network Systems,* 189–207. Data Browser 03. London: Autonomedia.

Scholz, Trebor, and Judith Rodenbeck. 2006. "Whitney Biennial 06." *New-Media-Curating Discussion List,* 30 May.

Schubert, Karsten. 2000. *The Curator's Egg.* London: One-Off Press.

Schubiger, Caroline. 2005. "Interaction Design: Definition and Tasks." In Gerald Buurman, ed., *Total Interaction: Theory and Practice of a New Paradigm for the Design Disciplines,* 340–351. Basel: Birkauser.

Searle, Adrian. 2002. "Being Here Now." *The Guardian,* 23 July. Available at http://arts.guardian.co.uk/features/story/0,,766127,00.html.

Seijdel, Jorinde. 1999. "The Exhibition as Emulator." *Mediamatic* 10 (1). Available at http://www.mediamatic.nl/magazine/10_1/seijdel_exhibition/seydelem_1gb.html.

Shanken, Edward A. 2007. "Historicizing Art and Technology: Forging a Method and Firing a Cannon." In Oliver Grau, ed., *MediaArtHistories,* 43–70. Cambridge, Mass.: MIT Press.

Shaw, Jeffrey, and Peter Weibel, eds. 2002. *FUTURE CINEMA: The Cinematic Imaginary after Film.* Cambridge, Mass.: ZKM and MIT Press.

Shedroff, Nathan. 2002. "Information Interaction Design: A Unifield Field Theory of Design." Available at http://www.nathan.com/thoughts/unified/index.html.

Sherman, Tom. 2002. *Before and after the Information Bomb.* Edited by Peggy Gale. Banff, Canada: Banff Centre Press.

Siegelaub, Seth. 2008. "Seth Siegelaub" In Hans Ulrich Obrist, *A Brief History of Curating,* 116–130. Zurich: JRP Ringier & Les Presses Du Réel.

Simmons, Ian. 1999. "Exhibit *Building Secrets 2*—What Visitors Do." Available at the British Interactive Group—*Exhibit Building Secrets* Web site, http://www.big.uk.com/knowledgebase/exhibits/exhibit_building_secrets_2.htm.

Skrebowski, Luke. 2006. "All Systems Go: Recovering Jack Burnham's 'Systems Aesthetics.'" *Tate Papers* (Spring). Available at http://www.tate.org.uk/research/tateresearch/tatepapers/06spring/skrebowski.htm.

Sollfrank, Cornelia. 2004. "Project descriptions: *Female Extension, Net.art Generator.*" In Cornelia Sollfrank, *Net.art Generator,* 132–137. Nurnberg: Verlag fur Moderne Kunst.

Spellman, Naomi. 2004 . "Re: Locative." *New-Media-Curating Discussion List,* 17 May.

Stalder, Felix. 2008a. *Open Cultures and the Nature of Networks.* Novi Sad, Serbia: Futura Publikacije and Revolver.

Stalder, Felix. 2008b. "Torrents of Desire and the Shape of the Informational Landscape." In Branka Curcic, Zoran Pantelic, and New Media Center_kuda.org, eds., *Public Netbase: Nonstop Future. New Practices in Art and Media,* 88–95. Frankfurt: Revolver.

Stalder, Felix. 2006. "On the Difference Between Open Source and Open Culture." In Marina Vishmidt with Mary Anne Francis, Jo Walsh, and Lewis Sykes, eds., *Media Mutandis: A NODE.London Reader. Surveying Art, Technologies, and Politics,* 188–196. London: NODE, Mute.

Stallabrass, Julian. 2003. *Internet Art: The Online Clash of Culture and Commerce.* London: Tate.

Staniszewski, Mary Anne. 1998. *The Power of Display: A History of Exhibition Installations at the Museum of Modern Art.* Cambridge, Mass.: MIT Press.

Stein, Suzanne. 2008. "Interview: Rudolf Frieling on the Art of Participation." *SFMOMA | Open Space >> The Art of Participation.* Available at http://blog.sfmoma.org/2008/11/05/interview-rudolf-frieling-on-the-art-of-participation.

Stenakas, Carol. 2001. Presentation at the "I'll Show You Mine If You Show Me Yours . . ." workshop on new media spaces, 13 October, the Media Centre, Huddersfield, U.K. Notes by L. Wurstlin. Available at http://www.crumbweb.org/getPresentation.php?presID=9.

Stevens, May. 1980. "Is the Alternative Space a True Alternative?" *Studio International* 195 (990): 69–73.

Stone, Allucquére Rosanne. 1995. "Cyberdammerung at Wellspring Systems." In Mary Anne Moser and Doug McCleod, eds., *Immersed in Technology: Art and Virtual Environments,* 103–117. Cambridge, Mass.: MIT Press.

Struppek, Mirjam. 2002. "Interactionfield—Public Space." Available at the CultureBase Web site, http://culturebase.org/home/struppek/HomepageEnglisch/Kategorien.htm.

Sutton, Gloria. 2004. "Taxonomies, Definitions, Archives, Etc." *New-Media-Curating Discussion List,* 7 September.

Sutton, Gloria, Trebor Scholz, and J. Fiona Ragheb. 2002. "Voiceover." *Afterimage* (May–June): 18.

Svenle, Elna. 2006. "Interview with Magnus af Petersens and Ulf Eriksson." *EAI Online Resource Guide for Exhibiting, Collecting, & Preserving Media Art.* Available at http://resourceguide.eai.org.

Tate. 2001. "Moving Image as Art: Time-Based Media in the Art Gallery." Available at http://www .tate.org.uk/onlineevents/archive/ic.htm.

Thea, Carolee. 2001. "Barbara London 12/2000." In *Foci: Interviews with Ten International Curators,* 112–123. New York: Apex Art Curatorial Program.

Thomas, Catherine, ed. 2002. *The Edge of Everything: Reflections on Curatorial Practice (Naming a Practice).* Banff, Canada: Banff Centre Press.

Thompson, Sarah. 2002. "Re: Curating Critically." *New-Media-Curating Discussion List,* 12 February.

Thomson, Jon. 2002. "A Good Curator." *New-Media-Curating Discussion List,* 13 March.

Thomson, Jon, and Alison Craighead. 2006. "Response to 'TELEMATIC, ROMANCE, AND THE POETICS OF TIME AND PLACE'" *Personal Debris Blog,* 13 September. Available at http://www .personaldebris.com.

Usselmann, Rainer. 2003. "The Dilemma of Media Art: Cybernetic Serendipity at the ICA London." *Leonardo* 36 (5): 389–396.

Van Heeswijk, Jeanne. 2000. "The 21st-Century Museum—a Pre-programmed Game Machine?" In Gavin Wade, ed., *Curating in the 21st Century,* 71–78. Wolverhampton, U.K.: New Art Gallery, Wallsall, and University of Wolverhampton.

Van Heeswijk, Jeanne, Axel Lapp, and Anja Lutz. 2007. *Jeanne van Heeswijk: SYSTEMS.* Berlin: The Green Box.

Van Mourik Broekman, Pauline. 2005. "On Being 'Independent' in a Network." In Will Bradley, comp., *From Tomorrow On: Art, Activism, Technology, and the Future of Independent Media,* 5–8. Manchester, U.K.: MIRIAD, Manchester Metropolitan University. Also available at http://freebitflows .t0.or.at/f/about/broekman.

Van Mourik Broekman, Pauline. 2004. "*Mute:* Ceci n'est pas un magazine." In Lucy Kimbell, ed., *New Media Art: Practice and Context in the UK 1994–2004,* 270–274. London: Arts Council of England.

Viola, Bill. 2003. "Will There Be Condominiums in Data Space?" In Noah Wardrip-Fruin and Nick Montfort, eds., *The New Media Reader,* 463–470. Cambridge, Mass.: MIT Press.

Vishmidt, Marina. 2006a. "Introduction." In Marina Vishmidt with Mary Anne Francis, Jo Walsh, and Lewis Sykes, eds., *Media Mutandis: A NODE.London Reader. Surveying Art, Technologies, and Politics,* 3–5. London: NODE, Mute.

Vishmidt, Marina. 2006b. "Twilight of the Widgets." In Joasia Krysa, ed., *Curating Immateriality: The Work of the Curator in the Age of Network Systems,* 39-62. Data Browser 03. London: Autonomedia.

Vishmidt, Marina, with Mary Anne Francis, Jo Walsh, and Lewis Sykes, eds. 2006. *Media Mutandis: A NODE.London Reader. Surveying Art, Technologies, and Politics.* London: NODE, Mute.

Wade, Gavin, ed. 2000. *Curating in the 21st Century.* Wolverhampton, U.K.: New Art Gallery, Wallsall, and University of Wolverhampton.

Weinbren, Grahame String. 1995. "Mastery: Computer Games, Intuitive Interfaces, and Interactive Multimedia." *Leonardo* 28 (5): 403–408.

Weintraub, Linda. 2003. "Political Success—Diffusing Concentrations of Power: Daniel Joseph Martinez." In *Making Contemporary Art: How Today's Artists Think and Work,* 374–383. London: Thames and Hudson.

Wellsby, Claire. 2008. *Interventtech.* Available at http://interventtechnewsandreviews.blogspot .com/2008/10/ekow-eshun-close-live-media-arts-at-ica.html.

Whid, T. 2006. "New Media Art Shouldn't Suck." *Rhizome Digest,* 18 August. Available by e-mail at digest@rhizome.org.

Willats, Stephen. 1976. "From Objects to People: Interaction in the Art Museum." In Christian Kravagna and Kunsthaus Bregenz, eds., *The Museum as Arena: Artists on Institutional Critique,* 62–64. Cologne: Walter Konig.

Wilson, Mick. 2007. "Curatorial Moments and Discursive Turns." In Paul O'Neill, ed., *Curating Subjects,* 201–206. Amsterdam and London: De Appel and Open Editions.

Wilson, Stephen. 2001. *Information Arts.* Cambridge, Mass.: MIT Press.

Winet, Jon. 1999. "Riding the Tiger." Available at Jon Winet's Web site, http://www.uiowa.edu/ ~interart/jwinet/dossier/works/riding_the_tiger.pdf.

Wood, William. 2000. "Still You Ask for More: Demand, Display, and 'the New Art.'" In Peter Wollen, Michael Newman, and Jon Bird, eds., *Rewriting Conceptual Art,* 66–87. London: Reaktion Books.

Woolley, Benjamin. 1992. *Virtual Worlds: A Journey in Hype and Hyperreality.* Oxford: Blackwell.

Wooster, Ann-Sargent. 1991. "Reach Out and Touch Someone: The Romance of Interactivity." In Doug Hall and Sally Jo Fifer, eds., *Illuminating Video,* 275–303. New York: Aperture.

Youngblood, Gene. 1999. "Virtual Space: The Electronic Environments of Mobile Image" (excerpt). In Timothy Druckrey with Ars Electronica, eds., *Ars Electronica: Facing the Future,* 360–365. Cambridge, Mass.: MIT Press.

Youngblood, Gene. 1986. "VIRTUAL SPACE—the Electronic Environments of Mobile Image." Available in the Ars Electronica Archive, http://www.aec.at/en/archives/festival_archive/festival_catalogs/ festival_artikel.asp?iProjectID=9296.

Zentrum für Kunst und Medientechnologie (ZKM) and Margaret Morse, eds. 1998. *Hardware-Software-Artware: Confluence of Art and Technology. Art Practice at the ZKM Institute for Visual Media 1992–1997.* Ostfildern, Germany: Cantz.

Zimmer, Robert. 2007. *Culture-Mining: Time-Based Cultural Documents and Online Meaning-Based reSearch Tools.* A Tate Research project. Available at http://www.ahrcict.rdg.ac.uk/activities/strategy _projects/zimmerupdate.pdf.

Zimmerman, Patricia. 2001. "The Role of New Media Art Education and Curators." *New-Media-Curating Discussion List,* 25 March.

Zurbrugg, Nicholas. 2004. *Art, Performance, Media: 31 Interviews*. Minneapolis: University of Minnesota.

Zurbrugg, Nicholas. 2000. "Postmodernity, Metaphore Manquée, and the Myth of the Trans-avant-garde." In Nicholas Zurbrugg, ed., *Critical Vices: The Myths of Postmodern Theory*, 41–63. Amsterdam: G&B Arts International.

Index

Exhibition and artwork titles are shown in *italics*. Illustration page numbers are in **bold**. (*See also* exhibitions index.)

Exhibitions Index

Curators' or directors' surnames appear after the title of the exhibition. Illustration page numbers are in **bold**.